The Igor Moiseyev Dance Company

The Igor Moiseyev Dance Company
Dancing Diplomats

Anthony Shay

intellect Bristol, UK / Chicago, USA

This book is for my dear friend Philip C. Nix

First published in the UK in 2019 by
Intellect, The Mill, Parnall Road, Fishponds, Bristol, BS16 3JG, UK

First published in the USA in 2019 by
Intellect, The University of Chicago Press, 1427 E. 60th Street,
Chicago, IL 60637, USA

A catalogue record for this book is available from the
British Library.

Copy-editor: MPS Technologies
Cover designer: Aleksandra Szumlas
Cover image: Painted by Khosrow Jamali
Production manager: Jessica Lovett
Typesetting: Contentra Technologies

Print ISBN: 978-1-78320-999-6
ePDF ISBN: 978-1-78938-012-5
ePUB ISBN: 978-1-78938-011-8

Printed and bound by Short Run Press Limited, UK.

This is a peer-reviewed publication.

Contents

Acknowledgments

One of the most joyous tasks that an author can exercise is thanking the many individuals and organizations that provide help and support along the journey of creating a study. First, I want to thank my colleagues and the administration of Pomona College for the generous support for travel they provided for me as I conducted research and wrote this book. Two Pomona College research grants enabled me to travel to New York, Cres, Croatia, and Moscow. Thank you also to Pomona College for the generous subvention to support the publication of this book.

I also thank the unsung heroes of the library staff, especially Holly Gardinier, at the Honnold Mudd Library of the Claremont Colleges and the New York Public Library Jerome Robbins Dance Collection.

I thank Gediminas Karoblis and Egil Bakka of the University of Norway, Trondheim, who run the European Union's Choreomundus Project, and all of the students who took part in the program, for generously inviting me, as a pioneer researcher, to both join in the teaching project and for inviting me to give a lecture on Igor Moiseyev and The Igor Moiseyev Dance Company in May of 2015. I had a fascinating time bouncing ideas off the students and I most enjoyed the discussions I had with Gediminas on modernism and the Ballets Russes, for which we both have a fascination.

I want to thank Elena Shcherbakova, the successor to Igor Moiseyev's artistic mantle, which he personally passed on to her, and her staff and the performers who hosted me in Moscow in May and June 2016, during their busy rehearsals and concert preparations. It gave me the opportunity to see the company up close and realize that they still have the magic that Igor Moiseyev instilled in them and which they carry out with reverence to his memory. All images throughout this book are sourced and used with permission from the The Igor Moiseyev Ballet.

I wish also to express my gratitude to Mieczslaw Buduszynski, my colleague in the Politics Department at Pomona College, who generously offered me the opportunity to present a lecture at the Politics Seminar that he directs annually on the Island of Cres, Croatia in July 2017, in which I lectured on the influence of Igor Moiseyev, not only in dance, but in the politics of the Cold War and the establishment of state-supported dance companies throughout the Communist World and beyond to give meaning to the term "choreographic politics."

I thank Philip C. Nix, a good and patient friend, who read every page of the many drafts I produced and gave me much needed feedback from the viewpoint of an intellectual and interested reader. The recent passing of my dear friend and companion Mario Casillas saddens me because he was always so proud of my writing and wanted to read the book. I have been blessed for the many years we shared together.

I also thank the two unnamed readers of the manuscript who made important suggestions to make the study more effective and save me from errors. Any errors of fact remain mine.

Always, I save for last the heartfelt thanks to my life's helpmate Khosrow Jamali, who always listens to my ideas, offers interesting solutions, and helps to fortify the writing process with delicious meals, love, and support. Without him, life would not be the joyous process it has become.

Introduction

I first met Igor Aleksandrovich Moiseyev when I was 22 years old, just as I was beginning my career in the world of dance. Fortunate circumstances have provided me with the wonderful experiences of being a dancer, choreographer, artistic director, and finally, a dance scholar and historian. My embodied experiences in dance have allowed me to articulate the themes about which I write today, including dancing several Moiseyev works like the *Old City Quadrilles*. In this study I write about the life and career of Igor Moiseyev, dancer, choreographer and artistic director, and his company, which throughout its amazing history awed the world. I want to explore the choreographies he created, his company's impact on world affairs, and how his legacy echoes today.

In its long existence The Igor Moiseyev Dance Company visited over one hundred countries, representing first the Soviet Union, and subsequently its successor state, the Russian Federation, which it still represents more than eighty years after its founding. I am honoring a debt that I strongly feel that I owe Maestro Moiseyev (1906–2007) for my own career. His example of magical choreographies and the powerful performances of his ensemble of virtuosic dancers and musicians empowered me as a young man in my early twenties to attempt to create my own dance company and my own choreographies, which could hold the stage for full evening performances of folk and traditional dance. In the realm of folk dance, this had not been attempted in the United States. I lovingly created many dances for a span of fifty years. I succeeded beyond my wildest dreams, and thus, I owe Mr. Moiseyev a debt to introduce him, or in many cases reintroduce him, to dance students and scholars. In the English-speaking world, Igor Moiseyev is largely forgotten, and little information about him exists. Even many dance historians do not remember him and his long, distinguished, and rich professional career.

This neglect came, in part I believe, because in the 1950s, when The Igor Moiseyev Dance Company first appeared in the United States, dance scholarship had barely begun, and the scholarship that existed at that time was devoted almost exclusively to concert dance, which means ballet, modern dance, and its practitioners. Igor Moiseyev's work constituted a kind of hybrid genre that scholars, and even dance critics of the time were unable to successfully characterize. Some trained observers at that time understood that they were not viewing "authentic" folk dance, and that the Moiseyev dancers clearly had ballet training. Typical of the writing of the time, *The New York Times* dance critic Anna Kisselgoff stated: "The Igor Moiseyev Dance Company is, of course, a ballet company in disguise, it is a troupe of professional, ballet-trained dancers" ("Moiseyev Company Visits

with its Legendary Bravura" Moiseyev Publicity Packet, n.pag.). While partially true, this claim is simplistic and misses several important points. In this study, I am making another, more nuanced argument: Igor Moiseyev actually created a new genre of dance, in which ballet constitutes only one of the elements from which he constructed it. Most of all, he used his new genre to create a new type of spectacle: staged folk dance, what I call ethno-identity dance because it is a genre of dance that is prepared for performances before audiences for purposes of representation, and has specific ethnic references. It is not folk dance by which I mean dances that mostly rural and tribal populations dance as an organic part of their lives (Shay, *Ethno-Identity Dance for Sex, Fun, and Profit*). Quite simply, neither Igor Moiseyev nor the Soviet Government was interested in authentic folk dances, but rather something that they could call folk dance. They wanted and needed spectacle and monumentality, which I can call the celebration of the big that characterized Soviet art and architecture throughout the Soviet era (Bown, *Art Under Stalin*). Igor Moiseyev had the genius to understand that need, to brilliantly fulfill it, and in doing so with such immense international success that other governments and practitioners understood the political and aesthetic power of Moiseyev's choreographies and performances and either imitated, emulated, or were inspired by his model to create dance companies in the Moiseyev image. In this introduction I will highlight some of the themes that I will discuss in the following chapters.

Why Dance? What Kind of Dance?

During the formation of the Soviet Socialist state dance played a crucial role. As dance historian Elizabeth Souritz observes "The 1920s and 1930s, saw a dance boom in Soviet Russia" (21). However, it was only in the beginning of this period, the only time freedom in artistic expression occurred in the history of the Soviet Union, there was a great deal of experimentation in the wake of performances and teaching by Isadora Duncan, under the influence of German *Ausdruckstanz*, and theatrical experimentation that was rampant in Russia at that time. "By the mid-1930s, all tendencies in dance expression except classical ballet and folk idioms were 'outside the law'" (Souritz 21). It is within this climate that Igor Moiseyev created his company.

Contemporaneous with these dance activities in Russia, the opposite happened in the United States. "The antiacademy and anti-elitist basis of modern dance fit nicely within the mission of proletarian culture, just as the proletarian worker proved an eager student and enthusiastic audience for an emergent art" (Graff 319). Thus while modern dance was banned, and its performers were persecuted in the former Soviet Union, ironically it was valorized by communists, fellow travelers, and progressives in the United States. "'Dance Is a Weapon in the Revolutionary Class Struggle' was the slogan of the Workers Dance League, an umbrella organization formed to develop and organize efforts of the various workers'

dance groups" (Graff 319). In the United States "Revolutionary writers and dancers argued over the relative merits of a 'revolutionary' technique. Should it be based on communal and folk forms?" (Graff 319). Thus, it was only over the role of folk dance that these two disparate groups could agree.

Dance became a potent weapon during the Cultural Cold War, and Igor Moiseyev was the focus and beginning of a new dance genre that dominated world stages for the next half century. His new genre was called folk dance, but it was not folk dance.

Why Folk Dance? Why Folklore: Glorifying the Peasant

For Europeans, particularly in Eastern Europe a virtual shatter belt of ethnicity, throughout the nineteenth and twentieth centuries romantic nationalism swept the Continent and was largely underpinned by folklore studies. I identify the figure of the philosopher Johann Gottfried Herder (1744–1803), as a seminal figure in this movement.[1] "Herder aligned himself with the folk, for the folk was 'the most genuine and unblemished part of the nation and therefore should be the authentic interpreter of the national spirit'" (Coccharia 174). This statement, which Herder first enunciated in 1767, later resulted in a quest for language-based folkloric expression: "Collecting lieder became a national duty" (Coccharia 175). Perhaps among the most famous of these efforts was that of the Grimm Brothers, Jacob and Wilhelm, who published the famous fairy tale collection, *Kinder- und Hausmärchen* (1812–14) that are still widely read today. Thus, the folk and their language-based cultural production proved, in the eyes of the romantic nationalists, the most pure and authentic expression of national identity. These folklorists and philologists collected folk poetry, stories, songs, humor, riddles, and sayings because wherever these existed in village settings, that was where German, Russian, or Estonian nationality existed and, by extension, the nation states that came into existence had the right to the territory on which these cultural practices existed. In the beginning, collectors often noted the verses without the music, but over the next century, games, music, and dance also became more proof of the national patrimony. They receive scant attention in Coccharia's study.

By the Soviet period, folk dance and music offered symbolic representation of the national soul, not sourced in its authentic village forms, but as a field to be mined for purposes of representation on domestic and international stages. This dovetailed with the announcement of socialist realism, first advanced in 1932. Moiseyev's colorful "its fun in the village" scenes fit well with the newly "instituted elusive aesthetic doctrine of 'socialist realism', advocating the portrayal of an idealistic reality in its 'revolutionary development'. In so doing, the resolution ended a period of flexibility and began an era of state controlled cultural regimentation" (Ferenc 13). Almost every scholar of the Soviet Union notes the ambiguity in meaning and execution that social realism presented as an aesthetic concept. In

short, I would describe it not as reality, but the artist is bound to show how life and art could be in the best sense of the word. I will explore this topic in more depth later in the study.

Igor Moiseyev's New Dance Genre

One of the main points that I stress in this book is that Moiseyev created a new dance genre, which the Soviet authorities called folk dance. Denied and frustrated at not achieving success in his chosen path as a ballet choreographer at the Bolshoi Ballet, Moiseyev wisely turned to folk dance in the early 1930s, in its many authentic and ethno-identity iterations, as a source for his future work. Through the 1930s, when the Soviet Union increasingly turned to folklore and folk dance in its ethno-identity forms as a primary field of representation of the state and its multiethnic peoples, Moiseyev saw opportunity for developing his choreographic skills. Climaxing a series of directorial activities in festival settings through the 1930s, he ultimately created the dance company that dazzled the world. In a time of travel restrictions for the Soviet people, Moiseyev and his dancers traveled the world and created political capital for both the former Soviet Union and the Russian Federation. Audiences around the world expressed admiration and awe over the company's performances as they do today. Dance historians Nancy Reynolds and Malcolm McCormick observe: "Although many of Moiseyev's concert numbers were no more (and no less) than elaborated folk material, such dances as *Bulba* (1937) a harvest piece from Belorussia (which Moiseyev created out of whole cloth rather than an extant folk dance); *Kolkhoz Street* (1938), about the satisfactions of collective farming; and *The Partisans* (1950), an encomium to the brave of World War II, indicated Moiseyev's political commitment" (254). The creation of new themes and contexts for dance, which celebrated work and patriotism, and Marxist idealizations of peasants' and workers' labor, secured Moiseyev's place in the Soviet artistic hierarchy, and added to his new genre.

Igor Moiseyev's new dance genre used elements from ballet character dance but using boots and shoes rather than ballet shoes, some authentic folk dance steps and figures, new movements, mass synchronized movements, planned choreographies, more intricate and varied group patterns and new innovative floor patterns, for which Moiseyev had a special inventiveness, the use of gymnastics and athletics, especially in the form of the squats and kicks known as *prisyadki*, new contexts and themes such as *Pictures of the Past* and battle scenes found in *The Paritsans*; professionally trained dancers; "its fun in the village" scenes; stylized musical and rhythmic accompaniment; and stylized, streamlined, color-coordinated costuming. He was especially adept at creating new mass movement patterns, never seen in the specific way in which he had created them (see Chapter 6). All of these elements contributed to the creation of Igor Moiseyev's new dance genre, which do not exist in traditional folk dance contexts. These are the ingredients for choreographic spectacle. There could be no mistaking Moiseyev-spectacularized dances with folk dance in the field for the insightful viewer.

Moiseyev honed the technical elements of choreography that he understood would appeal to both the political elite and the common man and woman, and created choreographies that raised him to the pinnacle of artistic fame in both the former Soviet Union and in the Russian Federation. When I was in Russia in 2016, Vladimir Putin was planning to send the company to Greece to celebrate the millennium of the Orthodox Christian faith in the fall of 2016 according to the current artistic director, Elena Shcherbakova (personal interview, May 28, 2016).

Born in 1906, he lived through the Russian Revolution and the difficult years that followed when starvation and want stalked Russia, through Stalin's terror, in which he was extremely visible and vulnerable because he was personally known to the Soviet leader when Stalin, at a whim, named individuals, some of whom had helped Moiseyev, calling them "enemies of the state," and had them summarily executed. In his autobiography, *I Remember* (*Ya Vsponimaiu*), Moiseyev recounted how he never knew if Stalin's hand on his shoulder, literally, indicated whether he would live or die. He was once called into the NKVD and wondered if he would leave alive, indicating that the Soviet population, especially those living in Moscow under Stalin's nose, knew that they were in the midst of Stalinist terror, and Stalin was so capricious that one never knew when exile, torture, and execution would be one's fate (Moiseyev, *Ya Vsponimaiu* 36). The Igor Moiseyev Dance Company was Stalin's favorite dance company, which may well have saved him. Later, as the Cold War began to slightly thaw, the Soviet government chose the company to be the first Soviet attraction to appear in the West. This history, in part, tells that fascinating story, emphasizing the central role that Igor Moiseyev played in that historic event: the launching of the Cultural Cold War. Thus, the first 1958 tour, which I witnessed, is one of the central dramas in Moiseyev's narrative and one of the focuses of this study.

I want to bring the reader into the complex edifice of the life of Igor Moiseyev and the place of his dance company by looking at the times in which he lived and the context in which he created his works. In order to understand the life, career, and the choreography of Igor Aleksandrovich Moiseyev, I will train three important historical and scholarly lenses on the descriptions and analyses of his work: spectacle, Russian nationalism, and the Cultural Cold War. Without paying attention to those three phenomena, it is not possible to understand the full impact and salience of Igor Moiseyev's choreographic output and career.

The Problem with Russia

When I began this study in 2015, prior to the election of Donald Trump, Russia did not occupy the news as it does today. Following the election of 2016, in many ways the adversarial position of the Russian Federation and the United States has become similar to the way Americans were fascinated with the Soviet Union, and its leaders in 1958, when The Igor Moiseyev Dance Company became a catalyst for the Cultural Cold War. Americans did not, in general, know

the difference between Russia and the Soviet Union, and, with the exception of a few scholars, they used the two terms interchangeably. The relevance of this study seems to grow as the Russian scandal in the White House has come to occupy every newscast, because newscasters regularly compare the two eras. Igor Moiseyev and his company were very much a part of the former era and my hope is that my analysis and descriptions of his life and times can shed light on what that historical period was like.

As I wrote this book, I realized that I had to take a long step back in order to clearly see Igor Moiseyev and his place in history. Raised at the height of the Cold War and McCarthyism, I felt a familiar negative knee-jerk reaction and emotion to the Soviet Union that was always depicted in American propaganda and which I, along with millions of other children of the era were fed, as a drab, Orwellian, creation-killing society; communism was a poison that could infect innocent young Americans. Indeed, I had three times traveled to the Soviet Union (1977, 1986, 1989) and saw Soviet life up close and there were enough aspects of the Soviet Union that I saw that supported such a reaction, but it was far from the total reality. I had to take that step so that I could look at Mr. Moiseyev and his place in the Soviet system to make a clear-eyed analysis of both the advantages of that system and its drawbacks. One cannot compare Moiseyev with any Western dance figure because the ways in which art functioned in the former Soviet Union and the West were so different. I realized that had not Josef Stalin's paranoia required the enormous financing of an immense military complex at the expense of providing social services and goods for the benefit of the Soviet general population, the history of Soviet Union might have been very different. This lack, combined with the climaxing of the disastrous invasion of Afghanistan (which America has repeated), created the circumstances for the collapse of the monolithic state. The Soviet Union had a command economy; everything that occurred in the former Soviet Union had to begin at the center; there was little space for individual initiative. Igor Moiseyev had to carve out his professional life in that context. By that statement, I do not wish to imply that Igor Moiseyev was a pawn in a soulless system, but rather he was an astute man who knew the system and how to succeed under the circumstances he had been given. And, succeed he did!

This did not mean that artists could not create, but in that setting, it had to be in the service of the state. Soviet authorities neither understood nor tolerated art for art's sake, they capitalized on its political meanings. Igor Moiseyev understood that (Moiseyev, *Ya Vsponimaiu*; *Ya Vsponimaiu*, updated edition), and still managed to be creative. I had to set aside my prejudices and assumptions about the Soviet system as the totally evil environment that Americans were taught, and I found that taking that step back was intellectually liberating to see both Igor Moiseyev's Soviet Union and my America more clearly. While many Americans certainly lived better than their Soviet counterparts, like all systems there were winners and losers. In the Soviet system, artists, athletes, and the ruling military and civil elite, the so-called *nomenklatura*, were winners and received enormous support, had countryside homes and access to luxury goods, and led good lives, unless, like Dmitri Shostakovich, they did not work comfortably within the system. In the American system, the rural and urban poor and ethnic, racial, and sexual minorities were largely the

losers. Many deserving artists did not receive support, many deserving young people never made it to college. Americans willfully turned a blind eye to the reality of class and privilege, as they largely do today, clinging to the Horatio Alger myth that everyone could make it to the top if they just tried hard enough.

I found taking that critical step backward was crucial in understanding not only the Soviet system, but also in understanding Mr. Moiseyev and his fascinating career and creative life within that system. For balance, to compare Moiseyev's successful career to an artist with a more tortured legacy, I briefly look at Dmitri Shostakovich's more troubling life and the dark trajectory of his creative career, in which he experienced persecution and suffering under that same system, which hounded him to despair, and which many in the West were largely unaware of because his music has enjoyed so much success here.

I came to realize that not everything about the former Soviet Union was repugnant. Their finest hours were in the construction of the socialist state in the 1950s when their economy expanded exponentially and their role in World War II was significant. Within weeks of the German attack in 1941, they recovered militarily and the civil population was moved east and within days they had set up factories and millions of Soviet citizens were laboring mightily to save the homeland. From all accounts, America and Great Britain could not have defeated Nazi Germany without the herculean efforts of the Soviet population. "Simply put, the Soviets out produced the Germans" (Fuller 331). It was their finest hour.

In general, Europeans had a much more balanced and nuanced perception of the Soviet Union than Americans, which allowed them, for example, to construct social safety nets and health systems that covered their entire population. The term "socialism" was not an epithet, and in most of Western Europe a version of it was embraced. Several of the European nations, like France and Italy, tolerated communist parties, which allowed them to see the Soviet Union in a more realistic light, both the negative and positive aspects. When the Soviet Union invaded Hungary in 1956 and Czechoslovakia in 1968, many of the more idealistic Communistic Party members in those countries recoiled at Soviet brutality and left the party. Americans, by contrast, reacted to the former Soviet Union with hysteria (see Chapter 3).

In conducting the research for this study, peeling through the layers of simplistic and always sunny verbiage written by Soviet sources and the program notes of his American tours about Mr. Moiseyev and his career, I uncovered the fact that not only had he created a new dance genre, but he occupied an even more central role in the Soviet Union's dance scene than I had imagined in earlier studies that I had written (Shay, *Choreographic Politics*; "Spectacularization of Soviet/Russian Folk Dance"). He became the central mover in a huge network of a state-sponsored amateur folk dance company movement that was spearheaded by the Soviet Union beginning in the 1930s. The government created courses for the directors and they provided cultural centers, appeared in large state-wide festivals throughout the nation, and the system ultimately produced professional folk dance ensembles that appeared outside the country as a major field of representation for the Soviet Union. Thus, Moiseyev did not create the new

dance genre only for his dance company, and then others simply emulated him. Rather, his new genre, first developed for amateur folk dance companies that engaged millions of participants that were housed in cultural centers, factories, kolkhozs (collective farms) and other social centers around the Soviet Union, became ubiquitous. The movement ultimately culminated in the formation of his own ensemble, the first professional folk dance company in the world. Russian dance historian Tatyana Aleksandrovna Filanovskaya calls this new genre "the new staged (*stsenicheskoi*) form of folk dance" (218) in spite of the fact that all of the literature produced in the Soviet Union referred to it as folk dance. This confusing use of the term "folk dance," which I will deal with throughout this study, ultimately drove me to create a new term, ethno-identity dance, to differentiate the dance genre that Moiseyev created, widely emulated by national dance companies around the world, from actual folk dance in the field (Shay, *Ethno-Identity Dances for Sex, Fun and Profit*) "Dance had a new function, to serve the state. Such a climate led to the virtual canonization of folk dance as the true expression of the people" (Reynolds and McCormick 254). The ultimate goal of this new genre of dance was to represent the Soviet Union as a happy, optimistic society in which people were happy dancing innocent folk dances, an important manifestation of social realism, the guiding principle of art creation in the former Soviet Union.

From this organizing of how the new folk dance genre was to be taught resulted in the creation of courses for artistic directors of these amateur companies. Filanovskaya notes that in the year 1934, 22,400 individuals attended these courses. That indicates how important the system that Moiseyev developed became to the Soviet Union in determining how folk dance was to symbolically represent the nation. Building on these courses, beginning in 1931 and continuing over the next two decades, so-called choreographic institutes (*koreografski instituty*), which in fact were high schools for the arts, in this case dance, were founded and produced graduates who took their places in classical ballet companies, folk dance companies, or in other professional capacities, such as teachers. These dances were taught in public schools (see Shay, *Choreographic Politics*).[2]

Following the signing of the Lacy-Zarubin agreement (named for the two negotiators) in 1958 The Igor Moiseyev Dance Company was the first Soviet company to perform in America as part of the Cold War cultural exchange. The results were breathtaking. As dance historian Naima Prevots succinctly put it: "The Igor Moiseyev Dance Company took America by storm" (71). I saw that first performance in Los Angeles, and later that year at the World Fair in Brussels. It was a life-changing event for me, and I am sure, for many others who witnessed the company's performances.

The State Department and the Military Industrial complex were totally unprepared for this first act of the Cultural Cold War. The company's victorious coup set the stage for the Soviet-American cultural exchange that ensued for the next thirty years in which dance would be a key element. The rush was on between the two sides to see who had the most spectacular and aesthetically pleasing dance companies to symbolically represent vibrant

youthfulness and athleticism, and by implication, military superiority. America wanted to appear as spectacular as the Soviet Union, but was totally unprepared. America had never officially supported the arts, except briefly during the Depression, much less dance. That changed after the 1958 Moiseyev and 1959 Bolshoi Ballet tours. "The belated arrival of government funding in America in the mid-1960s – unlike Europe, where artistic subsidies had long been a matter of course – was a decisive factor in keeping the momentum of the dance boom alive. Historically, the arts had not been an important factor in its national life, as they were seen to serve only the privileged few; the arts were considered effeminate, and, moreover, it was believed that a nation of capitalists should generate entertainment that paid for itself" (Reynolds and McCormick 495). Compared to the Soviet Union at that time, we had little in professional dance that could be offered, largely due to its associations with homosexuality, elitism, and intellectualism in the anti-intellectual, conformist 1950s. For the first time America was prepared to spend millions of dollars on the arts to face down the Soviet threat, and fight an artistic battle. In order to do this, Americans had to be prepared to like the arts. Television became a major vehicle for education, featuring dance companies, symphony orchestras, especially the New York Philharmonic with Leonard Bernstein giving music lessons, opera, and brilliant theatrical performances, unknown before or since.

It would be almost impossible for anyone not present at those first appearances to grasp the impact that The Igor Moiseyev Dance Company made on American audiences. As Americans were less experienced dance watchers than Europeans, because good ballet existed only in a few urban centers like New York, Chicago, and San Francisco, it should be no wonder that the country was "taken by storm."[3] It would be safe to say that jaws dropped both at the live concerts and on the *Ed Sullivan Show* where some forty million viewers saw The Igor Moiseyev Dance Company perform (Prevots). It certainly challenged the American government, which was totally unprepared for the threat it perceived in the huge success that The Igor Moiseyev Dance Company achieved in humanizing the Soviet Union through its performances.

Great differences existed between a man of Moiseyev's generation, and mine. For example, issues of authenticity in folk dance, which dominated my thinking and aesthetic production, were diametrically 180° distant from Moiseyev's, who, I will argue in this study, created a new dance genre, distant from what I call folk dance in the field. This is due to the nineteenth-century world view that he inherited from his experience with character or national dance in ballet that he underwent in his Bolshoi training in the early twentieth century. He and many others who underwent that training felt that they could "study" people and extract the one or two most basic elements in their "national" character and distill it in their choreographies. As a trained anthropologist, that attitude feels naïve and simplistic, but nineteenth- and early twentieth-century audiences believed that when they saw the Spanish or Italian national variation in ballets like *Swan Lake* and the *Nutcracker*, they were experiencing authentic Spanish and Italian national characteristics. It was a form of travel and the choreographer was their guide.

Moiseyev's dances also encapsulated the attitudes toward the well-known prudish gender and sexual attitudes that were commonplace in the former Soviet Union, which, despite the presence of pornography, continue under Putin's Russian Federation. Quite simply, the Soviets were puritanical and uncomfortable with any public expression of sexuality. "We know that Stalin was outraged by sexual scenes in literature, theatre, and film. Rather crude in his own life and free with swear words in his small circle, the ruler could not stand sex in art" (Volkov 95). Stalin was reflecting the general attitudes of the Soviet population. Igor Moiseyev's choreographic depictions of young, almost asexual appearing characters never crossed this line, which was characteristic of the arguably prudish attitudes that characterized Russia throughout Soviet history. Igor Moiseyev never made a show of sex, which probably contributed to his success in an equally puritanical 1958 America, as the country was still in shock from the appearance of the Kinsey reports a few years earlier (*Sexual Behavior in the Human Male*; *Sexual Behavior in the Human Female*).

All of this digging into the life of Igor Moiseyev and his dance company led me down unexplored academic paths that have continued to fascinate me to this day in which I address issues of ethnicity and nationalism, gender and sexuality, and the history of the turbulent political period following World War II. For all of these reasons, I have chosen to write about Igor Moiseyev and his resilient company, because of his pivotal role in the Cultural Cold War, and his contributions to the construction of Russian ethnic and national identity, and national identity in the Soviet Union resonate in the current political climate.

As a scholar, I studied Igor Moiseyev and his dance company's cultural and artistic output, which demonstrated that dance could have a political component. That was an eye-opening realization for me, as it continues to be for my students. Living in America, one tends to think of dance in three ways: a form of social activity like dancing in a nightclub discotheque or a wedding, dance as an art form like watching a Martha Graham performance or *Swan Lake*, and finally, dancing as entertainment such as the dancing found on Broadway or Hollywood musicals. For Moiseyev, or at least to the Soviet authorities, dance was very much a political vehicle and a diplomatic tool, as he tells us in his autobiography (*Ya Vsponimaiu* 68). It is eye opening for my students that dance can be regarded as political, a shocking concept for those who have been taught art for art's sake. This study will emphasize how choreographic politics dominated world stages over the second half of the twentieth century, and for the reader to understand the arts, especially dance as an embodied art, can in fact produce powerful results in its performances, especially as a field of representation for ethnicity and nationalism. Students are always surprised that several modern nation states and ethnic groups as diverse as Turkey, Ireland, Hawaii, and Ukraine, among others, have turned to dance for building and creating national and ethnic identities (Shay 2016c). This does not merely entail highlighting folk dance traditions in the lives of its peoples, but rather creating what I call ethno-identity dance, that is, dances elaborately and spectacularly arranged and choreographed for purposes of representation to various publics. Ethno-identity dances are used for self-presentation, in order to create national and ethnic identity, to raise

emotions of patriotism and ethnic pride, and to internationally represent one's national and ethnic identity dressed in one's Sunday clothes. The Igor Moiseyev Dance Company was the first to fulfill this role, the first professional folk dance ensemble in the world, and his model became widely emulated by nations of different political stripes. In this study I want to show how this phenomenon, widely emulated once The Igor Moiseyev Dance Company demonstrated what a powerful political tool that a national dance company could be, showed the way. I believe that the "Moiseyev effect" still echoes today in spectacularized performances such as *Riverdance and Anatolian Fire,* as well as the less-political *Cirque du Soleil.*

I will examine Igor Moiseyev's choreographic and movement strategies to describe and analyze how Moiseyev and his company scored enormous political capital for the Soviet Union. Their tours had a major impact on the ways in which people around the world positively viewed the Soviet Union and its peoples. From the outset, The Igor Moiseyev Dance Company created an important front, to use a military term, especially in its first tour of the United States in 1958, when they created a beachhead in the Cultural Cold War. Their subsequent performances here, while always enjoyable and almost always critically acclaimed, never had the impact of the 1958 tour, which produced a shock to the viewers' senses.

Most Americans believe that dance is an innocent and marginal past time or art form, but even more so during the 1950s when The Igor Moiseyev Dance Company's first tour occurred when Americans had much less exposure to serious dance. American government officials and politicians were totally caught off guard at the positive response The Igor Moiseyev Dance Company engendered in its American audiences, especially after the State Department, the military, and Hollywood films prepared Americans through their sometimes crude propaganda to loathe and fear the Soviet Union since the end of World War II (see Prevots *Dance for Export*; Hallinan "Cold War Cultural Exchange"). For those who did not live through the political climate of the Cold War, poisoned by Republican senator Joseph McCarthy, it is important to demonstrate that in the face of the miasma of suspicion that enveloped the American people, Americans nevertheless overwhelmingly responded positively to the performances of The Igor Moiseyev Dance Company. More importantly, they responded directly to the young dancers themselves, seeing them as representatives of the Soviet people who appeared to be "just like us." As an individual wrapped up in folk dancing, meeting the members of The Igor Moiseyev Dance Company, as I did in their first two visits (1958, 1961), they appeared to be very interested and excited about interacting with Americans. They were absolutely charming and it felt genuine.

As historian Victoria Anne Hallinan states in her important dissertation, "The Cold War narrative [...] depended on specific conceptions of American and Soviet identity [...] McCarthyism sought to define a single American identity that was strongly anti-communist" (16). But that is not what occurred. The powerful McCarthy had been taken down. Instead, Americans embraced The Igor Moiseyev Dance Company to a degree that shocked American government officials. The American media and public breathlessly

followed their every move: profiling the dancers, writing about their reactions to supermarkets and department stores, to movie stars and to that peak of American identity and culture: Disneyland.

I will suggest in this study that it was the power of dance, especially the virtuosic dance that Igor Moiseyev created with such success, to shape the ways in which audiences throughout the world viewed his performances, and by extension the Soviet people. I will also suggest in this study that scholars can mine the arts as an under-used lens and conceptual tool with which to view political, social, and economic phenomena more profoundly.

One can safely say that Igor Aleksandrovich Moiseyev enjoyed enormous success at home and abroad. He and many of his company members won many awards throughout his life and that continues today. During the company's tours, many foreign governments feted and honored him and his company. He was an honored artist in his own nation because he fully grasped the political conditions and what kind of aesthetic choreographic products to produce in the political and social climate of his very long life; which began in tsarist Russia, spanned the entire history of the Soviet Union, and continued into the Russian Federation. He choreographed until he was ninety. His company still exists and continues to flourish, and in my visit to them in May and June 2016, they looked as wonderful and enchanting as ever. Clearly Mr. Moiseyev planted a strong tree.

But, Moiseyev created his company at one of the darkest periods in Russian/Soviet history: the period of high Stalinism, a fact never alluded to in program notes. The period of 1936–37, witnessed the height of disappearances, torture, executions, and perhaps ten million people from all walks of life being sent to the Gulag. That was the moment of the founding of The Igor Moiseyev Dance Company. In all of the fluff written by Soviet sources, this story never saw the light of day. For purposes of demonstrating Igor Moiseyev's success and ability to navigate the dark currents of that dangerous period, it is instructive to compare Igor Moiseyev to Dmitri Shostakovich and their relative positions to Josef Stalin, who was rumored to have micromanaged every note, step, and movie frame in Soviet art production (see Moiseyev, *Ya Vsponimaiu*; Volkov, *Shostakovich and Stalin*). As we will see, Moiseyev understood what worked in his dance performances and he created his choreographies within the anti-formalist (meaning not easily accessible to the masses) attitudes established by Stalin and his cultural lieutenant Zhdanov (the repressive state control was called *zhdanovshchina*), while at the same time Shostakovich floundered and very nearly lost his life and sanity in those trying times because his creative aesthetic rejected the state's imperatives of creating within social realism in Stalin's eyes. I will suggest in this study that contrary to the narrative that Soviet publications pushed, as did Moiseyev himself, that all of his success was due to "chance," his success lay in his astute grasp of his time and place. This almost mythic narrative weaves the tale that Moiseyev was simply a guy doing his job, just wanting to dance, allowing chance to guide him to success. By contrast, I will present Igor Moiseyev as a man who carefully and precisely walked on a high wire to the pinnacle of the Soviet art scene, and created a company that became a major arts organization, famous throughout the world. I suggest that instead of the "gotta-dance" guy, he was a well-educated,

sophisticated man who profoundly understood the world around him and his place in it. The climate of the Soviet Union under Josef Stalin was not only dangerous, but also required careful planning in order to attain success. In that world, chance had no place.

My Lenses for This Study

Igor Moiseyev was a man of his time. By that I mean that he profoundly understood the historical, artistic, political, economic, and social events that swirled around him and acted appropriately to maximize his skills and talent to achieve his dreams and ambitions. His life and career spanned over a century and he lived in a time of both high drama and extreme want in the first half of the twentieth century, as well as his highly successful career, which earned him numerous awards, prizes, and honors in the second half. Clearly, he possessed a major choreographic ability and artistry, and I argue that he was especially adept in the movement of large masses of performers. I also argue that Moiseyev was not the King of Chance, as he, and his chroniclers, asserted, but rather I will argue that he was astute, highly intelligent, and had the presence of mind to seize opportunities as they arose throughout his career by creating a decisive weapon in the Soviet diplomatic arsenal. In the 1930s, he understood that folk dance was becoming of extreme importance to the Soviet Union, and was increasingly supported by the state on the amateur level before he founded his company in 1936–37. He seized that opportunity and successfully exploited the possibilities that existed in the creation of a new folk dance genre.

The Soviet Union provided significant funding for recording and notating actual folk dances all over the different republics. Its political use, in Marxist terms was undoubted: "Studies of folk dancing in Soviet times were facilitated by their close connection with the practical tasks advanced by the victory of the revolution and the need to record the richest multinational art of folk dancing and *bring it within reach of the masses*" (Zhornitskaya 79–80, emphasis added). In other words, studying folk dance for learning about it as a branch of learning per se was not the goal, but rather in Marxist terms, what were its uses for the state and the people? As Zhornitskaya observes: "A timely revealing and recording of this heritage will enable us to preserve the folk dancing and theatrical art of these peoples […] as well as *ensuring the further development of folk dancing*" (86, emphasis added). And that further development was Igor Moiseyev's new dance genre, which included spectacle and monumentality, and proved a symbolic boon to the international standing of the Soviet Union.

The Structure of the Book

In Chapter 1 I open with a discussion of spectacle and its meanings. I suggest that the Moiseyev approach to choreography utilized spectacle in a new way, and enabled the state to package a relatively small number of performers into a moveable spectacle. Totalitarian regimes rely on

spectacle, especially in the form of mass gatherings and monumentality, seen in the 1930s and 1940s in Italy, Greece, Germany, Spain, and the former Soviet Union in the forms of gigantic folk festivals and parades and monumental structures as stand-ins for political mass support that they never actually enjoyed. Instead, Moiseyev advanced this agenda in the Soviet Union: he packaged a fully achieved festival with 100 professional dancers and an orchestra that could be ready to tour in a moment. This became a popular weapon in the Cultural Cold War beginning with tours of Eastern Europe right after World War II.

In Chapter 2 I address Russian nationalism, its extremely important and evolving place within the former multiethnic Soviet Union when Moiseyev formed his company, and what elements constitute Russian identity. I first look at nationalism as a relatively recent phenomenon and then I describe and analyze the specific contours of Russian nationalism and how it fits into the nationalism phenomenon that makes it a unique form of nationalism. I look specifically at how The Igor Moiseyev Dance Company formed an important component in the creation of the construction of Russian nationalist identity that the Soviet government actively encouraged, especially at the historic moment in the 1930s when the former Soviet Government began the process of rehabilitating and promoting Russian identities over all other Soviet nationalities, declaring that the Russian had become the ideal Socialist Man. The wily Josef Stalin understood that without the powerful patriotic emotions produced by Russian nationalism, he would be unable to confront Hitler's powerful military machine. The Igor Moiseyev Dance Company's early focus on Russian dances produced strong feelings of Russian identity that fit into Stalin's strategy.

Moiseyev lived to see the example that he set in dance, which was widely emulated and imitated the world over as governments in many regions of the world began to found and finance national dance companies. However, it can be argued that no company, however spectacular, ever outpaced The Igor Moiseyev Dance Company for technical prowess, spectacle, and the ability to make audiences gasp in wonder. Government authorities on both sides of the Iron Curtain understood the Moiseyev model of spectacle and its symbolism, prominently on display at the Brussels World Fair in 1958, and countries with as disparate political hues as the Philippines, Mexico, Iran, Turkey, Ghana, and Senegal, among others outside of the Soviet sphere of influence, understood the value of ethno-identity dance in symbolically creating and displaying national identities. I will argue in this book that not only was he the first to create dance on a scale never seen before, but his company served as the model for the majority of state-sponsored folk dance companies, in which highly virtuosic, choreographed "folk dance," and his spectacularized choreographies also served as the impetus for further iterations of spectacularized dance such as *Riverdance* and *Cirque du Soleil*.

In Chapter 3 I follow the trajectory of The Igor Moiseyev Dance Company, as the first company to appear in the West (France and England 1955, the United States 1958), and address the Cultural Cold War, for example Moiseyev predicted that dance would become a principal weapon. I will argue Moiseyev's appearance triggered a mass support for and

interest in dance as an art form in the United States where it had never been popular before. From the first performances of The Igor Moiseyev Dance Company, America's collective jaw dropped. Americans had never seen such athletic and precision dancing. Media coverage of The Igor Moiseyev Dance Company was intense, and largely favorable, to the great alarm of the American government.

In Chapter 4 I follow the life of Igor Moiseyev, especially in the early 1930s until the Cold War. At that time, prior to his founding of the State Academic Ensemble of the Folk Dances of the Peoples of the USSR, known in the West as The Igor Moiseyev Dance Company (now called The Igor Moiseyev Ballet) in 1936–37, Moiseyev directed several different kinds of parades and folk festivals for which he staged and choreographed mass movement. He had a prodigious memory and remembered every dance and movement he ever saw, from all accounts. No experience went to waste. Everything he ever saw that could be used eventually made its way into his over 200 choreographies. This prepared him and inspired him to suggest to the Soviet authorities that a spectacular folk dance company would provide the state with the symbolic political capital it craved. They agreed, and in early 1937, after a period of preparation, his company began rehearsals.[4]

In Chapter 5 I look at The Igor Moiseyev Ballet. As Victoria Anne Hallinan noted in her dissertation, a great deal of mythology surrounded the company, its origins, and Igor Moiseyev (2013). In Chapter 5 of this study, which is about the history of The Igor Moiseyev Dance Company, I will attempt to get behind the mythology and provide a more real assessment of the company and its history. In part, having founded a folk dance company, and studying many others, no matter how much state support one receives, it takes years to achieve the kind of success that Igor Moiseyev achieved. It is clear that had it been another individual who did not possess Moiseyev's talents and skills, the history and the world's reception of the company might have been quite different. It could easily have been a failure had it not been for the sheer hard work, ambition, and energy of this unique man. However, it became a huge success, winning critical acclaim, accruing political and economic capital, and a model that governments around the world tried to emulate.

The date of his company's founding was not a casual coincidence: it was the culmination of Josef Stalin's drive to use folk song and dance to raise the patriotic feelings and emotions of the Russian population in preparation for the inevitable attempt by Adolf Hitler to conquer the Soviet Union. Igor Moiseyev and his company served as tools of the state's political toolkit to inculcate Russian nationalistic pride in the Russian half of the Soviet population. They also played a role, through their many performances during World War II in not only building patriotic enthusiasm, but building morale among the Soviet forces through their wartime touring.

In Chapter 6 I describe and analyze the movements and choreographic strategies that Igor Moiseyev utilized and developed to create his successful presentations. In that chapter, I look at issues of authenticity, and the elements that Moiseyev incorporated into his company's performances.

Sources

Given what I consider his important role in the history of dance, I was startled, and a little chagrined that when I began to research his long life and career, that I found very little about him written from a critical scholarly perspective in English. I found a bare two-page entry in Oxford University Press' *International Encyclopedia of Dance* (Isareva, 443–446). Victoria Anne Hallinan's Ph.D. dissertation focuses largely on The Igor Moiseyev Dance Company's first 1958 tour of the United States and its reception by Americans, but it also critically addresses the beginnings of the company, and I am grateful for her many insights, which dovetailed with my findings. Her study also contains a useful list of the repertory that can be compared to the listings in Ilupina and Lutskaya 1966, n.pag.), Moiseyev's complete list of his works can also be found as an addenda to his autobiography (*Ya Vsponimaiu; Ya Vsponimaiu*, updated edition), as well as the souvenir programs, which I have in my complete collection of Moiseyev programs from each of his visits to the United states. Dance scholar Naima Prevots has provided important mentions of Moiseyev, also in the same Cultural Cold War context, and how Americans greeted The Igor Moiseyev Dance Company (Prevots, *Dance for Export*). Robinson includessome mentions of Moiseyev and his relationship with the impresario Sol Hurok, who brought the company to the United States mentions him as an individual who was a close friend of Hurok (*The Last Impresario*). An excellent article by Estonian dance scholar Sille Kapper discusses in great detail the ways in which Igor Moiseyev's dance vocabulary and choreographic strategies influenced the ways in which Estonian dance, and by implication other Soviet republics, came to be produced, and how that echoes to this day ("Post-colonial Folk Dancing"). Her article serves as an example of how the Moiseyev effect lives on in several areas of the former Soviet Union and Eastern Europe. Dance scholar Andriy Nahachewsky (*Ukrainian Dance*) also usefully discusses Moiseyev's influence on the Ukrainian State Dance Company, the Pavlo Virsky Dance Company.

Also, I turned to Elizabeth Souritz's ("Moscow's Island of Dance") excellent study of a potentially rival company, the Island of Dance Company, located in Moscow, which existed and toured with Russian folk dance programs, parallel to the period of the founding of The Igor Moiseyev Dance Company. The existence of this company may have influenced the way in which Igor Moiseyev created his choreographies and structured his dance company. We will never know, for in his own book and Russian-language biographies, it is never mentioned.

Most of the other writings consisted of the multiple critical reviews and obituaries that I found in the New York Public Library in Jerome Robbins' Dance Collection about his passing from around the world, short essays in which he had written about his creative process in the many programs of the company which I had saved over the years, as well as the many critical reviews of the company's performances which I have in my own files. In addition to these sources, the former Soviet government produced a number

of glossy publications, featuring many photographs of the company's repertoire and the kind of propagandistic language that glossed over the realities of Soviet life and that were expressed in platitudinous language (Chudnovsky, Ilupina, and Lutskaya). These ever sunny and sugary accounts of The Igor Moiseyev Dance Company history, even though written after Stalin's death, and Nikita Khrushchev's famous denouncement of Stalin after his death, reflect the all happy, all the time attitude that masked the reality of Stalin's regime.

I also located short references that wrote about him as a classical ballet choreographer, often largely ignoring his role in the creation of a new dance genre that revolutionized the way in which folk dance was created for the stage, the echoes of which still reverberate in the form of *Riverdance, Anatolian Fire,* and other blockbuster theatrical productions that have followed in the steps that Moiseyev, a pioneer in creating such spectacularized folk festivals, opened for many of us (see, for example, Ezrahi *Swans of the Kremlin;* Slonimsky et al., *The Soviet Ballet;* Swift, *The Art of the Dance in the USSR*). Thus, his importance in the history of dance cannot be understated because it continues to influence individuals to create choreographic spectacle. The most important sources about Igor Moiseyev are in Russian. So, it became clear that I would need to learn Russian so that I could translate the Russian language texts, an enjoyable challenge.

I was pleasantly surprised to find two biographies of his life and career, as well as important information about the founding of The Igor Moiseyev Dance Company written by Evgeniia Koptelova (*Igor' Moiseyev: Akedemik*) and Lidia Shamina and Olga Moiseyeva (Moiseyev's daughter from his first marriage) (*Teatr Igoria Moiseyeva*), and startled to find that I could purchase them on Amazon, as well as finding a second treasure, Igor Moiseyev's autobiography (*Ya Vsponimaiu*, and a second edition of *Ya Vsponimaiu*), which determined that I was going to learn Russian in order to translate these works for the book. In a Moscow bookstore, I saw a book about the history of dance pedagogy in Russia (Filanovskaya, *Istoriia Khoreograficheskovo*). I also translated the section on Russian folk dance, which was written by Tamara Tkachenko (*Narodny Tanets*) that provided the background information for the instruction of Russian dances that appears in that volume. These dances are typical of Igor Moiseyev's choreographies and movement vocabulary. (See also Lawson, *Soviet Dances, More Soviet Dances* for an English language translation of the movements and choreographies of Russian dance, without the background notes.)

In this digital age, Youtube and the Internet provide many examples of his choreographies, often in multiple performances, and I suggest that readers view them before reading Chapter 6 in which I describe and analyze some of Moiseyev's well-known choreographies. In addition, there exist many DVDs that permit multiple viewings of his work (see bibliography). A gritty and sweaty documentary, *Dance Is Pain* (in Russian with English subtitles), follows two young Moiseyev dancers providing a backstage look at The Igor Moiseyev Dance Company's rehearsals, performance scenes, filmed some years after

Moiseyev's passing (2007). Elena Shcherbakova, kindly provided me with a DVD of the Company's 75 Anniversary Gala Celebration, which featured some of the most successful works that the maestro created in his lifetime.

In 1937, Igor Moiseyev was charged with founding and directing the State Academic Ensemble of Folk Dances of the Peoples of the Union of Socialist Soviet Union, which when on tour in the West came to be known as The Igor Moiseyev Dance Company. Moiseyev's Company survived the collapse and disappearance of the former Soviet Union, which had honored Moiseyev many times, and is currently called The Igor Moiseyev Ballet.

Chapter 1

Spectacle

Introduction: Spectacle, Dance, and the State[1]

For any scholar to do justice to the artistry and legacy of Igor Moiseyev, he or she must see his work through three lenses: spectacle, Russian nationalism, and cultural diplomacy during the Cold War. Igor Moiseyev's genius was sourced in spectacle. He understood its power and how to create it, and for this he was very useful to the Soviet state, which, like many nations, sought spectacle to symbolize the power of the state. He helped establish the creation of Russian national identity through his spectacularized choreographies of Russian dance, and played a central role in the Cultural Cold War representing the human face of the Soviet Union around the world; his company's performances in Paris and London in 1955, and as the first Soviet company to perform in the United States in 1958, mark the opening of the Cultural Cold War in Europe and between the Soviet Union and the United States. Thus, it was Igor Moiseyev who established that spectacularized "folk dance" would be a principal weapon of choice in the Cultural Cold War, which lasted for the next fifty years.

Spectacle is our starting point (Guss, *The Festive State*; Shay, *Choreographic Politics*). We will look at Russian nationalism and the Cultural Cold War in more depth in separate chapters.

We all think we know what spectacle means, but I think it is useful to look at the meaning of the word in a more formal fashion to enlarge the discussion of Moiseyev's choreographies as spectacle. The *Microsoft Encarta College Dictionary* defines spectacle in three ways: (1) Something remarkable that can be seen: an object, phenomenon, or event that is seen or witnessed, especially one that is impressive, unusual, or disturbing; (2) Lavish display: an impressive performance or display, especially something staged as a form of entertainment; (3) Unpleasant center of attention: something or someone that attracts attention being unpleasant or ridiculous. *You are making a spectacle of yourself* (1386, original emphasis). We will be looking to all three meanings in this study, in other words, high-cultural and low-cultural aspects of spectacle; however, it will be clear that the spectacle that Moiseyev created falls into the first two meanings of the *Encarta* entries.

Spectacle and its Discontents

Several writers and scholars have used the notion of spectacle to critique society, especially stressing the third *Encarta* entry that I introduced above. Marxist Philosopher Guy Debord wrote a harsh indictment of modern life noting that real life has been replaced by spectacle

and commodity, that spectacle is illusion: "In societies where modern conditions of production prevail, all of life presents itself as an immense accumulation of *spectacles*. Everything that was directly lived has moved away into representation" (*Society of the Spectacle*, essay 1, original emphasis). Debord importantly adds, "In all it specific forms, as information or propaganda, as advertisement or direct entertainment consumption, the spectacle is the present model of socially dominant life [...]. The spectacle's form and content are identically the total justification of the existing system's conditions and goals" (*Society of the Spectacle*, essay 6). In other words, Debord's notion of spectacle as reflective of a society's justification, which renders, as I will demonstrate in the analysis of Igor Moiseyev's work, dance-centered spectacle, more often than not contains an important political element.

Art historians Charles R. Garoian and Yvonne M. Gaudelius emphasize the political aspect of spectacle. "This 'politics of spectacle' as cultural critic Christopher Lasch has labeled it, represents a form of propaganda that 'create[s] in the public a chronic state of crisis, which in turn justifies the expansion of executive power and the secrecy surrounding it'" (27). In a recent critique of how it came to pass that Donald J. Trump ended up as the candidate of a major political party, regular editorial writer for the *New York Times*, Roger Cohen writes, "It is possible because spectacle and politics have merged and people no longer know fact from fiction or care about the distinction" (A-21). Thus, Roger Cohen concludes that this comingling of spectacle and politics has allowed a candidate whom he characterizes as "[...] a thug, who talks gibberish, and lies and cheats, and has issues, to put it mildly, with women" (A-21) to be "a hairbreadth from the Oval Office" (A-21). Certainly, Stalin, who shared many of the same thuggish tendencies, saw the value of spectacle as a political tool.

Chris Hedges chillingly characterizes American society and its failing institutions, all masked by spectacles:

> The moral nihilism embraced by elite universities would have terrified Adorno. He knew that radical evil was possible only with the collaboration of a timid, cowed, and confused population, a system of propaganda and mass media that offered little more than spectacle and entertainment, and an education system that did not transmit transcendent values or nurture the capacity for individual conscience. He feared a culture that banished the anxieties and complexities of moral choice and embraced a childish hypermasculinity.
>
> (91)

Political theorist Sheldon S. Wolin responds in a similar fashion to the dangers of possible totalitarianism in the United States, which he calls "inverted totalitarianism," a type of political and economic domination by corporations rather than individual demagogues and dictators. "Wolin writes that in inverted totalitarianism, consumer goods, and a comfortable standard of living, along with a vast entertainment industry that provides spectacles and appealing diversions, keep the citizenry politically passive" (quoted in Hedges 148). Spectacle and entertainment constitute a metaphor, like bread and circuses, to permit individuals to

place their heads in the sand and avoid the moral position of critiquing the society in which they live. In many ways, the 2016 presidential election primaries with crowds being whipped into a fury by the hate mongering of Donald J. Trump, who turned his political rallies into spectacles of animosity toward the Other, embodies the worst of the fears that Hedges and Wolin describe and analyze in their studies.

While I agree with much of what Hedges, Wolin, Barth, and Debord have to tell us about spectacle, as a societal illusion and societal distraction, I find that spectacle in which dance is a centerpiece also has a reality, and dance-centered spectacle needs to be deconstructed and analyzed differently, using different lenses. Igor Moiseyev's work offers a good example in which to analyze and critique modern spectacle, using modern lenses of Russian nationalism and the Cold War political arena. In both the Ancient world and the early modern period, in Italy and France, elites utilized dance-centered spectacle as a vehicle for aggrandizement and glorifying the rulers in increasingly absolutist states.

I want to look at the way in which different authors and theorists deploy the term "spectacle," because the term has taken on significantly negative meaning with some writers. Thus, spectacle has become an illusion, a simulacra, an empty gesture, something vulgar to be disdained, and curiously other writers and thinkers suggest that spectacle is modern. How does the choreography of Igor Moiseyev and the performances of The Igor Moiseyev Dance Company dovetail with the various concepts of the theorists that I look at? I suggest that spectacle, especially in the case of The Igor Moiseyev Dance Company, as it was as well in the court of Louis XIV, and the performances of Roman pantomime dancers, was governed by intensely political intent.

Socialist Realism as Dystopia

French theorist Guy Debord states, "The spectacle is the acme of ideology, for in its full flower it exposes and manifests the essence of all ideological systems: the impoverishment, enslavement and negation of real life" (151). Debord's Marxist, dystopian viewpoint is of great value. Spectacle, such as that which Moiseyev created, masks exactly what Debord described: the grim reality of everyday Soviet life, the suppression of certain ethnic identities, the Stalinist purges, and vast forced movements of entire populations, like the Tatars and the Baltic elites, all subsumed in the "its fun in the village" choreographies in which the Soviet people, as depicted in *Soviet Life*, the state organ, were all smiling all the time.

Debord makes the important point about the valorization of the state and societal values of the former Soviet Union and how they were expressed in Igor Moiseyev's choreographies. In the formative period of the company, it reflected the state's demands for socialist realism in all of the arts. Virtually all observers note that socialist realism was never clearly defined (Ferenc 13; Kenez 124). Socialist realism meant that art was always to be used in the service of the state, which both Lenin and Stalin explicitly

stated. According to art critic Matthew Cullerne Bown, the term "socialist realism" "probably first occurred in print in an article in the *Literary Gazette* in May 1932" (89). Nevertheless, Bown emphasizes that the term "socialist realism" was never fully defined, "Its theory was elaborated progressively throughout the 1930s. In this and subsequent decades, the theory was subject to constant emendation and reinterpretation by the party and by artists. Thus socialist realist art was never a static phenomenon [...]" (90). A major component of Soviet socialist realism was executed in monumental and commanding forms of art: statuary, architecture, and music and dance as well (Bown 172).[2] The Igor Moiseyev Dance Company constitutes a part of monumental art that the Soviet government supported. "Today's Company troupe counts 140 artists" (Shamina n.pag.). The Igor Moiseyev Dance Company, with its large cast, constitutes one of the largest dance companies in the world.

Types of Spectacle

Various types of spectacle exist: military, religious, athletic, artistic, and architectural, among others. In this study I underscore the idea that spectacle is man-made, although many people misname natural settings like the Grand Canyon as spectacular. Spectacle can range from gladiatorial bouts and chariot eer racing in ancient Rome or Hollywood as depicted by films like *Ben Hur* to flash mobs. In this study, focusing only on those spectacles in which dance and choreographic movement are involved will enable me to contextualize and situate Moiseyev's spectacularized oeuvre.

The discerning anthropologist John MacAloon characterizes spectacle as a "megagenre" (quoted in Manning 294). With the often lavish use of costume, music, dance, lights, and sets, large casts or large numbers of participants all moving with synchronized precision, both ancient and modern spectacle qualify as megagenres. In the field of dance, The Igor Moiseyev Dance Company qualifies as spectacle, and utilizes many of those elements. The Soviet Union used megagenres and vast size as a major feature of socialist realism, whether using architecture and statuary or dance and music, and we can justly call that feature of Russian/Soviet art as gigantism or monumentality (Bown, *Art Under Stalin*).

Spectacle, I would add, is created to be unforgettable. Those who saw Moiseyev's dazzling displays have not forgotten them; some of us remember the performances in great detail. "His dancers, especially the men, could without exaggeration be described as sensational, capable of executing an exhausting number of split jumps, turns on the head or forearm, and of course, the signature step in which legs are kicked out from a squatting position – the *prisijadka*" (Reynolds and McCormick 254). The West had never encountered such male dancing when The Igor Moiseyev Dance Company burst on the scene as the opening act of the Cultural Cold War in which dueling dance companies and musical virtuosi competed in a titanic cultural struggle.

The University of Chicago Press

REVIEW COPY

Published by Intellect Ltd

Distributed by the University of Chicago Press

ORDERING INFORMATION

Orders from the U.S.A., Canada, Mexico, Central and South America, East and Southeast Asia, and China:
The University of Chicago Press
Chicago Distribution Center
11030 S. Langley Avenue
Chicago, IL 60628
U.S.A.
Tel: 1-800-621-2736; (773) 702-7000
Fax: 1-800-621-8476; (773) 702-7212
PUBNET @ 202-5280

Orders from the United Kingdom, Europe, Middle East, Africa, and West and South Asia:
The University of Chicago Press
c/o John Wiley & Sons Ltd. Distribution Centre
1 Oldlands Way
Bognor Regis, West Sussex PO22 9SA
UNITED KINGDOM
Tel: (0) 1243 779777
Fax: (0) 1243 820250
Email: cs-books@wiley.co.uk

Orders from Japan can be placed with the Chicago Distribution Center or:
United Publishers Services Ltd.
1-32-5 Higashi-shinigawa
Shinagawa-ku
Tokyo 140-0002
JAPAN
Tel: 81-3-5479-7251
Fax: 81-3-5479-7307
Email: info@ups.co.jp

Orders from Australia and New Zealand:
Footprint Books Pty Ltd
1/6A Prosperity Parade
Warriewood NSW 2102
AUSTRALIA
Tel: (+61) 02 9997-3973
Fax: (+61) 02 9997-3185
Email: info@footprint.com.au
http://www.footprint.com.au

For Information:
International Sales Manager
The University of Chicago Press
1427 E. 60th Street
Chicago, IL 60637
U.S.A.
Tel: (773) 702-7898
Fax: (773) 702-9756
Email: sales@press.uchicago.edu

Spectacle in the Ancient World

Although many writers claim that spectacle is a sign of modernity, as Guy Debord in his seminal study of spectacle has claimed (*Society of the Spectacle*). I will argue that, in fact, spectacle was a feature of many historical societies as well.

Frank Manning argues that, "The spectacle is especially characteristic of modern societies, socialist and capitalist" (291). On the contrary, I argue that spectacle, in which dance or choreographed movement had a part, actually has ancient origins and its political intent and goals of justifying and symbolically supporting and glorifying rulers was frequently the same as that in modern life.

In ancient Egypt, the pharaoh, his household, and members of the elite participated in spectacular religious processions and festival activities, such as blessing the inundations of the Nile River (the *opet* and *sed* festivals for example) that are depicted on the pylons that I saw at the temple at Karnak and in the private tomb of the royal vizier, Kheruef (tomb 192) (see also Smith, *The Art and Architecture of Ancient Egypt*; Hodel-Hones, *Life and Death in Ancient Egypt*; Reeves, *Akhenaton*).

In ancient Persia, the bas-reliefs showing the ritual processions of conquered peoples bearing tribute for the king of kings at Persepolis decorates the north side of the former palace constituted a political spectacle. I viewed the way in which they are depicted in bas-reliefs carved and sculpted with amazing precision on the Apadana staircase leading up to the former palace showing each of the gift bearers in costumes highlighting their ethnicity and gifts appropriate to the region that they represented in an annual spectacle to celebrate the power of ancient Persia (see Allen 74–75; Hicks 128–29).

In ancient Rome, gladiatorial games and triumphal processions for conquering military leaders, like Julius Caesar, to celebrate the defeat of an enemy or the acquisition of territory constituted spectacle with numerous floats and thousands of defeated enemies paraded before the public. "From chariot races to gladiatorial combats, spectacles were one of the most characteristic features of Roman civilization" (Kyle 7). Kyle stresses the notion that in the investigation of spectacle as a social and political phenomenon, one must look at ancient spectacle: "Some also offers insights into spectacles as instruments of cultural and political hierarchy and hegemony" (Kyle 7) (see also Goldsworthy 152–53, 468–70; see Beacham, *Spectacle Entertainments*; Dodge "Amusing the Masses; Potter, 'Entertainers in the Roman Empire'"). The coliseum was specifically constructed for spectacle and spectacular events so beloved of Hollywood films.

In addition, the emperors needed to provide entertainment to amuse the masses. Classics scholar Richard C. Beacham notes, "the spectacular and the theatrical became pervasively embedded in every aspect of public life under the emperors" (xi). David S. Potter ("Entertainers in the Roman Empire") describes and analyzes the kinds of entertainers and genres of performances, while Hazel Dodge describes in detail the venues in which spectacle and entertainment took place.

The first dance-focused spectacle for which we have detailed information might be the spectacular and popular pantomime performances that began, as far as we know, during the reign of Augustus.[3] Classics scholar Ismene Lada-Richards describes his performance:

> Ancient pantomime was an expression-filled dance form, predicated on the mute delineation of character and passion. Impersonating in close succession a series of characters (drawn predominantly from Greek myth and classical tragedy), to the accompaniment of instrumental music and verbal narrative (partly recited and partly sung), a male masked dancer celebrated the spectacle of form "in flux", the human body's marvelous capacity to mould and re-mould itself in a fascinating array of sensational configurations (13). She adds, that his performances featured stunning turns that could stop on a dime and strike an evocative pose and virtuosic leaps and jumps.
>
> (32)

Classics scholar Ruth Webb reminds us that, "the remains of ancient theaters, massive Roman structures" from France to North Africa and the Eastern Mediterranean were built during the Roman and Hellenistic periods. It was in these theaters that could seat thousands of spectators where one could see pantomime performances (1). So popular were the pantomime dancers that they had fan clubs who carried their images to performances, and woe unto the individual who said anything denigrating about their performing idol, or who failed to applaud appropriately.

Aside from the performances of the pantomimes, which could raise the passions of the audience members to sometimes riot, other types of bloodier spectacles with wild beasts and gladiators were also featured in Roman arenas. Contributing to the spectacle of the pantomime dancers, aside from the spectacular movements and passionate acting qualities of the male performer and his costumes, these theatres could sometimes provide spectacular scenery, aquatic effects, as well as a full orchestra and chorus, sometimes with a cast numbering over sixty individuals. (Shay, *Dangerous Lives of Public Performers*) Emperors and elite individuals made themselves popular by underwriting their performances, or cause rioting if they withdrew them. Their performances continued for several centuries, "even until the end of the seventh century" (Lada-Richards 25).

Spectacle in Early Modern Europe

Our next encounter with dance as a centerpiece of spectacle, at least in Europe, does not occur until nearly a millennium after the spectacle found in Rome, in the Renaissance courts of Italy and France, especially with the establishment of the *ballet de cour* genre made famous by the Valois and Bourbon kings of France.[4] The first ballet of this genre is generally acknowledged as occurring in 1581 with the performance and creation of *Le Ballet Comique de la Reyne*, marking the marriage of Catherine de Médicis's son, Henri III, prepared and

staged by Balthasar de Beaujoyelx, an Italian dance master and musician. "Of all the court productions, the most reflective of noble identity – and the most important for an understanding of court society – was the *ballet de cour* or court ballet. This genre drew together the king and the best noble dancers [...]" (Cowart 5). These ballets were specifically designed to glorify the monarchs and the ruling dynasties.

Contrary to the case of ancient Rome where Roman men did not dance, the elite males of these courts *did* dance, including especially kings and upwardly mobile courtiers. In this period dance was a very masculine activity, thought by many to provide a man with the skill to fence. "To succeed at court, a man of ambition had to be as accomplished in dancing as he was in riding, fencing, and fine speech" (Jonas 74). Although we sometimes credit Louis XIV as the creator and the exceptional performer in this genre of theater dance, in fact, this style of dance, and dance as spectacle, began in the Italian renaissance courts of the Medici and Sforzas a century earlier. However, this genre of court dance spectacle probably reached its highest point under Louis XIV, for Louis was reputed to be a dancer of such virtuosic technical ability, taking flattery of the central royal figure into account, that he could be compared to a professional dancer. He danced in many ballets over a twenty-year period and he was famous for playing the Sun God Apollo, thus conveying a message of power, and the position of Louis XIV as the center of the state, because, "[...] the music and dance of spectacle were seen not only to reflect, but also to emanate from his royal divinity [...]" (Cowart xix). One of the important ladders to success for men of all classes and to be on terms of intimacy with the king was to participate at some level in these productions. "Clearly, the nobles who served as creators and dancers enjoyed a certain intimacy with Louis XIV, who danced by their side and committed tremendous energy, time, and expense to this common endeavor. Anyone who has participated in a dance performance, requiring long hours of rehearsal to create a professional-level performance, will recognize the potential bonding that occurs between the performers. The professional creators of the ballet, such as Lully and Benserade, also enjoyed a close relationship with the king, along with rich opportunities for artistic and political advancement" (Cowart 47). Thus, participating in dance could provide both economic and political advantage.

In an age of increasing royal absolutism, Louis XIV utilized spectacle that constituted a means for the king to gather power around himself by keeping potentially revolutionary nobles busy participating in the elaborate spectacles that were a central aspect of life in Versailles. "In order to obtain advancement, *les grands* were increasingly obliged to live at court for at least a portion of the year, where they were gradually transformed from a powerful group of independent vassals to a more docile breed of courtiers" (Cowart 12). In his ascendancy to an absolute monarchy, the king housed the nobles there in order to keep an eye on them. For the nobles dancing well and participating in the spectacles, which featured the king, was an important rung on the ladder to success.

It is sometimes difficult for the modern reader to understand to what degree dance was used as a vehicle for conveying political messages because the concept of dance as a medium of political communication is alien to them. Dance historian Jennifer Nevile notes, "[...]

dance was part of the political process in a way that is often difficult to appreciate today, when the two are viewed as distinct worlds" (1).

The spectacle of the Baroque era included music, poetry, spectacular scenic and costuming effects, and they could also be part of larger court pageantry that might include tournaments and jousts, hunting, balls, and other courtly activities. While these activities might provide entertainment, and be what we would think of as "fun," spectacle for its participants and viewers were serious activities, and the French and Italian courts spent a huge amount of their finances on these dance-centered activities. As Nevile observes, "Spectacles […] were theatrical events in which the power structures that existed in a country were acted out and presented in a symbolic fashion […] often an enactment of how those structures *should* be operating, they were not just occasions for 'entertainment'" (12, original emphasis; see also Prest, "The Politics of Ballet at the Court"). The funds required for these elaborate theatrical ballets sometimes verged on the ruinous. They occupied so much of time of the rulers who were featured in them that ambassadors frequently complained that it was difficult to conduct pressing business.

It is important to note that the dances from the ballroom, supported and documented by a plethora of dance manuals, were generally the same as those found in the ballroom. Baroque dance historian Wendy Hilton underscores this point: "So similar did this aspect of dance at court and theater remain that in the early eighteenth century a couple dance might be performed first by professionals in the theater, and then adopted as a ballroom dance; this did not mean that theatrical dance was simple, but that social dance was complex" (9). It was so complex that the participants, and their children, needed the services of a professional dance master to perfect and perform them. This form of dance eventually developed into the classical ballet with which we are familiar today. When Louis XIV in 1661 created the *Académie Royal de Danse*, the first of the French academies, it marked the division of dance into professional and amateur spheres. Louis' last stage appearance was in the *Ballet de Flore* in 1669; however, he continued to dance socially.

The Festive State

In order to frame this discussion around dance and spectacle in the twentieth and twenty-first centuries, I first turn to anthropologist David M. Guss' concept of "The Festive State," which The Igor Moiseyev Dance Company embodies, perhaps even more than the creation of the faux festivals that Guss describes for Venezuela. Guss points out that: "an important strategy for relocating festive practice in the sociopolitical reality in which it occurs has been to view it as cultural performance" (7). Because "states too have always recognized the incomparable power of festivals to produce new social imaginaries" (Guss 13). Nowhere was this more in evidence than the history of festivals displaying colorful rainbow ethnicity through folk dance in the former Soviet Union, some of which Igor Moiseyev directed. The Igor Moiseyev Dance Company performances can be conceived of as instant festivals,

portable and more manageable than the traditional festivals with thousands of performers and viewers. In order to make his new choreographic inventions of folk dance more effective, its "superabundance of symbols and meanings, [should] be shrunk as much as possible to a handful of quickly and easily understood ideas […] an icon of 'national tradition,' a borrowed image of difference made to stand for the nation as a whole" (Guss 13). That The Igor Moiseyev Dance Company was a stand-in for the former USSR as a whole, and currently the Russian Federation, cannot be in doubt.

In order to be effective as spectacle, "folklore had to be cleaned up. It would be colorfully costumed and dramatically rechoreographed. In short, it would be repackaged so that it could compete onstage with other art forms no matter how classical or refined" (Guss 114). Taking folk dance as inspiration, Igor Moiseyev created a new dance genre. The result of this manipulation of folk dance as Guss points out:

> The aesthetic makeover required in order to translate these forms into national spectacles shares many features cross-culturally. The privileging of the visual, accomplished through colorful costumes and dramatic choreography, combines with technical excellence and virtuosity to present a cheerful, unceasingly optimistic world. This increased theatricalization abjures any mention of true historical conditions and replaces them with the staged creation of a mythic detemporalized past.
>
> (14)

Thus, Guss' concept of the festival and the invention of tradition allows us to understand the multiple cultural, political, and aesthetic levels that characterize a Moiseyev performance. Within that concept of the Festive State, I will then describe and analyze Igor Moiseyev's work.

Folk Dance as Spectacle and the Glorification of the Peasant

Following World War I, as chauvinistic nationalism fueled the establishment of radical fascist, oppressive monarchical, and *soi dire* communist regimes, especially throughout Central and Eastern Europe, folk dance and music became a major political tool that many governments utilized for political ends. Throughout the late eighteenth and increasingly in the nineteenth and early part of the twentieth centuries, the peasant, the latest candidate for the Romantic role of noble savage, became the symbol of the nation. Following the writings and thoughts of German philosopher Johann Gottfried von Herder (1744–1803), the elites of many of these countries elevated the status of the peasant as representing everything pure of the national essence: language, folk tales, folk songs, and folk dance.

Since there was no widespread popular political support for most of these authoritarian regimes – in Greece, Hungary, Rumania, Yugoslavia, Italy, Spain, Germany, and the Soviet Union, among others – symbolic support had to be created. And what better symbol was

made available than large-scale festivals in which thousands of peasants, dressed in their colorful festive costumes, performed their native dances and music in spectacularized settings? Large numbers of peasants could easily be brought to the large cities by trains and buses, perform, be given a free lunch and sent home. The sites in which they appeared were frequently enormous, Olympic-size stadiums in the principal cities of the respective nation-state, but also "Festivals, parades, competitions, local houses of culture, and amateur troupes at various levels of support, proficiency, and national visibility provided places and moments, hooks on which to hang the acceptable forms of music- [and dance-] making" (Slobin 3). The peasant, then, became the perfect stand-in for the nation as a whole, and their performances of traditional dances served as a visual symbol of mass support for non-democratic regimes of all political stripes that claimed the nostalgia and innocence of the Golden Era of the Pure Peasant as the basis of their often-violent regimes. Even non-totalitarian political movements based on ethnicity, such as the Croatian Peasant Party, utilized folk music and dance to gain political ends and acquire support. (For Greece, see Loutzaki, "Dance as Propaganda"; for Germany, von Bibra 379–82, for Croatia, Sremac, "Folklorni Ples u Hrvata od Izvora"; for the USSR, Miller, *Folklore for Stalin.*) Folklore was selected by these governments, like the Soviet Union, because of the popularity of folklore that existed prior to the Revolution and because the Soviet Union was "a government eager to miss no opportunity to spread Bolshevik ideology" (Miller 4). Mass folkloric displays of dance and music served as the vehicle for demonstrating their popularity with the masses. I do not wish to in any way compare these very different authoritarian regimes, only to suggest that what they had in common was that they utilized spectacularized performances of peasants to symbolically imply support for their regimes.

In *Choreographic Politics* (Shay), a study that I wrote over a decade ago, I made the point that dance can be and is a potent political tool that certain nation states utilize in a variety of ways. In this chapter, I want to take a more nuanced look at the ways in which national states use folklore in general, and more specifically how they use folk dance as a political vehicle not only to reflect political ideologies, national priorities and national identities, but to proactively create nationalist sentiments and national identities through dance.

As Jens Giersdorf pointed out for the state folk dance ensemble of East Germany, the Erich-Weinert-Ensemble, built on the Moiseyev model, and like Moiseyev's new dance vocabulary it also included dance manuals to illustrate and describe them (see Tkachenko, *Narodny Tanets,* for a similar Soviet model). The very use of folk dance in general took on serious meanings: "The steps, turns, and holds in *Spinnradl* and all the other dances in the manual were never seen by the East German government as solely folk dance movements; they were also movements capable of carrying an ideological message and transforming practitioners into better East German citizens" (Giersdorf 32). Folk dance was seen as wholesome, expressing a kind of innocence that the Soviet Union emphasized in the descriptions of The Igor Moiseyev Dance Company.

These nation states sought something beyond the performance of folk dances by peasants. Folk dance, in our case ethno-identity dances, had to be spectacular to be effective as David

Guss (*The Festive State*) so effectively argues. Thus as Giersdorf importantly noted we can see that dance served multiple purposes, sometimes even contradictory purposes, for national governments, and as we will see in the case of the Moiseyev example, the purposes could also change with time and with new national priorities as the Soviet Union passed through successive political phases. All of these phases had different political agendas, sometimes as Giersdorf indicated, conflicting objectives.

The sheer volume and number of performances of folk music and dance could be staggering: "Every year in the USSR, approximately eleven thousand professional folklore collectives give over four million performances, attended by more than five hundred million people" (Miller 3). Outside of the USSR, the number was multiplied.

In the earlier part of the twentieth-century, these government and official efforts to valorize peasants and their material and cultural production was also designed to familiarize the urban populations with authentic folk traditions, and to garner respect for authentic peasant dances, music, and clothing, and to turn urban attention away from the "decadent" urban popular music dances such as the fox trot, and later rock 'n roll, that originated in the United States, England, and France.[5] But, during the 1930s and beyond, the various governments, through departments, schools, ministries of culture, and publications, began to dictate just what folklore was to consist of – an official folklore was created, and the creation of a new folk dance genre and The Igor Moiseyev Dance Company was part of that process. To support this official folk dance, the Soviet government produced a series of how-to dance books. (See Tkachenko, *Narodny Tanets,* as an example; Lawson, *Soviet Dances* and *More Soviet Dances,* provide English translations.)

For much of the nineteenth and early twentieth centuries, actual peasant cultures and peasants were widely despised by the urban classes for their perceived backwardness, conservatism, poverty, and lack of education and sanitary facilities. During that time dance masters choreographed ballroom dances, based loosely on peasant dances for urban audiences, in order to express their nationalism, and city people performed these dances – folk-inspired forms or character dance, and these came to be called "national dances." As dance historian Lynn Garafola observes:

> The 1830s and 1840s coincided with a veritable craze for folk-derived forms on the stage and dance floor alike. At the Paris Opera, the official headquarters and disseminator of ballet romanticism, national dance figured in over three-quarters of the house offerings, operas as well as ballets, while at public halls, regardless of whether they catered to an elite or popular clientele, polkas, mazurkas, and that earlier "ethnic" import, the waltz, dominated the proceedings.
>
> ("Introduction" 3)

Thus, it was not easy to convince urban dwellers, especially members of the intelligentsia that there was value or interest in peasant cultural expression unless urban composers and

choreographers mediated it. As Garafola indicated, these dances had to be sanitized, urbanized, and tamed before they were acceptable. These efforts to create new, sophisticated, and professionalized folk dance and folk music began apace – in the mid-1930s in the Soviet Union, and after World War II elsewhere and under the aegis of the Soviet government.[6] Igor Moiseyev was a pioneer in this project. "In the dance, the same lack of authenticity, characteristic of such ensembles as the Moiseevtsy [sic], even won an international reputation" (Harkins ix). As Harkins noted, The Igor Moiseyev Dance Company had little interest in authentic folk dances.

After World War II, in Eastern Europe urban youth was increasingly attracted to the "new," invented, spectacularized folklore that attracted hundreds of thousands of youthful practitioners in the Soviet Union, Bulgaria, Rumania, Hungary, Poland, and the former Yugoslavia. These young urbanites dressed as peasants and performing folk songs and dances indicate that "the Russian intelligentsia's appropriation of the culture of their historical Other – the Russian peasant" (Olson 4) was in full swing. Throughout this region, the performance of folklore by urban performers, from authentic to invented, became a cottage industry with millions of participants (Sremac, "Folklorni Ples u Hrvata"; Hanibal Dundović, personal interview; Swift, *The Art of the Dance*; Overholser, "Staging the Folk: Processes and Considerations").

Historically, the Communist Party has held changing, sometimes diametrically opposed ideas of how to utilize folk dance, and other forms of folklore, for purposes of propaganda. The soviet state turned folklore into a cult that proclaimed "folklore as a leading indicator of ethnicity and ethnic culture" (Harkins ix). And nationality and ethnicity loomed large throughout the entire history of the former Soviet Union, and folklore and staged folk dance served as a vehicle in the construction of ethnic and national identity.

Dance Spectacle in the Twentieth Century

We next encounter dance in spectacular form in the twentieth century. This time however, due to a number of reasons that I referred to above, folk dance forms the focus of new political states. Folk dance has always had a special appeal for the modern nation state and the spectacles that they created. Spectacle presents the opportunity to show the population in rainbow colors of tradition, and constitutes a form of visual symbolic political support for the state. Since the late eighteenth century, and increasingly into the nineteenth and early twentieth centuries, under the influence of Johann Gottfried Herder (1744–1803) and his followers, including the Grimm Brothers, the folk, usually peasants and tribal populations, have been perceived as constituting the most basic, pure, and authentic representation of the nation state. "The idea of individual genius, so important to Romanticism in Germany found its collective counterpart in the concept of the original and the instinctive creative capacity of the *Volk*. Folk songs, fairy tales, and legends were established as artistic products in their own right [...]" (Giersdorf 28).

This belief in the genius of the folk launched the field of folklore, and Herder's followers began the collection of peasant tales, language, rhymes, and poetry, and later music, and finally dance, as the most authentic representation of a nation's origins, beginning with Germany and spreading throughout Central and Eastern Europe. The earliest emphasis was on language, and aspects of folklore that used language like tales, riddles, jokes, proverbs, and musical lyrics all constituted important forms that were to be collected, as the purist form of national expression. This collecting process of folklore, albeit in a much-expanded and more professional context, continues in many countries unabated today (see Zhornitskaya for example).

In many cases the rural population, even today, constitutes the potent symbol of the basis of a particular state's existence as homeland to these ethnic groups, which greatly explains the popularity of folk dance, with colorful costumes and particular musical styles, as a powerful vehicle for national representation. However, in order to be effective as a cultural and political representational tool of the state, the dancing, colorfully garbed peasants, as Guss reminds us, must be spectacular (*The Festive State*). Dance scholar Jens Giersdorf reminds us that both the Nazis and the East German communists utilized folk dance and mass choreographed movement to create identities and symbolized support for the regime. "The Nazis streamlined dance and physical culture by melding disparate ideas into a single-minded force, most notably through the extensive employment of folk dances and songs for education of the Hitler Youth" (Giersdorf 29). After the war, he chronicles how the East German Government turned again to spectacle, following ironically, both the Nazis and practices from the Soviet Union that Igor Moiseyev originated. "Leipzig became the center for these socialist mass choreographies [...] the opening ceremony, which included more than ten thousand participants and was staged in the newly erected central stadium, eventually became the signature event for all these festivals" (Giersdorf 4). And, these involved the audience in the choreographed mass movement designed as a vehicle for creating a new national identity.

Creating spectacle can be accomplished in two possible ways. In its earliest version, large masses of participants were used in spectacularized venues – the Greek dictator Ioannis Metaxas' mass rallies, the Nazi German use of masses of peasants in German national costume, and the Soviet *dekady*[7] and the Communist Party Youth festivals of the former Soviet Union come to mind (Loutzaki; Von Bibra; Swift). Russian folklorist Izaly Zemtsovsky characterized the *dekady* of the former Soviet Union as: "Thirty-five pompous Ten-Day Festivals of 'national arts' were staged in Moscow from 1936 to 1960 merely for show and propaganda. These music and dance events were performed in conjunction with the well-known 'All-Union Exhibition for Achievements of National Economy,' a huge exhibition of buildings representing each national republic in the Soviet Union (so-called VDNX). In brief, folklore was generally replaced by fakelore" (8). These types of festivals became a feature of cultural life throughout the Soviet Bloc. As Guss noted, folk festivals continue to be popular as a vehicle to package colorfully dressed peasants who sing, dance, and play musical instruments, in many countries, like Bulgaria, Serbia, and Croatia. These serve as

both tourist attractions and are also popular with native urban populations. "An important strategy for relocating festive practice in the sociopolitical reality in which it occurs has been to view it as cultural performance" (Guss 7). Thus, even after the totalitarian state gives way to more democratic political forces, the state has an interest in festivals even as they move from political vehicles to tourist attractions.

The second and more recent means of producing spectacle, and ultimately the one that prevailed, seen on world stages for over fifty years, was to spectacularize the dances, which required the development of a new type of dance genre, sometimes based on older dance traditions, and sometimes entirely invented dances, new choreographic strategies, and a new type of dancer: the professional folk dancer. This was the method that Igor Moiseyev (1906–2007) used when he invented, or created a new style of Russian folk dance, as well as dances from all of the Soviet republics, for presentational purposes. Igor Moiseyev can be described as a master of the art of the spectacularization of dance. So brilliantly did he succeed that many nation states in the world followed and emulated his innovations. (See Chapter 6 for a description of Igor Moiseyev's choreographic strategies.)

Performances of The Igor Moiseyev Dance Company and its many emulators dominated the concert dance stages of the world for over fifty years, drawing the largest audiences to their performances than any other dance genre, precisely because of the promise of spectacle. Most of these ensembles still exist and perform. Major impresarios like Sol Hurok produced tours of these companies during that period throughout the Western world because of their "accessibility" for audiences (Robinson, *The Last Impresario*). The former Soviet Union reveled in the success that The Igor Moiseyev Dance Company garnered through their performances, in which they obtained hard currency from the West, and scored political points in the newly liberated former colonies, now emerging after World War II and subsequent wars for independence, as independent states of Asia and Africa. Moiseyev's choreographic strategies of representation, in which the dances of the Asian and Muslim populations that were part of the former Soviet Union were featured alongside the Russian dances, made a political impact, especially in contrast to America's blatant racism. This programming strategy became a popular aspect of Moiseyev's performances in what was called at that time the Third World. The Soviet Union frequently sent The Igor Moiseyev Dance Company to perform in the developing world. This goal of representation of the rainbow of Soviet ethnicities replaced emphasizing Russian national identity after the Second World War in order to fulfill new political needs, especially during the Cultural Cold War.

This programmatic strategy, which represented all of the ethnic and national groups as living in colorful harmony, also served to highlight the intense racism that characterized the United States at that period of the Cold War and that became an increasing embarrassment to the diplomatic efforts of the United States. "Within the United States, there was a growing realization among those concerned with international relations that Jim Crow not only was analogous to Nazi treatment of the Jews and thus morally indefensible but was also contrary to the national interest" (Fredrickson 129). This was true especially in the 1950s and 1960s, the

period of the height of success of The Igor Moiseyev Dance Company during its most visible touring period in the developing world (1950-1980), and both the United States and former Soviet Union were out to win hearts and minds. His programming of the many Islamic groups that inhabited the former Soviet Union strongly resonated in the Middle East and Africa.

Igor Moiseyev and Spectacle

As I noted above, Igor Moiseyev followed the second way of creating spectacle: spectacularizing the dances. Igor Moiseyev was the first and the original creator of modern spectacular ethno-identity dance. "Moiseyev's and [Pavlo] Virsky's dance repertoires are superbly consistent with Socialist Realist aesthetics" (Nahachewsky 207). This required the development of a new type of dance genre, sometimes based on older dance traditions, and sometimes entirely invented dances, new choreographic and athletic movement strategies, new political contexts, such as his choreography *The Partisans*, colorful village scenes, and a new type of dancer: the professional folk dancer. This was the method that Igor Moiseyev (1906–2007) used when he invented, or created a new style of Russian folk dance for presentational purposes. (See Chapter 6 for a detailed description and analysis of some of Moiseyev's choreographic and movement strategies.)

Many dance critics agree that Igor Moiseyev was unique. For example, one of the most discerning dance writers and critics John Martin of the *New York Times* famously wrote, "Among the truly creative figures in the art of the dance of our time, place high the name of Igor Moiseyev. Not since the golden days when the modern revolution swept through the field and restored an art in decay to human experience has anything so vital occurred as Moiseyev's return to fundamentals" (The Igor Moiseyev Dance Company. Program, 1965, n.pag.). Major impresarios like Sol Hurok produced tours of these companies during that period throughout the Western world because of their "accessibility" for audiences (Robinson, *The Last Impresario*). The choreographies that he created, which still have the power to awe many audience members today, and this new dance genre became popular throughout the world.

So powerful were Moiseyev's choreographies that even today dance spectacles like the Chinese company *Shen Yun*, *Riverdance* of Ireland, and *Anatolian Fire* from Turkey continue in that tradition, and each new iteration in the Moiseyev mold attempts to be more spectacular than the one before it.

According to David Rockwell and Bruce Mau, spectacle is not constrained by eliciting a uniform response. An architecturally spectacular structure like the Eifel Tower provokes a different response and emotion than, say, a dance performance, such as that of The Igor Moiseyev Dance Company. They characterize spectacle and the spectator's experience as potentially embracing the following: "big, bold, brief, connect, immerse, transform" (Rockwell and Mau 16). Spectacle can direct itself to various audiences; spectacle does not assume that all audiences will love Russian dances. The best possible outcome is when the

audience rises as one to its feet, perhaps after a moment of stunned awe, but with enthusiasm and joy. There needs to be a feeling of communal connection though the appreciation of the spectacle. That is a measure of its success as spectacle. In Moiseyev's autobiography and the fluff literature produced by the Soviet government written about the company, scenes of cheering audiences abound. But, they existed. I saw them during the tours the company made to the United States, and recently in Russia.

Spectators

Spectators are an element of spectacle; spectacle is created for the spectator. Spectators can interact with spectacle on a number of levels from passive viewing to full, physical participation, such as the Woodstock festivals and concerts. Performance theorist Richard Schechner usefully reminds us, "[…] the boundary between the performance and everyday life is shifting and arbitrary, varying greatly from culture to culture and situation to situation" (70). And, I would add, from historical period to historical period.

John Martin notes that Igor Moiseyev had the spectator in mind in the creation of his work: "Moiseyev selects, arranges, composes out of the boundless riches of the vocabulary at his command; he is concerned not with the subjective satisfactions of the dancers, which constitute the main view of folk dancing, but with providing the spectator with a vicarious experience" (The Igor Moiseyev Dance Company. Program, 1961, n.pag.). While no director can be certain that his or her intentions will be realized, they create their works with very clear intentions. The spectacle must move the audience emotionally and it must shape the author's reception of the culture it celebrates. The audience should be convinced it has seen the "real thing." This is not always difficult because the audience wants to believe it is seeing the real thing, what the poet Samuel Taylor Coleridge characterized 200 years ago as "the audience's willing suspension of belief," a well-known adage in the theatre world (www.Bartelby.com/209/970.html). In the case of The Igor Moiseyev Dance Company, the audience must be convinced that they have seen the real Russia, and they must believe in the superiority of the USSR.

The issue of audience reception is complex. This is because each audience member brings a different level of education, experience, and knowledge of a particular genre of performance when they come to a theatre or stadium. Following theatre historian Douglas Kennedy, I largely avoid discussions of audience reception because as he notes: "A spectator is a corporeal presence but a slippery concept. [...] [A]udiences are not (and probably never have been) homogeneous social and psychological groups, their experiences are not uniform and impossible to standardize, their reactions are chiefly private and internal [...]" (3).[8] Thus, for example, when I attend a Kabuki performance, a genre I have seen only a few times, and thus, barely know, my responses will almost certainly be different than that which a connoisseur from Japan who brings sophisticated knowledge to the same performance feels and evaluates it. That individual will have an appreciation for the form and the quality of the performers' abilities and artistry that I do not have.

Audience response is tempting to chronicle and analyze because audience members, culturally and historically situated, often respond in predictable, sometimes ritualistic ways to a performance. In my decades of experience with American audiences, they typically applaud at the end of a performance, even a poor or substandard one, with more or less enthusiasm because it is the polite way to behave.

In the same way, I will avoid chronicling too many newspaper accounts, although I will try giving a few descriptions of critical and audience reactions to Moiseyev performances to give a flavor of audience reception, because, especially during the 1958 tour of America, it was politically important. Critical reviews can also be flawed because as Kennedy notes, "journalist-critics manage to divine group response from their own responses and from the reactions of those around them" (3). In other words, the journalist-critics' reaction, although in print, reflects the opinion of just one person, and for that I will rely on my own supply of reviews from both the clipping file in the New York Public Library and my personal collection, and Victoria Anne Hallinan's detailed and careful study in which she quotes from several newspaper dance critics ("Cold War Cultural Exchange").[9] I will suggest that if there exists a critical mass of reviews, as is the case for The Igor Moiseyev Dance Company, they can provide at least a sense of what those performances were like, and how the audiences responded on a surface level. Another gauge of audience reception is attendance numbers, which indicate the desire to see a performance, and I remember well, in the case of The Igor Moiseyev Dance Company's first tour in Los Angeles they performed to completely full houses. Individuals were scalping tickets at ten times the value on the front stairs of the Shrine Auditorium, and dance historian Naima Prevots (71) and dance historian Victoria Anne Hallinan write of similar instances for New York and other locales (149) audiences responded ecstatically – there can be no other adjective.

In dance performances I will suggest that several elements, all found in Moiseyev's choreographies, create spectacle. What Nahachewsky calls "monumentality," which consists of many dancers moving in unison. All Moiseyev choreographies, except certain solos, contain what I call large numbers of performers moving together, performing the same movements. All state-sponsored performance companies emulate this aspect of Moiseyev's work, even when, as was the case with Croatian State Folk Ensemble, Lado, and the Dora Stratou Greek Folk Dances Theatre, the choreographies generally appear to be simpler to many individuals. In addition to large numbers of performers, moving all together, costumes, props, spectacular lighting, sets, and musical effects can contribute to the spectacle, but the first two elements are the most important.

Inherent in certain genres of spectacle, especially with dance or choreographed movements as a centerpiece, one can find political power embedded and expressed choreographically. Depicting a scene of Queen Elizabeth II in a royal carriage, surrounded by thousands of parade-dressed military figures, a massive horde of individuals marching in high-stepping ritual steps, Raoul Trujillo, the host of the television series "Dancing" announces portentously: "*This* […] is a dance of power." There were so many participants in the ritual that it appeared as if the entire military of Great Britain were present, which

one might say they symbolically were. Spectacle, as in this case, frequently carries political messages of power.

Watching the highly choreographed truly spectacular opening ceremonies of the Beijing Olympics in 2008, I was struck by the not-so-subtle message that was being sent around the world, a choreographed message that would have been impossible to send in words with any degree of diplomacy. I interpreted that message as: While the twentieth century may have been the American century, the twenty-first century will be the Chinese century, because only China has the resources, the will, the money, the talent, and the people to produce this spectacle on this scale. Those who witnessed the Beijing Olympic opening ceremonies, numbering in the millions via television, experienced an extremely sophisticated spectacle that was carefully choreographed. Thus, we see that spectacle constitutes a powerful medium to send political messages. This aspect of spectacle is sometimes difficult to explain to American audiences who believe that art for art's sake stands apart from politics. One American reviewer was naïve enough to write as late as the nineteen eighties: "[…] The Moiseyev is the most non-political artistic ensemble imaginable" (Stasio 1986).

I would also suggest that the Beijing opening ceremonies has its roots in strategies begun by Igor Moiseyev, because the Chinese had seen and experienced Moiseyev performances both on tour beginning in 1954, and during the many youth festivals that were held throughout Eastern Europe and the Soviet Union. And, like the Eastern European states, they founded a state-supported "folk" dance company that continues to exist today and that utilizes the same choreographic strategies that Moiseyev created, which they, like the other nation state, adapted to specific Chinese tastes and needs.

It is sometimes difficult for the modern reader to understand to what degree dance was used as a vehicle for conveying messages because dance as a medium of political communication is very common, especially in authoritarian states. Viewing the Beijing Olympics opening ceremonies of 2008 makes that clear. Dance historian Jennifer Nevile notes, "[…] dance was part of the political process in a way that is often difficult to appreciate today, when the two are viewed as distinct worlds" (1). In the contemporary United States, for example, dance is thought of as entertainment, social interaction, and art, a world away from the political aspects found in the court theatrical presentation of the Court of Louis XIV or Igor Moiseyev's choreographies designed to insinuate the athletic prowess, accenting the power and athleticism of the male body, and thus the implied military might of the Soviet Union.

The Spectacularization of Folk Dance

After a major reorganization of their arts programs in 1936, in which they established the All Union Committee for Affairs of the Arts in the Council of People's Commissars, the government of the Soviet Union, after years of sponsoring massive festivals that showcased the rainbow assortment of ethnic amateur performances of groups and nationalities within their borders, the so-called *dekady*, turned to Bolshoi-trained choreographer and dancer

Igor Moiseyev, who had administered and directed the All Union Festival in Moscow, to found a professional company. According to many of the programs (See various The Igor Moiseyev Dance Company programs), "The first meeting of the company took place on February 10, 1937". (The Igor Moiseyev Dance Company. Program, 1961, 9). With the official state imprimatur, Moiseyev founded the State Academic Ensemble of Folk Dances of the Peoples of the Union of Soviet Socialist Republics, known in the West as The Igor Moiseyev Dance Company and began producing a series of choreographies, most of which are still performed today (see The Igor Moiseyev Ballet website). In later chapters, I will deconstruct the myth of the founding of the company.

Thus, Moiseyev ushered in a new era in the history of concert dance: from the era of folk dance as spectacle to the era of the spectacularization of folk dance, for The Igor Moiseyev Dance Company, and the age of the state-sponsored professional folk dance ensemble, which Moiseyev's vision inspired, began in earnest after World War II. Igor Moiseyev was hugely successful with his new company for beginning with Mr. Moiseyev's ensemble, many nation states of all political stripes founded professional folk dance ensembles, all of which owe their existence to the success that he generated with his choreographic diplomacy, and these ensembles dominated world concert stages for the next half century. Kodat observes that his dances "were built to deliver mass-appeal spectacle of what 'one likes to see'" (3).

It is crucial to note that despite all of the rhetoric about how much Moiseyev loved folk dance that is found in program notes, interviews, and numerous books about the company and its director, Igor Moiseyev did not turn from classical ballet to dance ethnology as a source for his new dance genre. His dances reflect very little of dance in the field, although there exist exceptions such as his choreography of *malambo*, an Argentinian gaucho dance, which already is inherently spectacular, with the three dancers wearing boots and spurs, and carrying knives. Igor Moiseyev sought the spectacular. The Zorba dances, the Jewish Wedding, and the Bulgarian Šop, on the other hand, are much faster, have larger movements, and more spectacularized than their parallel dances in the field.

A viewing of authentic dance in the field in Russia reveals little of the spectacular and as the video advances, the careful observer can see that each performance becomes increasingly sophisticated; many of the performers, mostly peasants, clearly have experience performing before audiences and on festival stages (*JVC Music and Dance Library*, Volume 23). As ethnomusicologist Theodore Levin observes of the invented tradition of Russian folk music, which applies equally to dance, "regional differences largely melted away before the overwhelming, homogenizing force of a Russian-Soviet national folk style" (25). For example, an important element of authentic Russian folk dance is improvisation. By contrast, nothing is an accident or improvised in Moiseyev's choreographies; dancers and their movements are choreographed to the eyebrows. From the exact turning of heads left to right, to the level of hands and arms, to the exact pointing of feet, Moiseyev's choreographies leave nothing to chance; his choreographies constitute machine-like, well-ordered drill team reviews. Repeated viewings of his works reveal that even the walking or standing poses that the dancers perform are carefully and artfully arranged.

Moiseyev's new Russian genre of "folk" dance was even more all-encompassing than just for Russian dances: it could be used by the entire Soviet Union. "The Soviets invented 'national' dance styles based upon Soviet ballet for cultures whose own dance styles did not seem appropriately athletic or flashy" (Olson 251, n. 109). Or as it was more euphemistically expressed: "Russian 'brothers' were sent to teach the natives in the republics how to create authentic folk dances, suitable to each republic" (Shay, *Choreographic Politics* 65). All of the Russian dances, not to mention those of the Ukraine and other republics, show little sign of regional, or even national, difference that one finds in authentic folk dance.

In fact, Moiseyev created a new folk dance tradition with a new vocabulary of movements for the stage, and this new vocabulary was firmly informed by, and embedded in, classical ballet practices; his dancers were trained in ballet. Ballet training was a requirement for all the company dancers. And, yet it is much more grounded than ballet, and although it also takes elements from character dance, it is different and unique. New stylized steps and figures were created and Tkachenko (*Narodny Tanets*) details them. Above all, Moiseyev created new floor patterns and mass-synchronized movement. A close study of the Russian and Ukrainian dances in the Moiseyev repertoire reveal that these steps and figures reappear over and over in Moiseyev's Russian and Ukrainian choreographies. The choreographers did not focus on folk material, but rather constituted an invented choreographic tradition that barely resembled actual folk dance as depicted on the JVC video. The staged quality of Moiseyev's choreographies also extended to the costumes that became almost uniforms, often, as in the Gopak, color coordinated, and the music he utilized that the composers and arrangers for the company created to accompany the dances was played by a theater orchestra that constituted a small symphony orchestra, sometimes using balalaikas or accordions for special effects. Over the period that Moiseyev worked, his new movement genre became the official style of folk dance. And, like many invented traditions, so successful was Moiseyev's new folk dance that many Russians came to believe that it *was* the authentic Russian dance tradition.

I would argue that the term "folk dance" in terms of The Igor Moiseyev Dance Company is an ironic misnomer: the very notion of folk dance is a form of dance that is performed unselfconsciously by those people who did not receive training in a formal setting like a dance studio, and constitutes an organic part of their lives. So that Moiseyev created both a new style of dance that required ballet training and a new type of dancer. And, as we will see, while Moiseyev's new dance tradition was informed by ballet, and to some degree folk dance, but it was not ballet, nor even quite character dance, but a new genre of dance that appeared to be much more earthbound and authentic than classical ballet character dance.

Crucially, the Moiseyev School of dance movement and choreography became the official folk dance style of the Soviet Union. The movement vocabulary is detailed in a major book (Tkachenko, *Narodny Tanets*), and a series of subsequent booklets that were published by the government, and distributed for choreographers throughout the Soviet Union to use as a basis for public performances.[10]

In a classicizing gesture, the movements and figures are named, as is the case for classical ballet so that professional dancers pass on a frozen dance movement vocabulary to future

generations, creating a static, frozen corpus of movement, which is the opposite of the ever-changing world of actual folk dance found in the field.[11] Tkachenko's book begins with a general overall set of positions and movements, in essence the basics of ballet character dance.[12] A chapter follows this on each republic, beginning with Russia, the Ukraine, and Belarus, and then the rest of the republics by size of population from the largest to the smallest. Each dance tradition is described in broad strokes, and then the steps and figures of the tradition are described in detail allowing the book to serve as a dance manual for choreographers. In addition, each chapter on one of the republics provides the interested reader with two or three typical choreographies. The numerous booklets that followed in the same format, featuring the same illustrations and choreographic symbols, provided additional choreographies for amateur companies or school groups to use. This entire system of professional and amateur ensembles, and a literature to underpin them became the official way in which folk dance was to be presented.

Chapter 2

Russian Nationalism: The Nation Dances – Russian Identity and The Igor Moiseyev Dance Company[1]

Identity and Identity Construction: Introduction

In this chapter, in order to discuss Russian nationalism, I first look briefly at how many individuals experience their national identity as one part of an individual's overall identity. Then I address nationalism in general, Soviet identity, nationalism in the Soviet Union, Russian nationalism and its specific contours within the context of Russian history, how folk dance and music were used to construct Russian identity, and finally how The Igor Moiseyev Dance Company fits into the new Russian Federation.

In general, I regard national identity as historically and socially constructed. Individuals, such as those who were subjects of the Russian, Hapsburg, or Ottoman Empires did not have nationalist feelings toward those political entities; if they harbored feelings of identity it was toward the ruling dynasties of those now-gone empires. That is why they could not survive in the new era of nationalism ushered in by the end of World War I, which culminated in the founding of many new ethnically based nation states.

In many ways the Soviet Union was the last of the multiethnic–multinational empires, a political move by the Bolsheviks to seize the former Russian Empire and incorporate all of its territories. From the beginning, Soviet authorities had ambiguous attitudes toward the national entities they created, and to what degree individuals were permitted to express national or ethnic feelings.

As Max Fisher notes in the *New York Times*, in discussing the current mess in Afghanistan, "After all, humanity lived for millenniums in something resembling low-grade anarchy. Modern nation-states grew out of that chaos only recently" (A4) underscores my position that national identity is new, constructed, and contingent, and not always successful. That does not mean that many individuals do not feel strong emotions surrounding their nation and are, perhaps, ready to die for it. However, in order to understand Russian or any kind of other nationalism, the basic fact of the recentness of nationalism needs to be understood.

States, Nations, and Nation States

Following Coakley's definition, "A state is a self-governing territorial entity with a central decision-making agency which possesses a monopoly of the legitimate use of force in ensuring compliance with its decision on the part of all persons within its borders" (11). I adopt Coakley's definition of state, which is simple and readily grasped and will inform my arguments.

I use the terms nation, state, and nation state as synonyms for the purposes of this study; even though nation certainly refers to the people as "the French nation," many use nation in the popular usage as a territorial unit as I will do from time to time. Many consider the formations of nation states to be inevitable and "natural." "But we must not accept the myth. Nations are not inscribed into the nature of things; they do not constitute a political version of the doctrine of natural kinds. Nor were national states the manifest destiny ultimate destiny of ethnic or cultural groups" (Gellner 49). In fact, to a large degree as Gellner suggests, nations and states are socially constructed entities, often supported by mythical origins promoted in order to build powerful feelings of patriotism and nationalism, in order to enable the nation state to coalesce and survive.

Identity and National Identity

Each human being has a unique identity, which consists of bundles of elements: gender and sexuality, marital status, age, religion, political belief, profession, ethnicity and nationality, among others. Identity is largely socially and contextually created; that is, each individual is born into a specific family, in a specific city or village, and into a specific neighborhood; he or she has or does not have a specific religion, has or does not have a specific political belief. Frequently, as individuals we regard the elements of our unique identity as "natural," that is to say we regard our sexuality, our religion, our ethnicity, and other aspects of our identity as unchanging, and even as unchangeable. We feel that the elements of our identity are "natural" and inevitable. However, as individuals, we can change virtually every aspect of the elements that make up the bundles of identity markers, even though it might be difficult. Some elements are more easily changed than others: it is perhaps easier to change or evolve into a new profession, a new political position, than adopt a new religion, or a new sexual status. In other studies, I have looked at sexuality and ethnicity as socially constructed elements of our identities (Shay, "The Spectacularization of Soviet/Russian Folk Dance," "Lado, The State Ensemble of Croatian Folk Dances"), in this study, I consider national identity, especially in the context of nationalism, an emotion that is deliberately created by political actors, often associated with national governments, as socially constructed and historically contingent.

In my conceptualization of identity, each individual experiences each part of his or her identity differently: for some their religion is their most important identity marker, whereas for others their sexuality, or their status as a parent. In other words, identities can be experienced as fluid. Each of these elements can surface depending on context: one's country is attacked, one's religion is threatened, one's sexuality is persecuted. These situations can trigger strong feelings within an individual, making him or her feel powerful identity emotions. Recently, such emotions have been labeled identity politics, and are increasingly appearing in the streets of American cities in protest marches against Donald J. Trump and his political actions.

We can see the rise of these aspects in the rise of religious extremism that result in terror attacks in Europe and North America, the Black Lives Matter movement, the violence that Trump followers increasingly exhibit, and among other movements in religious extremism in Indonesia, the Philippines, and Myanmar; one can see that powerful identity markers rise and fall as a result of the emotions that they engender.

The Nation State

Whatever the next decades hold, today the nation state constitutes the single most hegemonic political unit across the globe, although with independence movements in Flanders, Catalonia, Quebec, and Scotland, as well as the earlier split between the Czech Republic and Slovakia, Pakistan and Bengal, and the creation of six new nation states in the wake of the breakup of the former Yugoslavia, it may change as various interested groups challenge the status quo (see Minder, "Catalonia Plans Vote"). In time, nationalists, ethnic, political, and religious groups may create new political maps.

I would characterize nationalism as an inclusive discourse about identity and the nation state and the individual's role within the nation. In creating citizens who believe in the special identity of the nation state and loyally serve it, respective governments inculcate the citizens of their particular specific nation state through various agencies – educational, military, artistic, and political – with strong, and positive, feelings about their nation.

Almost everyone in the contemporary world "belongs" to a state, like a subject in some case, or identifies with one or another nation state as a citizen, and the resultant citizenship will inform their sense of identity. So internalized is this concept of the nation state to most individuals that most people live it as a fact of nature that every person in the world should belong to one. Thus, individuals have a national identity above or behind every other aspect of their identity. This concept, as Roland Barthes suggested in *Mythologies*, is one of those things that everyone "knows" and no one questions, as if it were a "natural" order of social arrangements rather than an order that is socially constructed and historically contingent. The received idea that everyone should belong to a nation, and love it, and be ready to sacrifice for, and even die for, which is an important part of nationalism, is so deeply embedded in many contemporary men and women that when a nation state, like Belgium, fails, or has the potential to fall into its constituent parts, in this case Flanders and Wallonia (see Erdbrink, "After Attacks, Many Argue"), or when Scotland, Catalonia, or Quebec wish to become an independent state through votes to separate from Great Britain, Spain, and Canada, respectively, pundits and politicians raise a hue and cry about the imminent end of the world – that financial, political, and social chaos and collapse are around the corner, and there exist many individuals who agree with them. National identity is, in fact, where essence precedes existence, reversing the existential claim. National identities are created identities, not a "natural" part of one's existence.

Although breaking a state apart into smaller national units, as with the former Yugoslavia or former Soviet Union, creating a nation state can be fraught: "Building nation-states, even in the best of circumstances, is not, to use Mao Zedong's phrase, a tea party" (Motyl 103). Kemal Pasha Ataturk, the creator of the modern Turkish nation state would have agreed; it took him decades to create the Turkish Republic and a loyal cadre of citizens with strong emotions of patriotism toward the new Turkish state. Folklore, especially dance and music, played a major role in the construction of Turkish national identity (Shay, *Choreographic Politics*).

Somehow it is assumed that the borders of the nation states are sacrosanct, no matter how artificially constructed as is the case with Iraq and Kuwait, which have several straight lines for borders. After I penned these lines, the *New York Times* reporter Tim Arango wrote that several figures in the United Nations recently, as well as Vice-President Joe Biden several years ago, have suggested that Iraq should be broken up into its three component parts: Sunni Iraq, Shia Iraq, and Kurdistan. Ali Khedery, a former American official in Iraq, has written in *Foreign Affairs*, "[…] that a confederacy or a partition of Iraq might be the only remedy for the country's troubles. He called it 'an imperfect solution for an imperfect world'" (quoted in Arango A6). I would argue that Iraq is a piece of fiction, drawn up, according to Mr. Arango, by Gertrude Bell, famous as a British official and spy, who also translated Persian poetry, "is credited with drawing up the borders of modern Iraq after World War I" (A6). She created a political mess, which the United States government, still trying to keep this fictional nation together, has instead created a political and ethnic quagmire that only exacerbates the ethnic and religious turmoil there by its presence. Afghanistan has presented the world with a similar problem: a state riven with ethnic strife. Clear-thinking individuals need to rethink the position of the nation state as a zero-sum end.

Nationalism scholar Anne McClintock points out, "More often than not, nationalism takes shape through the visible, ritual organization of fetish objects – flags, uniforms, airplane logos, anthems, national flowers, national cuisines and architectures as well as through the organization of collective fetish spectacle – in team sports, military displays, mass rallies, the myriad forms of popular culture" (274). Ethno-identity dance with its colorful costumes and symbolic capital often serves the state very well in this capacity of fetish spectacle, especially a company that projects spectacle in the way that The Igor Moiseyev Dance Company does. Ethno-identity dance, like national identity, is also a modern phenomenon, developed through a wedding between character dance, ballet, gymnastics, and elements of dance in the field (Tkachenko 18). Ethno-identity dance as we know it began with The Igor Moiseyev Dance Company, the first state-supported dance ensemble, the very embodiment of an invented tradition, in Hobsbawm and Ranger's (*The Invention of Tradition*) terms (Shay, "The Spectacularization of Soviet/Russian Folk Dance"). In this study of Igor Moiseyev and his dance company, I will emphasize often that he considered his creative endeavors as art, not ethnography. Regarding Russia, "The country's artistic energy was almost wholly given to the quest to grasp the idea of its nationality" (Figes xxvii). Art like Moiseyev's became

crucial for the construction of Russian national identity and Russian nationalism, as Stalin cannily grasped, and personally supported.

In order to describe the contours of Russian nationalism, and situate and describe the specifics of those cultural boundaries of Russian nationalism, we must define closely what the terms "nationalism," "the nation state," "nationality," and their close relative, "ethnicity," mean. In political scientist John Coakley's useful study, *Nationalism, Ethnicity and the State*, he points out: "As a political force, nationalism is very broad in its reach, and hard to pin down" (3). Importantly, he adds, "For some it is one of the most progressive forces in history, while for others it is a dangerous stage […] in short, for some it is a sacred force, and for others a curse" (Coakley 3). Importantly, Coakley notes that in the study of nationalism one of the major problems is that nationalism "lacks an agreed terminology" (4). Further complicating any discussion of nationalism and the nation is that, "[…] it has long been acknowledged that 'nation' in English, the same term in French, *Nation* in German, *nación* in Spanish and *nazione* in Italian all have slightly different meanings" (Coakley 5). So it is important to define the terms found in this study and the ways in which I choose to use them.

Historian Philipp Ther notes in his study, *The Dark Side of Nation-States: Ethnic Cleansing in Modern Europe*,

> The twentieth century, more than any other era in history, was shaped by organized terror. It was the century of concentration of camps, gulags, and ideologically motivated mass murder […]. Ethnic cleansing is a product of the nation-state and hence one of the basic components of modern Europe. This explains in part why it occurred on such an extensive scale, affecting at least thirty million people in Europe in the twentieth century and laying waste to a large part of the continent.
>
> (1)

Ther, in his study, underscores the dark side of extreme nationalism. In Russia, for example, extreme nationalism has always contained a stain of anti-Semitism. Pogroms had been supported by the tsarist regime, that also occurred during the civil war following World War I. Stalin's anti-Semitic actions, and other events over the past century are examples of the dark side of Russian nationalism (See Zelnik 219; Fuller 346).

Certain nationalism scholars like Ernest Gellner agree with Ther and claim that modernity and industrialization are necessary conditions for nationalism to exist (*Nations and Nationalism*). However, one can look around the world and see many states like Afghanistan or Somalia in which both industry and modernity are nearly absent. This underscores the fact that there are successful and unsuccessful states. John A. Hall in a more nuanced approach states: "But a further distinction needs to be drawn here, between societies that have built their nations before industrialization and those that face modernization after nation-building has begun" (8). Nationalism scholar Roman Szporluk notes that even in Europe, "the Poles had their own elite even when they were under foreign

rule, their nationalism had by far anteceded industrialization" (35–36). Nationalism is not always modern.

Polish nationalism, like American nationalism, is a romantic form of nationalism in which the playing of the national anthem at athletic events can reduce grown men to tears. This is the kind of nationalism educator Philip C. Nix called "the reassurance that you matter and belong" (personal interview, February 6, 2016). In Norway it takes the form of many people wearing colorful costumes, which are expensive and readily available in shops; the frequent display of the Norwegian flag; and parades that feature the local moustache club in which recent immigrants are invited to join in the fun. One can see young Muslim girls in hijab wearing Norwegian costumes. In Iran, national pride often forms around the recitation of the *Shah-nameh*, an epic poem that depicts the romantic and heroic history of pre-Islamic Iran. Thus, the national symbols vary from place to place. Unlike the ethnic cleansing described and analyzed by Philipp Ther, these latter ethnonational symbols appear to be benign.

However, I also like nationalism studies scholar Anthony Smith's definition of a "nation": "a named human population sharing an historic territory, common myths and historical memories, a mass, public culture, a common economy and common legal rights and duties for all members" (quoted in Coakley 6). Smith's definition fits Russian nationalism, of which a mystical and misty past of Kievan Rus constitutes an important element, although I would argue that it is less useful for newer states carved out of former European colonies like Kuwait, which are too new and artificial to have common myths, and unlike Russians, Kuwaitis possess a competing Arab ethnic identity. Kuwait constitutes a political entity rather than an ethnic one, which further complicates attempting to pin down what constitutes nationalism and national identity. In this study, I emphasize that there exist many nationalisms, some widely embraced by the citizens of the state, others less so.

I was very amused by Charles Clover's study of Russian nationalism in which he characterized the nation and its accompanying nationalism: "Nations are wispy, flighty, arbitrary things until they, with astonishing rapidity, become hardened facts, incapable of retraction. They take on a permanence that is hard to explain. Where nationalism takes root, in other words, it stays" (7). This explains why failed states like the former Yugoslavia fail, through competing nationalist and ethnic identities, and a specifically Yugoslav nationalism never developed in consequence despite Tito's efforts.

Ethnicity and Nationalism

Ethnicity, as I define it refers to a group that believes that they have a common descent, a shared historical past, and attachment to certain cultural symbols, and who may share a common language, and or religion, among other characteristics. In many ways it shares the elements found in national identity. In short, ethnicity is an "us and them" identity (Shay and Sellers-Young, "Introduction"). Ethnicity is an older identity than national identity,

although they feel similar, if not the same. Ethnicity and national identity do not always align. Russians definitely constitute an ethnic group; the problem with Russian ethnic identity is that the Russians' own concept of identity frequently includes a kinship with their two nearest neighbors, Ukrainians and Belarusians, whom many Russians consider to be "Little" and "White" Russians, respectively. Among the reasons they regard these people Russians includes mutual intelligibility between many speakers of the three languages, membership in the Orthodox Church for many, and a common descent from the historical and loose political entity, Kievan Rus' as the foundational moment of the creation of the Russian people. In part, aside from Vladimir Putin's personal ambitions, this is why we see the current attempts to include swaths of Ukrainian territory into Russian possession, a project that is supported by many Russians.

By contrast, I argue that Americans do not have an ethnic identity, only a national one. While many ethnicities exist in America, there is no single specific American identity.

Nationality is having a nation, belonging to a nation state, upon which nationalism scholar Ernest Gellner commented, "A man must have a nationality as he must have a nose and two ears. […] Having a nation is not an inherent attribution of humanity, but it has now come to appear as such" (6). Thus, like nation and state, nationality is a social construct. In many ways a person's nationality parallels citizenship, and in this way it may not correspond to one's ethnicity. For example, in the contemporary Russian Federation, not everyone is Russian. It is the home to many other groups like Tatars and Bashkirs. Philosopher Paul Gilbert adds an important component to the contours of nationality: "Their membership must be a clearly legal status, conferring certain rights and imposing certain duties. This status, I suggest, is what lies at the heart of the legal conception of nationality" (9). Thus, one of the important elements of nationalism is the sense of belonging to and having rights and privileges of being a member of one's nation.

People have multiple identities and national identity is only one among many. The degree to which that national identity is important to individuals differs among individuals as well. For some individuals a racial, sexual, professional, or religious identity may be more salient in their lives than a national identity. National identity can also wax and wane in an individual's life, especially in times when the nation state is under threat, such as September 11, 2001. Philip Nix noted that a Canadian friend of his observed that "if a 9/11 occurred in Canada, no one there would become more Canadian" (personal interview, February 6, 2016).

Also, many people live in nation states whose government they loathe. I found this to be the case in Iran in the 1950s when I was a student there. Although, Iranian nationalism certainly existed and could be strongly expressed, nevertheless, many individuals were opposed to the Shah's regime, and this created considerable ambiguity in relation to the nation state of Iran. While many people felt a deep love and pride in their Iranian identity, the Shah's government never managed to harness those feeling of loyalty to the state and to the royal government. Instead, as was witnessed with the formation of the Islamic Republic, feelings of nationalism and love of country overturned the royal establishment, which in

many ways has become as unpopular as the former royal regime among many Iranians who unsuccessfully attempted to revolt in 2009.

Nationalism, as I use it, constitutes the feelings and attitudes toward the nation state in which one lives. Nations, in the form of the government and other patriotic organizations, create a project to foster feelings of nationalism, which respective governments sense they need to ensure the nation's survival. We will see this in Stalin's project to develop strong feelings of Russian nationalism in order to face Nazi Germany beginning before World War II, because he understood that while the Russian population would sacrifice for Mother Russia, most would not have done so for the Soviet Union.

Nationalism can be benign, and consist of festive celebrations as I witnessed in Norway in May, 2015 in which Norwegians celebrated their patriotism and their strong love of Norway through the wearing of traditional costumes and carrying flags as they marched to the music played by local school and community marching bands, and featuring the local moustache club, or, negatively descend into chauvinism, jingoism, and xenophobia as was the case in Serbia in the late 1980s and early 1990s, and the subsequent violence the Serbs unleashed on the unarmed populations in Croatia, Bosnia, and Kosovo.

Craig Calhoun, who generally regards nationalism as a force for good, not a necessary element of each individual in the world, observes: "Nationalism is not a moral mistake. Certainly it is too often implicated in atrocities, and in more banal but still unjust prejudices and discriminatory practices. It too often makes people think arbitrary boundaries are natural and contemporary global divisions ancient and inevitable. But it is also a form of social solidarity and one of the background conditions on which modern democracy has been based" (1). The problem with Calhoun's definition is that democracy can be fragile and anti-democratic elements in every part of the world can surface rapidly. Every nation state attempts to attribute its population's loyalty through instilling a love of country, often creating patriotic citizens in a school or military environment, in order to ensure the continued existence of the nation state. Unfortunately, that can descend to jingoism.

The issue of ethnicity dominated Soviet life, and, ultimately, as the economy floundered, ethnic tensions, beginning with the Estonians, Latvians, and Lithuanians, followed by the other ethnic and national groups, brought an end to the Soviet Union, which splintered along ethnic lines.

Nationalism and its Discontents

Since the United States attacked Iraq, I have repeatedly heard in the media, or read in print, that Iraq is a country, whose national integrity must be protected at all costs. In fact there is no such thing as Iraq as a country with a "natural" political constituency. Iraq is a piece of political fiction. It was an artificial state cobbled together out of several *velayats* (Ottoman administrative units) after the collapse of the Ottoman Empire in 1918 by Great Britain to reward a branch of the Arab Hashemite family for the support they gave against the

Ottoman Empire in World War I (the other two countries they created became Jordan and Saudi Arabia). After the fall of the Hashemite monarchy in 1958 with crowds rioting in the streets of Baghdad, it was held together in a fragile political arrangement under the Baath Party, in the person of Saddam Hussein, a Sunni, ruling over a Shi'a majority. After the American invasion, the artificiality of this arrangement was revealed, and Iraq fell into chaos that continues to grip it in destructive recriminations, massacres, and civil war between the Shi'as and the Sunnis, with the Kurds as a third party, who have established an independent Kurdish state in the north, standing aloof from their Arab co-countrymen. Deadly bombings have become daily occurrences, and the Maliki regime, which the United States supported, exacerbated the situation by mistreating the Sunni minority. It is increasingly evident, at least to me, that Iraq needs to be divided into three parts: a Shi'a state, a Sunni state, and a Kurdish state. When I heard a pundit on the *PBS News Hour* suggest the very same thing, the other pundits reacted sharply, exclaiming that the integrity of the Iraqi nation had to be preserved at all costs. Why? (see Arango, "Reviving an Old Idea for an Iraq Still in Turmoil").

I remember Bill Clinton, George W. Bush, and some of his fellow heads of state in Europe threatened Slovenia and Croatia, when they exited the former Yugoslavia, which many Slovenes and Croats had regarded as a political prison, that the United States and its allies would not recognize them.

In 1991, President George H. W. Bush opposed the breakup of the Soviet Union, warning Ukrainians that, "freedom is not the same as independence" and "Americans will not support those who seek independence in order to replace a far-off tyrant with a local despotism." The same year, after Croatia held an independence referendum, the State Department made clear that the United States was committed to the "territorial integrity of Yugoslavia within its present borders" – though that did little to prevent the country's disintegration.

(Keating 10)

They formed independent republics anyway, and the world went on, and generally speaking, Slovenia and Croatia became more prosperous and politically satisfied that they were as part of Yugoslavia. I often heard complaints from Croatians that in the former Yugoslavia a large part of their taxes and Croatian income went to poorer regions in the south of Yugoslavia. Nations, like people, get divorces, some acrimoniously and deadly as in the former Yugoslavia, some more peacefully like the Czech Republic and Slovakia parting ways.

Most nationalism theorists understand the constructedness of the concept of the nation and the nation state. Importantly, the contours of particular nationalisms shift with time and circumstance: "The fact that the content of nationalism can and does change, and that 'nation' itself can be a flexible concept, does not mean, however, that nationalist beliefs can be equally and easily manipulated in all circumstances" (Tuminez 3).

Most scholars concur that the nation state and nationalism are entirely modern concepts. Prior to the nation, individuals lived in city-states, kingdoms, empires, religious states like the Islamic caliphate, and tribal groupings among others. Nationalism scholar Liah Greenfeld notes, "[…] nationalism is the most common and salient form of particularism in the modern world" (8). Each nationalism is particular to a specific nation, that is to say that Croatian, Australian, Norwegian, or Nigerian nationalism, and national identities are different from one another and particular to its own nation, and each has a specific historical trajectory. That is why I prefer to refer to the contours of a specific nationalism as opposed to theories of nationalism, or better, nationalisms, because as Liah Greenfeld (*Five Roads to Modernity*) has shown with great rigor, each path to nationalism is different and historically specific.

Today there are two basic types of national identities that characterize most contemporary nation states: ethnic national identity in which nations, like Russia, have ethnic identities reflecting the majority of its population congruent within the boundaries of their states, and civic national identity in which citizenship is equated with the nation but not a specific ethnicity. The United States, Canada, and Australia serve as examples of civic national identity. No definitive American or Canadian ethnicity exists; instead America and Canada encompass a wide spectrum of American-ish or Canadian identities unaligned with any particular ethnic identity. America's national identity, for all that it is socially and historically constructed, is a reality for most Americans, and many, if not most, feel that this identity constitutes an important, and sometimes central, element in their lives. This becomes especially visible in election cycles, during which candidates call upon that identity to bolster their arguments "to make America great again," their audiences chant "U – S – A," and the candidates and their supporters tout their right to possess the "real" American identity. One can see the deep-seated emotions of American nationalism become visible at football games when tears appear in the eyes of grown athletes during the singing of the national anthem.[2]

First, I want to make the point that there exist multiple nationalisms. In order to demonstrate how different states utilize, or do not utilize, dance within the context of nationalism, I first want to show how I use the term nationalism, or more precisely nationalisms, in this study. Some nation states and national identities are older, with deeper historical trajectories, such as those of France, England, and the United States; newer states like Macedonia and Southern Sudan have not yet developed national narratives like that of England.[3]

Why is it that nationalism and national identity feels so ancient and "natural"? I think Craig Calhoun answers that question in discussing Roman society: "Many features of modern nations were thus in play well before the modern era" (2). Calhoun, along with Anthony Smith, points out the way in which certain nation states have their current existence buried in ancient ethnic roots and identities.

Some nationalisms are more or less deeply felt by a nation's citizens. Certain smaller nations like Greece and Serbia have what Alkis Raftis suggested to me ("President of the

Dora Stratou Theatre") a "fortress identity" and the people feel threatened by outside forces who would potentially destroy national and ethnic identity. The citizens of these smaller nations often feel their nationalism more keenly than those in larger nations like France or England. So embattled do those imbued with strong nationalistic feelings feel that governments like those of Greece and Turkey deny the existence of any other national or ethnic identity within their borders. One can see this in the ongoing strife between the Turkish government and its large Kurdish minority, and its former intolerance of Greeks and Armenians.

National identity, and thus nationalism, requires time to build, and I stress again that national identity, as I understand it, however fervently felt, is a social construct. Eugene Weber in his ground-breaking study of French national identity, *Peasants into Frenchmen*, points out that fully half the population of France could not speak, read, or write standard French by the end of the nineteenth century, and a standard language is one of the important vehicles for creating a national identity through the educational system. He writes, "In short, French was a foreign language for a substantial number of Frenchmen, including almost half the children who would reach adulthood in the last quarter of the [nineteenth] century" (Weber 67). Another example, cited by Geoff Eley and Ronald Grigor Suny, "In one of the best-known instances, it has been calculated that in 1861 only 2.5 of the total Italian population could actually speak Italian, while the rest inhabited a 'forest of dialect'" (7). As Eley and Suny state, "Citizenship, that is moral membership of a modern community required literacy, which had to be produced by a nation-size education system in a chosen language" (6). A modern aspect of national identity is a standard language, which each nation state attempts to control through its educational system and media.

For much of history, national identity seemed to be an organic, primordial identity. "[…] Nationalism grows neither in primordial mists nor in the abstract. It grows in relationship to other political, cultural, and ethnic projects" (Calhoun 28). However, beginning in the 1960s when scholars began to question and deconstruct nationalism and its origins, Ernest Gellner, one of the earliest scholars of modern nationalism studies, was among the first to critique the primordialist concept of nationality, "[…] for much of history tribes, villages, city-states, feudal settlements, dynastic empires, or the 'loose moral communities of a shared religion' were far more pervasive political units than nation-states" (Quoted in Eley and Suny 6). Thus, national identity is a relatively modern identity. However, in certain cases, what we might call proto forms of nationalistic emotions can be identified in England, France, and Iran, for example.

Nationalism is often conflated with ethnicity, and there can be a deep connection between them, for example, Mexican ethnic identity and the Mexican state; however, Mexico like many nation states is a multiethnic entity and Mexican national identity is frequently competing against a variety of local ethnic, native identities. Ethnic identity, that is, a "we versus them" identity, often trumps national identity for many individuals in a nation state. That is why many nation states with multicultural and multiethnic populations such as Mexico and the Philippines attempt to build a "Mexican" or "Filipino" identity among their

citizens. National dance companies in such countries frequently have a role in that process to cement the relationship between the national identity and local identities. The national dance company showing the spectacle of the rainbow array of ethnicity in Mexico with Ballet Folklorico or the Philippines with the Bayanihan Dance Company serves to build the pride and patriotism in the respective nation state, and pride in their local identity in that process.

Many scholars of national identity and nationalism argue that national identity is a modern identity, and that national identity did not exist before the American and French revolutions. Scholars of nationalism and when nation states, as we known them, came into existence do not always agree. For example, Liah Greenfeld convincingly claims that England, the first nation state came into existence when Henry VIII effected the separation of the English Church from the international Roman Catholic Church, considerably earlier than the French Revolution (*Five Roads to Modernity*).

There are also many ethnic groups – the Catalans, the Basques, the Galicians – who can claim a national identity, but do not have a state of their own. The Arabs have numerous states, and some Arab nationalists have been frustrated in their inability to establish a single Arab nation state, instead of most of the current ones whose borders were created by Great Britain and France.

Nationalism frequently begins with national elites and intelligentsias long before it percolates into a widely held self-identity. Political scientist Walker Connor notes, "Nationalism is a mass phenomenon. The fact that members of the ruling elite or intelligentsia manifest national sentiment is not sufficient to establish that national consciousness has permeated the value-system of the masses. And the masses, until recent times totally or semi-illiterate, furnished few hints concerning their view of group-self" (212). Such confusion over identity can be seen in the ways that the former Ottoman and Austro-Hungarian identified their multilingual, multiethnic populations, whose ethnic identities under new regimes often changed several times.

Modern nation states, their very existence, as the case of Turkey amply demonstrates, are predicated on a "created" or constructed identity. Further, I want to stress, following Özkırımlı (*Theories of Nationalism*), there cannot exist a single theory of the genesis of nationalism. As Barbara Sellers-Young and I point out similarly about ethnicity, there exist too many variants to account for a singular form of ethnicity, so too, there exist many variants of nationalism (*Oxford Handbook of Dance and Ethnicity*). At best, we can show nationalism's contours, a conceptual hermeneutic that I created for looking at phenomena such as masculinity or ethnicity, in order to create a useful meaning of the term. Nationality is always in flux, and therefore, a dynamic exchange with an individual's sense of self in the nation.

Not only is nationalism not a single phenomenon, or even one that varies with particular nationalisms, but as Umut Özkırımlı usefully reminds us, "Any study of national identity should acknowledge differences of ethnicity, gender, sexuality, class or place in the life-cycle that affect the construction and reconstruction of individual identities" (11). In other words,

national identity and nationalism vies with myriad other identities – political, religious, social, professional, sexual – in an individual's life.

I disagree with the stance of the United States refusing to recognize new states. *New York Times* writer Joshua Keating writes, "Would be countries are likely to face the opposition of the international community, including America [...] America's aversion to border changes is generally shared by the world's major multilateral institutions [...]" (10). However, I support Keating's notion: "There are very real reasons for skepticism about all of these independence movements [Catalonia, Kurdistan]. But that doesn't mean that maintaining the world's current arrangement of countries within their existing borders needs to be a guiding principle. Above all, the preservation of existing countries ought to guide our thinking less than the well-being of the people who live within them" (10).

Soviet Identity

The issue of Soviet identity compared to Russian or other nationality identities was a complex one in the former Soviet Union. Sometimes Russian identity became equated with Soviet identity. Historian Karen Petrone notes of this enmeshing in her discussion of Soviet celebrations in the mid-1930s: "[...] the ideas that the special enthusiasm of the soviet people made it their destiny to lead the way to communism, that the great cultural achievements of the old Russian elite now belonged to the entire Soviet people, that Soviet art should be realistic and 'genuinely popular,' and that Russian culture bound all of the Soviet nationalities together as one mighty country" (3).

The Soviet Union can be usefully compared to the former multiethnic Yugoslavia, in which the dictator Josip Broz Tito attempted to create a Yugoslav identity to supersede previous ethnic-based identities such as Serb or Croat. However, those identities proved to be too resilient, and in spite of the Yugo-nostalgia that can be found among some older people, when the economic deterioration ramped up in the 1980s and 1990s, the country broke down into its ethnic-based republics. So too, the former Soviet Union, in spite of models like Soviet Man, in large part most individuals never embraced their Soviet identity in place of their ethnic and national identity. This is perhaps because Yugoslav and Soviet identities are even more constructed and artificial than Russian or Serbian identities.

"National identities were supposed to be relegated to the background and become irrelevant with the growth of Soviet patriotism and the formation of the new identity, the *sovetskii chelovek* (*homo sovieticus*)" (Prazauskas 154). Senior researcher Algimantas Prazauskas suggests that although never specifically stated, "the idea was inspired by the American example" (154). He adds, "The '*homo sovieticus*' blueprint may have looked good on paper, but was as utopian as the idea of communist society itself" (154). The Soviet government was always conflicted and often obscure about its nationalities policies and decisions, which were frequently changed. This underscores the fact that the Yugoslavian model constitutes a good comparison, especially since, during the rise of Nazi Germany, as

I later explain in this chapter, Soviet identity took a backseat to Russian nationalism, just as Yugoslav identity gave way to Serb and Croat identities: "The clearest example of the soviet state's co-optation of Russian nationalism occurred during Stalin's regime, particularly in the 1930s and through the end of World War II. During this period, nationalism coexisted with the excesses of Stalinist communism and proved indispensable to the defense of the Soviet state when confronted with potential destruction by Hitler's war machine" (Tuminez 176). Thus, when the chips were down, Russian national identity and patriotism trumped Soviet identity.

Historian Peter Kenez underscores my point: "From the beginning of the 1930s, in an ever-accelerating fashion, there was a revival of a particular form of Russian nationalism. Citizens of the Soviet Union were to be motivated by two types of nationalism: they were expected to be patriots of the empire (i.e., the Soviet Union) and also of their own nation. At the same time it became ever more explicit that the Russians were to be the leading nation in this family of nations" (121). It was in this nationalist and political climate in which Igor Moiseyev founded his company to celebrate both Russian *and* Soviet multinational identities; however, in the beginning Moiseyev's many Russian choreographies valorized Russian identity to raise Russian patriotism to protect the homeland, and later, following World War II they were tasked to demonstrate the rainbow ethnicity of the Soviet Union living together in harmony.

Too, one cannot take the Soviet Union identity and compare it with that of American identity. The Soviet population had ethnic and national identities that competed with a Soviet identity; the Soviet government hoped that these (often) new identities would eventually disappear in favor of a Soviet identity, and Soviet Man would emerge, whereas, I argue that there is no single American ethnic identity; there is only American national identity.

Nationality in the Soviet Union

Historian Yuri Slezkine emphasizes the importance of national and ethnic identity in the former Soviet Union, which was, "[…] the first state to institutionalize ethnoterritorial federalism, classify all citizens according to their biological nationalities and formally prescribe preferential treatment of certain ethnically defined populations" (204). Over the past decades, several scholars began to characterize the former Soviet Union and its nationalities policies as almost a plaything, in which Lenin and Stalin created capricious republics and autonomous regions, and even ethnic groups from whole cloth. One can still find these kinds of statements in soviet studies. In those writings, it was frequent to encounter the specter of the Lenin and Stalin sitting over a map and, willy-nilly, creating nations. This has no substance in ethnographic fact. As an example of that point of view: "The architects of the USSR did not treat the republics as real or potential nation-states. Moscow delineated their borders deliberately so as to make the republics incapable of independent existence" (Szporluk, "Introduction: Statehood and Nation Building" 6). One of the reasons for this

view was that scholars had little to no access to Soviet archives. Another reason was that in the popular mind, at least in the United States, "Russian" and "Soviet" were synonymous terms. Francine Hirsch's study, *Empire of Nations*, has called this once-popular idea of fictional republic and autonomous region borders into question. The entire question of Russian nationalism and the way its contours have changed over time require an understanding of the nationality question in the former Soviet Union, and the place of Russian national identity within that state.

"No issue was more central to the formation of the Soviet Union than the nationality question. The Bolsheviks had set themselves the task of building socialism in a vast multiethnic landscape populated by hundreds of different settled and nomadic peoples belonging to a multitude of linguistic, confessional (religious), and ethnic groups" (Hirsch 5). The new Soviet government began the arduous task of creating territories for these peoples and created national identities with which they were never comfortable. "Taking as a given that the Soviet Union bore a strong resemblance to other modernizing empires and that its constituent parts, the national republics and national oblasts (districts), looked somewhat like nation states […]" (Hirsch 4). And so much a part of Soviet Union did these national spaces become, that when the Soviet Union collapsed, these newly constructed spaces such as some Central Asian identities and republics, like Kirghiz and Kazakh, became living realities.[4]

Natural nation states do not, in general, have straight-lined borders, but rather they have mountains, rivers, seas, and other natural features to constitute their entity as a nation state. Surprisingly, many people *do* accept such straight-line borders as if they were the natural order: "African colonies, territorial boundaries – as established by the colonial powers, and accepted, for the most part, as legitimate by anticolonial nationalists – were not even approximately congruent with cultural boundaries" (Brubaker 81). France and England deliberately created such boundaries in the same manner as the former USSR created the various republics and autonomous areas through tactics directed toward a specific goal: to prevent the establishment of new viable independent states. That is why, for example, the city of Samarqand, the largest Tajik city in the former Soviet Union, was gerrymandered into the Republic of Uzbekistan away from the Republic of Tajikistan, and Nagorno Karabakh, the autonomous area with its Armenian majority, was placed within the Republic of Azerbaijan, resulting in a bloody conflict in which thousands died. These are only two examples, among several, that illustrate why scholars have critiqued the nationality policies of the former Soviet Union and other colonial powers. They do not reflect the lived ethnographic picture of that failed nation state.

Hirsch writes that "Many portrayed the Russian nationalities as the hapless victims of 'Soviet-Russian' rule, as inmates of the Soviet 'prison of peoples' […] The end of Soviet rule brought about a major paradigm shift […]" (2–3). Her main point was that rather than capriciously drawing and redrawing the map, creating phantom political entities, as many scholars claimed, Soviet authorities attempted to genuinely create actual political entities. However, I question her evaluation. In the case of Central Asia, large Tajik populations, including the cities of Samarqand and Bukhara, were gerrymandered into Uzbekistan.

The ethnographers, and the accompanying census-takers, some of them without any training fanned out over the Soviet Union and assigned everyone a nationality. Valery Tishkov, who participated in this process, notes that they encountered several difficulties in this assignment: "Large-scale recruitment into ethnonations began throughout the country gradually replacing regional, religious, clan and other group identities. My colleagues from the Institute carrying out field research in the Ukrainian-Russian bi-cultural belt cited several examples where local people described their ethnicity thus: 'under one regime we were Ukrainians, under another – Russians, but frankly speaking we do not know who we are" (20). This was the case in many of the regions, particularly in Central Asia where religious identity rather than ethnic or national identity was more common.

Russian Nationalism in the Soviet Union

In the Soviet Union of the 1920s, under Lenin's rule, Russian identity and Russian nationalism, and its associations with Russian colonialism in Central Asia and the Caucuses, was suppressed. Under Lenin, the Russians formed the backdrop for the other nationality groups. In the 1930s, under Stalin, that was to change dramatically.

With a suspicious eye on an increasingly bellicose Nazi Germany in the 1930s, Stalin reversed all of this. He realized he would need the Russian population to confront the danger of Nazi Germany, and that would require the Russians to have a strong sense of Russian nationalism. The degree of foregrounding the non-Russians had a very important effect on the current Russian state because "Soviet political, administrative, and military elites, where there were predominantly ethnic Russians, and in the weak institutional differentiation between the Russian Soviet Federal Socialist Republic (RSFSR) and the USSR. Thus, until 1990-1991, the RSFSR was the only soviet republic without its own Communist Party, KGB, or Academy of Sciences, making the CPSU, the USSR KGB, and USSR Academy of Sciences simultaneously Soviet and Russian institutions" (Brudny 7). Small wonder, then, that the current Russian state seeks to reassemble the former Soviet Union within its sphere. For the Russians, the Soviet Union and Russia were the same.

While Stalin was bent on saving communism, he understood that Russians would prefer to save Russia. Peter Kenez notes that, "[…] for the great bulk of the Russian people it was the defense of the motherland, not the defense of communism, that mattered" (153). Kenez notes that Soviet propaganda of the period was very skillful, and to heighten Russian nationalism there also occurred "an officially sponsored revival of pan-Slavism […] which greatly comforted the Russians and convinced them that they were not alone against the brutal Teutons" (152). Thus, the move to valorize Russian identity began.

It is often thought that Russian industry began with advent of the Soviet Union, but by the mid-nineteenth century, a powerful merchant class had already appeared as an important economic force in Russia. Like their American counterparts, these powerful men supported the arts. Many of them collected impressionist painting that can be seen in the Hermitage

today. However, they also collected Russian art based on peasant forms. In the 1860s, 1870s, and 1880s, "[…] the interest in peasant crafts that stimulated the neonationalist movement of those decades implied an equally critical view of academic styles and gentry values. Like realism, neonationalism received generous merchant support. Many built homes in the Old Russian style. […] Sergei Morozov endowed the Moscow Museum of Handicrafts and gave generous support to village artisans" (Garafola, *Rethinking the Sylph*).

This explains the love of the country house, the *dacha*, and activities like going into the countryside to find mushrooms are such popular activities in Russia, even today. Yitzhak Brudny notes that, "[…] village prose of the 1950s provided the basis for liberal and conservative Russian nationalism" (17). The performances of The Igor Moiseyev Dance Company not only fit comfortably into the idealized Russian village, they embody it with attractive young men and women in colorful, if often modernized, costumes, and idealized scenes of village life. Many historians commented on this change. "The clearest example of the Soviet state's co-optation of Russian nationalism occurred during Stalin's regime, particularly in the 1930s and through the end of World War II. During this period, nationalism coexisted with the excesses of Stalinist communism and proved indispensable to the defense of the Soviet state when confronted with potential destruction by Hitler's war machine" (Tuminez 176). Russian identity was promoted, and Stalin "[…] adopted chauvinist policies, and relied on Russian nationalist ideas to mobilize the population during World War II […] By the late 1930s official policies included glorification of the Russian past, cultural and linguistic russification of non-Russians […]" (176). Figes notes, "Communism was conspicuously absent from Soviet propaganda in the war. It was fought in the name of Russia […]" (489). Moiseyev's Russian dances helped to revive that identity.

Russian Nationalism

According to Liah Greenfeld, Russian nationalism began with Peter the Great and Catherine II, the Great: "Two autocrats can be held directly responsible for instilling the idea of the nation in the Russian elite and awakening it to the potent and stimulating sense of national pride: these were Peter I and Catherine II" (191). It is important to note that there was no mass response, but rather that, slowly during the Petrine period, increasing references to the state and the Russian state appear, which increasingly gave birth to the idea of a Russian identity. Nevertheless, these were autocrats with no expectations outside of complete and immediate obedience to their demands.

Music historian Richard Taruskin also recognizes that Russian national consciousness began with Peter the Great: "To begin with, Russian national consciousness was an aspect of westernization. The same eighteenth century that witness the Petrine reforms and their aftermath – the construction of an Italianate 'window on the West' atop the Neva marshes […] was also the century in which the cultivated Russian elite first established a national

literary language distinct from the archaic ecclesiastical idiom first wrote up the national history, first began to look upon the livers of those indentured lives [peasant serfs] as repositories of a tradition worth knowing and preserving" (3). This followed the pattern established by elites in many nations in Europe: identifying the peasant as the repository of the essence of national identity.

The most important elements of Russian national identity have been described and analyzed in Laura J. Olson's important study (*Performing Russia*) of revival dance and music in Russia: hypermasculinity in the form of Cossack identity (also popular in Ukraine), a popular vision in folkloric presentations, Russian Orthodoxy, the village, at least idealized ones seen through the mist of nostalgia and such activities as mushroom gathering and keeping a vegetable plot, and the dream of having a country house, a *dacha*. And while these may seem simplified elements to some readers, Figes states: "what Nabokov called the 'very Russian sport of *hodit' po gribi* (looking for mushrooms) – were more than the retrieval of a rural idyll: they were an expression one's Russianness" (xxxii). All of these symbolic elements in Russian identity, in fact, call forth the constructedness of Russian national identity that underscore the constructedness of national identities that I claim in this study.

Visually underscoring Olson's observations, a state-sponsored dance and music ensemble, the Don Cossacks of Rostov toured the United States. It was in the presentation of masculinity that they differed from the Moscow-based ensembles like The Igor Moiseyev Dance Company. In the latter, the men appear young, fresh-faced, and asexual, in line with the prudish standards that obtained in the former Soviet Union, whereas the Don Cossacks all had virile moustaches, and portrayed a raffish, devil-may-care sexuality. Interestingly, in the souvenir program, the ensemble poses in front of a huge Russian Orthodox Church, which dwarfs them.[5]

Nationalism and its components and underpinning beliefs change through time, and there often exist competing conceptual frameworks, and Russian nationalism is no different. Prior to the Revolution, much of the peasant mass had little ethnic identity beyond their Orthodox faith because "the gulf between the privileged few and the masses could not be narrowed quickly enough," which is a common pattern in other states. First the elite feel nationalistic feelings and, through the media and the educational system, inculcate this identity to the masses (Dixon 51). However, in contrast to Peter I's attempts to emulate the West, the last tsars attempted to fasten Russian identity to anti-Western Muscovy and the Orthodox Church, and Putin utilizes these same elements (Clover 4).

We can conceive of Russian nationalism as a continuum from a type of nationalism expressed in a harmless folkloric approach, supported and favored by the Communist Party in the former Soviet Union, but also to remember that violent eruptions of virulent nationalism as manifest in the tsarist-era Black Hundreds political movement and the contemporary radical right-wing Vladimir Zhirinovsky's nationalist Pamyat Party, which include strong strains of anti-Semitism and xenophobia. These latter movements and parties might attract a rabid minority, but in times of trouble, such as during the collapse of the former Soviet Union, they become extremely visible. If we recall Coakley's definition of

a nation-state: "A state is a self-governing territorial entity with a central decision-making agency which possesses a monopoly of the legitimate use of force in ensuring compliance with its decision on the part of all persons within its borders" (11), then that would seem to be the model of some kind of perfect state, an ideal definition of a nation state. But at times, the "central decision-making agency," through temporary or permanent weakness, cedes power to other political movements, as was with the radical right-wing parties of Russia, which threaten the cohesion of the nation. Thus, Coakley's observation becomes crucial in conceptualizing Russian nationalism because his is the "ideal" state that is at variance with reality in which the government falters and other forces come to the fore.

Nationalism often begins with intellectual elites and spreads through educational institutions to the masses. This was certainly the case in Russia, "At a time when the inhabitants of the Russian countryside thought of themselves simply as 'Christian folk' (*krest'yanye*) or 'the Orthodox' (*pravoslavniye*) and would never have dreamed of claiming their *barin* (the owner of the land to which they were confined by law) as their countryman [...]" (Taruskin 3). The social divide between town and county, elite and mass, characterized many states in Central and Eastern Europe – they occupied two different worlds.

Historian Orlando Figes, in his study of Russian national identity makes an important point about Russian nationalism: "Russia was too complex, too socially divided, too politically diverse, too ill-defined geographically, perhaps too big, for a single culture to be passed off as the national heritage. It is rather my intention to rejoice in the sheer diversity of Russia's cultural forms (xxviii). And, yet, as will see, the Soviet government, through the performances of The Igor Moiseyev Dance Company and the Pyatnitsky National Chorus, attempted to create a unifying national dance and vocal style that would be identifiably the "Russian national style" and, to a large degree, they were successful in establishing a national image through their performances because this "national" style continues in the Russian Federation.

Greenfeld notes one of the most important elements of creation of Russian nationalism was "[...] reflected in the instantly torturous character of Russian nationalism and its frustrating, ambivalent, and ineluctable dependence on the West" (222), which one can see in pronouncements like Nikita Khrushchev's famous: "We will bury you" (Gaddis 84) to Putin's response to NATO and negative Western reactions to his invasion of Ukraine and Crimea. Putin's reaction embodies "*ressentiment* – the existential envy of the West" (Greenfeld 250). She concludes, "The ingredients of the Russian national consciousness, and the definition of the Russian nation, were already present by 1800" (260). However, during that period certain elements continued to be present in Russian nationalism. "The linkage between greatness and imperial power emerged as a dominant theme in Russian political pronouncement and in poetic, historical, and popular literature, beginning at the dawn of Russian national consciousness in the eighteenth century and continuing throughout the rest of tsarist rule" (Tuminez 31). Josef Stalin, in seeking to promote Russian nationalism in the 1930s turned to some of these same elements, including rehabilitating tsars like Peter I as heroic figures of Russian history. Later, elements of the population venerated the Romanov tsars as a part of their Russian nationalism.

As Slezkine showed above, the Soviet Union underscored the biological origins of ethnicity in creating the republics and ethnic regions ("The USSR as a Communal Apartment"). However, the Russians were excluded from this scheme. During Lenin's period, Russian nationalism was condemned as the manifestation of imperialism, and he foregrounded the identities of the non-Russian groups for two reasons: to demonstrate that Communism was a class battle, and to show that the de-emphasis on Russian identity supported internationalism while characterizing Russia as the "oppressor nation" (quoted in Tuminez 176). In the former USSR, which Slezkine refers to as a "communal apartment," "[…] then every family [ethnic group] that inhabited it was entitled to a room of its own […] But what about the Russians? In the center of the Soviet apartment there was a large and amorphous space not clearly defined as a room, unmarked by national paraphernalia, unclaimed by 'its own' nation […] but in Russia proper they had no national rights and no national opportunities (because they had possessed and misused them before)" (217). He adds, "'Russian' was a politically empty category" (218).

As we have seen in the 1930s, with the rise of Hitler, Stalin needed to act. In the mid-1930s, Stalin, a native Georgian, had a change of heart, and Lenin's policy of suppressing expression of Russian culture and language while supporting the other nationalities came to an abrupt end. Stalin's role in the support of Russian nationalism was pronounced even earlier: "Like another non-Russian – the Pole Feliks Dzierzynski at the head of the Cheka – Stalin, as Commissar for the Nationalities, had proved to be more Russian than the Russians in Lenin's government. Stalin wanted the Soviet constitution to reflect Russia's pre-eminence in the revolutionary movement, and he got his way […] The same Georgian that rescued Russian domination of the new socialist state in the 1920s resided, from 1934, not only over a predominantly Russian elite, but also over a revival of Russian imagery" (Dixon 54–55).

He began the promotion of Russian folklore and culture as synonymous with Soviet culture: "Rather than being a neutral background to set off the other nationalities, Russian nationality emerged as an ethnic group in itself. In fact, Russian now stepped forward as the dominant nationality – more 'equal than all the rest'" (Olson 38).[6] It is clear that Stalin's *volte face* was driven by a motive deeper than his love for Russian folk songs and dances: the rise of Nazi Germany, and the voracious appetite they had for other people's land loomed dangerously near. "In cold, pragmatic terms, Stalin was probably able to see plainly that the Marxist ideology could not mobilize the Soviet people to defend their land, and appeals to vague social forces could not exhort them to throw themselves on German bayonets. He tugged on the heartstrings of Russians' love for their land and for each other" (Clover 101). Stalin needed and lavishly utilized Russian folklore, such as The Igor Moiseyev Dance Company, to build a sense of patriotism, ethnic and national pride, and a readiness for the Russian majority to defend the Motherland.

The valorization of Russian identity proceeded apace. "With the country's entry into war in 1941, glorification of patriotism increased tenfold" (Laruelle 16). The Igor Moiseyev Dance Company was part of this plan, and they toured widely on the frontlines to instill Russian pride and patriotism during the war years.

Josef Stalin particularly liked The Igor Moiseyev Dance Company. He understood in some way that the visual impact of spectacularized dance evoked a powerful and emotional Russian identity, and had the power to provoke strong feelings of Russian nationalism. One can still see that power, when at the close of a Moiseyev performance, Russian immigrants in Los Angeles leave the theatre with tears in their eyes, and they attend Russian nightclub performances in the same Moiseyev style.

The way in which some accounts of Russian nationality are written, one can receive the impression that Russian nationality was suppressed by the Soviet authorities, or it was hidden. The Communist Party certainly went through various phases of strongly or weakly supporting Russian nationalism. Russian nationalism writer Charles Clover notes, "The first concession of the regime to the nationals came in 1965 when a number of prominent nationalists petitioned the Kremlin to allow them to create a new organization, the All Russian Society for the Preservation of Historical Monuments and Culture (the clunky VOOPIK in Russian). It was tightly controlled by the Communist Party […]" (119). Some scholars claim that after Stalin's massive support for Russian nationalism, which continued even after World War II, Stalin received less support after he died in 1953. In fact, according to Clover, "nationalism had served its purpose, and the genie had to be put back in the bottle" (102). Nationalism, in Stalin's view, threatened socialism (or what passed for socialism) in his regime, which Clover characterizes as "a preposterous human phenomenon beyond all comprehension: the combination of a mutated strain of cruelty and perversion of impersonal bureaucracy on a monstrous scale, paralleled only by the Holocaust" (97). No one will ever be able to put an exact number of those who perished during the Terror, the Gulag, the Ukrainian Famine, the Katyn Forest massacre, and other crimes that Stalin committed in his two-decade rule, but estimates must reach at least forty million souls (see Clover *Black Wind, White Snow*; Conquest, *The Harvest of Sorrow*).

But, in spite of his evil actions, scholar of Russian history Andrej Krickovic states, "Stalin is still revered among Russians because he was the head of state during World War II, known in Russian as the Great Patriotic War" (public statement, July 10, 2017). "You cannot say anything bad about the Great Patriotic War because it was Russia's finest hour. Everyone sacrificed. World War II is sacrosanct because World War II is the only thing they feel good about" (public statement, July 10, 2017).

Astrid Tuminez writes, "Under Nikita Khrushchev, Stalin's successor, state authorities emphasized Soviet patriotism while suppressing the most visible expressions of Russian nationalist ideology and cultural hegemony" (178). However, Soviet studies scholar Yitzak Brudny argues in contrast that "[a]lthough Russian nationalism did not become a prominent force in soviet society until the mid-1970s, a decade after Khrushchev's fall from power, the period between 1953 and 1964" (30). Moreover, this did not seem to affect Russian individuals: "Russian nationalist writers, movie directors or painters earned national recognition between 1953 and 1964. The success of this group clearly indicates that Russian nationalism in the post-Stalin era was not a manifestation of frustration caused by increased competition from members of other ethnic groups or blocked career opportunities" (Brudny 37).

I would add that it is significant that the first companies to be sent to the West for purposes of cultural diplomacy during the Cold War were Russian companies such as The Igor Moiseyev Dance Company and Beryozska, who largely represented an idealized Russian bucolic life.

Laruelle states, "The first is to avoid falling into the trap of thinking that nationalism is undergoing a 'renaissance' in post-Soviet space. Nationalism was not born of the collapse of the communist regime; it existed *underneath* and *in* it, much more than *against* it, and had only to adapt itself to the events of 1991" ("Rethinking Russian Nationalism" 2, original emphases). Russian nationality has always had a presence in the Soviet Union as today in Russia; it just had, as do many nationalisms, periods of waxing and waning. My observation during three trips to the former Soviet Union was that Russian national identity was the identity against which all non-Russian identities measured themselves. Russian was the lingua franca, and the prestige language in the former Soviet Union, and for many non-Russians it was the prestige language of higher education and administration – a means to rise in society.

One of the difficulties of addressing Russian nationalism is that it has an amorphous quality, difficult to pin down, even for Russians. When the Soviet Union collapsed, Gregory Freeze notes, "Interestingly, no popular front emerged in Russia itself, reflecting not only the ethnic diversity but also the lack of national consciousness in the largest republic," (392), which created a dramatic contrast with, for example, the intense nationalism on view in the Baltic Republics of Estonia, Latvia, and Lithuania. NPR reporter Anne Garrels in her study of Russia echoes Freeze's observation: "Friends start talking positively about a resurgent Russian identity, though they are hard-pressed to explain what they mean" (13).

Briefly, the history of Russian nationality is inextricably entwined with Soviet identity and the Soviet state. "First of all, the idea that Russia was the 'leading nation' was never overcome. Although condemned as 'Great Russian chauvinism' during the revolution, this principle was revived a generation later, grew stronger during World War II, and never left the scene again. Thus the New Soviet Man was to speak Russian. He [the non-Russian] was to relate to Russian Lost Empire history and symbols, and give up forever all dreams of national independence" (Rywkin 4). Michael Rywkin's observation may be one of the reasons that Americans, even many knowledgeable ones, were never able to discern between a Russian and Soviet identity, because it was also conflated in the Soviet Union. While promoting the notion of a multinational state to the world, in fact, the plan was that Soviet Man and Russian Man would be one and the same with the total consolidation of a socialist state.

Staging Russia: Folk Dance and Music in the Construction of Russian Identity[7]

Ernest Gellner notes, "Nationalism usually conquers in the name of a putative folk culture. Its symbolism is drawn from the healthy, pristine, vigorous life of the peasants, of the *Volk*, the *narod*" (577). We will see that in the case of Russian nationalism that was certainly the

case. Josef Stalin attempted to arouse Russian nationalism and feelings of patriotism, in contrast to Vladimir Lenin who had suppressed Russian nationalism as being linked to imperialism in the 1920s, to combat the growing Nazi threat from Germany in the late 1930s by valorizing Russian folk culture in the form of literature and folk dance and music. After all, how dangerous could singing and dancing folk songs and dances be? "The revival of folk music that was viciously assaulted during the Cultural Revolution therefore became a natural part of the 1930s normalization in [Russian] culture. Its peasant content, though stylized, reinforced love of the land and thus of the nation or *narod*" (Stites, "The Ways of Russian Popular Music to 1953" 25). Stalin pushed this folk song and dance movement because he needed to build Russian ethnic pride and quickly.

The valorization of folklore had already began in tsarist Russia and continued into the Soviet period, because a large sustaining component of Russian nationalism is nostalgia for the village. This can be seen in the models of an idyllic golden age of peasant life in Moiseyev choreographies and in the nostalgia of Russian folk songs found in the Pyatnitsky repertory. Soviet Union historian Lewis Siegelbaum notes,

> Folklorism, characterized by Richard Stites as "politicized folk adaptation", made a strong comeback via Igor Moiseyev's Theatre of Folk Art [later the State Academic Ensemble of Folk Dances of the Peoples of the USSR] founded in 1936, and a national network of amateur folk choirs and dance ensembles. These "prettified and theatricalized Stalinist ensembles […] [promoted] images of national solidarity, reverence for the past, and happy peasants", images that were reinforced by highly publicized photographs of smiling peasants, decked out in "ethnic" or folk garb, meeting Stalin in the Kremlin.
>
> (309)

The important aspect of Siegelbaum's observation, which underscores the points that I make, is that, while the non-Russians were represented in the repertory of The Igor Moiseyev Dance Company, Russian ethnicity was foregrounded and stressed across all of these performances.

My interest here is not to go into the minutiae of Russian nationalism that Liah Greenfeld (1992) and Astrid J. Taminez (2000), and many others, have so admirably done, but rather to paint it in broad strokes in order to situate The Igor Moiseyev Dance Company and Moiseyev's genius in bringing to the stage an idealized Russian village and how that played out in the environment of the rehabilitation of Russian nationalism and Russian identity by Stalin. I want to distinguish how Russian nationalism and the way in which Stalin valorized it affected the visual impact of The Igor Moiseyev Dance Company and its use of spectacle ultimately determined the direction the company took. Part of the success of the Moiseyev was its sheer size. This falls in line with the Russian Communist preoccupation with large size, a major aspect of socialist realism, seen most visibly in state architecture and prominently display statuary. Historian Peter Kenez argues that what I call monumentality was so much in evidence: "the main reason was a communist belief that large size equaled modernity and

progress" (198–99). Within that concept if one balalaika is good, thirty balalaikas are thirty times better and this love of the big is seen in folk dance, music, and vocal groups with their large memberships. And, while I agree with Kenez, there is evidence from other studies, such as that by Laura J. Olson (*Performing Russia*), that large folk choruses and orchestras were already a feature of life in pre-revolutionary Russia, but large-size folk choruses, folk dance companies, and folk orchestras marked Soviet life in a major way as Mary Grace Swift's (*The Art of the Dance in the USSR*) study shows, and my own experience revealed during three visits to the former Soviet Union to study their folk dance ensembles (1976, 1979, 1989).

As we have seen in the early years of the Revolution in Russia, in the mid-1920s, after Stalin consolidated his power, the Communist Party attempted to de-emphasize Russian folklore, to show their internationalist leanings, and to demonstrate their brotherhood with the other nationalities who inhabited the USSR and abroad; thus, the Party supported non-Russian folkloric genres. Russian folklore was demeaned as the backward expression of ignorant peasant women, and many party radicals wanted to eradicate Russian folklore for its reminder of backwardness.

Folklore in the former Soviet Union, as in much of Eastern Europe, was a primary means of expressing national identity. A scholar of the former Soviet Union and its successor states, Marléne Laruelle notes, "In the soviet tradition 'nationalism' was a term that designated aggressive attitudes in which the interests of one ethnic group were placed above those of others, whereas folkloric glorifications of one's 'nationality' were, on the contrary, perceived to be positive and harmless" ("Rethinking Russian Nationalism" 4). In the former Soviet Union, having one's own dance company became an important means of expressing that ethnicity and the comfort in knowing that one's identity is important. "In the mid-1950s, folk dance groups sprouted in hundreds of towns and cities, with even the NKVD [predecessor of the KGB] having its own Song and Dance Ensemble" (Swift 241). It would be difficult to imagine the FBI having a performing square dance group, which would be an analogous situation. The Cossacks, who fell out of favor with the Communist Party for being on the wrong side of the civil war that followed the 1917 Revolution petitioned to form their own dance companies. "In 1935, groups of Don, Terek, and Kuban Cossacks were given official sanction to form their own song and dance groups" (Swift 106). The formation of a national dance company affirmed a special Cossack identity (*Don Cossacks of Rostov*). In the political climate of the Soviet Union, having one's own folk dance company came as close to a political nationalist statement that the government would allow.

Music scholar Andy Nercessian reminds us that, even though Russian chauvinism existed in the former Soviet Union,

Nevertheless, folk music, sheathed by its unique capacity to represent the lesser-known cultures, and by extension, nations of the Soviet empire, received its share of attention. Despite Western arguments that the Soviet Union was governed by Russian chauvinists

concerned essentially with Russifying the entire country, the Soviet authorities encouraged what they considered harmless forms of national assertion, and music was as harmless a medium for such assertions as the Soviet authorities could hope for [...]. Indeed, the latter played an important role in encouraging the use of music to fulfill the demands of national self-assertion, and went as far as institutionalizing the process.

(148–49)

Dance was considered even more harmless, because unlike music, in which politically dangerous lyrics could be embedded, dance was mute as a form of expression. Nercessian adds one further point concerning the value of folk music to those who have no other form of free expression, "If the importance of folk music (and consequently its study) derives much of its force from the value assigned it by society to represent national culture, it should come as no great surprise that it is worth more to cultures that are striving to be heard [...] than to cultures that are firmly established in the eyes of their others" (148). Igor Moiseyev, unlike the Pyatnitsky Chorus and the Beryozka Dance Company, included the dances of other republics and regions in his repertoire, generally consisting of half of the program, while Russian folk formed the other half, and were generally among the largest choreographies and casts.

The rehabilitation of Russian folklore began in 1934 with a highly publicized and emotional speech by the famous Russian writer Maxim Gorky who declared folklore to show: "The optimism of folklore expresses the deepest aspirations of the masses [...] the most artistically perfect types of heroes were created by folklore" (quoted in Miller 8). Right after the speech, the Party began to redirect the way in which folklore was studied, and above all, performed, because they realized that "the right kind of folklore could make the masses aware of their role in Russian history and could advance communism and foster patriotism among them" (Miller 9). But, the move to rehabilitation of Russian identity and the development of folkloric genres had already begun by 1930 with state directives about how folk dance would be shown. This folklore was abetting a particular nostalgia for the village, which had appealed to Russians even before the Revolution, and by extension the motherland, to be protected at all costs. In the 1920s, the Bolsheviks savagely attacked folklore as a sign of backwardness, but in the 1930s the change toward valorizing Russian folklore produced an about face.

Stalin's December 1935 speech addressing the "Friendship of the Peoples" underlined this shift in policy with a new definition of nationalism, which claimed that the various peoples of the USSR now completely trusted each other and shared strong bonds of friendship. Rather than identifying Russian culture and identity with imperialism as they once had, the different peoples of the Soviet Union could now trust and admire all things Russian. Indeed, rather than encouraging the development of culture and identity of different nationalisms, the Russian identity and Russian people would be put first.

(Hallinan 50)

As Laura J. Olson points out in her study of Russian revivalist folk song (*Performing Russia*), the revivalist process continues on the level of several parallel traditions, including the Soviet Russian style performed by professional ensembles like The Igor Moiseyev Dance Company. Unsure in their new ethnic and national identity, many Russians turned to forms of folklore to shore up and glorify their ethnic history. In this process, they created a new identity based on a romanticized vision of a glorious Russian past that according to Olson, included the valorization of the Russian Orthodox Church, the Don Cossacks, which represented a bellicose masculinity and love of freedom and political independence, and the mythic Russian village, where life was pure in some Golden Age, so that "Russianness itself is sacred because the Russian people are 'chosen'" (156).

Gellner states, and he could well be referring to the former Soviet Union, "[…] a modern, streamlined, on-wheels high culture celebrates itself in song and dance, which it borrows (stylizing it in the process) from a folk culture which it fondly believes itself to be perpetuating, defending, and reaffirming" (58). Describing Russian folk music specifically historian Richard Stites states, "The revival of folk music that was viciously assaulted during the Cultural Revolution therefore became a natural part of the 1930s normalization in culture. Its peasant content, though stylized, reinforced love of the land and thus, of the nation or *narod*" (25). The Soviet Union had no interest in actual folk songs and dances, many party officials disdained folklore as backward, but rather they wanted to celebrate themselves in spectacle.

The Russia that was to be portrayed through The Igor Moiseyev Dance Company and the Pyatnitsky State Chorus was not going to be representative of any ethnographic verisimilitude. "In 1936, Igor Moiseyev established a Theatre of Folk Art in Moscow and his own folk dance ensemble that brilliantly combined the rigor of classical ballet with folkloric steps and village scenes" (Stites, "The Ways of Russian Popular Music to 1953" 25). Music scholar Robin LaPasha follows the way in which many amateur groups became professionalized during the 1930s as part of Stalin's Great Retreat, in which "The singers and dancers then became a state (and state-supported) folk ensemble of the provincial philharmonic; the process was mirrored by other groups that were professionalized in the late 1930s, most notably the Piatnitskii (Pyatnitsky) Folk Choir and the Sveshnikov State Academic Russian Choir" (139).

All of this change of heart required the Party to completely reorganize the way in which folklore was to be publicly presented and represented. "In 1936 the government intervened directly in the study of folklore and the field was subject to constant party supervision until the death of Stalin in 1953" (Miller 9). So it is not surprising that The Igor Moiseyev Dance Company was founded early in 1937, shortly after this reversal of Soviet policy on the use and presentation of Russian folklore. "The folk revival had begun in the mid-1930s as part of Stalin's cultural legitimation program, and the folk ensemble with peasant costumes and balalaikas became a familiar part of the cultural landscape. In wartime, these ensembles were sent to the front. […]" (Stites, "Frontline Entertainment" 132). These appearances in a time of national need ensured the popularity of these ensembles in the period directly after the war.

When The Igor Moiseyev Dance Company arrived in the West in 1958, this change of attitude was pervasive in the repertoire in which I noticed immediately how much importance and emphasis was given to the Russian repertoire, both in the number of dances, and the number of dancers in the Russian choreographies. The company's official history, produced by the state printing house states: "Russian folk dances occupy a place of primary importance among the dances of the many nationalities inhabiting the USSR" (Chudnovsky 43). And, indeed, during that first tour Russian folk dances comprised nearly half of the entire program, and they were especially featured in the most spectacular numbers with the largest casts of dancers. The other half of the program was devoted to the dances of the other peoples of the Soviet Union.

Stalin found that once Russian nationalism was let out of the political Pandora's box, it could not be returned. Part of his plan of directing Russian nationalism and channeling it in the direction he wanted it to move resulted in the founding of The Igor Moiseyev Dance Company in 1937, alongside the Pyatnitsky chorus and dozens of amateur folk song and dance ensembles, involving tens of thousands of performers, which was designed to instill a love of and pride in the Fatherland in the majority Russian ethnic population (Tkachenko 18). "Folklorism – i.e. politicized folk adaptation – became a major industry in the Stalin era. Folk song and dance came back into favor on the wave of the Stalin's 'Great Retreat', a campaign to preserve or revive certain elements Russian history and culture" (Stites, "The Ways of Russian Popular Music to 1953" 25). The Igor Moiseyev Dance Company fits perfectly into this new cult of Russian identity, nested in a larger Soviet identity. It should come as no surprise to the reader that The Igor Moiseyev Dance Company accrued enormous popularity during World War II when they appeared before Soviet troops and factory workers to bolster morale.

Folk dance had to be spectacular to be effective as David Guss (*The Festive State*) so effectively argues. Thus, as dance scholar Jens Giersdorf noted, we can see that dance served multiple purposes, sometimes even contradictory ones, for national governments, and as we will see in the case of the Moiseyev example, the purposes for which the company continued to receive financial government support could also change with time and in order to meet and fulfill new national priorities.

I want to mention that as time passed, beginning in the 1980s when I was startled to see in my Intourist Hotel in Moscow a group of singers and dancers, clearly urban individuals who were performing in a style that was attempting to emulate villagers that Olson so well describes and analyzes (*Performing Russia*).[8] This was a clear pushback against the Soviet-sponsored unified, stylized, one-size-fits-all Russian music and dance that characterized the state-sponsored folk dance and song ensembles, with their huge casts. Some young people were beginning to dig into their roots. The vocal quality was a combination of the stylized vocal style of the Pyatnitsky Chorus and villages. Subsequently, on April 15, 1997, I attended a concert that had small groups from seven different districts of Russia (*Russian Village Festival*). These were clearly actual villagers; however, it was also clear that they had experience performing before audiences as seen by their sophisticated stage demeanor. That

having been said, the national dance style of Moiseyev and the vocal style of the Pyatnitsky Chorus still largely prevail into the period of the Russian Federation. For many Russians, who have viewed and heard these ensembles, they have become the "authentic" Russian music and dance.

Russian Nationalism after the Soviet Union

Currently, Russia, with 82 percent of the population of the Russian Federation, is more of an ethnic state. This is not a discussion devoid of real political issues. Roman Szporluk notes, "The question is not whether the USSR, or Yugoslavia, can be reconstituted – they cannot – but whether their successors, which have chosen to declare themselves nation-states (rather than multi- or supranational entities), will develop a civic or an ethnic definition of nationality" ("Introduction: Statehood and Nation Building" 7). Vladimir Putin's interference in the affairs of Georgia and Ukraine, not to mention Syria, makes this an important question.

These examples underscore the fact that certain nation states may not survive as nations; we can consider Somalia, Afghanistan, Iraq, and Syria, which constitute exceedingly fragile political entities as failed states. When strife occurs, the ethnic and national identities reveal the constructed nature of the nation, revealing them as less than natural identities. When the USSR ended in 1991, expressions of Russian nationalism, some of it crudely anti-Semitic, came strongly to the fore (see Clover *Black Wind, White Snow*). Tuminez notes that, "In brief time Putin has been the center of Russian politics, it has become clear that nationalism will be an important feature of his leadership" (297). We must remember that Putin has publically stated that the breakup of the former Soviet Union was a catastrophe. He was not alone in this belief. "Unlike all the other formerly Soviet nations, whose distinct identity the Russians recognize, Ukrainians and Belarusians are commonly perceived in Russia as being Russian, not only by imperial or statist but also by historical and cultural/ethnic criteria. Their 'leaving' is felt very strongly because it is costly not only economically but also emotionally" (Szporluk, "Introduction: Statehood and Nation Building" 8). This background to some degree informs us that Vladimir Putin's political stance vis-à-vis Ukraine has popular support. Andrej Krickovic adds that "What Russians want now is to be a great power again. With 1/10 of the American GDP, Russians feel that one way that they can achieve that status is to partner with the US in world affairs" (personal interview, July 10, 2017).

Astrid S. Tuminez states, "Nationalism, articulated in different variants, has become the most prominent ideological force in Russia since the collapse of the Soviet Union (USSR)" (174). Russian nationalism scholar Marléne Laruelle disagrees, arguing that, "Nationalism in one form or another today dominates the whole of the Russian field, confirmation both of the narrowing of political life in Russia around the presidential party and of the Kremlin's drive to monopolize the discourse on the nation. […] Words and terms that were

confined in the 1990s to the most radical and unappealing nationalist movements, like that of Zhirinovsky, are today fully part of Russian public life and can no longer be viewed as extreme" ("Rethinking Russian Nationalism" 23–24). With the current machinations of the volatile Vladimir Putin, who relies on the support of Russian nationalism, no predictions can be made on which directions Russian nationalism will move. However, as I will show below, through the recent study of Charles Clover, Russian nationalism is taking on a new tinge called "Eurasianism," and its main thrust is for Russia to once again dominate and reform the former Soviet Union.

Clover notes that, "For 15 years of rule by Vladimir Putin and his circle, the Kremlin has drifted towards this idea, aimed not at mass mobilization behind public slogans, but at consolidating an elite behind a set of understood (if unspoken) truths, deniably vague statements and opaque politics; it is the subject not of booming speeches but of whispered codes" (4). This "new" form of Russian nationalism, is called "Eurasianism," in fact, as Clover demonstrates, Eurasianism began around the time of the fall of Tsarist Russia, and Vladimir Putin uses Eurasianism to serve as a code word to indicate his intention to reconstitute the former Soviet Union under Russian rule. And, as Clover states, "And these ideas would make themselves clearer 15 months later, when Russian soldiers quietly seized airports and transport chokepoints across Crimea, starting a domino effect that would lead to war in eastern Ukraine" (4). So, we see that like Stalin, Vladimir Putin called forth many of the same symbols of Russian identity, and used them to mobilize Russians to invade Ukraine. The question that remains: will Putin succeed in reconstituting the former Soviet Union? According to Krickovic, Putin's future in Eurasianism will be pursued in a partnership with China (personal interview, July 10, 2017).

After the breakup of the former Yugoslavia, the state-supported dance ensembles dropped the repertoires of dances other than their own ethnicity. By contrast, The Igor Moiseyev Dance Company retained all of its non-Russian works, reflecting Putin's interest in the reassembling of the old Soviet Union.

After the breakup of the Soviet Union, many Russians, unsure in their new ethnic and national identity, turned to forms of folklore to shore up and glorify their ethnic history. In this process, they created a new identity based on a romanticized vision of a glorious Russian past that according to Olson included the valorization of the Russian Orthodox Church, the Don Cossacks, which represented a bellicose masculinity and love of freedom and political independence, and the mythic Russian village, where life was pure in some Golden Age, so that "Russianness itself is sacred because the Russian people are 'chosen'" (156).

The Russian population, which dominated the former USSR, has many more feelings of nostalgia for the Soviet Union than most other nationality and ethnic groups, since they enjoyed a superior political and social position. Currently, two issues dominate historical memory: First, the role of the Russians in the Great Patriotic War (World War II), which is highly contested by Russia's neighbors to the west. "Since the second half of the 2000s, political tensions have heightened around questions of memory and their weight in relations between post-Communist states, in particular in the Russia-Ukraine-Baltic countries-Poland

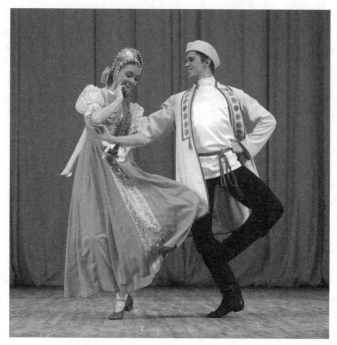

Figure 1: Scene from *Old Russian Suite.*

regions – one of the zones most marked by the violence of the Second World War and the brutal (re)Sovietization that followed" (Laruelle, "Negotiating History" 75). Certainly, as I toured the Baltic Republics, the intensity of negative feelings of Estonians, Latvians, and Lithuanians frequently expressed toward Russia and Russians, especially those who still live in the Baltic states, was powerful.

Another reason to use the term "nationalisms" in the plural is because the elements of nationalism change and alter over time, even within the same nationalism. Russian nationalism is a good case in point. The terminology of Russian nationalism can be complex and tricky. For example, as Charles Clover points out about Vladimir Putin, "when he spoke of Russia's broader identity he used the term 'Eurasia.' When he refers to Russians, he increasingly frequently uses the term '*Russky*' (meaning ethnic Russians), rather than '*Rossiisky*' (referring to a more civic and inclusive definition of the Russian nation state)" (4). This latter term is to include Tatars, Kalmyks, Yakuts, and other non-Slavic ethnic groups. Only time can reveal the direction that Russia and Russian nationalism will take.

For many Russians The Igor Moiseyev Dance Company represents the quintessential Russia – the Russia they want to see. As the concierge in my hotel reminded me with a big smile as I made my way to see a Moiseyev concert, "Tonight you will see the real Russia" (June 2, 2016).

Chapter 3

The Cultural Cold War: Dance and The Igor Moiseyev Dance Company

The Red Scare

Of all of the chapters of this book, this one about the Cold War has been the most difficult, and in many ways rewarding, to write. I locate myself at various distances from the three lenses that I have chosen for examining the creative works of Igor Moiseyev: spectacle, Russian nationalism, and the Cultural Cold War. I created spectacle through some of my own choreographic works and frequently viewed spectacle in dance performances like those of The Igor Moiseyev Dance Company, so I am able to enjoy spectacle in dance when it works for me artistically. My reaction to spectacle was mild and I remember with pleasure the effects of the opening of the 2008 Beijing Olympic Games in which spectacle was the main event. I attribute such modern spectacle in dance and movement to the genius of Igor Moiseyev.

I was able to look at Russian nationalism through a long-distance lens that provides ample scholarly distance. I was able to maintain a comfortable distance most likely because I have never personally experienced powerful feelings of nationalism, and certainly not ethnic fervor of the kind found in Nazi Germany or the huge manifestations which people in the Soviet Union often viewed. But the Cold War and its chilling effects touched me personally, as I am sure it did countless other Americans, on a number of levels – in my case as an artist and as a gay man. Thus, the three lenses were held at various distances from me – some safe, some less so.

No biography of Igor Moiseyev would be complete without contextualizing his work and his long-lasting imprint in both the dance world and the political world of the Cold War. Igor Moiseyev knew full well that his company was a tool in the Soviet government's arsenal of political propaganda. He stated in his autobiography, "Throughout the life of the company they made use of their [the government's] propaganda aims" (*Ya Vsponimaiu* 68). In many ways, the first performances of his company in the West, using over one hundred performers, in 1955 in France and Great Britain, and in 1958 in the United States, was the opening gambit of the diplomatic minuet known as the Cultural Cold War, an intricate set of moves and countermoves by the United States and its allies and the Soviet Union and other Eastern Bloc nations. If nothing else, his was the first company to be brought to the United States from the former Soviet Union after the signing of the January 27, 1958 Lacy–Zarubin agreement for cultural exchange between the United States and the USSR (named after the two signatories to the agreement, American and Russian, respectively). No one in America had seen such a huge dance company, utilizing spectacle in a new way, with over one hundred performers that danced with awe-inspiring

precision and virtuosity.[1] The Cultural Cold War constitutes a subset of the Cold War, and therefore, I will indicate when I am talking about the Cold War, which lasted from 1945 to 1990, for purposes of this study, and the Cultural Cold War, which was shorter since the American government, always adverse to arts funding, ceased to sponsor large-scale dance and music exchanges after the collapse of the Soviet Union as it did at the height of the hostilities.

America was not ready to believe or even conceive of the idea that "Dance had a new function, to serve the state. Such a climate led to the virtual canonization of folk dance as the true expression of the people; it was reflective as well of the values of hard work and unquestioning allegiance to the government" (Reynolds and McCormick 254). But America soon followed suit: dance became an unlikely weapon with which to fight the Soviets, given conservative America's puritanical reaction to dance because of its homosexual associations. However much America tried to maintain the high ground during the Cold War, they were unable to. The government continuously morally besmirched itself by attempting to fight fire with fire, because they adopted soviet tactics to do so: The McCarthy hearings mimicked the Soviet Show Trials, and the secret services peered into many lives, illegally, certainly into mine. Many Americans lost everything in their lives, and some committed suicide in despair. It is difficult for many individuals to understand the depths that America reached as a result of the Red and Lavender Scares (see Shay, "Dance and the Red and Lavender Scares").

The Arrival of Moiseyev in America

Moiseyev's company members, for many Americans, represented the face of the Soviet Union, as all state-sponsored folk dance companies are designed to symbolically "perform" the nation they represent – the dancers become stand-ins for the entire nation (Shay, *Choreographic Politics*). Americans were eager to view what an actual Russian looked like due to "their grim fascination with their remote rivals" (Belletto 3). Historian Victoria Anne Hallinan notes, "Americans looked to the Company and its dancers to provide answers about what Soviet life was like" (13), although how a group of privileged dancers could fulfill that desire might be questioned.

On their first visit in 1958, the members of The Igor Moiseyev Dance Company were followed everywhere and profiled in the media, which reported everything about them – what they ate, what they wore, how they reacted to American department stores, and what their favorite rides at Disneyland were – all were chronicled by the press and the television, and consumed by avid American readers eager to find out everything about them. Above all, they wanted to know if they had horns and tails, as the American Government had proclaimed through Hollywood films and television programs since the end of World War II. The American government and Hollywood, using not so subtle propaganda that demonized Russian/Soviets, did everything in their power to portray the "evil" communists in a negative light (see

Hallinan, "Cold War Cultural Exchange").[2] Harlow Robinson, Sol Hurok's biographer, noted that the impresario who brought The Igor Moiseyev Dance Company to America, jokingly referred to the Moiseyev dancers as "Creatures from Outer Space," referring to the exoticism they represented and the excessive media hoopla they engendered for a public that wanted to see what a "real" Russian looked like (355). The anti-communist Hollywood films depicting the Russians as monsters were so simplistic they seemed designed for morons as one looks back at them: "Two years later [1947] Hollywood was churning out anti-Communist films, mostly of B-movie quality and lacking even commercial 'carry'" (Caute 162). After The Igor Moiseyev Dance Company's performance, the observation made by many Americans, often spoken in wonder, was "They look just like us." Thus, The Igor Moiseyev Dance Company performed in just the way that the Soviet government hoped (see Hallinan 220, 262). The exuberant response by the American public caught the State Department and the American government by surprise. The extreme popularity and even happiness with which Americans greeted the company caused the State Department to immediately begin to set up panels of artists to build an artistic exchange program. "Never far from the panelists' minds was the desire to counteract the positive impression created by Soviet touring attractions like the Bolshoi and Moiseyev dance companies. This consideration led to long debates […] about the relative merits of classical ballet and homegrown modern dance as representations of American culture. Should the United States emphasize its indigenous dance achievements – modern dance, traditional folk dance, Native American dance – or its ability to compete with the Soviets on the terrain of classical ballet?" (Foner 4). The State Department was even ready to finance a folk dance company, but the dance panels had no experience of traditional dance in America and were unable to imagine what an American Moiseyev-style dance company might look like (Shay "Dance as the 'International Language'"). As we will see, they had the money to create such a company. As Francis Stonor Saunders (The Cultural Cold War) vividly depicts the dynamics of the cultural Cold War, the FBI, CIA, and State Department was awash in huge sums of money for the use of anti-Communist propaganda in what amounted to one of the largest money laundering events in American history.

If they did not understand it clearly prior to the arrival of The Igor Moiseyev Dance Company on American shores, every government official understood that art had become a powerful political tool. "I was a firm believer in the complicity thesis of Cold War cultural productions. In other words, I believed (as many did and some still do) that the steep rise of cultural development and export during the era of federally funded programs was prima facie evidence that artwork produced and distributed under the aegis of such programs was a species of government agent" (Kodat xi). America now understood, what Louis XIV could have told them: that dance could make one look powerful. And Igor Moiseyev provided the proof.

Except for the rabid right fringe, the John Birch Society especially, the Moiseyev dancers received an amazingly warm welcome from most Americans who responded to their charming manner, their youth, and, above all, to their dancing skills and prowess. This warm welcome was especially surprising, given the suspicious atmosphere of the Cold War, created

by the American government. Victoria Hallinan notes, "At the same time, the Moiseyev represented a carefully crafted tool of Soviet propaganda that served to 'fight' the Cold War culturally by utilizing an idealized positive view of how the Soviet treated the different nationalities living within its borders" (43). And, from what I saw and witnessed as a regular member of the audience, the meticulous packaging of "innocent" folk dances performed by "innocent" appearing, fresh-faced young men and women, American spectators largely ate it up with relish. And, as Hallinan noted, "American public reaction to the Moiseyev did not change significantly for later tours, as audiences continued to receive the company with open arms and frank exuberance" (203). The newspaper critics, too, were respectful, and fulsomely praised the artistry and physical abilities of the company.

The Igor Moiseyev Dance Company was probably the company that had the most spectators in the United States of the many companies which Sol Hurok brought to our shores. They appeared several times, beginning in 1958, 1961, 1965, 1970, and then several more times over the next several decades in the twentieth century, including appearances after the fall of the Soviet Union, in 1991, 1995, 1999. In 1999, the company was in the United States for its eleventh visit. For Sol Hurok, the company was the most profitable of all the large Eastern European dance companies and its other artistic attractions, which attested to its popularity with the ticket-buying American public (1994). The folk dance-based repertoire and the athletic, masculine appearance of the company were more accessible to a public that in the 1950s was overwhelmingly unfamiliar with classical ballet, the other major Russian/Soviet choreographic offering.

In this chapter, I will briefly describe the general contours of the Cold War, and its effects on American life, followed by a description and analysis of the Cultural Cold War, and the place of dance, and The Igor Moiseyev Dance Company within it. It is important to distinguish between the Cold War, a political phenomenon, and the Cultural Cold War, a subset of the Cold War. Because, following the dropping of two atomic bombs on Japan near the end of World War II, as well as deadly tests in the South Seas, Truman and Stalin could see the destruction the mushroom cloud wrought, and seeing the destruction they caused, these leaders, and those who followed them, realized that to engage in a "hot" war, directly with one another, would destroy everyone in the world, including one's own population. As historian John Lewis Gaddis notes, "A kind of moral anesthesia settled in, leaving the stability of the Soviet-American relationship to be valued over its fairness because the alternative was too frightening to contemplate. Once it became clear that everybody was in the same lifeboat, hardly anybody wanted to rock it" (180). For this reason, a Cultural Cold War served as a proxy for a hot war: ballet dancers and athletes would be the troops on the ground on both sides, rather than the armies and weaponry of the USSR and the United States engaging directly. "In this context, the term 'Cold War' can be understood not merely as a military conflict deterred, held in reserve, but also as the continuous pursuit of victory by other means. Every Soviet ballet company returning from America to triumphant acclaim and without suffering the defection of a prima ballerina [...] was worth a Red Army division on the Elbe" (Caute 5). This struggle created a "dance

war" and a so-called "dance boom" in America (see also Caute, *The Dancer Defects*; Croft, *Dancers as Diplomats*). This is because the Russians and other European nationalities in the former Soviet Union were balletomanes and dance enthusiasts since the tsarist era, and thus, their highly athletic dance companies, richly funded by the Soviet government, were the most powerful weapons in their artistic arsenal. Thus, while dance was a "natural" vehicle for the Soviet Union, it was not for America. But, the United States government had to follow suit, once The Igor Moiseyev Dance Company made its startling debut, they had to quickly create a dance program. Dance, with its homosexual associations, was not a good fit for prudish, puritanical American politicians, who had never supported government funding for the arts. Dwight Eisenhower quickly saw that this was a priority and pushed legislation through congress to support it. As soon as politically feasible, two decades later, the support stopped.

The appearance of The Igor Moiseyev Company had created so much good will among so many Americans that the State Department and CIA searched for a choreographic "answer" to The Igor Moiseyev Dance Company. In short, the choreographic prowess and athleticism of The Igor Moiseyev Dance Company was so jaw dropping and visually overwhelming for the American public that word spread fast and virtually all of the halls in which the company appeared were sold out.

Unlike the Soviet Union, in America dance was little known in that period, and less appreciated outside of New York City and San Francisco elites. Moreover, dance threatened the ideals of American manhood with its associations with effeminacy and homosexuality. Americans, therefore, did not know how to respond to the threat posed by The Igor Moiseyev Dance Company, the Bolshoi Ballet, and other Soviet dance ensembles, and the State Department and others searched for the proper American choreographic weapons with which to confront this new threat. Thus, Igor Moiseyev and his company were in the forefront of that Cultural Cold War battle, its shock troops. The American government was alarmed and there did not exist at that time either a professional folk dance company, or a folk-based dance company. It is the Cultural Cold War, and the dance performances, especially those created by Igor Moiseyev, that characterized that period, and so dance, especially the Moiseyev oeuvre will occupy most of our attention in this study of the Cultural Cold War.

Of course, other cultural vehicles were employed in the Cold War: "[...] a wide range of activities relating to US foreign relations, including covert operations; cultural and educational exchanges; space exploration and scientific cooperation; book publication, translation, and distribution programs; nuclear energy and disarmament; diplomatic negotiations [...]" (Osgood 5). These, however, rarely attracted the attention of the general American public. However, dance was a major symbolic art, because it was an embodied art that carried the potent symbol of physical strength and athleticism, especially as manifest in the spectacularized The Igor Moiseyev Dance Company performances, and many of those writing about the Cold War often overlook it; so it is important that I focus on that genre, and its salience, in this study.

The Cold War

I will briefly sketch the basic events of the Cold War because, as historian John Lewis Gaddis, in his magisterial history of the Cold War, observes about his students: "When I talk about Stalin and Truman, even Reagan and Gorbachev, it could as easily be Napoleon, Caesar, or Alexander the Great" (ix). It is a period that many Americans would prefer to forget, and the Cold War in many ways brought dishonor to America and the hysterical way that the American government, politicians, and many Americans reacted to it. For the youth of today reading about the Cold War, it produces a surreal and phantasmagorical effect – the 1950s and 1960s were charged with social, sexual, and political hysteria that is difficult to imagine now.

I suggest that there were, in fact, two Cold Wars. The first was a foreign-oriented war, which was constructed from the period of President Truman to the fall of the Soviet Union and was designed to confront the Soviet Union and Communism. The foreign war produced "a militant nationalism and created a consensus by focusing on the evil Other" (Ryan 63). This was the Cold War in which the United States, and to some degree, its allies, confronted the Soviet Union and its satellites. The war was not always cold, but the United States never entered battle directly with the behemoths: China or the Soviet Union. Hot wars were fought in places like Korea, Angola, and Vietnam.

The other war was domestic, and that war was waged largely and ferociously against the gay and lesbian community, who served as surrogates when few actual communists could be found (Corber *In the Name of National Security*; Johnson *The Lavender Scare*). Politicians like Joseph McCarthy, the American government, and other political figures equated gay men and lesbians with communists and, therefore, an enemy.

Outside the United States, the Cold War was waged between the Soviet Union and the United States and their allies and proxies. It was "[...] clear by February 1947, the administration hit on a more consistent, clearly articulated policy: containment [of the Soviet Union and Communism]. The essential stance of the United States for the next forty years, the quest for containment entailed high expectations. It was the most important legacy of the Truman administration" (Patterson, *Grand Expectations* 105). In this war of containment, America's Cold War Warriors and Dirty Tricksters fought Communism and Communists (commonly called Reds and Commies by forces of the American right) with vigor and almost religious fervor.[3] And yet, "Despite all the hyperbole of US Cold War rhetoric, recent research indicates that Stalin had no plans to invade Western Europe, and wanted to avoid war with the United States" (Ryan 54). The fingerprints of the CIA could be found on much of the covert political activity around the world, like the toppling of the legally elected government of Mohammad Mosaddegh of Iran in 1953, and later Salvador Allende in Chile.

One of the most important aspects of the Cold War, designed to protect freedom, was "a concerted campaign to promote the 'American way of life' throughout the world [...] freedom became increasingly identified with consumer capitalism or, as it was then

unfailingly called, 'free enterprise' [...] The celebration of consumer society assumed a prominent place in the Cultural Cold War" (Foner 2). The result of this was the infamous "kitchen debate" that took place in a model American kitchen in Moscow in 1959 between Vice President Richard Nixon and Soviet Premier Nikita Khrushchev amidst the hi-fi sets, automobiles, appliances, and other proud samples of American culture.

One of the abiding reasons for the Cold War was the deep-seated mistrust and fear that existed between the United States and the USSR. During World War II, the United States and Great Britain had to suspend their hostility toward Communism because of, "The stark fact that the Americans and the British could not have defeated Hitler without Stalin's help [...]" (Gaddis 9). The Soviet Union bore the brunt of the German assault because "the United States [which suffered 300,000 casualties in all theatres of war] was able to choose where, when, and in what circumstances it would fight" compared to the Soviet Union, which lost "27 million citizens [who] died as a direct result of the war – roughly 90 times the number of Americans who died" (Gaddis 8, 9). The result was that "[...] Americans emerged from the war with their economy thriving" while the Soviet Union, "with its cities, towns, and countryside ravaged, its industries ruined" furnished a stark contrast (Gaddis 8–9). "Early in 1946, in his famous Long Telegram from Moscow, American diplomat George Kennan advised the Truman administration that no modus vivendi with the Soviet Union was possible" (Foner 1). With this pronouncement, the Cold War began in earnest.

Such a difference in experiences helped to create the climate within which fear and resentment built. Almost at the moment of the close of World War II, as the Soviet Union occupied Eastern European countries that Roosevelt and Churchill ceded to them at Yalta, the drumbeat against the evil Communists began. "By the early 1950s, communism was increasingly seen as a threat, not only from without, but also from within the American body politic. In 1950, American policymakers set out a long-term strategy, NSC-68, that emphasized the Soviet Union's aims to 'contaminate' the Western world with its communist ideology" (Field 3). Truman, following George Kennan, a scholar of the Soviet Union and a presidential advisor, created a policy of "containment" (NSC-68) of the Soviet Union and communism, although Douglas Field insists that the policy was, in fact, to "vanquish it" (3).

The Eisenhower regime upped Truman's ante. "An advocate of psychological warfare throughout his military career, Eisenhower believed that effective propaganda would help ensure world peace and promote democracy. He accorded information activities – both overt and covert – the same stature as military, economic, and diplomatic operations" (Belmonte 50). And he backed up this belief with generous funding, especially for the arts. Kenneth Osgood notes that he was, "'surprisingly involved' in shaping American propaganda strategy (6). So much for the "benignant, grandfatherly figure many thought him to be. He was a Cold War warrior from the outset of his presidency. What many, if not most, Americans never realized was that propaganda was aimed at them as well as the populations of neutral nations, and, of course, those behind 'the Curtain'" (Belmonte, *Selling the American Way*; Osgood, *Total Cold War*). In this quest against communism and socialism, which still echoes

today, the United States, employing unscrupulous political, economic, and martial methods, as in the useless and morally bankrupt war in Vietnam, and in the process, besmirched itself.

Josef Stalin and his murderous policies of repression loom large in the demonizing: "Stalin's postwar goals were security for himself, his regime, his country, and his ideology, in precisely that order [...] Narcissism, paranoia, and absolute power came together in Stalin: he was, within the Soviet Union and the international communist movement, enormously feared – but also widely worshipped" (Gaddis 11). But, instead of supporting political freedom as a contrast to Stalin's vicious political strategies, paranoia gripped the United States as well, and, ironically, through the CIA and the FBI, Americans would adopt many of Stalin's methods in order to confront him and his successors for nearly half a century. This gigantic struggle dominated the world political stage for the second half of the twentieth century. And, The Igor Moiseyev Dance Company successfully played the first act of the Cultural Cold War in that struggle.

Gaddis states, "[...] it is difficult to say precisely when the Cold War began. There were no surprise attacks, no declarations of war, no severing even of diplomatic ties. There was, however, a growing sense of insecurity at the highest levels in Washington, London, and Moscow [...]" (27). As I argued above, it began in 1946 with the famous Kennan telegram, but certainly by 1950, the Soviet Union and the United States, especially with the rise of Senator Joseph McCarthy in the grips of the Red Scare, had jointly launched the Cold War. This was certainly exacerbated on both sides, "From 1957 through 1961, Khrushchev openly, repeatedly, and bloodcurdlingly threatened the West with nuclear annihilation" (Gaddis 70). The Cuban Missile Crisis of 1962 brought the two powers to the closest actual confrontation and possible nuclear war for 13 days, October 16–28. News cameras showed Americans what that would look like with the images of the destruction of cities and Japan, and later Pacific atolls. Through those years the threat of World War III haunted the world.

In the context of this titanic struggle between the world's two super powers, propaganda became an important weapon on both sides. "Psychological warfare experts developed a 'camouflaged' approach to propaganda that used the independent news media, nongovernmental organizations, and private individuals as surrogate communicators for conveying propaganda messages. The imperative of camouflaging US propaganda efforts behind a private façade shaped US persuasion campaigns on my levels" (Osgood 5). Uncounted millions of dollars secretly obtained by the CIA were poured into that struggle. The Igor Moiseyev Dance Company was an important element in Soviet propaganda.

Communism and homosexuality were frequently equated and both were feared as covert and infectious: communists, gays, and lesbians were the new domestic enemies. "In *Enemies Within*, Jacqueline Foertsch (2001), convincingly argues that the Cold War era in America was like a plague, 'not of communism or of bomb-related illness, but of paranoia, xenophobia, and red-baiting that took on witch-hunt proportions'" (Field 8). Science-fiction films like the *Body Snatchers* served as a metaphor for the danger of communism to innocent, unsuspecting Americans, while Arthur Miller's *The Crucible*, set in the Salem witch trials, served as a metaphor for McCarthyism. Even suspicion of being a communist

or sympathetic to leftist causes could end a career and make finding a job impossible. Thousands of people caught in the vicious dragnet found their lives in tatters.

The operations of the CIA brought considerable dishonor and unwanted attention to the United States through its obsession with crushing governments of which they did not approve: "The number of C.I.A. employees involved in covert operations grew from 302 in 1949 to 2,812 in 1952, with another 3,142 'contract' personnel. They were stationed, by then, at forty-seven locations outside of the United States – up from seven in 1949" (Gaddis 163). People around the world were not stupid; the CIA left its sticky, and sometimes bloody, fingerprints everywhere. Gaddis notes: "Rumors of American involvement in the Iranian and Guatemalan coups began to circulate almost at once, and although these would not be confirmed officially for many years, they were persuasive enough at the time to give the C.I.A. publicity it did not want" (466). It did not matter whether or not if the CIA confirmed it, although some agents bragged about it. Five years after the events in Iran while I was a student at the University of Tehran, many Iranians talked about the CIA's involvement with great certainty and bitterness. This interference by the CIA haunts American–Iranian relations to this day.

The Soviets on their side, with the invasion of Hungary in 1956, Czechoslovakia in 1968, and later Afghanistan, 1979, also repulsed many individuals around the world. Thousands of French and Italians resigned their membership in the Communist Party as a result (Gaddis 153). The Cold War was a bumbling and destructive affair on both sides.

Although carried out and fostered by the American government, the fight against Communism also had wide support among the American population: "A specially religious people, many Americans approached foreign policies in a highly moralistic way [...] the United States had a God-given duty – a Manifest Destiny [...] to spread the blessings of democracy to the oppressed throughout the world" (Patterson, *Grand Expectations* 88). According to the pronouncements on the 2016 electoral stump speeches, and Donald J. Trump's subsequent flirtation with Vladimir Putin and the Russians, to which even conservatives react negatively, this attitude has not faded in many quarters.

Many Americans feel that the Cold War waned after the 1960s, but in fact, until the fall of the Berlin Wall, the Cold War "remained the central issue of American foreign policy" (Patterson, *Restless Giant* 102). In fact, the Cold War was comfortable and familiar with American politicians on the right and any attempt at détente stoked the fire to maintain the status quo: "Détente had not succeeded in promoting warmer relations between the United states and the Soviet Union. Moreover, it faced determined enemies at home. One of these was Defense Secretary [James R.] Schlesinger [served 1973–1975], who thoroughly distrusted the Soviets" (Patterson, *Restless Giant* 102). He was not alone. Communism and its guilt-by-association cousin socialism remain bogeymen to this day among many Americans.

Although the Cultural Cold War began in the 1940s, right at the end of World War II, for purposes of this study, we will begin in the 1950s when the cultural exchanges began. The 1950s, the years in which I came of age, attended junior high school, graduated from

high school, received my BA, and ultimately found myself living in Iran for a short time as a student, is best described by historian David Halberstam: "Young people seemed, more than anything else, 'square' and largely accepting of the given social covenants. At the beginning of the decade their music was still slow and saccharine, mirroring the generally bland popular taste" (x). For those who were older: "For the young, eager veteran just out of college (which he had attended courtesy of the G.I. Bill), security meant finding a good white-collar job with a large, benevolent company, getting married, having children, and buying a house in the suburbs" (Halberstam x). And while Halberstam rather accurately describes the experiences of the white middle class, he failed to mention that image was only valid if you were white and heterosexual. "Since being normal was inextricably wed, in the lexicon of Cold War American culture, to success [...]." The period was rife with hysteria. "Cold War fears rose to the center of American society, politics and foreign policy in 1949 and early 1950, generating a Red scare that soured a little the otherwise optimistic, 'can-do' mood of American life until 1954," the year that Joseph McCarthy overreached and was destroyed by his many enemies (Patterson, *Grand Expectations* 165).

The Cold War first thrust itself in the lives of most American children in the form of classroom drills to dive under our desks in order to protect us from an atomic blast that could come at any time. "CBS fuelled nuclear frenzy with 'What to Do During a Nuclear Attack', a documentary hosted by Walter Conkrite [...]." (Nadel 150) The message of these frequent programs was: "that nuclear assault could occur at any moment [...]" (Nadel 150). This diving under the desk lasted throughout my elementary and junior high school years, which traumatized many children by the constantly expressed idea that they would die at any moment in a bombing attack.

Television, newly introduced into American life, played a role in the hysteria: "Thus at every turn television differentiated American acts and values from un-American activities and objectives. People who did not consider religious broadcasts a form of public service, people who had not allowed their families to pray or stay together, people who espoused controversial positions or associated with those who did (or were even accused of associating with them): these people were suspect" (Nadel 150). The government used television to keep the population in line and moral. This was a period that was marked by the explosion of media diffusion.

"The Red Scare of 'McCarthyism' helped to besmirch American politics and culture for much of the next five years" (Patterson, *Grand Expectations* 179). Senator Joseph McCarthy, ever the opportunist, was central to the hysteria that informed the era. He and his minions in the senate saw communists under every paper pin and paper clip in the halls of the American Government. "These outbursts revealed the volatility of popular opinion, the growing capacity of the State to repress dissent, and the frailty of civil libertarians" (Patterson *Grand Expectations* 179). Life was not so bland after all; it merely appeared that way in films and television programs of the period such as *The Lucy Show* and *Leave It to Beaver*. These programs also stressed that it was men who counted as breadwinners, whereas women hardly counted in the 1950s.[4]

Even the so-called liberals, like Senator Hubert Humphrey of Minnesota, introduced tough legislation to combat Communism (Patterson, *Grand Expectations* 263). And, the most demeaning act was Eisenhower introducing "Executive Order No. 10450, which replaced the network of loyalty decrees created by Truman," which served as a criterion for dismissal from work, or a reason to deny hiring (Patterson, *Grand Expectations* 262). I signed one for the Los Angeles Public Library in order to work in 1963. Such loyalty oaths were commonplace in most hiring interviews in city, state, and federal government agencies, academia, and private industry. Even menial jobs required such loyalty oaths.[5]

During this period, the Soviet Union and the United States vied with each other to attract those areas of the world that were non-aligned to embrace their respective political ideologies, "to capture hearts and minds" as it was expressed. As European colonial powers lost their grip on their former colonies, new countries emerged, and the USSR attempted to woo them with the promises of Communism and the United States with the wonders of capitalism and democracy, though the latter's efforts were often derailed by the virulent racism that marred American life in that period. "As it intensified, the Cold War produced crisis after crisis, a spiraling arms race, dozens of covert and military interventions, and 'hot' wars in Korea, Vietnam and Afghanistan" (Osgood 2). No facet of life in the United States, its allies, and the Soviet Union and its satellites was untouched by the Cold War.

Halberstam adds that in the 1950s: "Americans trusted their leaders to tell them the truth, to make sound decisions, and to keep them out of war" (*The Fifties*, x). And what were those sound decisions and how did their leaders keep them out of war? "When Kissinger had served as Nixon's national security adviser, he had played a key role, along with the CIA, in abetting the violent overthrow on September 11, 1973, of Salvador Allende's left-leaning democratic regime in Chile. Kissinger [...] also supported the murderous military junta that seized control of Argentina in 1976" (Patterson, *Restless Giant* 103) All of these activities, including the overthrow of legally elected governments in Central America, Iran, and Lebanon were carried out in the name of the Cold War and keeping these governments out of communist, or even worse, democratic hands. Thousands of people perished in these violent government overthrows.

Apparently the passionate anti-communist American leaders approved of and supported the murder and torture of thousands of young Nicaraguans, Iranians, Argentinians, and Chileans, including their military throwing them out of airplanes, because if they did not respect their repressive leaders, they must be "leftists" or Communists, and therefore deserved their fates. Even Carter, "felt obliged to stiffen America's Cold War posture" (Patterson, *Restless Giant* 123), as the USSR, for unknown reasons, invaded Afghanistan, which after a protracted war there, probably became one of the reasons of the collapse of the Soviet Union in 1991.

Toward the end we saw the dismal spectacle of Ronald Reagan's goals: "winning the Cold War, shoring up traditional values, embracing the American Dream of upward social mobility [...] while blaming liberals for bing 'soft' on Communism and 'permissive' about developments at home" (Patterson, *Restless Giant* 153). The Cold War was so deeply embedded in the American psyche that even when Reagan concluded an advantageous treaty with

Mikhail Gorbachev it proved problematic to "convince Cold War hard-liners to accept the treaty" (Patterson, *Restless Giant* 216). This is not too difficult to imagine after years of Reagan labeling the Soviet Union as "the Evil Empire," he lacked the credibility to bring it an end (Patterson, *Restless Giant* 195). As we will see in discussing the Cultural Cold War, in order to fight Stalin, the CIA and leaders in the American government adopted some of his most notorious methods of deceit. Stalin was murderous; millions perished in the Gulag, millions of others perished in the 1930s in the artificially induced famine in the Soviet Ukraine in order to force peasants to collectivize, others were simply shot. In America, the government leaders simply chose to wreck lives, especially if they were gay and lesbian lives, since by now gays and lesbians were equated with Communists (Johnson, *The Lavender Scare*).

Toward the end of the Cold War, many in the political class were comfortable with the Cold War; it was familiar. "For just as the Cold War had frozen the results of World War II in place, so détente sought to freeze the Cold War in place" (Gaddis 198). The Cold War warriors did not want to give up. Gaddis supports my notion that the Cold War became a comfort zone for politicians on both sides: "The reason was that stability in Soviet-American had come to be prized above all else" (226). The US military seemed particularly needful of the old status quo with a familiar enemy, because it permitted them to scare the American government and people into giving them obscene amounts of money to buy and create weapons that would never be used. And after 1991, it was all gone.

Unlike Mikhail Gorbachev who thought the USSR and the Communist Party could be saved through severe surgery, Boris Yeltsin, his rival, on the other hand, at long last was ready to save Russia and close down the USSR, and he allowed the former soviet republics to fall into their respective successor states. As a former Cold War warrior, Vladimir Putin, on the other hand, would be pleased to reconstitute the USSR, as his actions in Ukraine, Crimea, and Georgia demonstrate.

American Studies scholar Steven Belletto suggests that the Cold War, in many ways, is still with us. "And yet, as suggested by the lingering effects of the game theory narrative, the Cold War is still with us – both as a powerful explanatory framework with which to understand the recent past and as an Ur-influence on American culture post-1989" (129). In agreeing with Belletto's assessment, I would posit that the removal of the knee-jerk reaction to difference and the Other is difficult to remove. The rise of Vladimir Putin, his invasion of Crimea and Ukraine (although he denies it), and his role in the Syrian conflict, has raised anxieties that one can hear in Sunday morning news interviews: Russia still has the same leopard's spots that characterized the former Soviet Union.

The Cultural Cold War

Frances Stonor Saunders notes, "During the height of the Cold War, the US government committed vast resources to a secret program of cultural propaganda in Western Europe. A central feature of this program was to advance the claim that it did not exist. It was managed,

in great secrecy, by America's espionage arm, the Central Intelligence Agency" (1). Saunders meticulously documents this process and the multiple and nefarious ins and outs of how this program worked. It should be required reading for every American. "At its peak, the Congress for Cultural Freedom had offices in thirty-five countries, employed dozens of personnel, published over twenty prestige magazines, held art exhibitions, owned a news and features service, organized high-profile international conferences, and rewarded musicians and artists with prizes and public performances" (Saunders 1). Saunders documents how many writers and the CIA, a story that did not break until nearly two decades later, in the late 1960s – some knowingly, some unwittingly – subsidized scholars. "Whether they like it or not, whether they knew it or not, there were few writers, poets, artists, historians, scientists, or critics in postwar Europe whose names were not in someway linked to this covert enterprise" (Saunders 2). Saunders does not state whether dance was part of the CIA covert activity. Certainly, CIA front organizations like the Rockefeller Foundation funded dance activities.

The scandal of the behind-the-scenes role of the CIA in the Cultural Cold War caused surprisingly little attention in the United States. "In some eras of American cultural diplomacy, the government has hidden not just its political agenda but also its role. The most publicly fraught moment in the relationship between politics and arts funding occurred when the CIA covertly sponsored cultural programs in Western Europe after World War II. The CIA designed the programs to diffuse cultural elites' passion for communism […]" (Croft 19). Such programs were also designed to demonstrate that Americans were not backward and ignorant in the culture department.

The second feature was the Boston Symphony orchestra, paid for by the CIA. As historian Saunders notes, "Cultural freedom did not come cheap. Over the next seventeen years, the CIA was to pump tens of millions of dollars into the Congress for Cultural Freedom and related projects. With this kind of commitment, the CIA was in effect acting as America's Ministry of Culture" (108). The Boston Symphony Orchestra was to demonstrate that Americans were not total yahoos, incapable of appreciating culture, much less participating in it. This was a constant motif during the Cultural Cold War, in which the Americans felt second rate compared to Europe's artists.

The Lacy–Zarubin agreement of 1958, which ushered in the Cultural Cold War, and the subsequent first appearances of The Igor Moiseyev Dance Company, did not only enable dance companies to travel, but addressed a host of exchange activities with a wide span, "[…] this two-year agreement and those which followed it periodically, was actually a general agreement which included exchanges in science and technology, agriculture, medicine and public health, radio and television, motion pictures, exhibitions, publications, government, youth, athletics, scholarly research, culture and tourism" (Richmond, *US Soviet Cultural Exchanges* 2). Of course, both sides wanted something. Yale Richmond was involved in the negotiations in several of the agreements. He summarizes what each side wanted: for the Soviets it was, "Access to US science and technology has been and remains the main Soviet objective" (*US Soviet Cultural Exchanges* 5). They also wanted and needed

foreign currency. For the United States, especially given the obsessive atmosphere of anti-Communism, Richmond states, "The main US objective was to open the Soviet Union to Western influences in order to change its foreign and domestic policies" (*US Soviet Cultural Exchanges* 6). In other words, as we have seen, "to vanquish" the Soviet Union.

It should be emphasized that even though the Cultural Cold War was a proxy war, it was taken as seriously as a hot war:

The cultural contest between the capitalist democracies and the Communist states was a unique historical phenomenon which can be explored effectively only by comparing the narratives of both camps. No previous imperial contest had involved furious disputes in genetics, prize-fights between philosophers, literary brawls capable of inflicting grievous bodily harm, musical uproar, duels with paint-brushers, the sending of ballet companies home without a single pirouette performed, defecting cellists, absconding ballet dancers, the hurling of greasepaint between the theatres of divided Berlin, the theft of musical film scores, a great composer yelling hatred into a microphone, a national chess team refusing to travel if subject to fingerprinting on arrival, jammed jazz on the airwaves, the erection of iron curtains against the sound of rock, and the padlocking of painters (Pablo Picasso among them).

(Caute 3)

This was the Cultural Cold War, which had some amusing sides, as David Caute described. I will share my Cultural Cold War story. As the director of the AMAN Folk Ensemble, which performed the dances of Eastern Europe, the Middle East, and Central Asia, I began correspondence with several of the Soviet Republics (Armenia, Azerbaijan, Georgia, Tajikistan, and Uzbekistan) and in Eastern Europe with Bulgaria, Serbia, and Croatia. This began when I identified the fact that each of the Soviet Republics and every Eastern European government had a Committee for Friendship and Cultural Relations with Foreign Countries. I began writing and sending photographs of AMAN performing dances from the respective country. I thought little more about this until boxes containing phonograph records, maps and atlases, language grammars, costumes, books about music, costume and dance – a cornucopia of research materials-- began arriving at my door. Shortly after this, I began to receive regular visits from, and I am unsure which, CIA or FBI agents – people in badly cut suits with questions. "What are you writing these people for?" "Why would a patriotic American want to perform Bulgarian folk dances?" (I could have said, but did not fearing they would see my answer as un-American, that Bulgarian dances and music are exciting to do; square dancing not so much.)

The ultimate moment came when a sheepish agent arrived on my doorstep bearing a package, begrimed by many hands. I had received a hand-written manuscript from Bulgaria in the Bulgarian language on how to play the *gajda*, the Bulgarian bagpipe that the CIA intercepted in my mail. The CIA had spent nine months attempting to break the coded message only to find that the manuscript was really about how to play the *gajda*,

and nothing else. At that moment I felt myself to be a real participant of the Cultural Cold War, with a touch of John Le Carre tossed in. As amusing, and frankly amateurish as the story sounds, the CIA was, as Saunders observes, "[…] a ruthlessly interventionist and frighteningly unaccountable instrument of American Cold War power" (3). As Saunders chillingly describes, the CIA right after World War II, turned immediately to known members of the NAZI Party, such as Herbert von Karajan and Elizabeth Schwartzkopf to participate in the concert activities the CIA sponsored and paid for (13–14). In order to fight Communism, the CIA seemed to find no action too ethically or morally low to utilize as a weapon. It should be noted that obscene amounts of money were squandered during the Cultural Cold War.

Earlier attempts at some sort of cultural exchange had happened on both sides. "After the war, in October 1945 the Department of State offered to exchange performing artists, exhibitions and students, and it invited the Red Army Chorus to tour in the United States. Again, there was no Soviet response. In the 1960s and 1970s by contrast, the Soviets several times proposed to send the Red Army Chorus, but the state Department response in those years was a firm 'No' because of the Red Army's actions in Hungary in 1956 and in Czechoslovakia in 1968" (Richmond, *US Soviet Cultural Exchanges* 4). The USSR, by contrast, invited and received a touring company of *Porgy and Bess*, most likely to embarrass the United States over the racial injustice that characterized the United States at that period.

After several years of negotiation between the Soviet Union and the United States, and, above all, efforts by the impresario, Sol Hurok, The Igor Moiseyev Dance Company appeared in the United States in May of 1958. The occasion marked the opening salvo of the dance exchanges that characterized a central element in the Cultural Cold War. After The Igor Moiseyev Dance Company's appearance, performing arts exchange became common for the next four decades, and more than any other performing art, dance was the most important.

In many ways the cultural exchange probably had more benefits for American audiences who were exposed to professionalism in dance in ways they had not before experienced. "The is universal agreement that Hurok did more than any other single individual in the arts to introduce America to the riches of Soviet/Russian culture, that he played a major role in creating an American audience for ballet and modern dance, and that his pioneering work in bringing the performing arts on tour to the provinces led indirectly to the rise of regional dance and theater companies" (Robinson 468). His roster of artists was always impressive; as I look through my old Moiseyev programs, I see the international personalities, dance companies, opera stars, and musical figures that appeared in those programs advertising his season.

Prior to Moiseyev, and in general, lack of state support for the arts characterized the United States apart from European nations. Gary O. Larson, an administrator in the National Endowment for the Arts, characterized the arts in America: "The institutions of art themselves, most of which seem destined ever to earn their nonprofit, tax-exempt status with a vengeance, constantly court economic disaster, while it is impossible to scan the best-seller lists or the Nielsen ratings without harboring a few doubts about the nutritional

content of American culture" (xiv). Republicans, in particular, in puritanical fervor have always been suspicious of art, and attempt to characterize it as decadent and dangerous. Their Heritage Foundation labeled the National Endowment for the Arts as, "The National Endowment for Pornography" (Larson xv). Larson paints a dismal picture of the history of state funding for the arts in the United States, with many Republican congressmen charging that abstract art was "communist" (31).

Richmond in his studies of the cultural exchanges during the period of the Cold War wrote, "For Soviet performing artists and audiences, isolated from the West since the 1930s, the visits by American and other western performers brought a breath of fresh air as well as new artistic concepts in music, dance, and theater to a country where orthodoxy and conservatism had long been guiding principles in the arts" (*Cultural Exchange and the Cold War* 125).

One aspect of the Cultural Cold War that caused great consternation in the Soviet Union was the defection of dancers. The most dramatic event was Rudolf Nureyev's famous jeté into the arms of French plain-clothed police, barely escaping the KGB agents who had been sent to arrest him. David Caute notes, "No ballet scandal outstripped the Nureyev affair" (483). Caute adds, "According to Peter Watson's 'KGB file', the KGB devised two plans to get back at Rudolf, as well as Natalia Makarova. In one he was approached to see if he would work six months in the West and six months in Russia [...] The other plan was for both his legs to be broken" (501). One must remember that the term "war" is the operative one.

Each side in the Cultural Cold War attempted to score points, win, or otherwise advance their political position. "'Who wins, we or the Russians?' I was often asked when I worked on Soviet-Americans exchanges at the State Department in the 1970s [...] Some Americans regard cultural exchanges with the Soviets as a competition in which points are scored, tallied and one side or the other wins. And the communists, they argue, would not be promoting cultural exchanges so eagerly unless they had ulterior motives" (Richmond, *US Soviet Cultural Exchanges* 1). This would be an ironic observation were it not for Frances Stonor Saunders' study, perhaps exposé might be a better term, in which she has exposed the financial and political role of the CIA in the Cultural Cold War. Frankly I was shocked at the degree of the involvement of the CIA and the amount of secret funds they had. Her book should be required reading for every American.

Dance and The Igor Moiseyev Dance Company in the Cultural Cold War

With the appearances of The Igor Moiseyev Dance Company in 1958 and the Bolshoi Ballet in 1959, dance came to the fore as one of the central features of the Cultural Cold War.[6] Although dance was occasionally sponsored by the American government, or private individuals like Nelson Rockefeller, prior to the appearances of the first Soviet dance attractions, America sent some dance attractions, especially in Latin America to "win hearts

and minds," to use one of the Cold War's favorite mottos. For example, José Limón and his company was sent to Latin America in 1954 with great critical success.

However, four years later, in the face of the huge success of the Soviet dance companies, the State Department needed to rationalize and better organize their efforts to confront what they considered an imminent threat: that Soviet dance might be better and technically more advanced than American dance. Heaven forbid. "The ANTA Dance Panel had to decide how the United States should counter the Soviet guests. At first, the strategy was a defensive one: whatever the Soviets sent, the United States sent something of a similar genre. If the Soviet Union sent folk dance, as it did when the Moiseyev toured the United States in 1958, the panel looked for American folk dance companies" (Croft 43). The Cultural Cold War was very much a tit-for-tat operation of "Anything you can do, I can do better." For both the Americans and the Soviets, there had to be a winner.

However, the daunting success of The Igor Moiseyev Dance Company challenged the State Department for there were no American folk dance companies. The Dance Panel's first efforts ended in failure. For all of their efforts, "The Dance Panel never resolved the issue of creating a professional folk dance group" (Prevots 118). Agnes de Mille attempted to form one, which I saw in one experimental attempt and the performance looked like a Disneyland attraction and she was unable to find the funding to bring the project to fruition. Looking at the makeup of the panels, with individuals pulled largely from ballet and modern dance, they had no knowledge of the large store of American folk and traditional materials suitable for staging. To create such performances, they would have had to consult dance ethnologists, ethnomusicologists, anthropologists, and folklorists, a thought that never seemed to have occurred to them.[7]

"The Igor Moiseyev Dance Company took America by storm. With a company of 106, it was the first large Russian group to perform in America [...] In its eleven-week tour the Moiseyev performed in many cities, including New York, Philadelphia, Chicago, Los Angeles, and San Francisco. Newspapers reported that the group was seen by 450,000 persons and had grossed more than $1,600,000" (Prevots 71).[8] In addition, tickets were being scalped at ten times their value, and another estimated forty million viewers saw the company on the *Ed Sullivan Show*. Catherine Gunther Kodat noted, "[...] the public's already strong interest in the company developed into near-mania" (1). This is a good description I remember that in Los Angeles *tout* Hollywood showed up for the performance: "Later at the Shrine Auditorium in Los Angeles, movie stars formed a guard of honour for the Russian dancers after the performance" (1). Kodat tells us that the famous poet Marianne Moore wrote a poem about the company that "[...] subtly addresses the Moiseyev season as an aspect of the growing practice of using art as a tool to promote strategic national goals" (5). I still remember the glittering performances, and dancing the Virginia Reel with Moiseyev company members in an after party and reception, that in subsequent tours appeared in the curtain calls to delighted American audiences. Mr. Moiseyev signed my souvenir program, which I still have.

The newspaper critics were almost all agog over The Igor Moiseyev Dance Company's performances.[9] Typical was, "The dance critic John Martin, who had not been a fan of international artistic exchange when the Eisenhower program began in 1954, was ecstatic. Martin's review in *The New York Times* on April 15 registered his excitement about the Moiseyev's opening nigh performance at New York's Metropolitan Opera House" (Prevots 72). Martin's colleague Jack Gould wrote in the same newspaper a review of the program on the *Ed Sullivan Show*: "The entire evening 'scored a resounding hit [...] Their fantastic agility, vigor and precision were almost unbelievable; their sense of excitement altogether contagious'" (quoted in Prevots 73). Review after review, using superlatives, duplicated Martin's and Gould's assessments (see Prevots, *Dance for Export*; Hallinan, "Cold War Cultural Exchange").

Dance historian Clare Croft states: "The 1959 arrival of the Bolshoi Ballet on its first American tour, under joint sponsorship by Hurok and ANTA, eclipsed the early folk-company tours" (42). I would argue that, in fact, The Igor Moiseyev Dance Company (but not the all-female Beryozka) was much more popular than the Bolshoi Ballet and reached larger audiences. The Moiseyev repertoire was much more "accessible" to American audiences than the classical Bolshoi repertoire. Americans knew little about ballet, and many found it "sissy." This popularity of The Igor Moiseyev Dance Company is shown by the fact that Sol Hurok brought The Igor Moiseyev Dance Company many times over the next few decades, they seem to have been his best money maker, both for Sol Hurok and for the Soviet Union (Robinson). In addition, many American critics wrote that the Bolshoi repertoire was stale and old-fashioned. American critics were able to make such value judgments about the Bolshoi because they viewed a familiar genre; Moiseyev's spectacularized "folk dance" was an entirely new genre for them.

The State Department quickly saw that they were in no position to undertake the organization of such a project so "[a] contract was therefore signed between the State Department and the American National Theater and Academy (ANTA), authorizing ANTA to serve as professional administrative agents" (Prevots 37). ANTA had separate panels for dance, music, and theater, and those panels selected which American attractions would be sent abroad. Naima Prevots studied the records of the dance panel, which consisted of critics, performers, choreographers, and arts administrators as well as ANTA representatives, and the ideal number of panelists was fifteen. They first selected Martha Graham to tour Southeast Asia.

Prevots observes, "The tour could have been problematic, for she was sent to areas where there was anti-American feeling and where her work was totally unknown. Her choreography was not easily accessible, and even in the United States she did not enjoy a mass following. But the foreign press and heads of state applauded. We had sent them an American art they respected, responded to, and had never dreamed existed" (45–46). From the conservatives' in congress point of view, Graham's work contained sex, and no less than their puritanical and priggish Soviet counterparts, that was not acceptable.

From the very beginning, the dance panel had no problems choosing ballet companies to tour, because it was a favored art in the USSR, and because it was deemed, by American

critics at least, more advanced than Soviet ballet. American critics seemed to supply a never-ending stream of prose condemning Soviet ballet as backward, overly conservative and dull (see Shay, "Dance as the 'International Language'"). Moiseyev, on the other hand, did not receive bad reviews.

Modern dance was even more popular with both the ANTA dance panel and the State Department, as a uniquely "American" art form, although not with the political right congress. Dance historian Clare Croft notes, "Examining the structural mechanisms that shaped State Department sponsorship of international dance tour exposes another popular myth in the dance community: the idea that modern dance, the genre of dance most frequently exported, is uniquely American" (16). This insularity of thinking, promoted by many American modern dance programs in the United States, allows its proponents to forget that Vaslav Nijinsky and Mary Wigman, with their modernist choreographies, predated the modern efforts of Graham and Humphrey by two decades. "It is no longer true that American dance historians writing about early modern dance see American dance as entirely separate from and unconnected with early European modern dance. But it wasn't so long that they did" (Burt 121).

The question of who was to finance the touring of dance, or any "modern" dance form haunted all of the Cultural Cold War. "[…] 'high' art – especially painting, music, and dance – would shortly assume a place alongside movies, musicals, and top ten songs as weapons in the Cold War. Cultural diplomacy played a significant and complex role in this overall confrontation. Overseas, the State Department promoted a vision of American culture not universally accepted at home" (Prevots 3). From the outset, Republicans and conservative Democrats railed against financing "modern abstract" art like that of Jackson Pollock. They held hearings to investigate the entire enterprise, launched by Eisenhower in 1954, to tour music, dance, and art. According to dance scholar Naima Prevots, "The record makes for chilling reading. In an attempt to smear the entire arts exchange program, he (Senator John James Rooney [D – NY] asserted that several members of the Symphony of the Air were Communists or Communist sympathizers, and that taxpayer money was being spent on dangerous and subversive activities" (33). Those familiar with the tactics of Strom Thurmond and Jessie Helms and their attempts to destroy the National Endowment for the Arts in more recent times should be familiar with such tactics from many Republican politicians.

A subtext of funding dance, resisted by archconservatives, is that leading artists in the field were homosexual. "Of all the art forms sustained by government programs during the Cold War, none is more connected in the American imagination to women and homosexuals than the dance – and it was the dance that was the most frequent target of conservative opponents of federal funding for the arts" (Kodat 57). Much of congressional resistance to funding, "[…] was articulated in misogynistic and homophobic language […]" (Kodat 56).

But the American government could not ignore the success of Russian dance. "Yet even as dance stood, in the minds of many Congressmen, as the perfect symbol of all they found objectionable in art, it remained the case that ballet had become the Sputnik of

Cold War cultural combat, the art form in which perceived Soviet dominance posed the most compelling challenge" (Kodat 58). The State Department had to act fast to counter the success of The Igor Moiseyev Dance Company. The Igor Moiseyev Dance Company presented a fierce diplomatic challenge.

The former Soviet Union reveled in the success that The Igor Moiseyev Dance Company garnered through their performances, in which they obtained hard currency from the West, and scored political points in the newly liberated former colonies, now emerging after World War II and subsequent wars for independence, as independent states of Asia and Africa. Moiseyev's choreographic strategies of representation, in which the dances of the Asian and Muslim populations of the former Soviet Union were featured alongside the Russian, Ukrainian, and Belorussian dances, made a political impact, especially in contrast to America's blatant racism. This programming strategy became a popular aspect of Moiseyev performances in what was called at that time the Third World. The Soviet Union frequently sent The Igor Moiseyev Dance Company to perform in the developing world to score political points. This goal of representation of the rainbow of Soviet ethnicity replaced displaying Russian national identity after the Second World War.

This programmatic strategy, which represented all of the ethnic and national groups as living in colorful harmony, also served to highlight the intense racism that characterized the United States at that period of the Cold War and that became an increasing embarrassment to the diplomatic efforts of the United States. "Within the United States, there was a growing realization among those concerned with international relations that Jim Crow not only was analogous to Nazi treatment of the Jews and thus morally indefensible but was also contrary to the national interest" (Fredrickson 129). This was true especially in the 1950s and 1960s, the Moiseyev Company's most active touring period in the developing world when both the United States and former Soviet Union were out to win hearts and minds. His programing of the many Islamic groups that inhabited the former Soviet Union strongly resonated in the Middle East and Africa.

The State Department never seems to have selected attractions that were not recommended by the dance panel of ANTA. "A close look at the Panel minutes over the next few years show that choices were not always easy and often occasioned lengthy discussion. Some of the issues were entertainment versus art; how best to represent the diversity of the American heritage; what role idioms other than modern dance and ballet (such as tap and jazz) should have in the program [...]" (Prevots 51). However, since as Frances Stonor Saunders suggests, the CIA underwrote touring programs covertly, through American foundations like the Rockefeller and the Fulbright, which knowingly and proudly funded or served as pass through organizations for hidden CIA funds (Saunders Chapter 7). Prevots noted that the members of the panel were satisfied with their choices of Graham and Limón, but, "The dance Panel was less comfortable with choreographers who had struck out in new directions and were considered avant-garde" (51). In the 1950s, Alwin Nikolais and Merce Cunningham were considered too modern and avant-garde and did not receive approval. By the early 1960s, the panel began to look more favorably on avant-garde dance.

Of especial urgency to the State Department was to find African American artists, to counter the ugly specter of racism, for which the United States was justly notorious. The Soviet Union made huge gains around the world touting their own multiculturalism, especially in The Igor Moiseyev Dance Company repertoire, in comparison to the wave of lynchings that swept the South in the 1950s and 1960s in the age of television.

The United States government has never been comfortable funding the arts. This partly derives from the fact that many Americans of protestant background hold a deeply puritanical suspicion of the arts and their high-brow associations, and partly because congressmen, for the most part, did not understand that the performing arts in the form of opera, symphony orchestras, and dance require years of training by their practitioners, whereas entertainment, in the form of Broadway musicals and film require an outlay of investment money with the expectation of profit. In general, the arts do not pay for themselves because of the long-term training and the expense of mounting opera and ballet, for example. Congressmen reiterated over and over that the arts should pay for themselves and not receive public money. The Republicans have over the past few decades attempted to defund the National Endowment for the Arts several times, as they are attempting in 2018.[10]

As Gary O. Larson describes in his book, *The Reluctant Patron*, the "dance boom" died long before the Cold War ended. "By the late 1970s, funding for large dance company tours had mostly disappeared. The Cold War's end in the 1980s precipitated American cultural diplomacy's major decline [...]" (Croft 23). However, after the next major crisis on September 11, 2001, sponsoring the arts was back on the table: "Less than a month after the September 11, 2001 attacks, Congress convened hearings about cultural diplomacy" (Croft 23). The result: "The State Department created, first, Rhythm Road, a program that sent musicians, mostly jazz musicians, abroad, and then in 2010, DanceMotion USA" (Croft 23). The future will show to what degree America will use the arts as a potent weapon in their diplomatic quiver. The American congress has never understood that a symphony orchestra concert or a dance performance is cheaper than a bomb.

At this point in the narrative, I want to briefly discuss China, the Korean War, and the Vietnam War. Because this is study of The Igor Moiseyev Dance Company and its role in the Cultural Cold War, it is important to note that the United States treated Russia and China very differently.[11] Our encounter with China in the early 1950s came through the American experience in Korea in which China and the United States used North and South Korea as a proxy to conduct a shooting war. Historian Howard Zinn characterizes the Korean war: "The United states' response to 'the rule of force' was to reduce Korea, North and South, to a shambles, in three years of bombing and shelling. Napalm was dropped [...]. Perhaps 2 million Koreans, North and South, were killed in the Korean war, all in the name of opposing 'the rule of force'" (163). China retreated into isolation, and little more was heard about it, until 1969 when a hot war broke out between the Soviet Union and China (Gaddis 149).

The Vietnam War, too, had an impact on dance. Several of my dancers went to war there. However, all of these events largely lie outside of the narrative of this study whose focus is on the career of Igor Moiseyev and The Igor Moiseyev Dance Company.

Chapter 4

Igor Aleksandrovich Moiseyev and His Dance Company: A Life in Dance

Chronology

1906	Igor Moiseyev born in Kiev. January 21, 1906 [O.S. January 8].
1918	Begins his dance education under Vera Mosolova.
1920	Enters the Bolshoi Theatre's Ballet School.
1924	Graduates from the Bolshoi Theatre's Ballet School.
1924–1939	Dancer in the Bolshoi Theatre's Ballet Company; has many starring roles.
1930	Igor Moiseyev begins to choreograph several ballets for the Bolshoi Ballet, beginning with the *Footballers* (also known as the *Football Player*).
1930	Igor Moiseyev begins to seriously work with folkloric forms and to develop what was to become the official style of presentational folk dance in the Soviet Union. This includes working with ethnic and nation groups for presentation of folk dances in the *dekady*, the annual ten-day showcases of folklore of the various republics.
1936–37	Igor Moiseyev founds his famous dance ensemble: the State Academic Ensemble of Folk Dances of the Peoples of the Soviet Union, known in the West as The Igor Moiseyev Dance Company. Many of his most famous compositions date back to this period.
1942, 1947	Igor Moiseyev named State Artist.
1945	The Igor Moiseyev Dance Company begins to perform outside of the Soviet Union. It continues to do so today. It begins in Eastern Europe, China, and other locales.
1953	Igor Moiseyev named People's Artist of the USSR.
1955	The Igor Moiseyev Dance Company performs in Paris and London.
1958	The Igor Moiseyev Dance Company launches the Cultural Cold War between the United States and the Soviet Union. This is followed by a series of successful tours of the United States into the twenty-first century.
1958	Moiseyev prepares Spartacus for the Bolshoi Ballet to the music of Aram Khachatourian.
1958	Igor Moiseyev wins the Lenin Prize.
1966	Wins the Lenin Prize, a second time.
1976	Igor Moiseyev is named Hero of Socialist Labor.
2007	Igor Moiseyev passes away November 2, 2007 at the age of 101.[1]

The Life of Igor Moiseyev

Igor Aleksandrovich Moiseyev was born on January 21, 1906 in Kiev, to father Aleksandar Moiseyev (his patronymic Aleksandrovich derives from his father's first name, as it does for all Russians) and Anna Aleksandrovna Gren, who was half Rumanian and half French. His father attended the University of Heidelberg, where a large number of Russians came to be educated. Aleksandar Moiseyev, a minor Russian nobleman with little money, majored in law. His mother he describes as a "modiste" designing and sewing costumes in the theatre in Paris. His father met her in Paris and they married. Soon after, they returned to Ukraine, where Moiseyev was born.

In another study that I wrote about Igor Moiseyev, I suggested that for a number of reasons, he might be of Jewish origins.[2] Moises (Moses) suggested to me a name of possible Jewish origin (Shay, *Choreographic Politics* 66); however, one of my Russian colleagues said to me that the name Moiseyev would not necessarily suggest to a Russian that he was Jewish. However, as I began to read Igor Moiseyev's autobiography, he recounts how he journeyed to the Birobidzhan region, which the former Soviet Union had set up as a "Jewish" homeland (that largely failed), and the Jewish residents invited him to a banquet,

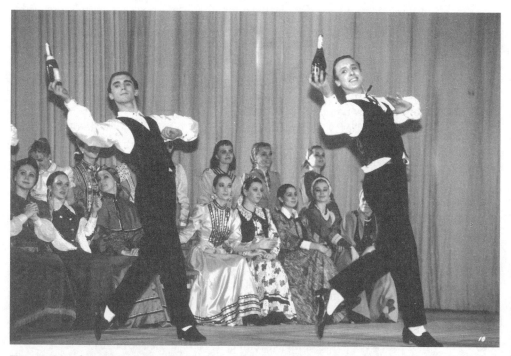

Figure 2: Scene from *Jewish Wedding: The Family Joys.*

expressing their interest in him, because, according to Igor Moiseyev, they, too, thought that he was Jewish based on his name. They were disappointed when he told them that he was a Russian Christian (*Ya Vsponimaiu* 62–63). The subsection of that chapter is entitled, "A Pity that Moiseyev Is Not a Jew." When I was in Russia in May–June 2016, I enquired of Elena Shcherbakova, the current artistic director, if it was possible that he was Jewish. She said that Moiseyev had told her that if he was Jewish, it would have been through his mother's side (personal interview, June 2, 2016).

He relates how his father "[…] so that his son would have a beautiful and rare name, he called me Igor. I was the only Igor among our acquaintance" (*Ya Vsponimaiu* 5). Moiseyev relates that his father was an anarchist, albeit not a bomb-throwing one, but a verbal one. This, and the fact that his father belonged to the minor and impoverished gentry, moved him to the margins of Soviet life, unable to practice as a lawyer for which he was trained. His father became a translator in French, English, and German. He remembered that the family moved back to Paris, but his father fell foul of the Tsarist authorities for his outspoken politics and was imprisoned. His mother left the very young five-year-old Moiseyev in a pension in Paris in order to arrange his father's freedom. He remembered, too, that the older children abused him and the teachers would not help him – a memory that never left him. His parents returned to get him after several weeks, and they moved to Poltava in the Ukraine, near his father's sisters. In order to prepare him for high school, his aunt taught him Russian, which was for him a foreign language. His father could find no work in Poltava, and though they had tickets to return to Paris, World War I broke out, which prevented the family from leaving Russia. He stated that if the family had returned to France, "I certainly would have become a French citizen" (*Ya Vsponimaiu* 7).

So the family moved to Moscow because there was no work in Poltava when Moiseyev was 13. And then came the Revolution. "It was a time of hunger" (*Ya Vsponimaiu* 9). The Soviet authorities were not pleased that Moiseyev's father was an anarchist, and from the nobility as well. They got used to life there, but Moiseyev remembers, "there was no money" (*Ya Vsponimaiu* 8). His father could not find work as an attorney. His mother sewed because people needed clothing, and her labor kept them together. Food was scarce, and life was perilous. Schools and businesses closed and life was chaotic.

"At the Bolshoi, led by the inspiring example of [Ekaterina] Geltzer and [Vasily] Tihomirov, the dancers performed with their breath clouding the air before them on the great ill-heated stage for the audiences of the future […]. With money worthless, dancers were often paid in food […]. Alexandra Danilova once received a winter's supply of firewood; Geltzer a saw and ax" (Reynolds and McCormick, *No Fixed Points* 243). The state provided free concerts, and some people, who had never seen a ballet, walked for miles for the experience, creating a growing number becoming balletomanes. In fact, as the entire nation descended into chaos, the Bolsheviks barely managed to keep power. Some regions were not pacified until the 1930s. Diversions like ballet were useful to the struggling regime.

Moiseyev at the Bolshoi

Aleksandar Moiseyev worried about Igor being on the streets and took him to Vera Mosolova, a famous ballerina, now a private ballet teacher. His father had good reason to be worried. "Seven years of warfare brought about a sharp rise in the number of homeless orphans, *besprizorniki*, who became a common part of the urban landscape in the 1920s. Frequently seen loitering in public spaces, they survived by begging and stealing. Gangs of *besprizorniki* terrorized citizens on public conveyances and presented a general threat to public security" (Husband 285). Money did not exist, and most individuals survived by barter; Aleksandar Moiseyev paid for Igor's lessons with firewood. Showing early promise, Moiseyev remembers "within two to three months the famous Vera Ilynichna [Mosolova] took me by the hand and walked with me to the school of the Bolshoi Theatre" (*Ya Vsponimaiu* 9). Technically, he was so advanced that she could do no more for him.

His father could not have made a better career choice. Unlike Western Europe, the United States, and other regions of the world, dance in Russia did not carry homosexual implications for male dancers, and Russians, probably more than any other ethnic or national group, accorded dance enormous support. This did not change after the fall of the Tsarist regime, but rather intensified, and Moiseyev was a major beneficiary of that system.

Socialist realism and Stalin's personal view of what constitutes "art," without a doubt, may have constrained Moiseyev in what he was allowed to express through his choreographies, however that is speculative. I voice that opinion because in his youth, and even as the artistic director of The Igor Moiseyev Dance Company he frequently went out on a limb to complain about the stagnation of ballet, such as that performed by the Bolshoi Ballet, in which company he trained, danced, and choreographed for many years. Moiseyev commented: "The Bolshoi, at that time [1937, the year he founded The Igor Moiseyev Dance Company] stayed in the same street all the time and never went anywhere" (The Igor Moiseyev Dance Company 1965 n.pag.). His critique of the Bolshoi Ballet Theatre essentially boiled down to its being divorced from reality, especially Soviet life, still relying on fairies and sylphs: "the inadequacy of our ballet when confronted with an up-to-date theme derives, above all, from its false relation to its traditions, from the stagnation which frequently passes for loyalty to tradition" (Moiseyev, "The Ballet and Reality" 13). He argued that, "Every appeal for new forms and new characters is still taken as an attempt to break up and destroy the classical ballet and its great traditions" ("The Ballet and Reality" 13). He concluded the result of all of this is stagnation in Soviet ballet: "This is a dangerous symptom, which indicates that, while preserving any number of the outmoded canons of the classical ballet, we are breaking with one of its most fruitful traditions, the unfolding of content and feeling through the language of the dance" (Moiseyev, "The Ballet and Reality" 14).

Igor Moiseyev was in his youth an avant-garde artist, which will come as a surprise to many readers. He trained and performed with the Bolshoi Ballet. Feeling himself to be a victim of the ossification of the Bolshoi Ballet, he had no hesitation in dismissing and denigrating their constricting vision of dance. "Moiseyev proposed to keep producing

ballets, but to turn them inside out, to highlight the character dances and mass scenes at the art, and to banish the elites and mythical swans to the periphery. Ballet needed to disassociate itself with the nobility in order to thrive in the Soviet context. Folk-staged dance was obviously much more compatible with Marxist ideology than classical ballet" (Nahachewsky 207). But the Bolshoi establishment was not having any of that, so in order to realize his vision, he had to leave and found his own company. In doing so, within the Soviet system he would survive, thrive, and achieve success throughout his career as the founder, choreographer, and artistic director of the State Academic Ensemble of Folk Dances of the Peoples of the Soviet Union, known as The Igor Moiseyev Dance Company, and later Moiseyev Ballet, in the West.

The importance of the act of enrolling in the Bolshoi Ballet School was crucial to Moiseyev's future. It is here that he met his teachers and mentors. He talked about the aesthetic importance and influence, for example, of Mikhael (later Michel) Fokine's *Les Sylphides*, "even though he had never met him personally" (Koptelova 38). In the Bolshoi Theatre, he flourished as a dancer and learned alongside famous dancers like Asaf Messerer, and completed the beginning work with distinction. It is here that he met two of the most important mentors of his career: Aleksander Gorsky and Kas'ian Goleizovsky (Koptelova 40–47). These two choreographers, alongside Michael Fokine, were important to bringing Russian ballet into the twentieth century. Gorsky was very vocal about his dissatisfaction with the stagnation of the Bolshoi, and Igor Moiseyev took class from him from the beginning of his student days in the Bolshoi Ballet School until his graduation in 1924 at the age of 18. Almost from the beginning, his prowess in dance was apparent, and he received several important secondary roles, and soon, star turns. Goleizovsky choreographed the first works in which he appeared. Both of them wanted to create new, modern works. In Golozeivsky's case, it was a personal experience that turned him to the modern, which I found delightful:

> Goleizovsky recalls his performance in the role of a butterfly in *The Goldfish*. Having run offstage to applause after a successful number, he suddenly stopped dead upon catching sight of his reflection in the mirror: doll's make-up – bow lips, languidly made-up eyes – "romantic" black curls down to his shoulders caught up in a golden band, silk tights generously decorated with velvet appliques, multi-colored wings on his back [...]. No, he had to either abandon the stage or make ballet into something else!
>
> (quoted in Souritz, *Soviet Chreographers in the 1920s* 155)

No wonder he wanted change. Reynolds and McCormick characterized him as "[...] a poetpainter, linguist, and musician, as well as an early champion of the use of twentieth-century scores for ballet" (248). Igor Moiseyev loved his choreographies.

The young dancers, spearheaded by Igor Moiseyev, at the Bolshoi Ballet came to loggerheads with the old guard, represented by Vasily Tikhomirov and his wife, the famous dramatic ballerina Ekaterina Geltzer. "Ekaterina Geltzer, daughter of one of the great mimes of the Moscow ballet [...] with her natural dramatic abilities, she blossomed into a ballerina

of fiery impetuousness and energetic abandon, with a vocabulary of circuslike tricks at her command, qualities that came to characterize the flamboyant Bolshoi style" (Reynolds and McCormick 238). These two figures became the vanguard of the old school classical dancers and choreographers, and they were the ultimate winners in the struggle with the younger generation.

Gorsky was the older of the two choreographers: "Gorsky [...] would find himself between two stools, castigated as too eclectically 'left' by the defenders of the imperial tradition and as too stagnantly 'right' by those who sought the reconstruction of ballet along new, proletarian lines. The Bolshoi was, Gorsky complained 'a stone box with chaos inside'" (Morrison 207). But as historian Simon Morrison says, "[...] his approach ultimately helped rescue the Bolshoi Ballet" (208). This was especially true because several hardline Bolsheviks wanted to close down anything to do with the former Tsarist rulers. In pursuit of modernizing the Bolshoi, Gorsky "was attracted by the art of the now world-famous Moscow Art Theater and the ideas of the great theatrical reformer Stanislavsky, which he tried to incorporate into ballet" (Demidov 9). Igor Moiseyev followed him in following Stanislavsky (Shamina and Moiseyeva 42–51). Above all Gorsky was original: "For ballet in Moscow his activity was of colossal significance. For all his mistakes, Gorsky was an artist with vigorous ideas and his own credo: one who was bold, impudent, and experimental. He stimulated ballet in Moscow, and led it along an original path [...]" (Demidov 122–23).

When Gorsky died in 1924, Moiseyev and other young dancers aligned themselves firmly behind Kas'ian Goleizovsky, who carried on the Gorsky tradition of attempting to free ballet of stagnation. Russian ballet historian Elizabeth Souritz notes that both sides were right: "[...] to a great extent the famous ballet dancers of the Bolshoi Ballet were right. In fact, it was fidelity to its academic foundations that helped ballet to survive" (*Soviet Chreographers in the 1920s* 87). However, she tempers that observation with the idea, "Modern ballet could not have emerged directly from nineteenth-century ballet without passing through the stages of Fokine's and Gorsky's creative work" (*Soviet Chreographers in the 1920s* 87). Alexander Demidov adds, "Above all, Goleizovsky favored the impressionistic manner: a dance of wavy lines and indistinct contours whose charm lay in its poetic understatement. That was why he earned fame through his experiments in the genre of the ballet miniature: the lyrical sketch, the fleeting vignette – similar to the choreographer's painterly sketches" (124). And following these two choreographers, whose exciting modern ideas appealed to Moiseyev and his young colleagues' search for the avant-garde, and they risked their futures for this belief. Demidov concludes: "Thus the traditions of the Bolshoi company were developed, on the one hand, from Gorsky's experiments, with their richness of naturalistic coloration, and on the other, from the work of Goleizovsky, with his striving toward poetic allusiveness – the symbolism of images" (125). Working with these choreographers was among the most important formative experiences for the young Igor Moiseyev.

Many scholars and observers give more credit to Gorsky than Fokine and their relative innovations. Russian historian Tim Scholl notes, "[...] Aleksandr Gorsky paved the way for the greater share of Fokine's innovations" (56). Gorsky, using the Stanislavsky method urged his

dancers "[…] to analyze their characters' motivations for their action on the stage" (Scholl 56). Igor Moiseyev also turned to the Stanislavsky method for his company (see Shamina and Moiseyeva 42–51). To a degree, the old guard won out because as Souritz observes, "Gorsky's original ballets were gradually pushed out of the repertory […] at the end of Gorsky's life not one of his productions […] was running in the theatre" (*Soviet Choreographers of the 1920s* 88).. Goleizovsky suffered a similar fate. Fokine's choreographies also had a great impression on the young Moiseyev (Koptelova 52).

Dance historians Nancy Reynolds and Malcolm McCormick agree with that assessment: "[…] Alexander Gorsky, whom Russian and Soviet historians consider as important an innovator as Fokine. Indeed, the two had many of the same ideas, and Gorsky often had them first: some of the effects with which Diaghilev dazzled Paris – one-act ballets and the individualization of characters within a group – had been seen in Moscow a decade earlier" (239). In many ways this format found a champion in Igor Moiseyev.

Like most individuals who make a life in dance, Moiseyev first appeared in the corps de ballet and with the first little money that he earned dancing in the corps, he went to the store and bought a teapot "in a shop across from the Bolshoi. Our old one was threatening to fall to pieces from the boiling water" (*Ya Vsponimaiu* 10–11). His mother was so proud she showed to the neighbors saying, "it had been bought with Igor's money" (*Ya Vsponimaiu* 11). For a short time, in his late twenties, and much younger than her, Igor Moiseyev served as the partner of the prima ballerina Ekaterina Geltzer.

In his teens, with few good male dancers at the time, he came to the attention of famous choreographers, especially Kas'ian Goleizovsky and Alexander Gorsky, and it was Goleizovsky who cast him as the lead in Goleizovsky's ballet "Beautiful Joseph" when the star Vasily Efimov took ill, and cast him in several other works. He appeared in the 1920s in several ballets, including the "Red Poppy" and "The Corsair." The noted Bolshoi ballerina Olga Lepeshinskaya stated, after seeing Moiseyev in the "Red Poppy": "He had a wonderful arabesque. This is a motion that drives all of the ballet. So, it is up to this day that I remember the lines of his arabesque" (quoted in Shamina 5). It is unfortunate that Moiseyev never realized his potential as a star in the Bolshoi Ballet, but Moiseyev leaves the impression that his future lay in choreography rather than dancing.

In the 1930s, Igor Moiseyev choreographed several works for the Bolshoi Theatre ballet, his first, *Futbolist* later became, in somewhat altered form, part of The Igor Moiseyev Dance Company's repertoire. He was twenty-seven when he choreographed it and he starred in it. "In the short-lived 1930 production of The Soccer Player (*Futbolist*) at the Bolshoi Theater, Lev Lashchilin and Igor Moiseyev sought to invigorate classical variations and ensembles with goal-scoring headers and penalty kicks – although the action, in truth, unfolded in a department store. It was supposed to delight but instead garnered mean-spirited reviews" (Morrison 270). He also choreographed *Three Fat Men*, which enjoyed immense popularity, with its ironic take on capitalism and a sardonic view of capitalists, depicted in the developing communist mythology as fat men. He later quipped that one thing that struck him in the West was that the majority of successful capitalists were slender and not fat.

Unfortunately, he is perhaps best remembered in his classical ballet work for his 1958 choreography of *Spartacus*, with music by Aram Khachaturian. The Soviet government was keen on producing this ballet of a slave uprising in the Roman Empire. It took the form of a particularly soviet socialist realism form of dance, the *dramballet*. These types of dramatic works emphasized the role of workers and those who struggled against oppression. They were often referred to in the West as "tractor ballets," which featured clunky, often risible, story lines. *Spartacus* was to be staged several times, finally by Yuri Grigorovich in 1968.

Moiseyev was the first choreographer of the work. Music historian Anne Searcy notes that "Moiseyev's 1958 version, the first to appear in Moscow, had by far the strongest connections to Khachaturian's conception of the work" (376). She adds that by 1952, "Moiseyev drafted a detailed description of the ballet with markings for Khachaturian indicating how long each section of music should be" (376). She states, "[…] it was colossal dramballet, heaped with spectacle and folk dance" (376). The opening scene alone "required seven dancers in major roles, eighty-five dancers in minor roles, fifty-four actors from the mime department, sixty men and sixty women from the choir, sixteen children from the Bolshoi Ballet School, eleven musicians for an off stage wind band, and to top it off, horses and their handlers" (377). The ballet displayed "muscular aggressiveness" and took four and a half hours but "was greeted with little enthusiasm" (379). "The greatest complaint was that it lacked dancing, although the music was widely admired" (380). It received only nine performances. In addition, according to historian Christina Ezrahi, "Costs were another concern. According to Lavrovsky, more than a million rubles had been spent on Moiseyev's *Spartacus*: at a time when there was a struggle for every ruble and artists had to be laid off […]" (208). Because of the musical score's success, and above all the theme of slave revolt, there were two further attempts to choreograph the work over the next decade, but they had little artistic success. Given Igor Moiseyev's genius for moving large numbers of dancers, the failure of the ballet seems surprising, until one realizes how unwieldy and lengthy the libretto was. Dance critic and writer Clive Barnes called *Spartacus* a "disastrous choreography" ("Igor Moiseyev," Obituary 138). This evaluation is repeated in the Shamina and Moiseyeva biography of Moiseyev in the chapter entitled, "*Spartacus*, the Great Failure" (91). It is important to remind the reader that most of Moiseyev's choreographies were hugely successful; reviews of most of his work demonstrate that. He is especially talented in the way he moves large groups of performers in an artful fashion, a particularly important aspect of Moiseyev's many choreographies.

The famous ballerina Maya Plisetskaya, who played one of the leading roles in Moiseyev's choreography observed, "When Igor Moiseyev produced 'Spartacus' at the Bolshoi Theatre, he was completely ruthless. Even cruel. Now I realize that is the only way to obtain the precise interpretation. He always knew what he wanted. And he always demanded what he wanted. And when it was done well he would say, 'Now it looks like the work of grown-ups.' It was a saying of his. From this point of view, his artistry is perfect" (quoted in Shamina 8).

Clive Barnes found Igor Moiseyev a "likeable, very affable man" ("Igor Moiseyev," Obituary 138), which agrees with my impression of him when I met him at a reception after a performance in Los Angeles in 1958. However, when he was in creative mode, from all accounts of his

dancers, he could be relentless in driving them to achieve the choreographic effect that he wanted keeping them in the rehearsal hall until he achieved it (see Shamina, *Khoziani Tantsa/ Master of the Dance*). He is still remembered by the young generation of dancers now in the company as a perfectionist, even when they had no direct experience of his rehearsals.

Shamina states that, "The theatre career [of Moiseyev] went smoothly" (4). However, Moiseyev's biography contradicts that. As a young performer, he was in the forefront of protests against the artistic stagnation in the Bolshoi Ballet, and never realized his full potential as either a dancer or a choreographer due to his outspoken stance vis-à-vis the Bolshoi establishment, one that he reiterated long after he ceased to work with them. As one of those young dancers who penned a protest letter against the establishment, he was dropped from the ranks of the Bolshoi artists within a year of his employment. He then took his case to Anatoly Lunacharsky, Lenin's Commissar of Enlightenment, which placed Lunacharsky in charge of education and the arts. Going to see Lunacharsky turned out to be a brilliant strategy, for he came to the notice of the Commissar. Today, looking at Moiseyev's work, it is difficult to think of him as an avant-garde artist, but his support of new works by Goleizovsky and Gorsky against the old guard of the Bolshoi, drew Lunacharsky's attention.

Lunacharsky, a die-hard, devoted communist, was nevertheless a man of culture and intellect. "The theater soon fell under the control of a jocular Swiss-educated Marxist named Anatoliy Lunacharsky [...] As the People's Commissar for Enlightenment, Lunacharsky toiled to keep the Bolshoi and other state theaters open; he signed orders ensuring the distribution of ration cards to artists and the procurement of footwear for ballet dancers" (Morrison 210–11). It was because of Lunacharsky that ballet was saved; hard-line Bolsheviks wanted to close down the ballet because it was an aristocratic art and tradition and the beginning of the Bolshevik period was a period of extreme want and starvation and Lunacharsky had to justify keeping the theaters and ballet companies open in the face of such need.

In part, factionalism was allowed to develop under Lunacharski's leardership of Narkompros (The People's Commissariat of Enlightenment). As a Bolshevik intellectual, Lunacharskii encouraged artists to pursue 'revolutionary inspiration' in their art, but also defended pre-Revolutionary cultural achievements as the legitimate inheritance of the proletariat and, so as to entice co-operation from highly skilled, politically independent professionals, recognized the need for creative freedom and individuality of expression.

(Ferenc 9)

Lunacharsky was a wily operator in the Soviet system and deftly juggled the political balls needed to keep the art scene, permitting both avant-garde arts and modern dance to flourish and even challenging Lenin's opinions. Lunacharsky's leadership is why the period of the 1920s saw a great surge of artistic experimentation in all fields of the arts. This all ended when Stalin came into power and ushered in tight state control of the arts.

Soon, through Lunacharsky's influence, Moiseyev returned to the Bolshoi, but he was never really forgiven, and he languished there for nearly a decade.

However, Lunacharsky took the youthful Moiseyev under his wing and invited him regularly to his *chetvergi* (Wednesday salons). Due to Lunacharsky's leading status in the art world, the salon was "where gathered the artistic intellectuals of Moscow [...] at that time I was nineteen years old" (Moiseyev, *Ya Vsponimaiu* 13–14). The many luminaries, such as Tairov, Mayakovski, Meyerhold, Utkin, and Barbusse, the latter with whom he spoke French, all of whom appeared regularly at the salons became important as Moiseyev's career advanced. These were all important figures in the world of Russian theater and literature.

> In April 1952, about a year before Stalin's death, Igor' Moiseev [sic] published a lengthy article on the state of soviet choreography in *Literaturnaia gazeta*. According to Moiseev, ballet was plagued by stagnation, conservatism, and a fear of the new. While Moiseev spent a considerable part of his article analyzing reasons for the lack of ballets on contemporary topics, his comments illuminated why many felt that dramballet had reached a blind alley; it regulated dance to an auxiliary role in ballet productions.
>
> (Ezrahi 103–04)

It was a courageous step to take at the time, but seemed to have little effect. He reiterated the same argument in the 1920s in a letter that he dictated to the Bolshoi Ballet management, which I referred to above. In spite of Lunacharsky's intervention, Moiseyev's fate was sealed and his days in the Bolshoi Ballet were numbered. The Bolshoi establishment resented his stance too much to relent. Nevertheless, it is important to note that Lunacharsky introduced the young Moiseyev to the Moscow artistic elite with the words, "Sirs, I want to present a young man, whom I predict, will have a big future" (Koptelova 51).

Confusion in the Arts

It is important to note the economic, social, and artistic chaos and dislocation that ensued in the wake of the 1917 Bolshevik Revolution. Conflicting attitudes at the top of the Bolsheviks' ranks ranged from destroying every vestige of arts that characterized the tsarist regime to encouraging only revolutionary art. Fortunately for the Bolshoi Theatre and Ballet and other artistic institutions, Anatoly Lunacharsky, with his respected credentials as a genuine revolutionary, was able to hold off the more crude approaches of many of his Bolshevik colleagues and persuaded Lenin and others that if they destroyed these institutions, the Soviet government would appear as a bunch of bumpkins in the eyes of the world. Thus, throughout the 1920s, experimentation in dance and the arts could occur (see Souritz, "Moscow's Island of Dance"). "When he was head of the soviet state, Lenin persistently tried to shut down the Bolshoi (and the Maryinsky whiles he was at it) in 1921–22. He felt that

state money should not be spent on the maintenance of this 'piece of purely bourgeois culture,' as he called it" (Volkov 47–48). But, Lunacharsky's persistence paid off and he saved these important institutions.

For a number of reasons, which I lay out below, Stalin, who did not lack artistic convictions, ended all experimentation and took the control of the arts into his hands, and he reversed the path that the arts had taken in the 1920s. Music historian Solomon Volkov tells us "Attending opera and ballet at the Bolshoi Theater was one of Stalin's greatest pleasures. As a cultural neophyte, Stalin retained a certain respect for 'higher' culture and its creators. Lenin lacked this piety completely" (47). Nevertheless, Stalin never let his personal taste in music and dance cloud his ultimate goal with the arts: the education and control of the masses. The government introduced the notion of social realism that was to inform all of the arts. "One of the most important aspects of socialist realism in the 1930s was its projection of the future onto the present as it celebrated the yet-to-be-achieved successes of the soviet state" (Petrone 6). The 1930s was the crucial period in which Igor Moiseyev created his choreographic model. For this reason Stalin carefully controlled the arts, personally interfering in artistic productions until his death in 1953. Regarding art production in the former Soviet Union:

> That of the 1920s featured a relatively lightly controlled pluralism, the Stalinist era produced a carefully controlled pluralism. The pluralism of the 1920s, however, emerged from below and from outside, and was created by forces outside the state. That of the 1930s, on the other hand, was manufactured, and its pluralist character did not indicate freedom of form and style, but only their variety. The coexistence of neo-gothic skyscrapers, musical comedy films, and jazzy music in Moscow hotel dining rooms reflected the eclectic viewpoint of political leaders and their cultural managers. Accessible pleasure for the masses, familiar and comfortable High Culture for the elite, monumentalism to match the gigantism of the great construction projects, and themes of happiness and heroism of the great construction projects, and themes of happiness and heroism to underpin the Stalinist ideology were all allowed.
>
> (Stites, "The Ways of Russian Popular Music to 1953" 24–25)

I quote this at length because of the extreme turn that was imposed on what was permissible in the Soviet Union, severely constricted artistic expression: jazz, modern dance, Western popular dance music like tango, all were henceforth forbidden. "The deadly purge of American jazz was a by-product of the cultural pogrom. Jazz bandleaders were arrested, jazz groups dissolved or toned down and renamed, and, in 1949, saxophones confiscated" (Stites, "The Ways of Russian Popular Music" 29).[3] Only classical dance and folklore in manufactured form were permitted. But even here, one must recall that unless the classical music was sweet and agreeable, it, too, was unacceptable to Stalin, because he felt that it appealed to the masses and that made it acceptable, otherwise it could be labeled "formalist" and that could be the death knell for an artist. One need only remember how viciously Stalin persecuted

artists, like Dmitri Shostakovich, who had the temerity to make their music sound modern and not a copy of nineteenth-century composition based on folkloric themes (see Volkov, *Shostakovich and Stalin*). Thus, while the 1920s constituted a moment of experimentations in the arts, in the 1930s, "Only controlled 'folk' customs such as wearing national costumes or performing dances were now permitted by Party officials" (Petrone 41). Enter Igor Moiseyev.

Mass Movement in the Soviet Union

It is important to note that the Soviet government had already recognized the value of mass movement, including physical culture parades, military parades, and mass dancing, which for them meant folk dance. Josef Stalin was personally involved in the physical culture movement through his sponsorship of physical culture clubs for which Moiseyev in successive years choreographed mass movements for parades and demonstrations on Red Square, which he describes in his autobiography, and how they took time away from rehearsing his newly founded dance ensemble (*Ya Vsponimaiu*). However, Moiseyev garnered valuable experience in how to effectively move large masses of people, one of the attributes of his developing dance genre. The physical culture parades, especially, produced strong symbols for the Soviet authorities on a number of levels: "They created an image of perfect order" (Petrone 23) and unity among the Soviet nationality groups.

Historian Karen Petrone in her illuminating study of Soviet celebrations states, "Describing the 1937 physical culture parade in Moscow, *Pravda* proclaimed, 'It was as if the whole country unfolded in front of the spectators, and they felt that in every corner of the country, no matter how far away, creative work was boiling, amazing human material was springing up whose equal did not exist anywhere else in the world'" (23). It is no wonder that the Soviet authorities micromanaged these events with great care. First, as historian Karen Petrone chronicles, one of the most important aspects was that the highest elite in the nation had the right to sit with Stalin and watch the event: "The audience of the parade on Red Square was made up of the highest-ranking members of the ruling elite. Less exalted Soviet citizens received the honor of appearing in the parade" (26).

The physical culture manifestations were different from all others, in that the participants had to have attractive, muscular, physical appearances. This proved difficult for Soviet authorities: "The ravages of years of hunger and repetitive factory labor made such athletes a scare commodity in Moscow factories in the 1930s and all the more desirable because the very shape of their bodies refuted the difficulties of soviet life [...] the most talented and physically attractive athletes were a scare resource over which various institutions competed" (Petrone 31). Soviet authorities scrambled to attract these bodies, as well as the talents such as Moiseyev's to maneuver and choreograph them. "The physical culture parade elevated strong, physically fit workers and athletes over weaker and less attractive Soviet citizens who were purposely excluded from the parade" (Petrone 31). Prizes were at stake,

and Stalin greedily coveted first prize. I suggest that Moiseyev's success in winning that prize for Stalin was one of the major reasons that he was selected to found the world's first state-supported folk dance ensemble.

The Role of Folk Dance and Music in the Soviet Union

Igor Moiseyev was an extremely talented, cultured, and intelligent man, and, while he suggested that many opportunities that came his way through chance (stated in both his autobiography published in 1996 and an updated edition published in 2016 on the event of his 110 anniversary, and in Shamina and Moiseyeva 14), rather I suggest that he sold himself short, or minimized his cleverness, talent, and hard work. Reading his autobiography, it is clear that he was a man who was intensely aware of his surroundings, and recognized and seized opportunities as they appeared. The Bolshoi Ballet was closed to him, largely because of his principled stance against the stagnation he saw there and his decision to buck the management. He did not repeat that stance.

Folk dance and music was in the Marxist air; the Soviet government began to recognize its value in the social and political field of representation and for purposes of propaganda: Happy costumed peasants were a regular feature of the visible photographs that were featured in

Figure 3: Igor Moiseyev demonstrates a series of different movements from his choreographies.

journals like *Soviet Life*. Igor Moiseyev seized the opportunity to create something new. His friend and colleague the famous ballet dancer Asaf Messerer stated that "In order to found such an ensemble, it was necessary for him to leave the Bolshoi Theatre [...] And, Moiseyev seized it" (quoted in Shamina and Moiseyeva 37). I think that Messerer's assessment is the correct one. To paraphrase Mae West's quip that "goodness had nothing to do with it" when describing how she acquired her diamonds, similarly, "chance" had nothing to do with it, it was Moiseyev's perspicacity and persistence, his talent and creativity that led him on the road to fame.

"The folk revival had begun in the mid-1930s as part of Stalin's cultural legitimation program, and the folk ensemble with peasant costumes and balalaikas became a familiar part of the cultural landscape" (Stites, "Frontline Entertainment" 132). I argue that Igor Moiseyev had the largest share of anyone in shaping the model and format of how these folk dance ensembles would appear. Under Soviet aegis

Character dancing would be emphasized, likewise athleticism, "physical culture." The school would also, in time, privilege the teaching of regional dances. Some of these dances purported to be authentic, imported from the campfires of the provinces, but most of them were abstracted and estranged from their sources, made more folk-like than the folk. Fantasy was better than the real thing, and so under Stalin, dancers and singers from Moscow would be sent to the provinces to teach the locals their own eccentric traditions. Thus in terms of how they sang and danced, the peoples of Armenia, Azerbaijan, Georgia, Uzbekistan and the other Soviet republics would be made into caricatures of themselves.

(Morrison 214–15)

Morrison's observation is somewhat overstated. Certainly, the government of the Soviet Union sought spectacular effects and athleticism to symbolically represent the youth and strength of the Soviet peoples, as well as symbolic mass representation of the state. However, if, as in Georgia or Armenia, there were individuals who had created ethno-identity dances, ready-made for the stage, Russians were not sent from Moscow. However, among ethnic and republic groups who did not possess such presentational music and dance forms, individuals like Igor Moiseyev were indeed sent to create stage-worthy dances, sometimes out of whole cloth, or inspired by a local tradition. These songs and dances were often prepared for the *dekada*, the ten-day festivals in which the various ethnic groups performed before Muscovites in the Bolshoi Theatre.

The *dekada* thus seemed to legitimize Soviet imperial aggression and the subjugation of so-called autonomous regions, but such polarizing terms obscure the actual complexities and realities of the situation. Rather than a simple example of the subjugation of the Kazaks, the first *dekada* of Kazak Literature and Art in Moscow in May 1936 served as the culmination of the effort to create a national space for the Kazaks. Three-hundred Kazak

actors, dancers, musicians, poets and writers descended upon Moscow for the festival starting on 17 May 1936.

(Rouland 190–91)

But as Nercessian noted above, many ethnic and national groups were eager to share their culture, and the *dekada* provided the opportunity to be on the national stage. According to Rouland, these groups appeared in front of all of the major political and cultural figures of the Soviet Union. The newspapers reviewed the programs, giving these performances national importance (Rouland 190–91).

Moiseyev described how in 1940 Stalin personally recommended that Moiseyev be sent as a choreographer to the Buryat Mongols for a *dekada*, and he prepared a work for them, *Tsam*, which was based on Buryat-Mongolian customs and beliefs. He later added it to The Igor Moiseyev Dance Company repertoire (Moiseyev, *Ya Vsponimaiu* 51–52). "The dancers wear masks, copied from the ancient originals preserved in Buryatia's monasteries. Igor Moiseyev discovered them when he went there in 1940 to train the local dance groups of the festival of Buryat art in Moscow. Those huge, weird and haunting masks gave him the idea for the ballet *Tsam*" (Ilupina and Lutskaya 6–7). Many of the sources of inspiration that Moiseyev found in such excursions into the countryside, which he used to create new works for The Igor Moiseyev Dance Company. However, I want to stress that his encounters with "the folk" were not those of an ethnochoreologist in her search for the authentic, but rather like the nineteenth-century classical composer mining field material for a fragment of a folk tune, which he would then alter almost beyond recognition for a symphony orchestra. Igor Moiseyev utilized the experiences and creation in these various events in future choreographies: "In the ensemble the 'parade' activities of Moiseyev, [he] effectively used elements in the choreographic picture *Work Holiday (Prazdnik truda)* and in his flotilla suite, *A Day aboard the Ship (Den' na korable)*" (Shamina and Moiseyeva 57). His *Futbalist* choreography for the Bolshoi Ballet inspired the choreography of the same name that he created for The Igor Moiseyev Dance Company.[4]

The Power of Staged Dance

Staged dance is not only a phenomenon of modern times. From early historic times various societies have found in staged dance a kind of power. In Japan, emperors have used *bugaku*, performed in the same way for over a thousand years, as a symbolic means of ensuring the continuity of the universe, a sacred duty. Although originally performed by the emperor and courtiers, for over a thousand years, professional dancers have passed down the tradition. Other Asian societies also have court dance traditions with deep roots.

Ancient Romans flocked to the powerful performances of pantomime dancers who became focuses of public adoration, their fans carrying pictures of them, ready to rough up anyone unwise enough not to applaud their performances, even though they were

counted among the *infamy*, a legal category with no rights. These ancient performances were staged with orchestras and choruses of up to sixty performers, which implies rehearsal and preparation. They toured widely throughout the known world, echoing twentieth-century practices. Powerful individuals who sponsored their performances could enhance their social and civic status (Lada-Richards, *Silent Eloquence*; Webb, *Demons and Dancers*).

In the court of Louis XIV, Louis embodied Apollo, the Sun God in carefully rehearsed court ballets, symbolically and visually making the king the center of the world. From the Renaissance period, the courts had sophisticated staging techniques and machinery available to create spectacular effects in court ballets. The costs of these productions were among the most costly expenses borne by the court, and participation in these dances could advance one's standing in the court (Hilton, *Dance of Court and Theater*; Nevile, "Introduction and Overview").

None of these examples were pressed into the service of the state as Moiseyev was: they glorified a Roman citizen as a civic donation or a monarch. The twentieth century witnessed the power of folk dance as embodying the essence of the new political entity: the nation state. In the beginning, governments, especially authoritarian ones, brought masses of peasants to large stadiums in order to create spectacle that symbolized mass support for the regime, but in the 1930s Igor Moiseyev created a new spectacularized dance genre under Soviet government aegis, that is, staged folk dance, with professional dancers, and changed the way in which millions of people saw and experienced folk dance.

Dance historians Nancy Reynolds and Malcolm McCormick note that in the 1930s "Dance had a new function, to serve the state. Such a climate led to the virtual canonization of folk dance as the true expression of the people" (254). Russian dance historian Tatyana Aleksandrovna Filanovskaya agrees with this assessment: The government saw the propaganda of folk dance to symbolically represent the "collective soul" of the Soviet people (216).

The government began to valorize folk dance by 1930, and the government took a series of steps, including the construction of large cultural houses in cities large and small all over the Soviet Union. These were frequently located in parks and supported all kinds of amateur activities, including an entire system of amateur folk dancing. "As a result of the emphasis given to national cultures in the mid-1930s, folk dance groups sprouted in hundreds of towns and cities, with even the NKVD [the KBG predecessor agency] having its own Song and Dance Ensemble" (Swift 241). Millions of people participated in these amateur dance companies. In the course of three trips to the former Soviet Union (1976, 1979, 1989), I visited several of these cultural houses and witnessed folk dance, ballroom dance, and other activities.

People in the West frequently do not understand how deeply popular folklore was in Russia and other parts of the Soviet Union. Westerners frequently characterize folk dance and folk music as naïve or esoteric, preferring instead classical or popular music and dance, but in many parts of Eastern Europe, folk dance and music, intimately tied to an individual's ethnic and national identity, was, and remains, deeply engaging. One of the largest and most

popular ensembles that purveyed folk dance and music was that of the Red Army Ensemble, which "was as much 'folkish' as it was martial" (Stites, "Frontline Entertainment" 132). In contrast to the West in which only military bands receive support, the various armed forces had music and dance ensembles. These culminated in the *dekady*, in which Moiseyev was involved, and then, in 1936, the government sponsored a huge folk dance festival with "1200 dancers and 58 dance groups. They performed more than 200 folk dances of 42 national groups of the Soviet Union […] the director of the festival was the young choreographer I. Moiseyev who organized the massive holiday on Red Square" (Filanovsakaya 217–18). All of this activity with folk dance clearly brought Igor Moiseyev to the attention of government authorities.

Moiseyev first suggested the idea that he would create staged folk dances for the Bolshoi Theatre. This suggestion was derided by the old guard, the classical artists who accused him of attempting to turn the Bolshoi Theatre into a "beer hall" (*pivar*). "He turned to folk dance after he felt that all choreographic possibilities at the Bolshoi had been closed to him in the aftermath of the antiformalism campaign of 1936" (Ezrahi 250). As Moiseyev was invited on the eve of World War II to choreograph *A Midsummer Night's Dream*, which was never realized, and as he himself wryly noted, "When the ballet was ready, I was [still] an official member of the Bolshoi Theatre, but I had not worked. Since the theatre participants had rejected me, all of my [choreographic] ideas were thrown out the door" (*Ya Vsponimaiu* 53). His career in the Bolshoi Theatre was essentially over, and folk dance was in the air. When I write "folk dance" I mean ethno-identity dance, dance used for the stage (Shay, *Ethno-Identity Dance for Sex, Fun, and Profit*). Igor Moiseyev was about to launch a new movement that would be taken up all over the world, first in the Soviet Republics, then the Eastern European satellite states, and then to a variety of countries of various political stripes such as Ghana, Egypt, Iran, the Philippines, and Mexico.

One of the reasons that he was given the reins of the company was his inventive creation of parades and exhibitions on Red Square, in which he was engaged "over a period of several years" (Moiseyev, *Ya Vsponimaiu* 35–45). These parades were, in fact, highly competitive. "These popular, ideological corporeal demonstrations celebrated physical strength in the Soviet approach, which were colossal attractions on the part of the authorities and personally by Comrade Stalin. Those who staged these events were highly esteemed – and [it was] dangerous; in case of failure the results of which could be serious, including arrest" (Shamina and Moiseyeva 52). His success for staging the team of athletes from Belorussia brought him to the unwelcome attention of Lavrenty Beria, then head of the NKVD (later the KBG), who invited Moiseyev to stage the NDVD's team, Dinamo for the following year, because they wanted to win the prize at all costs.

Throughout his autobiography, during the Stalin years, Moiseyev chillingly mentions different names of individuals he met, some of whom helped him, like Platon Mikhailovich Kerzhentsev, who encouraged him to approach Molotov with his suggestion for a professional folk dance ensemble. Kerzhentsev was shortly after that declared an enemy of the people and shot.

The period of the highest number of individuals killed and exiled by Stalin during his reign of terror occurred during 1936–38. "Emblematic of Stalinism, the 'repressions' – to employ the term more common in Russian parlance – of 1936–8 seems to have been so arbitrary in victimization, so elusive in motivation as to defy explanation" (Siegelbaum 311). Siegelbaum adds: "The total executed in 1937–8 represented 86.7 per cent of all death sentences carried out 'for counter-revolutionary and state crimes' between 1930 and 1953 [the year of Stalin's death]. Mass burial sites recently uncovered at Kurapaty in Belarus and elsewhere in the former Soviet Union, constitute one of the terrifying relics of the Stalin era" (315). This very elusive aspect of the great Stalin purge coincided with the founding of The Igor Moiseyev Dance Company. Between the first appearances of The Igor Moiseyev Dance Company, the dekady, the physical culture parades, and the All-Union Folk Dance Festival, Igor Moiseyev was in the cross-hairs of Stalin's attention – never a good thing. For example, a close friend and associate in the theatre, Vsevolod Meyerhold was arrested in June 1939, "he was tortured in prison before being executed" (Siegelbaum 306). No one could guess when he or she would hear the fateful knock on the door in the middle of the night. Clearly, Stalin was an unpredictable monster, and scholars remain unclear about his motivations.

Beria issued him an invitation to stage the Dinamo team with what Moiseyev called "a polite threat" (*Ya Vsponimaiu* 42). He was given a month to prepare, and the elaborate spectacle that Moiseyev prepared nearly became a disaster because of lack of rehearsal time, but ended in a success. Based on these successes of winning prizes for the Red Square stagings, Bolshoi dancer Yuri Faier "recommended me for the role of the head choreographer for the proposed theatre [the future Igor Moiseyev Dance Company]" (*Ya Vsponimaiu* 33).

Thus, we can see that Igor Moiseyev was uniquely placed to begin his lifetime adventure, one that would take him around the world. Dance historian Mary Grace Swift supports my claim: "[…] one of the most widely-traveled groups from the USSR would be the Moiseyev State Academic Folk Dance Ensemble, which was formed during the drive to recognize national arts" (244). The bottom line of all of this involvement in the arts, especially their premier dance companies – Kirov, Bolshoi, and Moiseyev – and why they spent millions of dollars, was: "The political architects of the Soviet cultural project hoped to use art to demonstrate the superiority of socialism and the Soviet system […]" (Ezrahi 162). Throughout the 1930s Igor Moiseyev was becoming extremely visible, which in that period of intense purges, disappearances, deportations, and executions, placed him in both a good and bad position.

Moiseyev Turns to Folk Dance

Sometime before 1936, when he was 30, he proposed to the Soviet government the idea of founding a dance company based on the staged folk dances of the Soviet peoples. His suggestion was approved by Vyacheslav Molotov, at that time the head of Sovnarkom, also known as Narkompros, the government agency that controlled the arts, and under the aegis of Nikita Khrushchev, the Secretary of the Communist Party in Moscow; he obtained what

he needed to begin his life work – the creation of The Igor Moiseyev Dance Company. After months of preparation, he had assembled a huge staff and the dancers and musicians for the first rehearsals in February 10, 1937, and the first performance, which took place in October 7, 1937 (Moiseyev, *Ya Vsponimaiu* 32–34). That, at least is the official narrative that the government sources follow, and by extension, program notes provided to audiences of The Igor Moiseyev Dance Company. It was within this new company that his choreographic genius was revealed in its fullness.[5]

In fact, by the time he had founded the company, he had developed a new system of staged folk dance that included elements of ballet, acrobatics and gymnastics, folk dance, and character dance, new and innovative ways of moving large groups of performers, new kinds of floor patterns, which the Soviet government adopted as the way in which "folk dance" was to be presented in the former Soviet Union (Filanovskaya 215–21). "This new style in choreography built upon a basic synthesis of folkloric dance and schools of classical dance, needed to be seriously organized" (Filanovsakaya 220). He founded a school to train professional dancers to specifically perform in his style; training professional dancers who could perform his difficult choreographies was an urgent priority for Moiseyev.

Widely called a philosopher of dance in the former Soviet Union, as well as in the title of a recent biography about him (Koptelova, *Igor' Moiseyev: Akedemik*), he wrote the justifications for the new dance genre he had created, which was "The purpose of my company… is to create classic national dances, to reject everything extraneous, to raise the skill of performance of folk dance to the highest artistic level, and to improve ancient dances in such a way as to influence the creation of new dances" (The Igor Moiseyev Dance Company. Program, 1986, 18). This latter statement places Moiseyev squarely in the same position as the choreographers of nineteenth-century character dance for classical ballet who believed that they could identify the essence of each national and ethnic group and reveal it in their choreographies. Their audiences believed that those choreographers had carefully studied people and they had the ability to show "national character" and reveal it to their viewers. For those audience members, it was a kind of travel and a cultural revelation. Moiseyev importantly adds that The Igor Moiseyev Dance Company "was to have its own unmistakable style and a repertoire so broad that it would truly reveal the national character" (The Igor Moiseyev Dance Company. Program, 21).

The problem of identifying the relationship between Moiseyev's new genre and actual folk dance (*narodny tanets*) in the field was that the Soviet government insisted on labeling both genres as folk dance, because the government wanted to present an idealized, bucolic image of Russian peasants. Happy village scenes became central to Igor Moiseyev's new dance genre. Like many Russians, Igor Moiseyev was inspired by the idealized village and set several of his choreographies in that context. As ethnomusicologist Paul Schauert states: "To do so, states [in the form of the choreographers of the national dance companies] seize culture from local community and ritual contexts, subsequently modifying and essentializing music/dance to suit new cosmopolitan, folkloric, and national domains" (18). Moiseyev carefully insists, in all of the writings I have read, that, "Our aim was not to act as literal copyist" (The Igor Moiseyev Dance Company. Program, 1986, 18) The last thing the authorities wanted was actual folk music and dance from the field, which the authorities felt would make Russia appear

backward. So, Moiseyev created a dance genre that would align with the political priorities of the soviet state. It is difficult to locate information on actual folk dances in the field because of the Soviet government's meddling in how folklore was to be presented and researched, according to Izaly Zemtsovsky and Alma Kunanbaeva ("Communism and Folklore").

And, while Moiseyev knew exactly what was wanted by the Soviet authorities, others were not so fortunate, "In February 1948 the party censured such distinguished composers as D. D. Shostakovich, S. S. Prokofiev, and A. I. Khachaturian for 'formalism' and insufficient use of folk themes" (Fuller 340). Not using folkloric material in the proper way could be deadly (see Zemtsovsky and Kunanbaeva, "Communism and Folklore"). In retrospect, I think that Igor Moiseyev somehow convinced his viewers, especially among governmental authorities, that what he created is what they wanted. To this day, Russian immigrants in the United States, many Russians believe that Moiseyv was producing actual, authentic Russian folk dances for his company.

Ultimately, Moiseyev notes, "We stopped limiting ourselves to folk dances already in existence. We started to create new choreographic works based on folk music and folk themes which, though alive, had not yet been expressed in dance" (*Ya Vsponimaiu* 22). All of Moiseyev's observations, which were often repeated, justify why I claim that The Igor Moiseyev Dance Company did not and does not perform folk dances, but they perform a new genre of dance that Igor Moiseyev created and which became the official system of "folk dance" that was officially sanctioned to the official, government-approved expression for all dance groups receiving financing during the former Soviet Union. This is why I am writing this study, because Igor Moiseyev occupied a position and exerted an influence in the Soviet dance world, and internationally, that has not been fully understood.[6]

Throughout the 1930s, Moiseyev directed this widespread standardization of Russian folk dance and the folk dances of other Soviet republics by creating the system and making it the official government-approved one, by directing and choreographing for festivals, and providing the justification for the system. Among other observations, Moiseyev states, "The purpose of my company is to create classic national dances, to reject everything extraneous, to raise the skill of performance of folk dance to the highest artistic level, and to improve ancient dances in such a way as to influence the creation of new dances" (The Igor Moiseyev Dance Company. Program, 1961, 11). The use of authentic folk dances did not interest him: "to present it in its primitive form would be undramatic, dull, not suitable for the stage" (The Igor Moiseyev Dance Company. Program, 1961, 18). Thus, a new system was needed to perform dances that were more spectacular, theatricalized, and exciting to symbolically represent the Soviet Union.

This system was also used by the professional Russian dance groups like Beryozka (founded in 1948 by Nadezhda Nadezhdina) and the dance unit of the Pyatnitsky Chorus (founded in 1938 by Tatyana Ustinova), as well as followed by all amateur performing ensembles. For interested readers, the system can be found in the book *Narodny Tanets* that was prepared by Tamara Tkachenko, a publication that was followed by dozens of supplements featuring new choreographies for each of the republics of the former Soviet Union, presented in order of importance and size, beginning with the Russian Republic.

From that moment, even though he participated in other artistic activities, especially in ballet, his life and that of his ensemble were inseparable. That is the narrative that has been given; however, in this study I question the official narrative, especially since, in general, the government, most notably under Stalin, directed all art. Stalin, according to most sources, micromanaged everything, and it is just as likely that Moiseyev was handpicked by Stalin due to his skills in choreographing and staging spectacles, especially directing large masses of performers, and organizing festivals. He had been directing masses of performers since the early 1930s, including a physical culture group that was under Stalin's patronage. Moiseyev staged the group in two rehearsals and won first prize for Stalin.

Changing the Official Narrative

To some degree I wish to destabilize the narrative provided by Soviet sources that the founding and first performances of The Igor Moiseyev Dance Company take on the fantasy vision of a Judy Garland/Mickey Rooney "Let's do a show" film. I think the truth is grittier than that, which is confirmed by some of the difficulties that Igor Moiseyev encountered and which he recounts in his autobiography (*Ya Vspominaiu*, updated edition).

I turn now to the steps that he took to arrive at that moment. Igor Moiseyev always credited chance, cited by several authors (Shamina, *Khoziani Tantsa/Master of the Dance*; Shamina and Moiseyeva, *Teatr Igoria Moiseyeva*). Chance led him to his destiny that spread before him. However, I will suggest that he clearly seized opportunities that presented themselves, and he had the talent and intellect to realize his vision. On a practical level, the Soviet government was not going to hand over financial aid, provide a rehearsal space, later allow him to found a school, and pay salaries and benefits to someone with no track record. Over a period of several years, Igor Moiseyev built a reputation through public appearances in directorial positions for a series of public displays, especially that of choreographing and staging events in which he moved large numbers of people on stages and public squares.

> Despite ballet's special position in society [as a courtly French genre reserved for the elite], a specifically Russian national style of dance began to take form and define itself during the nineteenth century [...]. Dance – not classical but popular and folk dance – has always been an integral part of life for the Russian. In the Russia of the past there exist a very complex, completely distinctive, folk ritualistic culture in which dance was prominent [...]. In ritualistic folk culture may be found the sources of the round dance that was developed so successfully on the classical foundations of Petipa's choreography.
>
> (Demidov 1, 3)

And that form was the *khorovod,* which Demidov characterizes as "big ensembles with very complex patterns of movement and unexpected transitions from on type of movement into

another, forming new and beautiful compositions every time" (Demidov 3). I discuss the khorovod in the section in which I describe Russian folk dance in the field.

Moiseyev lived to be 101 years old, which means that he lived his earliest years under the tsarist regime, his teen-age years in the want, chaos, severe deprivation, violence, and hunger that followed the 1917 Revolution, the Stalinist era, the post-Stalinist era to the collapse of the Soviet Union, and the founding of the Russian Federation. Through it all, he became a well-trained ballet dancer and award-winning choreographer, but he is best known for inventing an entirely new form of dance, and founding a world-famous company that lives on today, and which continues to venerate his memory. It was Stalin's favorite company, and played a seminal role in the Cultural Cold War.

"Though folk music was accorded an important place and much effort was expounded in attempting to raise its stature to that of classical music in most parts of the Soviet Union, few people within the Soviet Union took it as seriously as classical music" (Nercessian 148). I will argue against Nercessian that, in fact, folk music and dance were extremely popular among most individuals in areas like Russia and Ukraine and was used to imbue the population with patriotic emotions to sustain them during the war. Following historian Richard Stites who notes the beginning of the folk revival that began in the 1930s under government aegis had expanded significantly in the next two decades: "The most popular folksinger of the era, Lidiia Ruslanova, was among the most wanted entertainers in the frontline brigades. Military units with no access to the mobile brigades put on their own amateur folk productions" ("Frontline Entertainment" 132). It should also be noted that republics such as Uzbekistan, Tajikistan, and Azerbaijan had indigenous classical music forms that were extremely widely played throughout the former Soviet Union.

Folklore, too, was to be controlled and manufactured; there was an official style of folk music and dance, embodied in The Igor Moiseyev Dance Company and the Pyatnitsky chorus, which served as models for all their emulators.

> The revival of folk music that was viciously assaulted during the Cultural Revolution therefore became a natural part of the 1930s normalization in culture. Its peasant content, though stylized, reinforced love of the land and thus of the nation or *narod* […]. In many ways, it resembled the "happy peasant" image offered all across Eastern Europe between the wars, a device used to deflect away thoughts of real poverty and to co-opt themes of the various oppositional agrarian parties. Folklorism – i.e. politicized folk adaptation – became a major industry in the Stalin era. Folk song and dance came back into favour on the wave of the Stalin's "Great Retreat", a campaign to preserve or revive certain elements [of] Russian history and culture.
>
> (Stites, "The Ways of Russian Popular Music" 25)

Richard Stites came to a similar conclusion as I did about how The Igor Moiseyev Dance Company fit into this depressing picture: "In 1936, Igor Moiseev established a Theatre of Folk Art in Moscow and his own folk dance ensemble that brilliantly combined the rigor of classical ballet with folkloric steps and village scenes" ("The Ways of Russian Popular Music" 25).

Moiseyev understood all too well that he needed to fit his aesthetics and creativity into this context in order to succeed, and become Stalin's favorite dance company. As we will see in looking at Moiseyev's choreographies they fall into historian Kristin Roth-Ey's characterization: "Soviet culture, then, was characteristically both future-oriented and nostalgic; past and prospective glories were its polestars" (4). Moiseyev's works carry cycles of historical memories in several of his Russian suites such as the City Quadrille: "This is an episode from the cycle, 'Pictures of the Past'. It depicts the customs and traditions of pre-revolutionary Russia" (The Igor Moiseyev Dance Company from Moscow 18). This dance contrasts with "A Day on Board Ship": "It opens with the crew at work on deck and then changes into the ship's engine room where the sailors depict the actions of wheels and pistons with a precision matching the engine strokes" (The Igor Moiseyev Dance Company from Moscow 26). This type of choreography symbolically represented the ordered universe of Soviet life. This latter choreography plays with the machinery themes that made up futuristic ballet choreographies in the 1920s and 1930s. His cycle: "Soviet Pictures" depicts an ever cheerful and idealized composition of work in factories and collective farms (Moiseyev, *Ya Vsponimaiu* 211–12).

In fact, these companies can be considered as performing a Soviet Russian dance genre. "After the revolution the new 'School of Russian Ballet' was based more on character than on classical ballet style. This was the basis for the teaching of folk dancing in Russian schools" (Olson 252, n. 128). This new genre of revival folk dance has become the stereotype of Russian folk dance, both among many Russians, as well as among foreign viewers. For the Russians, this "new" music and dance constitute a potent symbol of Russian ethnic identity.

In order to study the revival music and dance of post-Soviet Russia, Laura J. Olson (*Performing Russia*) avoids the value-laden term "fakelore" and calls the performances of revivalist Russian musicians and dancers "folklorism." Thus, she defines folklorism as: "The process of inventing authenticities and national symbols – and asserting them as natural" that forms the focus of her study (6).

Igor Moiseyev, as we have seen began his remarkable career in the 1930s. Roth-Ey states,

The ideal type for Soviet culture was forged in the 1930s and transmitted largely intact to the postwar world, as was the case with The Igor Moiseyev Dance Company. The fifties, sixties, and seventies had altered the soviet mass culture formation. It was the same house with the same roof on the door as in Stalin's day. But now it was a house of many more rooms, corridors, closets.

(23)

It was in this expansion that Igor Moiseyev composed new choreographies beginning with his new genre of folk dance, then adding rooms to the house with classical ballet, and adding what I call his experimental works.

"The explosion of folk culture and the popularity of amateur Olympiads in Soviet Russia during the 1930s occurred because of a historical conjuncture of opportunity and political acceptability" (LaPasha 142). Thus, folklore, carefully prepared for the stage, would be one of the primary forms of cultural expression until the fall of the Soviet Union and beyond, and Igor

Moiseyev positioned himself at the apex of the artistic pyramid the state created with amateur dance companies at the bottom, semi-professional dance companies in the middle, and finally professional dance companies on the top, with The Igor Moiseyev Dance Company at the apex. Nevertheless, Moiseyev had to negotiate the uncertain shoals of Stalin's paranoia.

But the atmosphere in 1936 was just too threatening. In August the newspapers announced the Trial of the Sixteen, in which Grigori Zinoviev, Lev Kamenev, and other leading figures in the Party opposition were charged with "subversive activity" and trying to organize an assassination attempt on Stalin. They subsequently widely used label "enemy of the people" was introduced in this period. To the accompaniment of hysterical newspaper headlines ("Punish the Vile Killers Severely!" – "Squash the Foul Creatures!" – "No Mercy for Enemies of the People!") all sixteen defendants were shot. With the Trial of the Sixteen a new spiral of repressions against cultural figures ensued.

(Volkov 139)

Peppered throughout his autobiography, Igor Moiseyev cites friends and colleagues singled out as "enemy of the people" and shot (*Ya Vsponimaiu*). He never knew when Stalin's hand on his shoulder was a portent. It was a time when no one was safe. As Solomon Volkov reminds us, "Shostakovich at the decisive moment in his life displayed an amazing grasp of the new situation in which the creative fate and even the life of any prominent cultural figure came to depend on Stalin's personal attitude toward him or her [...] Stalin primarily valued people because they were needed, and that had to be proved over and over" (141). And, Moiseyev proved his creative worth over and over.

"When Andrei Zhdanov, the cultural enforcer of the early days of the Cold War, cracked down on Shostakovich and Prokofiev in 1948, it was partly because their music had allegedly strayed from its natural purpose: to reflect Soviet patriotism highlight deeply Russian themes, sing with soaring melodies, and be accessible to the masses" (Stites 30). Moiseyev did not commit the same error. His *Partizani*, for example, valorized the informal heroes of the Great Patriotic War and still has the power to bring tears to the eyes of those who lived through it.

"In many ways, artists were Soviet society's true heroes, because though the proletariat was the demiurge of history, artists were today's representatives of the radiant future; only artists were living as everyone out to live, in a contemporary state of grace" (Roth-Ey 4). Artists had privileges no one else had: they could travel (albeit under tight security), they had the best food, clothing, and other amenities. In many ways they were like members of the *nomenklatura*.

Igor Moiseyev and the Invention of Tradition

Another aspect of revivalist performances, that paradoxically is almost the opposite of revival, involves the "invention of tradition" in Hobsbawm and Ranger's terms (*The Invention of Tradition*). Because, in spite of the fact that Igor Moiseyev's work is often referred to as

revivalist, there is no revival process in his work, no attempt to exactly recreate old village dances, but rather the creation of something new to represent the old and the traditional. Throughout his autobiography (*Ya Vsponimaiu*), he writes about how much he loved folk dance and music, and he certainly encountered it on many occasions.

His father taught him that there were three sides to a trinity: "GDB (gymnastics [*gimnastiki*]), breathing [*dyhanie*], ballet [*balet*]). And this stayed with him all his life" (Koptelova 27). As we will see, these three elements form important elements in Moiseyev's works.

What we are dealing with is the invention of an entirely new dance genre. His biographers Lidia Shamina and Olga Moiseyeva state this unequivocally: "[...] The Ensemble of Folk dances produced a new genre of folk-theatrical choreography" (7). This chapter addresses what is frequently called revival folk dance, because it involves Russian individuals who did not learn Russian folk dances in the village, but in the studio, and they were highly trained ballet dancers. It also involves a ballet-trained choreographer, Igor Moiseyev, who, following the dictates of the state's directives, created a truly new form of dance with little connection to the forms of dance found in Russian villages. These factors lead to the use of the term "revival" folk dance in this study while I am claiming that, in fact, what Igor Moiseyev created was an almost entirely new dance genre to represent the old and the traditional. The same observation applies to the professional dancers of The Igor Moiseyev Dance Company. Russian immigrants in Southern California flock to see Moiseyev performances in Los Angeles concert halls, their eyes moist from the Russia that was a "cheerful, unceasingly optimistic world" evoked by these dances as Guss noted (14). They attend night clubs oriented to the Russian immigrant, to participate in the nostalgia that former Moiseyev dancers create in their performances. In other words, the dances that The Igor Moiseyev Company and others like them perform, for example the professional dance ensemble that performs with the Pyatnitsky Chorus or the Beryozka dance ensemble, have become so familiar with Russian audiences that many individuals consider these revivalist performances to be authentic folk dances that they could see in a Russian village.

Many authors recognize that Igor Moiseyev was not producing authentic folk dance:

Folklorism, characterized by Richard Stites as "politicized folk adaptation", made a strong comeback via Igor Moiseev's [sic] Theatre of Folk Art, founded in 1936, and a national network of amateur folk choirs and dance ensembles. These "prettified" and theatricalized Stalinist ensembles [...] [promoted] images of national solidarity, reverence for the past, and happy peasant, images that were reinforced by highly publicized photographs of smiling peasants, decked out in "ethnic" or folk garb, meeting Stalin in the Kremlin.

(Siegelbaum 309)

Igor Moiseyev's new style of choreography, however "prettified," acrobatic, or theatricalized, became influential first throughout the Soviet Union, with each ethnic group and nationality

group commanded to form a company in the Moiseyev mode, adjusting for ethnic difference between dances from such disparate groups as the Estonians, Kazakhs, and Armenians. Moiseyev's intent was to create a new art form altogether, inspired by folk dance. Elena Shcherbakova confirmed that in an interview (personal interview, June 2, 2016).

In fact, these companies can be considered as performing a Soviet Russian dance genre that was extended to the other nationality groups. "After the revolution the new 'School of Russian Ballet' was based more on character than on classical ballet style. This was the basis for the teaching of folk dancing in Russian schools" (Olson 252, n. 128). This new genre of revival folk dance has become the stereotype of Russian folk dance, both among many Russians, as well as among foreign viewers. For the Russians, this "new" music and dance constitute a potent symbol of Russian ethnic identity.

In order to study the revival music and dance of post-Soviet Russia, Laura J. Olson avoids the value-laden term "fakelore" and calls the performances of revivalist Russian musicians and dancers "folklorism." Thus, she defines folklorism as: "The process of inventing authenticities and national symbols – and asserting them as natural," which forms the focus of her study (6).

The issue of ethnicity dominated Soviet life, and, ultimately, as the economy floundered, ethnic tensions, beginning with the Estonians, Latvians, and Lithuanians, followed by other ethnic and national groups, brought an end to the Soviet Union, which splintered along ethnic lines. The cult of folklore came into being because, since the late eighteenth century, folklore was an indicator of ethnicity, and in the former Soviet Union, folklore was valorized. It is important to remember that in pre-revolutionary Russia, a romanticized folklore was very popular. Composers used folk music themes in their music. Wealthy Russians had a dacha, a country villa, in the countryside, which served as a stand-in for country life. Some patriotic Russians even formed folk choruses with their peasants. This nostalgia for the countryside continued after the Revolution, when the powerful members of the *nomenklatura* (the communist political elite) appropriated dachas in emulation of the good life of the pre-revolutionary elite classes.

As Laura J. Olson points out in her study of Russian revivalist folk song, the revivalist process continues on the level of several parallel traditions, including the Soviet Russian style performed by professional ensembles like The Igor Moiseyev Dance Company. In post-Soviet Russia, Russians were frequently bewildered by the hostility that their presence provoked outside of Russia, especially in the Baltic States. Unsure in their new ethnic and national identity, many Russians turned to forms of folklore to shore up and glorify their ethnic history. In this process, they created a new identity based on a romanticized vision of a glorious Russian past that according to Olson, included the valorization of the Russian Orthodox Church, the Don Cossacks, which represented a bellicose masculinity and love of freedom and political independence, and the mythic Russian village, where life was pure in some Golden Age, so that "Russianness itself is sacred because the Russian people are 'chosen'" (Olson 156). Of course, carried to extremes, political groups like Pamiyat and the archconservative Vladimir Zhirinovsky's followers infused this heady mixture of Russianness with anti-Semitism and anti-Western xenophobia.

Thus, while currently Russian revival music and dance are tied to romantic visions of a Russian past, by contrast during the period in which Moiseyev created his dance genre and created most of his famous choreographies, Russianness was a stand in for an overall Soviet identity, that of Soviet Man, because the Russians were the leading and most representative ethnic group of the former USSR, and therefore they were the ideal ethnic group to embody that identity.

Youth Festivals

After World War II, Igor Moiseyev played a key role in the organization of the series of youth festivals that were directed and controlled by the Komsomol (The Communist Party Youth Organization). I remember these festivals, which were covered by journals like *Life Magazine*, especially marking them as communist-front propaganda organizations designed to entice young people into the communist trap, a trope that appeared frequently in the American press during the Cold War. Many people that I knew, especially those interested in folk dance, attend them and loved them because there were athletic events and dance events, both folk dance and classical dance and music. They found the festivals very exciting because one could meet young people from many countries around the world.

For the first festivals, beginning with the 1947 in Prague, Igor Moiseyev was the president of the jury that evaluated and awarded prizes to the folk dance groups that appeared at the festival. The Igor Moiseyev Dance Company won first prize. He had two groups, one being the performances of the company dance school. Igor Moiseyev stated, "Both of my groups won first place. Really, at that time it was not difficult for us to win because other countries had not yet established national companies. But that situation changed rapidly from festival to festival" (*Ya Vsponimaiu* 82). Moiseyev was correct about that statement. Although amateur groups appeared at the festival, it was actually at these early festivals that Eastern Europeans, especially, but many underdeveloped countries' representatives from Asia and Africa, saw the Moiseyev phenomenon and quickly followed suit (see Schauert 2015).

In several interviews that I conducted to write about the history of the establishment of the Croatian Ensemble of Folk Dance and Songs, Lado, the amateur group, Jožo Vlahović, which formed the kernel of the new professional Croatian dance company, won second prize "by only 0.64 points" (Sremac 178). One participant stated, "Of course, it was almost a law that the first prize would go to Moiseyev. First, they were a professional company; but more than that, the Russians had to win everything. Still, for us to take home that coveted second prize, over all of the other thirty-four professional ensembles from eighteen different nations participating in that massive festival was a great thing" (personal interview, October 15, 1999).

Moiseyev understood this viewpoint and agreed with it. "To me it was amazing: why did we make such efforts to win in competitions that we organized, and drew in other countries? On the contrary, as organizers, it was necessary for us to be more modest [...] But the

Komsomols always fiercely battled to win first place, it had to be ours" (*Ya Vsponimaiu* 82). Moiseyev inquired of the Komsomol officials, including the first secretary Mihailov, why they had to win. Mihailov answered, "Comrade Moiseyev, if our participants do not take first place – our heads would be down [in shame]" (*Ya Vsponimaiu* 82). Moiseyev wrote that Maya Plesitskaya, the world famous ballerina won first prize every year for her performance of *The Dying Swan*. The attitude that Moiseyev noted that the Russians had to win the first prize in everything not only characterized the former Soviet Union, but continues in the Russian Fderation. This is an attitude that many of us remember during the past Olympic Games, that continues into the most recent Olympics, from which the Russian athletes were barred from many events because of doping. This need to win caused other countries to cease attending the Youth Festivals. The youth festivals eventually came to nothing. Moiseyev finally ducked out of the jury because he was uncomfortable with the Komsomol's need to win.

The Dancing Diplomats: Igor Moiseyev and His Dancers[7]

As we have seen, in the late 1930s and the early 1940s, Moiseyev honed the skills of his company and made a positive impression through their domestic performances and the performances they made for the soviet armed forces during World War II. Following the war, during the late 1940s and early 1950s, they toured throughout the socialist world in tours and venues like the Youth Festivals held in various communist countries. In the late 1950s, Igor Moiseyev was given a new post, that of the world's first dancing diplomat: to inaugurate the opening of the Cultural Cold War.

One of the appeals of The Igor Moiseyev Dance Company and its performances abroad for the former lay in its focus on the dances of the many nationality groups. "[…] the Kremlin ceaselessly points out that the nationalities subject to the USSR have found warm encouragement for their self-development. A cardinal point emphasized in Soviet propaganda that Russia, in contrast to the nations of the West, nourished and encouraged the most ancient folk art of less developed peoples – a point readily appreciated by African and Asian audiences" (Swift 158–59). To keep that point in perspective, it must be remembered that Jim Crow Laws and lynchings in the South were still commonplace at the time of the first performances in the United States in 1958.

Igor Moiseyev proved to be adept in his role of dancing diplomat, and through his company's appearances, which they executed with great aplomb and charm, they became one of the most important vehicles of the Soviet Union's diplomatic arsenal, a role they continue in the twenty-first century.

Chapter 5

The Igor Moiseyev Dance Company, The Igor Moiseyev Ballet, The
State Academic Ensemble of Folk Dances of the Peoples of the Union
of Soviet Socialist Republics: Three Titles, One Company

Since I wrote *Choreographic Politics: State Folk Dances Companies, Representation and Power*, scholars have increasingly understood the ways in which state ensembles embody the ideological ideals the state represents, and consequently they have begun to study these organizations. "Thus, the performance of music and dance in a national/stage context becomes a potent study object because it has profound impact on the social processes involved in constructing both a nation and the lives of individuals" (Schauert 18). In my study I began with a profile of The Igor Moiseyev Dance Company because the entire movement and construction of national identities through state-supported dance and music ensembles began with Igor Moiseyev, and the recognition by the Soviet state of how folk dance and music could serve as a vehicle for national identity construction and the building of patriotism.

According to the official version, The Igor Moiseyev Dance Company, founded in February 1937, supposedly began with 38 dancers who gave their first performance in October 7 of that year.[1] That may have been the first "official" performance, but they certainly appeared in August of that same year in an outside setting in a park in the city of Gorky, which sounds like an out-of-town tryout before the official opening later in the year. The myth-like narrative gets very specific: "The members of the new company held their first meeting on February 10, 1937 in Moscow, in a house in Leontyevsky Street. Forty-five people were present. The eldest was Igor Moiseyev, who was then thirty" (Chudnovsky 18). The Igor Moiseyev Dance Company known officially as the State Academic Ensemble of Folk Dances of the Peoples of the USSR, the ensemble soon numbered around 110 dancers and a theatre orchestra (Chudnovsky 18). The sources vary as to the number of performers. In 2016, according to Elena Shcherbakova, the current artistic director, they now have 85 dancers and 35 musicians, plus a staff, including a masseur, a boot and shoe-maker, costumers, rehearsal directors, and administrative personnel (personal interview, June 2, 2016). By any standards, this is a very large dance company. What the myth omits is that Igor Moiseyev worked for several years to perfect the new genre of dance that his company would bring to perfection. Thus, he had several years to create his new dance genre, which his new company, the first state-supported, professional folk dance company in the world performed with great success.

Another questionable statement is that the company rehearsed in a stairwell! No dance company can rehearse in a stairwell, and certainly not one the size and complexity of The Igor Moiseyev Dance Company, with its large, intricate mass movements. There would not be enough room to execute the types of movements and new types of floor patterns that

characterized the movements and complex choreographic strategies of this new dance genre that The Igor Moiseyev Dance Company performed.

"The impetus behind the group was to depict a positive picture of a unified Soviet Union through the use of stylized folk dances from multiple cultures living within soviet borders. With smiling faces, colorful costumes and folk dances representing the different cultures of the USSR, the Moiseyev danced its way across the Soviet Union and across the world" (Hallinan 17). Thus, the company was to become a diplomatic tool in the uncertain political landscape that looked back upon the ruins of World War II and forward to an uncertain future in which the atom bomb and its potential use created a forbidding backdrop for the next half-century. Anyone from my generation remembers that several times a month, pupils in public schools took shelter under their desks because everyone believed the evil Soviets would launch an atomic bomb. The Soviets probably thought the same.

An important question to be asked at this point is: how did The Igor Moiseyev Dance Company fit into the overall world of Soviet art and culture? And how did Igor Moiseyev aesthetically navigate that artistic environment? The company's mythic narrative would have the reader believe that the company went from critical triumph to critical triumph, in a seamless well-paved road with no bumps. First, we know that Stalin had enormous interest in the arts, and frequently did not hesitate to insert himself in the world of culture, as his infamous and troubled relationship with Dmitri Shostakovich attests (see Volkov, *Shostakovich and Stalin*). But, both Moiseyev in his autobiography and Victoria Anne Hallinan in her dissertation note, "Moiseyev acknowledged Stalin's favoritism and used this to develop his ensemble. This meant cooperating with Stalin's vision of Soviet culture and the Soviet regime's use of the ensemble as propaganda [...]" ("Cold War Cultural Exchange" 80). And, Moiseyev made some dangerous and powerful enemies along the trajectory of the company's history. He acknowledges them in his autobiography, but they do not appear in the company's narrative.

Confusion in the arts reigned in the Soviet Union in the 1930s. "That was Stalin's mood as he entered 1936, for he had planned among other urgent affairs, yet another domestic campaign in culture: the eradication of 'formalism,' that is, art that was complicated and incomprehensible to the masses, and therefore useless in the construction of Soviet culture" (Volkov 92). Moiseyev navigated these dangerous waters successfully; other artists like Prokofiev and Shostakovich were less successful, never knowing when Stalin would show them his fangs, enduring charges of formalism, that is, lack of mass appeal, in their music.

At the time that The Igor Moiseyev Dance Company began to tour the Western World, Nikita Khrushchev, whose relationship to Soviet Art was more tenuous, in large part because he was not a cultured man. As regards "'Soviet culture.' He had genuine grounds for boasting; already in 1959, the USSR had one of the most extensive infrastructures for culture the world had ever seen, and it was in the midst of explosive expansion" (Roth-Ey 1). And yet, "his pride in Soviet culture, backed by real achievements, and his insecurity in the face of competition; his dead certainty about the importance of culture and fuzziness about how to define it, especially beyond the halls of the Bolshoi Theatre [...]" (Roth-Ey 1) was

the new post-Stalin context in which Moiseyev successfully parlayed his company into one of the most emblematic dance companies in the USSR and in the world. As historian Kristin Roth-Ey sums up the expansion of Soviet art and culture: "Soviet culture in the media age demonstrated both terrific strengths and crushing weaknesses. It was, on its own terms, a very successful failure" (1).

By the time of the Cultural Cold War, the Soviet Union was famous for its support of the performing arts: opera, ballet, and classical music and professional arts critics around the world recognized that the Soviet performing ensembles were dazzling in their technical skill, if aesthetically old-fashioned in their content. But the world was unprepared for The Igor Moiseyev Dance Company because no one had ever seen anything like it before. I concentrate on their first successes, especially in the country of the Soviet Union's chief rival the United States.

Igor Moiseyev can be considered as creating a unique niche within the Soviet art world by labeling his new dance genre: folk dance. "The Soviet authorities did promote something labeled 'popular' or 'folk' (*narodnaia*) culture. But though this had roots in the varied peasant cultures of the USSR, it was rapidly professionalized and canonized. What Soviet culture prided itself on was the elevation of folk cultures to high-culture status" (Roth-Ey 3, note 8). In all of his artistic pronouncements, Moiseyev stressed that all of his efforts were to professionalize and valorize folk dance. Igor Moiseyev was at the very center of that professionalization process, and he was a key figure in its development (Filanovsakaya, *Istoriia Khoreograficheskovo*). Additionally, "Soviet propaganda made much of the idea that there was no distinction between low and high or mass and elite cultures in the USSR" (Roth-Ey 3), which is why charges of formalism became so dangerous to creative artists. *Soviet Life*, one of the chief propaganda outlets, frequently featured the company in their colorful costumes. This was one of the main purposes in suppressing what they called formalism, that is, art that was not easily understood by the masses. The entire raison d'être of the arts was to serve the government and the masses. Any art that did not fit into that project was condemned.

Nevertheless, there existed a hierarchy, and in that hierarchy, classical ballet was first and foremost, and this was a legacy of the tsarist era, and certain top officials who considered themselves cultured understood the prestige accorded ballet and classical music. I think that the reason Igor Moiseyev continued with his own company to produce mass ballet scenes like the *Night on Bald Mountain* to Modest Moussoursgy's music, and the *Polovtsian Dances* to music by Alexander Borodin was to demonstrate to the world that his company and his choreographic skills were equal to that of the Bolshoi Ballet. I am sure that he was pleased that The Igor Moiseyev Dance Company was sent to the United States before the Bolshoi Ballet, as the first act in the Cultural Cold War. The unexpected success that he enjoyed on that tour in 1958 sealed his high position in the Soviet world of dance.

Igor Moiseyev himself understood that: "[Andrei] Zhdanov [then cultural commissar] did not hide [the fact], that the role of our ensemble – our part was a above all political and our role was to melt the ice between the various sides" (*Ya Vsponimaiu* 68). Nations

do not sink millions of dollars into state-supported dance companies without a political motive, and Igor Moiseyev played the role of the world's first dancing diplomat with great success. He and his company survived the fall of the Soviet Union and the company still plays the same role of dancing diplomacy in the Russian Federation. For all of the talk of the "international language of dance," The Igor Moiseyev Dance Company began and remains an important political tool, of both the former Soviet Union and its successor state, the Russian Federation.

It should be noted that most writing about the Moiseyev in English, lasting for decades as the only sources about The Igor Moiseyev Dance Company, came from the Soviet Union, and they must be used with care for they all follow the mythic narrative that I introduced at the beginning of this chapter. Filled with enthusiastic and platitudinous praise in describing audience reactions, never noting any negative responses, the Russian writers pen uncritical and simplified prose. Here is a sample: "I was whirled away too by that swift dance and the extraordinary vitality of its performers. That joyousness of theirs flashed in their smiles and their lustrous eyes. This was temperament! No doubt about it!" (Sheremetyevskaya 6). Pages of this purple prose fill these short books. In this study I will interrupt the simple, almost Disneyesque narrative of the founding and the history of the company that the Soviet writers present. Only recently has that narrative begun to be challenged with new scholarly publications (Prevots, *Dance for Export*; Shay, *Choreographic Politics*; Hallinan, "Cold War Cultural Exchange"; Kodat, *Don't Act, Just Dance*; Shay, "The Spectacularization of Soviet/ Russian Folk Dance"). "The origin story of The Igor Moiseyev Dance Company became both simplified and mythologized as the Moiseyev became better known in the Soviet Union and internationally" (Hallinan 57). For years the primary sources that promoted the simplified and mythologized origins were three publications designed to hype the company: Chudnovsky (*Folk Dance Company of the USSR*), Sheremetyevskaya (*Rediscovery of the Dance*), and Ilupina and Lutskaya (*Igor Moiseyev's Dance Company*), as well as the souvenir programs, mainly prepared by the Sol Hurok agency, that touted the same colorful, if apocryphal stories that supported a leading myth that the company began spontaneously with peasant boys and girls, who appeared in an all-union folk dance festival, and were so pleased with the results that they gathered together to create a dance company that would spread the joys of living in a socialist state. This became a sort of socialist version of the hackneyed Judy Garland/Mickey Rooney "Let's do a show." And, that Igor Moiseyev, a genius in creating mass spectacle, happened, by chance, to be there to direct made this picture even brighter. In this chapter I challenge some of the simplistic narratives of the founding and legendary first performances of The Igor Moiseyev Dance Company such as the following:

Instead it would be appropriate to recall the Company's first show. Today, it would appear terribly raw, and Igor Moiseyev himself speaks about it critically yet with touching tenderness. "It was so primitive, so crude," he says. "Most of our dancers were just naturally gifted but had had so little training. Until then they had been operating machine tools. Working in offices and on farms [...] That's exactly why I was so proud of them. I knew

that they would master the skill through hard work and great love of the dance […] There we were – only 35 of us – and we gave our first performance in October 1937. We barely managed to stage enough dances to fill the programme [sic]".

(Ilupina and Lutskaya 4)

Such a myth is partially dispelled in Shamina and Moiseyeva's history of the company, in which they state that in winter of 1936 Igor Moiseyev and his associates advertised in the leading newspaper for ballet dancers (see below), which would have hardly attracted the office workers and peasants that Moiseyev described. Igor Moiseyev had a choreographic vision, and by all accounts, including his own, he was a perfectionist. That evaluation of his character appears over and over in every observer's account of him, and one can see that in the way in which the company rehearsals are organized (see *Dancing is Pain: Captivated by Genius*). He would never have countenanced working with non-professional dancers in a physically impossible stairwell to undertake the ambitious and physically demanding choreographies that he created. This was no cinematic Judy Garland–Mickey Rooney fantasy of "Let's do a show." This was serious business and his future and that of his company were on the line and depended on his skills as a choreographer, as an artistic director, and as a rehearsal director. Soviet officials would never have accepted an amateur performance from a company that they were heavily financing. And, Stalin and many other ambitious and dangerous Soviet officials were watching.

In addition to establishing the company, there existed potential competition. In 1935, there was a well-known International Festival of National Dance in which many groups from all over the world appeared. The authorities in the Soviet Union paid particular attention to this festival and the successes garnered by the dancers and dance ensembles that they sent. Soviet dance historian Elizabeth Souritz writes about how that stimulated competition and that a Moscow-based dance company, the Island of Dance, switched their repertoire from modern and experimental to folk dance:

The Soviet delegation consisted of representatives of many republics, among them for example, famous dancers such as Tamara Khanum from Uzbekistan (see Shay 2014, 228–231), and Iliko Sukhishvili from Georgia [a founder and soloist with the Georgian State Folk Dance Ensemble]. Before this, mainly classical and so-called rhythm-plastique dances predominated in the [Island of Dance] school and theatre repertoire. Now, particular attention was paid to folk dances.

(42)

Folk dance historian Andriy Nahachewsky, too, notes the salience of the London Festival: "A year earlier, Soviet Ukrainian dancers won first prize at the International Folk Dance Festival in London in July 1935 […] The Soviet Dancers were often described as Russian" (203). This success led to the founding of the Ukrainian State Folk Dance Ensemble: "In April of 1937, two months after the formation of the State Folk Dance ensemble in Moscow

[The Moiseyev Dance Company], a Ukrainian Ensemble was founded. Its mandate was to present 'the poetic and choreographic wealth of the Ukrainian people, the rapid development of the new national socialist culture,' and to include the dances of other peoples of the USSR" (203).

The Ukrainians and the Island of Dance were not the only competition. The Red Army Chorus, which included dancers already existed and had several promoters in the upper levels of the Soviet government, some of whom regarded Igor Moiseyev with a jaundiced eye. Clearly, the Soviet authorities saw the propaganda value of such appearances, which symbolically were designed to make the Soviet Union appear as a young, athletically powerful nation to the world and to bolster feelings of Russian nationalism, which as I described in Chapter 2 was a priority of the Soviet authorities during the crucial decade of the 1930s in the development of the arts, including The Igor Moiseyev Dance Company. It would have been astounding if Moiseyev had not known about the founding of another folk dance company in Ukraine.

He certainly knew about the Red Army Chorus, which had a dance unit because he writes about it in his autobiography (*Ya Vsponimaiu* 46–47). Moiseyev also had to be aware that a few blocks away in Moscow a potentially rival company was preparing a program to capitalize on the world-wide interest in staged folk dance that resulted from the newly-minted success of staged folk dance in the Soviet Union and festivals in London. The burgeoning Island of Dance Company could also not have been a secret. He does not write about this group in his memoirs.

The first performance by the students of the program *Dances of the Soviet Peoples* was on June 17, 1937. Those who took part are still proud that their program was shown two months before the one prepared by Igor Moiseyev, which became the basis for his celebrated folk dance company. The new program was commended in the press. In general, the Island of Dance had become established in the eyes of Moscow ballet critics [...]. This new program became firmly established in the company's repertoire and was constantly performed on their tours. When World War II came and many members served in brigades at the front, they often performed these dances at army concerts.

(Souritz 48, 50)

Clearly the Island of Dance Company knew of The Igor Moiseyev Dance Company. None of Igor Moiseyev's biographers, or those who chronicled The Igor Moiseyev Dance Company's history, mention this company anywhere, and yet, according to Elizabeth Souritz, the Island of Dance Company gave hundreds of performances of their program, the *Dances of the Soviet Union*. I would find it strange that Moiseyev could have not looked upon the spectacle of a rival group that was already successfully performing professionally choreographed staged dance concerts without considerable anxiety. His company had not yet given its first performance, and the artistic climate would have been fluid until he was able to prove himself as able to deliver the professional spectacle for which the Soviet government was

providing financial support. Elizabeth Souritz notes of the Island of Dance company that "For a time the collective enjoyed great success with Dances of the Soviet Peoples" (53). I argue that a man of Igor Moiseyev's stature and professional pride would not risk appearing less professional and technically polished than any competing company by using amateur dancers. They inserted advertisements for professional ballet dancers, and I believe that Igor Moiseyev would not have deigned to work with factory workers and milkmaids with no dance training. Perhaps the other dance companies' presence helped to spur him on to the many successes the company came to enjoy. The number of awards that he won can provide another measure of Igor Moiseyev's successful career. Shamina and Moiseyeva provide a list of the scores of awards – Soviet, Russian, and international – that he received. These included, tellingly, three times he received the Stalin Prize, up until the last year of his life (424–27).

"Chance" features in many works about Moiseyev, including his autobiography. The opening chapter of *The Master of Dance* is entitled "His Majesty, Chance" (Shamina 3). This appears to be a modest "aw, shucks" tone to cover, what in fact, what was a carefully planned and executed creation of a major dance company, the culmination of years of hard work developing his new dance genre. This dance company, unlike its founding mythic narrative, had a difficult journey, covered over by the written rhetoric of the Russian sources, in which they portrayed The Igor Moiseyev Dance Company as performing success after success from the inception of the company in a never-ending trajectory of successes.

I want to stress that, after years of studying state-supported ensembles I conclude that governments do not finance such projects unless they deliver a payoff. The payoff is the creation of a colorful, traveling spectacularized folk dance festival, a political tool that makes the government/nation state in question appear to be charming, innocent, strong, and the kind of people and country that audience members would spend money to visit, and perhaps sit down to dinner with them. In addition, "The Igor Moiseyev Dance Company represented the intersection of Soviet identities – the various nationalities of the Soviet Union, their political ideologies, and ethnicities. [...] [T]he Soviet regime's use of the Moiseyev was a carefully calculated decision and formed part of a larger propagandistic goal: to convince the world that under the soviet regime, different peoples were treated with acceptance and the regime even encouraged nationalism and national cultural expression" (Hallinan 30). This was especially important in the 1950s when the United States was particularly vulnerable to charges of extreme racism that caused the United States government shame, and the Soviet propaganda machine exploited and highlighted through performances of the ethnic rainbow provided by The Igor Moiseyev Dance Company. All of this supports my argument that The Igor Moiseyev Dance Company was a very important piece in the quiver of international political strategy of the Soviet Union, particularly during the Cultural Cold War.

As I described in the first pages of *Choreographic Politics*, while watching the Ballet Folklorico of Mexico, during which they represented the region of Chiapas, then undergoing a bloody civil war, with a lilting dance featuring nine women dancing in lacey black dresses

to a waltz tempo that masked the reality of what was really occurring there. The reality was presented nightly on television with guerilla soldiers in face masks skirmishing with government troops. So, too, certain Moiseyev choreographies masked the repressive treatment of ethnic and national groups who fell afoul of the Soviet government: the Tatars, the Volga Germans, Estonians, Latvians, and Lithuanians, among others, who were exiled by the hundreds of thousands to the wilds of Siberia, to perish, and who were replaced with Russian settlers. The Soviet government relied on American ignorance of geography and history to accomplish this.

Igor Moiseyev was aware of the reorganization of folk dance activities, announced by the government in 1930, and executed in 1931, that in the Soviet Union, folk dance would form a central arena of dance representation. He was central to this activity, and participated in creating a study course for teaching the new dance genre, organizing and adjudicating amateur groups in festivals, staging physical culture teams and parades on Red Square. His next step was to receive the governmental nod to create his dance company (Filanovskaya 215–21).

The reality of the founding of The Igor Moiseyev Dance Company, garnered from Moiseyev's autobiography (*Ya Vsponimaiu*; *Ya Vsponimaiu,* updated edition) and two other recent Russian-language sources: Koptelova (*Igor' Moiseyev: Akedemik*) and Shamina and Moiseyeva (*Teatr Igoria Moiseyeva*), indicate that preparations for the undertaking of the founding of the company had already begun in 1936: "In the winter of 1936 there appeared a notice in the newspaper *Vechrenii Moskve*: *The State Ensemble of Folk Dances* announces an audition to fill vacant positions and is in need of ballet artists" (Shamina and Moiseyeva 38), which is at odds with the origination story that Moiseyev began his enterprise with individuals who had performed in an all-union folk dance festival, which means that they would have had no ballet training. Thus, there are two tales of the company's origins, and I trust the version in which the perfectionist Moiseyev hired ballet artists not kolkhoz milkmaids and tractor drivers. As Shamina and Moiseyeva observe, "At that time in Moscow there were only two organizations in which ballet artists could earn a steady salary: The Bolshoi Theatre and the Operetta Theatre" (38), otherwise, ballet artists had to appear in the various music halls and be paid at the end of a limited engagement. There is no mention of the potential rival company, the Island of Dance, named for its school and theatre location in Gorky Park in central Moscow. The appearance of Igor Moiseyev's new professional dance company that paid steady salaries and benefits was most welcome in the dance scene in Moscow, and Moiseyev had no shortage of applicants. "The Moiseyev Dance Ensemble was the first professional folk dance ensemble to pay guaranteed salaries to its members" (Shamina and Moiseyeva 38). The Island of Dance Company also paid wages, although Moiseyev may have been able to pay more and given Moiseyev's perfectionism, the Moiseyev Dance Company may have also been technically and artistically superior.

The question then arises: why then would the Soviet government support two professional dance companies. My answer to this question is that Igor Moiseyev had already

demonstrated, through the organization of folk dance festivals, choreographing physical culture demonstrations, arranging parades, and contributing to the development of a system of a new, government-approved "folk dance," which was disseminated in the government reorganization plan first announced on July 23, 1930, and then certified by Narkompros on August 31, 1931, that courses would be given in both day classes and night classes for individuals involved in the direction of amateur folk dance ensembles (Filanovskaya 215). And Igor Moiseyev created and assembled these courses. Thus, he had proved to the state his considerable talents in this field. Although not mentioned, The Island of Dance Company may also have had a powerful political figure behind the scenes, who perhaps fell out of favor.

Moiseyev understood exactly what the state wanted. The company, more than any other, became one of the most potent weapons in the Kremlin's arsenal of propaganda, because I believe that Igor Moiseyev fully understood the political strengths his choreographies exhibited and their successful reception, even among populations that were hostile to the Soviet Union.

It is difficult to believe that a man as demanding and discriminating as Igor Moiseyev would have permitted anything less than perfection from any group that he directed. Over the several times that I have seen them over a period of fifty years, I have never seen anything less than perfection in a The Igor Moiseyev Dance Company performance. On the other hand, I understand, through experience, that a dance company requires time to be "seasoned," during which they learn to work together and become an ensemble, and his comments about the first performance being "raw" and "crude" might simply have indicated that the dancers had not yet reached his high standards in their first performance. I still do not believe with all of the competition, real or potential, that existed during the period in which he was creating and establishing his company, which would be the most important legacy of his career, that he would have left anything to chance or that he would have employed factory workers and milkmaids to realize his elaborate plans. I believe that Igor Moiseyev left nothing to chance.

The Igor Moiseyev Dance Company was known officially as the Academic State Ensemble of Folk Dances of the Peoples of the USSR, and the ensemble soon numbered around 110 dancers and a theatre orchestra (Ilupina and Lutskaya 3). The term "academic" has nothing to do with the university, but rather was a prized official designation that indicated that the high technical quality of the company was such that they could tour in the West. Because of fears of defections by disgruntled ethnic minorities and potential demonstrations by ethnic diasporic populations, the Soviet government awarded very few "academic" designations to non-Russian groups (Shay, *Choreographic Politics*).

Igor Moiseyev founded a company unlike any that came before it. Unlike the ballet companies, which featured stars, backed by a corps de ballet, Moiseyev created a company with no soloists. Igor Moiseyev stated, "Soloists? I'll fire the first man who dares to call himself this word!" (Shamina 16). Almost all state-supported companies followed this model, although they sometimes credited individuals who sang or danced a solo part.

Certainly, The Igor Moiseyev Dance Company programs listed prominent and featured dancers who were specifically designated as soloists (1958, 1961, 1965, 1986, 2002).

As someone who founded a large dance ensemble, albeit without any support from the government, I can tell the reader that directing and managing such an organization requires constant attention to details. All observers of Igor Moiseyev noted that he paid attention to every detail, and he had an infallible memory and enormous stores of energy. Organizing the company requires many preparations: Choreographies must be imagined and created, dance music must be arranged and rehearsed, costumes must be designed and sewn, the dancers have to be trained, and every part must have an understudy, theatres booked, publicity prepared and distributed, budgets prepared and bookkeeping and accounting overseen, and grant writing, among many other activities. Above all, one of the most demanding tasks that faces the artistic director is to create the program, which means the order must, like a piece of well-crafted symphony, have loud and soft musical passages, and bright and pale colors and to achieve this, the director needs to know where each and every dancer is at any given moment, and how much time it takes to change the costumes. Moiseyev noted in the first program, "Some of the dancers had to change as many as nine times" (Ilupina and Lutskaya 4). Attention to detail is required. Each and every one of these activities requires hours of preparation. Moiseyev was hampered by the time that he had to give to the physical culture stagings and organizing and directing festivals, and he recounted in his diaries that he had to work from early in the morning to late at night to both rehearse the company and to prepare the physical culture members for their appearances on Red Square (see Moiseyev, *Ya Vsponimaiu*).

Josef Stalin and Igor Moiseyev

Igor Moiseyev founded his company in 1937 during what historian Peter Kenez calls the time of "High Stalinism" (103). Moiseyev shared the extreme fear and panic it caused, when he came to Stalin's attention, especially if he placed his hand on your shoulder (*Ya Vsponimaiu* 45–51). He puts the human and personal face on living under a sadistic individual and "[...] the hysteria of looking for 'enemies of the people' everywhere" (Kenez 125). "Stalin, it seems ordered the destruction of his closest comrades by a nod of the head" (Kenez 103). Stalin not only was cruel and sadistic to his own people, but also condemned millions to death through enforced famine because they resisted collectivization, which I have written about extensively elsewhere, especially focusing on Ukraine (Shay, *Ethno-Identity Dance for Sex, Fun, and Profit*). He not only killed and banished millions of people, he was also sadistic on a personal level: "Stalin's main pleasure was to humiliate and embarrass those who were closest to him. He insisted that his entourage drink themselves insensible, and no one dared to refuse [...] Members of this all-male company were often forced to dance with each other – something for which they had not greater talent than they did for statesmanship" (Kenez 175). Moiseyev confirms a similar scene, most likely in the

early 1950s with someone standing next to him (Khrapchenko) was commanded to dance, during which Moiseyev noted that his own "inclination to guard himself became even sharper" (*Ya Vspominaiu*, updated edition, 50). Clearly, Igor Moiseyev, while directing a company that could be called upon to perform at any time, successfully negotiated the dangerous shoals of Soviet life.

Moiseyev noted, "Stalin did not like people who were smarter than he was, and being smarter than him was not that difficult" (*Ya Vsponimaiu* 48). Those lines could not have been penned during the Stalin period. And yet, Stalin helped him directly, ultimately providing Moiseyev with the headquarters in Tchaikovsky Hall, the company's current residence. Moiseyev's solution to the intense danger that surrounded him, and everyone else, was to keep his head down and not expose himself more than necessary, even though his company frequently performed for Stalin and the Politburo, and was expected to attend receptions and dinners following the performances. "I often visited the Kremlin and saw Stalin […]. My instinct prompted me, from where danger approached. I never wanted to join the circle of 'the better people', attending receptions the opportunity of such appearances. Perhaps, sitting in an automobile going wherever to eat fancy food […] Heeding the old soldiers principle: 'be near the kitchen and far from the bosses' saved me from disaster" (*Ya Vspominaiu*, updated edition 48). Clearly, even though frequently in the limelight as Stalin's favorite performing ensemble, Moiseyev acted prudently, partly because he felt responsible for his dancers and felt a need to protect them.

Lyubov Vasilevna Shaporina, wife of the composer Yury Shaporin, leaves a poignant memory of those terrible times in her diary:

The nausea rises to my throat when I hear how calmly people can say it: He was shot, someone else was shot, shot, shot. The word is always in the air; it resonates through the air. People pronounce the words completely calmly, as though they were saying, 'He went to the theater.' I think that the real meaning of the word doesn't reach our consciousness – all we hear is the sound. We don't have a mental image of those people actually dying under the bullets. From her apartment, she could hear the shots indicating executions being carried out at Peter and Paul fortress.

(Quoted in Hallinan 91)

Kenez notes, "The arrests spread, ultimately involving millions of people. From a moral point of view, the elimination of the top leadership of the Party – i.e., people who themselves in the past had not shied away from the use of terror – was less reprehensible than the incarceration and killing of millions of people who were guilty of nothing […] the exact number of victims cannot be precisely established; the numbers are passionately debated among scholars" (108). Kenez concludes that in his opinion, "Approximately a million people were executed, and maybe as many as ten million were sent to camps" (108). For the contemporary reader, that time period is unimaginable in the horror of one of the most criminal regimes in human history.

Nevertheless, Moiseyev needed Stalin. He and his company had major rivals, supported by important officials: his main rival was the Red Army Ensemble, supported by Marshal Kliment Yefremovich Voroshilov, who was jealous of Moiseyev and became a dangerous enemy, since Voroshilov was known to have condemned people to death with Stalin's approval (Freeze 353), but Moiseyev was shielded by Stalin (Moiseyev, *Ya Vspominaiu* 45–47). Needless to say, this background story did not make it into the Soviet profiles of the company.

Later, in 1954, Moiseyev created a new enemy: Nikolai Bulganin, who later became Khrushchev's co-ruler, at least in name. On the company's first tour of China, the Chinese, probably because of the rapidly deteriorating political situation between the two socialist world's super powers, attempted to sabotage The Igor Moiseyev Dance Company performance. They rehearsed on a gigantic stage, which the Chinese had led them to believe was to be the performance venue. The day of the concert, in which almost all of the leaders of the "Democratic" (read Communist) world were attending, they were shown to a tiny stage, which could not hold even half of the company, and the sound of the echoing space resounded with a huge rumble. After the performance, Nikolai Bulganin came and dressed Igor Moiseyev down, even using filthy language implying Moiseyev was having sexual activities with his mother. This was an even more dangerous enemy than Voroshilov. After a two-month tour of China, all of the members of the company were questioned by a commission that Bulganin had created, but Moiseyev stated, "Not one person said anything bad about me" (*Ya Vspominaiu*, updated edition 92). Shortly after, in 1955, Bulganin attempted to prevent Moiseyev from accompanying the company to Paris on their first tour there, but the French organizers went directly to Nikita Khrushchev, demanding that Igor Moiseyev personally accompany the company, and Khrushchev replied, "If you want Moiseyev – take him" (*Ya Vspominaiu*, updated edition 94).

Moiseyev's programs were greeted rapturously by the French critical press, as well as the general Parisian public, and they played for weeks to full houses. French women began to wear ribbons, like those seen in the Ukrainian *Gopak*, and hats like those of the *Partizani*, creating a whole new fashion craze. In Moiseyev's words, Paris was a triumph. Bulganin attempted to destroy the company, wanting to fire Moiseyev and reduce the company by half. The Minister of Culture called Moiseyev into his office and revealed all of this to him, but that they would not take such an action. Moiseyev realized that "Bulganin was helpless to wreak vengeance on him after the Parisian triumph" (*Ya Vspominaiu* 96). If the French outing established his reputation, then the first tour of America in 1958 would seal it forever.

Almost from the outset, the ensemble was successful and conducting nation-wide tours. This was the new official face of Soviet folk dance. The company's first performance, according to Chudnovsky occurred in Gorsky in August 1937 in an outdoor theater (Chudnovsky 74). Since the official date is in Moscow on October 7, it would appear that Igor Moiseyev wanted to have an out-of-town trial run, much like many Broadway shows try their first performances off Broadway. Even though Moiseyev claims that the first performance "was so primitive, so crude. Most of our dancers were just naturally gifted, but had had so little training. Until then they had been operating machine tools, working in offices and on farms […]" (Ilupina and Lutskaya 5), I am more inclined to believe the account in Chudnovsky

"The company gave its opening performance in August 1937 at the open-air Green Theatre in Moscow. The programmed included *Polyanka,* a Russian quadrille, Ukrainian *Metelitsa, Kryzhachok,* a comical Byelorussian dance, *Khorumi,* a martial Georgian dance, and the whirling *Moldovensyaska.* At its very first performance the company swept the audience off its feet" (19). Many of these same dances appeared in the first two tours of the United States (The Igor Moiseyev Dance Company. Programs, 1958, 1961).

At first the company began to appear throughout the Soviet Union. "The dancers visited Central Asia, the Caucasus, the capitals as well as the small towns of many distant republics, even performing in far-away mountain settlements" (Chudnovsky 77). After the onset of World War II, they were in great demand to provide entertainment for the troops and the working population' in factories. They performed on ships, makeshift stages, factories, town squares, and mines. These performances brought them popularity and good will.

The Igor Moiseyev Dance Company during World War II

As with the United States, in the Soviet Union also World War II produced "the greatest generation" who fought for altruistic reasons and deep-seated patriotism. Russia faced Germany with incredible bravery and grit. Known as the Great Patriotic War, in the several visits that I have made to the former Soviet Union, and more recently, the Russian Federation, one can still see a few older men wearing medals they received in the Great Patriotic War with pride. Many individuals remember the period, in spite of suffering never felt by Americans outside of the battlefront, as a time of happiness and freedom. It was also a break from Stalinism, when Soviet nationality groups fought for their own Motherland – Russia, Ukraine, Finland – but not the Soviet Union, and sometimes against the Russians and the Soviets.

Igor Moiseyev remembers in his memoires how they had to scramble to escape Moscow when the Germans attacked the Soviet Union in a surprise blitzkrieg in June of 1942. Keeping the company together was crucial to its survival, and could not have happened without his strong leadership. World War II destroyed the Island of Dance Company because the sudden German attack dispersed the company members.

During the World War II they toured the Far East, centered in Vladivostok, but also they spent several weeks on a ship, entertained the Soviet troops, and factory workers who had been relocated in the east and worked double shifts to support the war effort. In 1942 they performed over seventy concerts in Mongolia, their first trip outside of the Soviet Union, and notably Mongolia was firmly under their political thumb.

Americans are familiar with how such stars as Bob Hope toured war zones to entertain American troops. What many individuals do not know is that Soviet, and especially Russian, artists gave overwhelming numbers of performances, during the War, under much more dangerous conditions. Unlike America, in the Soviet Union, poetry and folk music and dance were among the most popular forms of entertainment: "there were no poetry readers or folk ensembles in the American armed forces entertainment network" (Stites,

"Frontline Entertainment" 129). But in the Soviet Union, folk dance, especially Russian folk dance and music was extremely popular: "the giant Red Army ensemble split itself into four detachments and went off to different sectors. Half of their 1,500 concerts were given at the front" (Stites, "Frontline Entertainment" 132). Like many individuals during wartime Russia, members of The Igor Moiseyev Dance Company expressed their enthusiasm for performing to keep up the morale of the troops and those who labored to support them working twelve-hour shifts in munitions factories.

The Igor Moiseyev Dance Company was among the most popular ensembles in the war effort. "Performances were held on all points of the compass: Vladivostok, a monastery in the Carpathian Mountains, Murmansk, Northern Norway, the polar seas, the Black and Baltic Seas – and hundreds of points between" (Stites, "Frontline Entertainment" 128). Members of the Moiseyev remember riding on donkeys through mountain passes and dancing on board ships, anywhere they were requested to provide entertainment to the fighters. They also remained popular after the War: "In wartime, these ensembles were sent to the front; and by 1944 the folk revival had erupted into a major cultural wave of festivals in Moscow, recently liberated Leningrad, Rostov, Gorky, Sverdlov, and Saratov; at the last concert nine hundred singers from thirteen choirs joined forces. The most popular folksinger of the era, Lidiia Ruslanova, was among the most wanted entertainers in the frontline brigades. Military units with no access to the mobile brigades put on their own amateur folk productions" (Stites, "Frontline Entertainment" 132). The Igor Moiseyev Dance Company was poised for its next big step: diplomacy.

Igor Moiseyev recalled that after World War II, as they toured Rumania, "The de facto master of Rumania was General Susaikov. He frequently mentioned our concerts and said how much our concerts helped the army" (*Ya Vspominaiu* 71). While they were in Rumania, "General Susaikov arranged our travel on our Eastern European tour with a train of five or six trains in gratitude" (*Ya Vspominaiu* 71).

"The Moiseyev dancers spent 18 months at the fronts, traveling from one sector to another. They went to the Urals and Siberia and there performed to wounded men at army hospitals. The company spent four and a half months with the Pacific Fleet, giving over 130 performances" (Chudnovsky 78). This account closely follows Igor Moiseyev's autobiographical accounts (*Ya Vspominaiu*). Through these performances, The Igor Moiseyev Dance Company built up a large amount of good will and popularity for its performances. "And finally after their many wanderings the dancers returned to Moscow to set to work on new programmes" (Chudnovsky 78). Moiseyev notes that after the hardships of the war period "Moscow was for us some kind of Mecca" (*Ya Vspominaiu* 65).

Folk Dancing for the State – The Cold War

After World War II the USSR had new national priorities for The Igor Moiseyev Dance Company besides valorizing Russian identity. The former Soviet Union scored political points in the newly liberated former colonies, now emerging after World War II and subsequent wars for

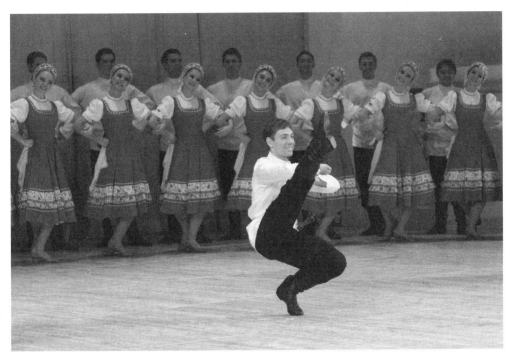

Figure 4: A Scene from *Leto (Summer).*

independence, as independent states of Asia and Africa. Moiseyev's choreographic strategies of representation, in which the dances of the Asian and Muslim populations who were part of the former Soviet Union were featured alongside the Russian dances, made a huge political impact.

This programmatic strategy also served to highlight the intense racism that characterized the United States at that period and that became an increasing embarrassment to the diplomatic efforts of the United States. "Within the United States, there was a growing realization among those concerned with international relations that Jim Crow not only was analogous to Nazi treatment of the Jews and thus morally indefensible but was also contrary to the national interest" (Fredrickson 129). This was true especially in the 1950s and 1960s, the period of the height of success of the Moiseyev Company's most visible touring period in the developing world. The Igor Moiseyev Dance Company became an important weapon in the Soviet government's Cultural Cold War arsenal.

It is difficult to grasp intellectually, but dance historian Lynn Garafola, in her meticulously researched history, *Diaghilev's Ballets Russes*, the term "choreographer" was not in general use until after World War I: "By June 1919 no less a bastion of linguistic conservatism than *The Times* was employing the neologism between inverted commas. Five months late the commas disappeared, and Massine's title was further Anglicized as 'choreographer' Usage, in this case, was more than a linguistic fashion. It implied a new way of looking at dance, an

awareness of movement as design" (337). This is important because Igor Moiseyev had begun his ballet training at this time, and so he was the first generation to look at choreography as a separate art.

Socialist Realism

It is also important to note that Igor Moiseyev, like all Soviet choreographers, labored under a type of artistic duress: state-sponsored socialist realism. "On October 26, 1932, another significant event reportedly occurred in the apartment of Maxim Gorky. There Joseph Stalin coined of the most artistically lethal terms of all times 'social realism'" (Swift 92). Socialist realism meant "realistic" art that must deliberately aid in the victory of communism. We can only imagine what kinds of choreographies Igor Moiseyev might have produced without the restraints of conforming to socialist realism. Choreographers and musicians disappeared in the Big Terror under Stalin. As Swift notes, "Actually, in Russia, the birthplace of Stravinsky and Prokofiev, the musical clock was turned back to the nineteenth-century romanticism of Tchaikovsky" (93). Reading what happened to Dmitri Shostakovich when his musical compositions displeased Stalin is still chilling.

Moiseyev worried when Stalin came to call, according to his memoirs. However, his choreographies did reflect the constraints because, in Swift's terms, he "portrayed Soviet life in optimistic manner, showing 'positive heroes'" (93). This is underscored in one of the official biographies of the company in which the authors note that many of Moiseyev's choreographies "are perceived as broad optimistic canvases" (Ilupina and Lutskaya 12). Because as Swift noted, no art in the former Soviet Union was exempt from this aesthetic straitjacket.

Moiseyev's work firmly falls into the category of socialist realism because social realism has nothing to do with real, but rather, it portrays life as it should be if everything was as good as it can be, what it might or can be. So, Moiseyev's work embodies that description of socialist realism: "Folk art, whatever its form, is always on the side of good, always wholesome and optimistic" (Chudnovsky 23). Little wonder that The Igor Moiseyev Dance Company became so popular with the Soviet establishment. The belief that folk dance resided in the rural populations, established by Enlightenment thinker Johann Gottfried von Herder (1744–1803), launched the field of folklore.

Dancers and Rehearsals

One of the first steps that Igor Moiseyev took upon their return to Moscow, in the closing years of World War II, was to found a school for training dancers specifically for his new dance genre, "to spread and develop our system of dance" (*Ya Vspominaiu* 66). In many ways this was the culmination of the educational program in his new folk dance genre that he had worked on for many years (Filanovskaya 219). Prior to that time, they took in many dancers from schools like that of the Bolshoi Ballet. Having their own school, which

Figure 5: Elena Shcherbakova, the current artistic director of the Igor Moiseyev Dance Company, with Igor Moiseyev, who personally chose her as his successor.

Moiseyev opened in 1943 permitted the company to fill in their ranks with young dancers ready to perform The Igor Moiseyev Dance Company repertoire. The current artistic director Elena Shcherbakova told me "95% of the dancers come from that school, which has a five-year curriculum" (personal interview, June 2, 2016). Moiseyev notes that "after the founding of the school, we never had problems filling the ranks of our company" (*Ya Vspominaiu* 67). Opening the school had been one of his fondest dreams. Also, The Igor Moiseyev Dance Company graduates would be capable of becoming members of Beryozka, an all-female dance company, or the dance unit of the Pyatnitsky Russian Choir.

Clearly The Igor Moiseyev Dance Company hit the ground running once their first appearance in October of 1937. They gave hundreds of appearances. "Its fifth anniversary the company marked by giving its 1,000 performance" (*Ya Vspominaiu* 67). That is a huge schedule for any company because they gave at least 200 performances a year.

Ilupina and Lutskaya state, "Every rehearsal is a happy occasion. And the nearer the work is to completion, the more pronounced is the holiday spirit" (14). I find this cheery appraisal of a Moiseyev rehearsal a propagandistic overreach much in the old Soviet style. One perusal of a Moiseyev rehearsal, such as the documentary made on Russian television (*Dancing is Pain: Captivated by Genius*, YouTube), the viewer quickly understands that a

Moiseyev rehearsal can be brutal. Moiseyev's choreographies are so physically demanding that dancers can be injured at worst, and exhausted at best. In the documentary, the viewer follows the professional lives of two dancers, who are currently in the company, one of whom was seriously injured during a performance. I attended several rehearsals and witnessed how tightly and strictly they are run. One can frequently hear: "Stop!, Stop!, Stop!" (literally the English world pronounced with a long "o"), as the rehearsal director corrects some aspect of the movement, and then repeating it. The dancers constantly watch themselves in the mirrors, as Igor Moiseyev's photograph looks down on the proceedings. The various rehearsal directors demonstrate throughout how demanding they can be as they carry out, almost reverently, Moiseyev's demands for perfection in the performance of his difficult to execute choreographies that test the dancers' physical limits. In his autobiography, Moiseyev writes about the rehearsal process. Many dancers love the hard work of rehearsing and the physical catharsis it provides, and prefer rehearsals to performances, as some of my dancers expressed it. Perhaps Igor Moiseyev is among them. In his autobiography he writes that one of the reasons he enjoyed working with Sol Hurok, the famous impresario that brought The Igor Moiseyev Dance Company to America on its first tours, was that Hurok always ensured that Moiseyev had enough rehearsal time (*Ya Vsponimaiu* 135–37).

The dancers begin the rehearsals with ballet exercises at the barre, and as they warm up, they execute demanding jumps and turns, before turning to rehearse specific portions of choreographies that the rehearsal directors deem need to be cleaned up, and then running through complete numbers. Igor Moiseyev stated, "Whenever any artist would tell me that they could not perform that last movement, I would get up and do it" (*Ya Vsponimaiu*, updated edition, caption for illustration 35). Many photographs show him executing certain movements, especially in rehearsal settings, even at the age of 90 (*Ya Vsponimaiu*, updated edition, figure 84).

The list of Igor Moiseyev's choreographies, created over his sixty-year choreographic career, found in the appendix of his autobiography (*Ya Vsponimaiu*, updated edition), lists 224 works. I need to explain too that when one is the director, and particularly the choreographer of a dance company that performs frequently, and maintains a high level of performance, the number of choreographies in the repertoire at any moment in time is relatively few. This is because the need to create new works, which require an immense amount of time with the dancers, must be balanced against the need to rehearse the current repertoire, and will be performed in the near future, which also puts demands on time.

The Igor Moiseyev Dance Company was, most likely, the first company to consist of nearly all group numbers, and few solos. Elena Shcherbakova, Moiseyev's successor, who appears in the documentary *Dancing is Pain* reinforces this several times during the course of the film, accusing one of the dancers of wanting to stand out. The young man in question during an interview was asked if he had a desire to be a soloist. He replied that he had thought about moving to a company where he could perform as a soloist, but he ultimately decided to remain in the company because "it was the best" and he believed Moiseyev's works to be the best, the work of a genius. The motto of the company: "'In company means together.'"

'Everyone does everything!' – from the first days of the Company's existence Moiseyev used to range the dancers in [a] circle and learn the motions with them" (Shamina 18). This makes sense, because that practice ensures that there is no hierarchy and that there are several understudies in case of an accident or illness.

Touring

Moiseyev's autobiography provides a full list of The Igor Moiseyev Dance Company's international touring history for the interested reader (*Ya Vsponimaiu* 213; also in Shamina and Moiseyeva 420–23). Rather, I am interested in tracing the highlights of the touring, especially the first tour of the United States in 1958, which was pivotal in establishing the unspoken rules of how the Cultural Cold War would be carried out. The company's appearances created political changes and diplomatic challenges, as in their first tours of Western Europe and the United States, or resulted in the founding of new companies in the wake of their performances, especially after their appearances in the several Youth Festivals that occurred after the Second World War and their spectacular appearance in the Brussels World Fair of 1958, rather than cataloging their extensive touring program, which can be found in the autobiography. While audiences greeted Moiseyev enthusiastically in subsequent tours, it was the first tour that caused choreographic and diplomatic shock and awe.

The Igor Moiseyev Dance Company began its touring in concentric circles, marked by focusing on the homeland during the war of World War II, and after the war, political considerations, such as the Soviet occupation of much of Eastern Europe, dictated where they toured outside of the Soviet Union for the first decade after the war. The company first traveled widely in the Soviet Union, especially Russia and Ukraine, almost immediately after giving its first concerts in Moscow and Leningrad, which were important because it was necessary to establish a reputation with the social, political, and intellectual elite of Soviet Union. In 1943, they returned to a newly liberated Moscow to rehearse and develop their repertoire and begin their training school, so that Moiseyev was able "to spread and develop our system of dance […] after which we had no problem filling the ranks with properly trained dancers" (*Ya Vsponimaiu* 66). The school still operates today. All of this could not have been easy, given the widespread destruction and hunger that stalked postwar Soviet Union, which had over twenty seven million casualties during the war.

Right after World War II, in 1945, the company toured Finland, a nation with which the Soviet Union had a tense relationship because of an early war, before the Germans invaded the Soviet Union. The Finns managed to keep their independence, keeping the Red Army at bay and inflicting massive casualties on it. However, recognizing their relative sizes, the Finns, in exchange for their independence, maintained a strict neutrality with the Soviet Union, while aligning economically with the West. By sending the Moiseyev Company, the Soviet Union was sending a subtle message that they would keep their part of the bargain. Moiseyev expressed his satisfaction that the tour of Finland was "a success" (*Ya Vsponimaiu* 68).

Later that year, the company toured the satellite states of Rumania, Bulgaria, and Czechoslovakia, spending several months in each country. The following year, the company toured other satellite states, Hungary, Yugoslavia, and Poland, shortly after which all of these states founded companies, based on, with national differences, often with choral units, the model of The Igor Moiseyev Dance Company. In Hungary, the famous composers and folk song gatherers, Bela Bartok and Zalton Kodaly, arranged the Hungarian State Dance Ensemble's choral and orchestral music. Over the next decade, the company paid visits to these same countries as well as China and East Germany, and eventually covering the entire communist-held world. These visits also enabled Moiseyev to learn dances to add to the repertoire. It was always a successful strategy to perform one or two dances of each country the company visited. This was a practice that became a feature of their presentations. In addition, they performed at the famous youth festivals that were held all over the Eastern Bloc, beginning in Moscow and Prague.

Everywhere in his autobiography, Moiseyev talks of their enormous successes. In Czechoslovakia, for instance, he writes, "After out last number, *Gopak*, a virtuosic dance, the public applauded for ten minutes. After our third encore, I signaled to turn off the lights, but the public sat in the dark applauding us. Finally, they turned on the lights hoping that the audience would leave. The public was disappointed, but we were so tired that we could barely make it back to our hotel" (*Ya Vsponimaiu* 73). Lest the reader suspects hyperbole, one must take into account a number of factors: (1) The company was brilliant and unique, there had never in dance history been a company like The Igor Moiseyev Dance Company. (2) Eastern Europe was in shambles and occupied by Soviet forces so clapping for the Russian company was diplomatically correct behavior. (3) During the war, people were deprived of high quality entertainment, and The Igor Moiseyev Dance Company provided first rate entertainment. (4) When they came to the United States, a potentially unfriendly reception could have awaited them, but instead the audiences were in raptures, as were virtually all of the newspaper reviews. Quite simply, The Igor Moiseyev Dance Company was unique, sensationally spectacular. The world had never witnessed such precision dancing. I am willing to take Moiseyev's word that the company conquered (his word) their audiences and commanded stages throughout the world. They traveled in those first tours under difficult conditions and had to rely on their gate receipts for their upkeep, but they received help from individuals like General Susaikov, and as diplomatic tools, they received official banquets such as the one hosted by Marshall Tito in Belgrade. "After our concert [in Prague], President Benesh [of Czechoslovakia] greeted us and said: 'we thank our Soviet artists for that, which they have brought us, their culture, which demonstrates that [culture] is no less powerful than weapons'" (Moiseyev, *Ya Vsponimaiu* 73).

However, because they were Russians, ethnically, they were not always loved and adored. Right after the war, with Warsaw nearly in ruins, The Igor Moiseyev Dance Company participated in part of a joint Polish–Russian concert. The first part of the concert had alternating Russian and Polish classical musicians and dancers, and it was arranged that The Igor Moiseyev Dance Company would take up the second half of the program. The Polish audience, largely deputies to the newly formed Polish government, cheered enthusiastically, demanding encores for the Polish musicians, but they sat silent through the Russian artists.

The Russian ambassador to Poland begged Moiseyev to save the evening from a diplomatic disaster. Moiseyev had planned to open the second half with a Russian Suite, but quickly notified the dancers and orchestra to change costumes and perform a Polish *krakowiak*. That melted the ice, and the rest of their program was greeted with enthusiasm. Throughout the tour, the Poles showed hostility. In Wroclaw they found bits of glass in their food and drink injuring some of the company members, and several dancers were sickened with poisoned sour cream. One member died of poisoned vodka. They buried him the next day, "like a soldier" (Moiseyev, *Ya Vsponimaiu* 80). That evening during the concert in a slow part with sad music, "the girls were in tears" (Moiseyev, *Ya Vsponimaiu* 80).

Indeed, The Igor Moiseyev Dance Company served the Soviet Union for sixty years as a primary political tool. They were about to prove that political value in their participation in the Cultural Cold War. In 1955, The Igor Moiseyev Dance Company made its first foray to the West, with a series of enormously successful appearances in France and Great Britain. They appeared, ironically at the Théâtre de la Châtalet in Paris, where over fifty years earlier, Moiseyev's mother had worked as a seamstress when she met Moiseyev's father at a lunch counter. These performances were like warm-ups for the main act: The Igor Moiseyev Dance Company's first appearance in the United States in 1958.

Moiseyev in America

From the very outset of their tour in 1958, The Igor Moiseyev Dance Company scored critical success. In his description of the first tour, Moiseyev termed it "Conquering America" (*pokoreniye Ameriki*) (*Ya Vsponimaiu*, updated edition). If anything, The Igor Moiseyev Dance Company were even more successful in the United States than they had been in France and Great Britain. "While it was not formed specifically to 'target' the United States, the Moiseyev's selection by the Soviets as the first group of cultural representatives sent to the United States was carefully planned" (Hallinan 18). Again, the narrative of chance is undermined by the evidence that Igor Moiseyev, the impresario Sol Hurok, and the Soviet government carefully planned every aspect of this first performance of the Cultural Cold War. I suggest that while the tour to Western Europe was important, the role of the United States as the major power confronting the Soviet Union, the visit to their main foe was crucial.

Historian Victoria Anne Hallinan makes a crucial observation about the importance of The Igor Moiseyev Dance Company's impact on the American political and social scene:

The American reaction to the Moiseyev Company complicates the Cold War narrative of unremitting conflict between the US and the USSR and establishes that this narrative was more complex [...] More specifically Americans – even if they held certain beliefs about the incompatibility of the American and Soviet ideals – felt the Moiseyev tours revealed Soviet citizens to be likeable, genuine people who were actually quite similar to Americans in terms of their hopes, dreams and interactions with others.

(14)

The Cold War warriors, under the simplistic notion that the Cold War consisted in stopping the spread of communism by any means, were shocked by the effect created by The Igor Moiseyev Dance Company. They were caught flat-footed by the company's appearances, and the rapt attention, which the American media and the public gave it. I can almost see in my mind how the American State Department officials reacted to the news that the first Soviet offering was to be a folk dance company. They must have felt relieved. How dangerous could folk dance be?

America had to begin to fight the Cultural Cold War with inadequate tools. One of the major themes that the State Department had to fight was the widespread notion that Americans were uncouth materialists with little culture, and indeed, in comparison with France and Great Britain with their state-supported opera, ballet, and theater, America was basically an artistic wasteland except for New York and San Francisco. Outside of those centers, public support for the arts did not exist. The situation is hardly better today. To this day Los Angeles does not have a professional ballet company, and, as I can attest, financial support for dance does not exist.

A second issue that America had to combat was being famous for the intense racism that was so wide-spread, and the southerners wanted to protect their right to stage spectacularized lynchings and torture. Their cruelty would finally be exposed throughout the 1960s in the nightly television programs showing the violence in Birmingham, Alabama, which forever changed America. But, in 1958, the Soviets in their propaganda could accurately depict America as a deeply divided country, which they did to great effect in the undeveloped world. However, as I demonstrated in *Choreographic Politics*, state-supported dance ensembles frequently masked unpleasant realities with bright and happy choreographies. As Hallinan reminds us, "[…] Stalin ordered the resettlement of all Tatars to Uzbekistan to be carried out by the NKVD. Even as this persecution occurred, the Moiseyev dancers performed the *Dance of the Tatars from Kazan*. With smiling faces, the dancers utilized humor and acrobatics to depict two young women playing a trick on two young men, an image of stark contrast to the reality of the Tatars' situation" (51).

By contrast, Soviet officials knew that they had landed a powerful blow with this powerful political weapon. The performances of The Igor Moiseyev Dance Company had successfully humanized the Soviet Union – a huge diplomatic success. These performances, depicting a multicultural Soviet Union, played with great effect in the underdeveloped world. Let the Games Begin!

The Repertoire of The Igor Moiseyev Dance Company

Igor Moiseyev lists the various dances in his repertoire, which number over 200, as an appendix to his autobiography (*Ya Vsponimaiu*; *Ya Vsponimaiu*, updated edition 210–19), followed by a list of annual tours outside of the Soviet Union from 1942 to 2000 (*Ya Vsponimaiu*, updated edition 220–22), which can prove interesting for the interested reader. It is interesting as well as revealing that the list begins with Russian works. Even at

the age of 21 in 1958, as I was becoming more fully aware of the phenomenon of ethnicity, especially in Eastern Europe and the Middle East, I realized that nearly half of the dances in the Moiseyev program were Russian. As I looked at the list of dances that he had choreographed over his long career, I counted 61 dances that were listed under both "Russian Dances" and the "Cycle: Pictures of the Past," as well as another 25 dances under "Cycle of Soviet Pictures," which, except for *Partizani, Futbal,* and *A Day on Board the Ship* were not often seen during the ten tours that the Moiseyev made in the United States.

In the earliest period of the company, Igor Moiseyev built up a repertoire to represent the various peoples of the Soviet Union. Upon a perusal of the souvenir programs over the ten years, several things strike the viewer. First, in the first two programs, there were always several Russian dances, a Belorussian dance, a Ukrainian dance, often the finale being the *Gopak,* a Moldavian Suite, and one Baltic republic (Estonia, Latvia, or Lithuania), a dance from one of the Caucasian republics (Armenia, Azerbaijan, or Georgia), a dance from one of the Central Asian republics, usually Uzbekistan, and finally two or three dances from the Siberian or Eastern Russian peoples (Kalmyks, Buryat-Mongolians, Marii, Chuvash, Yakut). Not unsurprisingly, the European republics had the most dances in the Moiseyev repertoire (Belorussia 6, Ukraine 10, Moldavia 15).

As the company began to tour, Igor Moiseyev made the diplomatic stroke of performing dances of the nations that The Igor Moiseyev Dance Company would tour. So, when the company toured China they performed the famous Chinese ribbon dance that Mao Zedong very much admired (*Ya Vsponimaiu* 86).

As their touring expanded, the Moiseyev Company added dances from all over the world. These are among some of the most striking numbers the ensemble performed, especially the *jota aragonesa* from Spain and the Argentinian gaucho dance, *Malambo,* which were regularly included in later tours. These two numbers were in the program I saw in Moscow in June 2016.

I remember being among recreational folk dancers on the first Moiseyev tour, and after refreshments, we danced the *Virginia Reel* with them several times. It appeared as an encore in subsequent tours. American audiences were enraptured, and clearly felt honored by the gesture, by clapping in time to the music as the company went through the movements of the familiar dance. I can only imagine that the response to The Igor Moiseyev Dance Company in the nations whose dances they performed were equally as rapturous. It was a dramatic and effective diplomatic move.

I think it was important to Igor Moiseyev to demonstrate his company's technical strengths by creating ballet choreographies. He created the *Polovtsian Dances* (music by Alexander Borodin), and *Night on Bald Mountain* (music by Modest Moussogsky). "It is because this company has shown itself capable of taking over and developing the folk-dance heritage of the many nationalities inhabiting the USSR Moreover it has steeped itself in Russian artistic traditions, particularly those of Russian and Soviet ballet" (Chudnovsky 6). An additional work that demonstrated the company's balletic skill was *Road to the Dance,* which opened with a mock rehearsal at the barre, and showing the athleticism of

the dancers in increasingly virtuosic movements. Since he was more or less forced out of the Bolshoi Ballet, I think he felt the need to prove his company's technical capacity.

Moiseyev in the World

The effect of Moiseyev's performances outside of the USSR after the Second World War was electrifying and immediate. Following the war, as the Soviet Union was consolidating its political and military hold on Eastern Europe, the Soviet government held a series of Youth Festivals, first in Moscow, and then in Prague, Warsaw, and other Eastern European capitals. Moiseyev participated, directed, organized, and served as an adjudicator in these Youth Festivals. Among other activities, such as athletic events, dance took pride of place. The Igor Moiseyev Dance Company was a staple of these events, and always took first prize in the dance contests, much as the Emperor Nero always won the first prize in music festivals in Ancient Greece and Rome two thousand years before – and for the same reason (see Sremac, "Folklorni Ples u Hrvata od Izvora do Pozornice").

The USSR directed each of its republics, autonomous areas, and the satellite states to found "folk dance" companies, and, of course, the model was The Igor Moiseyev Dance Company. Some of the companies, like the Polish State Folk Dance Ensemble, Mazowsze, slavishly copied the Moiseyev movement style, altering Polish folk dance to fit the character dance tradition, although their costumes were more authentic, and they added a chorus to sing syrupy sweet Polish "folk" songs to accompany the dancing; nevertheless, the result is a nearly Moiseyev look-alike company.

A few companies, like Lado of Croatia, Slask of Poland, and the Dora Stratou Dance Theatre of Greece, firmly and consciously resisted the spectacularizing gesture of Moiseyev, and chose instead to emphasize the maximum authentic elements of movement, costume, and music in their performances. But overwhelmingly, the majority of the dozens of companies that formed following World War II utilized many of the spectacularizing elements that Moiseyev had created to show off their respective ethnic groups and nation states in as spectacular way as possible, as David M. Guss so effectively describes and analyzes. From Ballet Folklorico de Mexico to the Bayanihan Dance Company of the Philippines, from the Turkish State Folk Dance Ensemble to the Mahmoud Reda Company of Egypt, from the Caracalla Dance Company of Lebanon to the Cuban National Company, and ultimately, Riverdance, the Moiseyev spectacular touch and his new "folkdance" genre, his invented tradition that dominated concert stages throughout the second half of the twentieth century, was felt around the world as millions of viewers in the twentieth century experienced "folk dance" exclusively in this format.

The much-decorated and venerated Igor Alexandrovich Moiseyev passed away in 2007 at the ripe old age of 101.

Chapter 6

Moiseyev's Movement Vocabulary and Choreographic Strategies

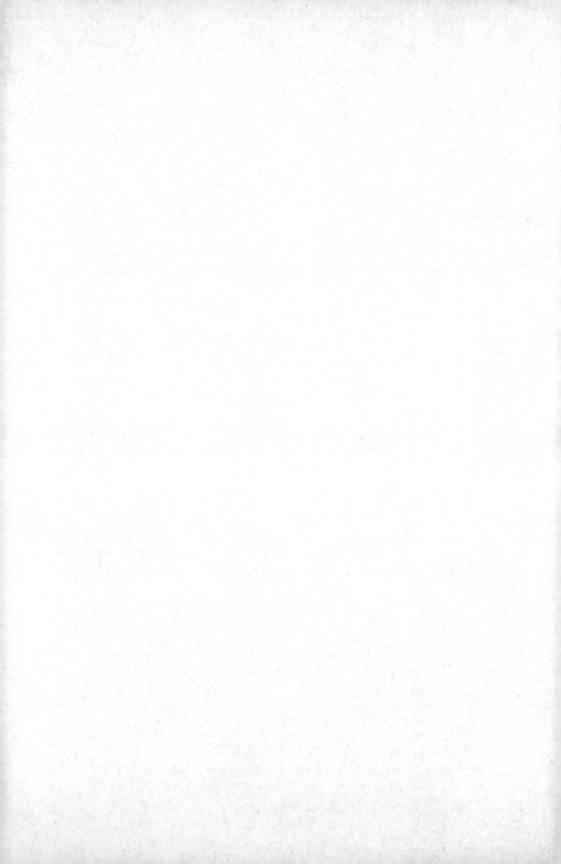

For purposes of this chapter, I watched numerous live concerts of The Igor Moiseyev Dance Company beginning in 1958, in Los Angeles, Brussels, and Moscow. I have not only viewed them in person over fifteen times, but I have studied their numerous videos, multiple times (see Videolog). In addition, I belonged to a folk dance group, the Gandy Dancers of Los Angeles, which had access to a black-and-white film, *The Nation Dances*, which Moiseyev made in the 1940s and was made available to us by the Soviet Consulate in San Francisco. At the time, we did not know that this was a professional dance company, in fact, the State Academic Ensemble of the Folk Dances of the Peoples of the Soviet Union, known in the West as The Igor Moiseyev Dance Company. The members of the Gandy Dancers studied those films and exactly copied the choreographies, step by step, and figure by figure, thinking that these were authentic folk dances, and so I learned and performed several of the dances from that film. We performed several of the Moiseyev choreographies for the annual festivals of the California Folk Dance Federation as well as events like Irwin Parnes's International Folk Dance Festival held in the old Philharmonic Auditorium in Los Angeles (see Shay, *Choreographing Identities* 179–86).

In addition, a colleague, Robin Evanchuk, received permission to stage *The Old City Quadrilles*, and she subsequently taught them to the AMAN Folk Ensemble that I directed (1960–77). I performed that dance countless times on the stage. So, my body is familiar with Moiseyev's movement vocabulary and several of his choreographies through both practice and observation. In many important ways, this is an embodied study. My last in-person viewing of The Igor Moiseyev Dance Company occurred in May–June 2016 when I attended rehearsals and a gala concert in Moscow in the Tchaikovsky Concert Hall, the company's home performance base, in which are also located their rehearsal hall, administrative offices, and wardrobe. Interestingly, the company appeared as fresh and spontaneous as I remembered them in concerts, which I had seen several times since 1958.

These dances were actually somewhat beyond the technical capacities of the Gandy Dancers because the Moiseyev dancers were professionally trained dancers, with superior ballet and gymnastic capabilities, who rehearsed for many hours a day, and performed numerous concerts around the world adding up to many monthly performances as they toured. The Gandy Dancers, on the other hand, worked on a dance for at most two hours a week, and some of the choreographic challenges were so great that at least one of the dancers ended up with broken bones. We generally never performed a dance more than two or three times in a year; this was a decade before the era of the founding of American-based professional-level folk dance companies like the AMAN Folk Ensemble and the AVAZ

International Dance Theatre in the early 1960s, and we only prepared one dance a year for performance. We called these prepared dances "exhibitions."

We had no idea, or at least I did not, what actual Russian folk dances looked like. The best multiple examples that I found many years later were on the DVD: JVC: *World Music and Dance*. The entire videotape covers a wide variety of Russian folk music and dance. Largely consisting of improvised movement, Russian dance in the field stands in stark contrast to the Moiseyev movement vocabulary. In addition, I looked at bibliographic sources and descriptions such as Tkachenko (*Narodny Tanets*), Zemtsovsky ("Russia"), and Uralskaya ("Russia: Traditional Dance"), in order to describe the various sources that Igor Moiseyev refers to when he choreographed Russian dance. While these latter sources contain useful information, they were produced in the former Soviet Union and remain problematic for careful scholarship in describing folklore (see Zemtsovsky and Kunanbaeva, "Communism and Folklore").

Before I turn to describe Russian folk dance, I want to clarify that the term "folk dance" is problematic; the very term is oversaturated with too many meanings. This term is used by most people to label everything from simple village dances, which form an organic part of those villagers' lives, to the most sophisticated production of The Igor Moiseyev Dance Company, and even to blockbuster dance productions like the Irish *Riverdance* and the Turkish *Anadolu Ateşi* (Anatolian Fire), which I stress are very distant from actual regional folk dances. "The Igor Moiseyev Dance Company insisted that their dances were authentic representations of national folk dances and that each dance did, in fact, represent the nature and character of a specific nationality. This rhetoric is problematic considering how much the dance itself, its costumes and its performers differed from the original dance [...]" (Hallinan 12–13). As the reader will later find, when Igor Moiseyev uses this term for his own work, he is using what I call ethno-identity dance: dance that is prepared for public performances on a stage or other performance venue that has ethnic references, but is not Russian folk dance found in the field (see Shay, "The Spectacularization of Soviet/Russian Folk Dance"). I am suggesting in this study that Igor Moiseyev created a new, technically demanding dance genre that the Soviet state, for political purposes, labeled as folk dance. It is an original genre created from a number of various elements: ballet, character dance, gymnastics, folk dance steps altered for the stage, and other choreographic bits and pieces. Moiseyev also created new forms of mass movement, added gravity-defying athletic elements, especially for the men, political and bucolic scenes, and totally new dances, like *bulba*, that came from his imagination. Some of his choreographies have political and social commentary, none of which exists in Russian, Ukrainian, or other folk dance genres. His new dance genre is much lower to the ground than ballet character dance, and it is performed in boots, character shoes, and other footwear. Elena Shcherbakova, current artistic director, handpicked by Igor Moiseyev to succeed him, supports my argument, insisting that what Moiseyev created is a new dance genre (personal interview, June 2, 2017). In viewing Moiseyev performances most professional dance watchers, such as dance critics, understood that they were not

watching authentic folk dance transferred to the stage, but the general public mostly thought they were seeing authentic folk dance, because it was the "official" state dance ensemble.

Character Dance

Character dance, also known as national dance, is an important, primary element in Moiseyev's new dance genre, which also includes elements from folk dance, ballet, and a huge overlay of athletics and gymnastics. But it was also an important part of classical ballet. Moiseyev learned character dance as part of his Bolshoi ballet training, and, in fact, he excelled in character dance (Moiseyev, *Ya Vsponimaiu*; Shamina and Moiseyeva, *Teatr Igoria Moiseyeva*). I suggest that his ballet education informed many of his choices as he created his new dance genre.

I want to turn to, and engage with, one of the most important essays on character dance, dance historians Lisa C. Arkin and Marian Smith's "National Dance in the Romantic Ballet." In their essay they state, "Please note that we use the term 'national and 'character' dance interchangeably in this article, as writers of the nineteenth century frequently did" (13). One of the major points that they make is that character dance has been neglected as an important part of ballet history. "For, though the type of dance referred to variously as 'national,' 'folk,' 'character,' and 'ethnic' is acknowledged to have constituted a part of the Romantic ballet, it is still generally treated only as a marginal adjunct in scholarly investigations of the subject, a lesser cousin to classical dance, a folk style that provided an occasional means to inject 'local color' but was peripheral to the genuine aesthetic of Romantic ballet" (11). They argue that it was equally as valued as classical ballet, and in their well-documented essay they state, "Simply put, national dance was performed regularly and frequently in the opera houses of Europe during the romantic period. It figured prominently within both operas and ballets, and in some theaters was featured in independent divertissements as well" (11). To illustrate their point, they add, "Consider the case of the Paris Opéra. From about 1835 until well past mid-century, national dance seems to have occurred in over three-quarters of the performances given there [...]" (11). This is not surprising at the height of romantic nationalism as nation states and their populations all over Europe were discovering their national and ethnic identity through the performance of dance and music.

Another reason for the neglect of character or national dance is due to the fact that in the twentieth century, character dance had become an increasingly rare part of ballet choreographies. However, in the nineteenth century it was as important as the classical dance. This can be clearly demonstrated, "It was an art that the highest-ranking soloists were fully expected to perform, along, with mime and classical dance" (Arkin and Smith 15). Some of the most famous ballet stars such as Fanny Elssler and Marie Taglioni were famous for their character dancing in solo recitals as well as in ballet and opera divertissements. Unlike most twentieth-century viewers, in the nineteenth century, "[...] character dance

struck observers as even more exciting than the other types of opera-house fare" (17). To understand its popularity, it is important to note that for the nineteenth-century dance viewer, character/national dances provided a form of exoticism. It gave them the feeling that they were visiting a foreign country.

In addition to the character dance that was performed on stage, choreographers and ballet masters arranged "national" dances for the ballroom so that elite populations could dance out their nationalist passions without having to perform actual folk dances (see, for example, Garafola, "Introduction"; Shay, "Lado, The State Ensemble"). "In the 1830s and 1840s, in fact, there was a veritable national-dance craze on Europe's public dance floors. Amateur dancers flocked to dance studios to take lessons in national dancing. They rented and purchased national costumes to wear to public balls" (Arkin and Smith 17). In Eastern Europe, where nationalism came later than in Western Europe, the performance of national dances for social use continued even later, right up to World War II.

This confusion between character dance and folk dance is exacerbated by the presence of character dance, that is, "peasant" dances with ballet movement vocabulary as part of ballet performances. Dance historians Arkin and Smith describe character dance from the nineteenth and early twentieth centuries:

It would be naïve to suggest that choreographers of the period made a regular practice of transferring the folk dances of the countryside to the professional stage without modification [...]. It seems highly likely that original folk dances were distilled to a certain repertory of steps, poses and gestures that were recognizably associated with a particular culture – with technical virtuosity [...]. A certain repertory of markers, then, was sufficient to function emblematically, reinforcing the spectators' sense that they were somehow gaining access to the essence of a culture or nation.

(35–36)

It was a commonly held notion among choreographers that through character or national dance they were able to "find" the national character. These characterizations could be distilled down from one to four clichéd words: warlike, graceful, merry, proud. Moiseyev fits into this nineteenth-century notion. Here is Moiseyev's own description of how he works with dance:

I try to express a people's character through its dances in the most laconic and convincing manner. I create a single variant out of a huge amount of materials, I include the typical elements and try to cast aside all the trifles. Grasping the people's character from its music, history, traditions, and customs. I try to emphasize all characteristic features in order to manifest the people's character in richer details. It's a work of a portrait artist who tries to reveal his model's character: to underline the essential by rejecting the insignificant.

(Shamina 1)

This belief that the entire population of a nation state or ethnic group can be reduced to a few essential "characteristics" strikes the twenty-first century individual as naïve, given the complexity of national and ethnic identity construction (see Shay, "The Spectacularization of Soviet/Russian Folk Dance"; Shay and Sellers-Young, "Introduction"). However, this belief was prevalent among ballet choreographers in the nineteenth and early twentieth century. Eighteenth- and nineteenth-century dance theoreticians like Gennaro Magri and Carlo Blasis supported these notions. "Like Herder, many ballet theoreticians of the late eighteenth and nineteenth centuries expressed a keen interest in the authentic, 'true,' and 'natural' folk expressions of various nations [...] Gennaro Magri, in his 1779 *Theoretical and Practical Treatise on Dancing*, likewise insists that an authentic rendering of a nation's expressive arts requires knowledge of its distinct cultural attributes" (Arkin and Smith 31). The implications of these ideas, is that it was not necessary to actually see authentic folk dances, but rather it was sufficient to "understand" the national character of each nation in order to stage a dance to represent that nation through careful observation. This led to the commonplace essentialization of entire groups of people. We are familiar with this kind of simplistic characterizations: "The French are rude"; "Jews are tight with money"; "The English are cold and supercilious." All of us have heard these reductions throughout our lives, and how they reduce people to stereotypes. Ballet choreographers who created character dances, as in Moiseyev's statement above, explicitly believed in their unique ability to determine national character, reducing it to two or three adjectives: passionate, tempestuous, proud, etc.

During the establishment of state-supported national folk dance companies following World War II, many of their choreographers clearly subscribed to this belief as attested by the program notes describing the different dances found in their repertoires. Moiseyev, through his training in the early twentieth-century was among them.

I would suggest that although it may have sometimes been the case that "original folk dances" were actually studied, in most cases, because of the urban disdain for peasants, the choreographers more often made up the steps because they thought that they "understood" the core spirit of each nation. Dance scholar Andriy Nahachewsky notes, "Other informal information, and the form of the dances themselves, suggest a much more distant relationship with the vival [by which Nahachewsky means actual, authentic folk dances performed in villages] originals than the promotional material claims [...]. Descriptions of Moiseyev's compositions often make claims about communicating 'the essence of the people' in his dances" (210). This thinking has a direct link to nineteenth-century romantic nationalism, that is, the belief that national or folk music and dance can provide an important building block in identity construction and find their way into dance productions.

Further muddying the water over the meaning of "folk dance" are statements like the following: "Soviet choreographers [...] rejected the idea that the ballet was neutral and timeless. Close integration with the folk dance has been one of the fundamental principles underlying the development of the Soviet ballet [...]. But besides being a well of strength for the classical ballet the folk dance has in its own right come to occupy an important place on the Soviet dance stage" (Chudnovsky 11). It appears that Chudnovsky collapses

these dance genres in the latter statement. It is this use of the term "folk dance" that easily confuses readers because that term has too many meanings. Folk dance is a term that many individuals think they know, but are unable to articulate: for some individuals it refers only to authentic dances in a village, for others it is ethno-identity dance, a term I coined (*Ethno-Identity Dance for Sex, Fun and Profit*), for dances that are especially prepared for public performance in public venues like outdoor festival stages and concert halls. For many individuals the term "folk dance" often means anything that falls in a general category of dances accompanied by folk or folk-sounding music and the performers wear some kind of costume. The dances that Igor Moiseyev created fall firmly into the ethno-identity category.

Reflecting Moiseyev's attitudes toward character dance, Chudnovsky writes:

In tracing the history of the character dance we find that it takes its origin from the folk dance. Long ago folk dances were brought into the ballet in their original form with all the freshness of folk melodies, rhythms and movements. Gradually, however, they underwent a transformation and were divested of their basic elements until they developed into an independent dance form which we know now as character dance. The true national features were thus almost completely obliterated.

(Chudnovsky 27)

First, folk dances were never brought into ballet in their original form, they were always mediated by ballet masters and choreographers (see Arkin and Smith, "National Dance in the Romantic Ballet"). It is in the last sentence of the quote that Chudnovsky gets to the point: Moiseyev alters folk dances differently than those who created character dance, by creating a new dance genre: "Igor Moiseyev, however, warned against indiscriminate fusion of classical and folk elements in the dance. He stressed the importance of finding ways of an organic marriage of these elements, whereby, far from conflicting with each other, each would complement the other. In such a fusion he saw the ballet of the future, the new choreographic art of the morrow" (25). This argument supports one of the major points that I make in this study: Igor Moiseyev created a new dance language utilizing elements of folk dance, athletic gymnastics, character dance, new choreographic and movement strategies and new and creative mass movement, ballet, and above all, spectacle.

The Soviet government was never interested in actual dances in the field being placed on stage and used for propaganda (see Zemtsovsky and Kunanbaeva, "Communism and Folklore"). They wanted the spectacularized dances that Igor Moiseyev and others like him created: ethno-identity dance. They consisted of many powerfully virtuosic movements that symbolized the youth and physical (and therefore, moral) superiority of the state. However, in the former Soviet Union, the authorities wanted the appearances of "folk dances." "They and their supporters argue that the choreographer has to have a deep knowledge of the people and their national spirit or else the dances will ring untrue [...] Statements about the choreographers' intimate knowledge of isolated villages and about 'the living source' that inspires them to create folk dances are seen as strategically validating their work"

(Nahachewsky 221). Thus, throughout the materials produced about Igor Moiseyev's choreographic productions, both in the Soviet Union and for concert programs outside, great stress is placed on making connections between what Igor Moiseyev created and dances in the field in Russian villages. "Because of the ideology of Marxist-Leninism and Socialist Realism, there remained a need to call even Moiseyev's activity – 'folk dance' *narodnyi*' dance – 'of the people.' Since the sources for folklore were seen to lie in the simple peasant folk, the local village dance groups were seen as a source of raw material from which the elite artists would select, and then further refine into great art" (Nahachewsky 216). Clearly, they wanted Moiseyev's work to be both "authentic" folk dance and great art.

Russian Folk Dances in the Field

Before we look in some detail at Igor Moiseyev's movement vocabulary and his choreographic strategies that makes him such a compelling choreographer worthy of our interest, we should look at Russian folk dances in the field.[1] Moiseyev, as well as other choreographers of folk genres, claim to use folk sources, and they also claim that their presentations show different degrees of authenticity. Certainly, folk forms provided Moiseyev with inspiration. As part of village life, peasants performed dance and music as part of ritual life. For example, as is true for most Slavic people, weddings have a series of dances and songs, performed in a particular order to ensure the happiness and fruitfulness of the ritual and the marriage. Musicologist Vadim Prokhorov notes, "It is widely believed that khorovod songs and, linked to them, dance songs, emerged from calendar ritual songs" (8). There are special dances and music for the in-laws and the parents, for the bride, to prepare the bride's headpiece, to ritually shave the groom, to escort the bride to her new home, etc. There was dancing to celebrate the changing of the seasons, to celebrate the harvest, midsummer, and for the coming of spring. In addition to ritual dances, in more formal events like weddings, Russian peasants danced in social settings such as working bees, evening gatherings, and social, informal gatherings of young people.

The songs and dances of the Russian peasant frequently allude to their difficult life: "The prenuptial khorovod, which was sung and danced by the village girls in spring, was a sad and bitter song about the life to come in their husband's home" (Figes 247). Although the Russian urban elites, at a safe distance from villages, frequently raised the peasant to a romantic and iconic representation of Russian identity, we cannot forget how difficult, short, and brutish their lives were in reality, especially under serfdom (see Figes 220–87).

The distance between the elite and the peasantry in Russia was much more blurred than in France or England, in which the elite performed different dances and listened to different music than the French and English peasantry for centuries. They lived in two different cultural worlds. In Russia this distance was much smaller and only changed to some degree in the eighteenth century when Peter the Great began his huge westernizing project, which involved many changes of habits in clothing, personal grooming, house furnishings, and

the introduction of Western music and dance for the elite, but not the peasantry. Before the Petrine reforms in the early eighteenth century, "The Russian nobleman of the Muscovite era (c. 1550–1700) was not a landed lord in the European sense. He was a servant of the Crown. In his material culture there was little to distinguish him from the common folk [...]. Most of the Tsar's servitors lived in wooden houses, not much bigger than peasant huts [...] in winter they sleep on flat-topped stoves [...] [lying] with their servants [...] the chickens and the pigs" (Figes 15, 17). After this change, as musicologist Richard Taruskin reminds us, "The autochthonous music of Russia, the tonal products of the soil and its peasant denizens, were not admired and not discussed" (xvi). However, the building of St. Petersburg also threw together peasant and elite in the same milieu again, which had consequences for later Russian classical music since the classical musicians were always surrounded by folk music whose themes sometimes appeared in their composition: "The most immediate musical consequence of the Petrine reforms was the sudden mass transplantation of folk song, together with its singers, into Peter's newly created metropolis on the Neva" (Taruskin 19). This transplantation would have important implications for the dances that people performed as well. As historian Orlando Figes notes in his analysis of the scene in Tolstoy's *War and Peace*, in which he describes and analyzes a scene of the heroine Natasha Rostov joining in a peasant dance, which the countess executes like a native peasant maiden (xxv–xxvi). Such a dance as that which Tolstoy describes would most likely have been an improvised composition like several of those seen in the JVC collection. The fictional countess was not the only noblewoman to dance rustic dances. After 1812, when Russian nationalism was on the rise after Napoleon's ignominious retreat, "Recreations were going Russian, too. At balls in Petersburg, where European dances had always reigned supreme, it became the fashion to perform the *pliaska* and other Russian dances after 1812" (Figes 105). Figes' study of the cultural history of Russia investigates this connection between the Russian elite and the peasantry, which I described and analyzed earlier in this study between Russian folk music and dance and their role in the construction of Russian national identity and nationalism. The Russian elite and urban dwellers retained a deep and abiding love for the countryside, its music and dance as part of their growing Russian identity.

In addition, we have the figure of the *skomorokhi*, a kind of Russian minstrel who roamed town and country to perform at various festivities, and formed a subject for one of Moiseyev's choreographies. "For nearly seven hundred years, from the eleventh through the seventeenth century, they provided both peasant and burgher, both low and high born, with entertainment ranging from dancing bears and puppet shows to the recitation of serious heroic verse" (Zguta xi). These professional performers would have carried songs, music, and dance far and wide that would have given a wider scope than the strictly local. Russell Zguta's study contains several medieval illustrations in which they are depicted playing musical instruments and dancing (Zguta 68–79). They are recorded as plying their trade from Kievan Rus to the eighteenth century. As with all public performers, they were scorned for their performances (see Shay, *The Dangerous Lives of Public Performers*).[2]

According to Tamara Tkachenko, there are three basic genres of Russian folk dances: *khorovod*, improvised solo dancing (*pliaska*), and patterned dances, of which the most popular are many variants of the quadrille (15).[3] This is confirmed as well by Iving ("The Russian Dance") and Uralskaya ("Russia: Traditional Dance"). Like many forms of folklore, dance demonstrates layers of different historical periods. The oldest level of dance performed in the Russian countryside is the *khorovod*. It is generally performed with simple steps, often a gliding walk, and the performers sing as they dance. Tkachenko states, "Russian *khorovods* among the Russians, are in many forms. They are characterized by a combination of movements and a mass of participants" (15). In other words, they are very public genres with many participants. One of the most important elements of the *khorovod* is that it is often accompanied by singing by the participants. Although Igor Moiseyev choreographed several *khorovod*, the dancers never sing.

It is also important to note that "In one region a song can be performed as a wedding song, and in another as a dance song. In different places the same song can be sung as a *khorovod* song and protracted song. At the same time, undoubtedly, an agricultural song or a wedding song can be danced; a soldier song can have lyric content; and comical content can occur in *khorovod* and dance songs in the wedding ritual" (Prokhorov 7). Thus, the songs that accompany the khorovod and solo genres may be in use in only one region or in multiple regions.

There are also complex *khorovods*, with many figures like passing under the arms of two of the dancers, or the *zmeyka* (snake) in which the leader of dance creates a serpentine figure, especially in a large space such as a large field or through the central road of a village or town. "Richest in content is the reel [*khorovod*] [...]. However, whereas in content the reels are richer than the couple and solo dances, their technique is poorer inasmuch as every dancer is willy-nilly compelled to coordinate his movements with those of his partners. Hence complicated movements requiring individual skill are hardly ever used" (Iving 140). There is generally a leader of the dance, and he or she creates the degree of complexity of the dance. There are *khorovods* that are performed only by female dancers, and there are mixed *khorovods*. One of the reasons that we know that this is one of the oldest layers of dance is that it is widespread among other Slavic and East European peoples as well. Another sign of its historical depth is that "Most often, the entire khorovod forms a circle in which the participants hold hands, or the ends of cloths they carry, or sometimes their hands are left free" (Tkachenko 16).

The *khorovod*, especially given its historic depth, has many variations, and different local styles, and it can be considered a complex of dances. Sometimes, the *khorovod* takes the form of a play party game, in which some or all of the participants mime the words of the accompanying song, which often feature agricultural movements. "Important *khorovod* songs tell about 'tilling the field,' 'sowing the millet,' and 'pulling the flax'" (Tkachenko 16). Other themes that abound are about the meeting of a bride and groom, quarreling and making up, and the treatment of a husband by his wife. Some *khorovod* songs and accompanying movements are about animals or birds, for example "*Utyona*" about how a duck swims, floats, makes a nest (Tkachenko 16).[4]

Russian Ethnomusicologist Izaly Zemtsovsky recognizes only two of these dance traditions: individual dancing, "[…] *pliasky*, accompanied by instrumental ostinato dance tunes (*naigryt'*'dance until you drop'); and collective circle and figure dances (sing. *khorovod*, *tanok*, pl. *krugi* 'circles') accompanied by the dancers' singing and/or, in the late twentieth century, instrumental music" (769). It is likely that Zemtsovsky ignores the patterned dances as foreign in origin, and therefore not indigenous forms.[5]

Zemtsovsky notes of the *khorovod* that "[…] in some places , a *khorovod* is performed exclusively by girls, and elsewhere girls are the main performers, sometimes paired with bachelors" (769). This characterization of the *khorovod* as a female-dominated choreographic genre fits with the way in which singing circle dances are performed in much of Eastern Europe, often with miming movements, either by soloists or the whole group. One characteristic of Russian *khorovods* that Zemtsovsky notes is that "[…] sometimes the dance rhythms and the song rhythms create polyrhythmic effects" (769). *Khorovods* were performed both inside and outside, depending on the weather. "In addition to its entertainment value, *khorovods* were believed to influence magically the harvest of flax and hemp" (Zemtsovsky 769). Thus, the *khorovod* serves in both secular and sacred events, creating one of the most basic and varied of Russian folk dance expressions.

The participants carried and moved kerchiefs, or held hands, or placed a hand on the shoulder of the person in front, or they moved independently in the circle. In one of the most famous *khorovods*, the dancers carry birch branches. Sometimes the dancers form two lines facing one another, and as they sing a dialog, the group approaching might ask a question, and the other half of the participants give the answer as they move forward and the other group returns to their place. Sometimes the dancers form columns and follow the leader through a series of movements. In some of the more formal *khorovods* the young men would invite their partners into the dance in an elaborate and chivalrous fashion.

"In northern Russia, the dances were distinguished by a slow and severe style […]. In central Russia, the dances were reserved; in the south, they were lively and openly joyful" (Uralskaya 444). As both Uralskaya and Tkachenko note in some detail, all three of the dance genres have distinctive regional differences.

Solo-improvised dances could take the form of competition. "Another type of Russian dance was the *pereplias* ('to outdo in dance'), a competition dance. Two men, surrounded by their male companions, alternated in performing increasingly difficult step combinations (*kolentsa*, literally 'knee joints,' meaning 'tricks') until one of the dancers emerged victorious. Then someone else challenged the winner with new combinations, and the competition continued" (Uralskaya 444). There also existed solo improvised dances for young women, who sometimes danced within the *khorovod* and executed the mimetic movements of the song. Additionally, in the southwestern regions, the khorovod is widely known as "*karakhod*" (*khodat'* is to walk) and constitutes a mass dance, but it is accompanied not by singing, but by instrumental accompaniment, with the instrumentalists standing in the center of the circle and playing a series of beloved and popular dance tunes:

Dancing in pairs or trios, but not holding hands, they [the dancers] move clockwise around the circle. Each pair (a boy and a girl) or trio (a boy and two girls) is completely independent. The girls dance one in front of the other or circling around one another and the two girls might join their [male] partner, stamping to the rhythm, sometimes jumping onto both feet. The partner might dance in front of the two girls showing his artistry. If it is a boy-girl pair, the girl more often dances in front of him, her back in the direction of the movement. From time to time one of the dancers, showing their happiness, shouts a short *chastushka* (Tkachenko 16) (According to the *Oxford Russian Dictionary* it is: *chastushka* is "a two-line or four-line rhymed poem or ditty on some topical or humorous theme").

(555)

Among the improvised dances, "Lyrical dances for couples were also common throughout Russia [...]. These young people represented the prototypes of the Russian people; she must be modest, hard working, tender, and soft spoken; he must be brave, daring, and courteous. This dance did not have specific rules; all the movements were guided by the deep feeling of the performers" (Uralskaya 444). These comments reflect the way in which folk dance was often written about until fairly recently, in which two or three "national" characteristics are selected, and somehow the dance movements and steps and the style in which it is performed "reflect" *the* national character. Typical of those descriptions:

The movements of the Russian dance reflect the four national characteristics of Russian man; the virtuosity of Russian men's dances communicate the strength and ability of the Russian man, his masculinity, creativity, kindness, and his respect for women. With girls' and women's dances, with its contained smoothness, primness, and modesty, the movements thanks to the containment and display of physicality, [the women are] conscious of the mastery of their virtue, sometimes playful, coquettish and graceful, [they] never pass into affectedness.

(Tkachenko 15)

That these dances are old is attested by the Dutchman Adam Olearius, who traveled in seventeenth-century Russia. He reports that "unlike the Germans, the Russians do not join hands while dancing, but each one dances by himself. Their dances consist chiefly of movements of the hands, feet, shoulders, and hips. The dancers, particularly the women, hold varicolored embroidered handkerchiefs, which they wave about while dancing although they themselves remain in place almost all the time" (quoted in Zguta 109). Thus, Olearius' description dovetails with those of twentieth-century dance writers.

Igor Moiseyev's program notes sometimes make these kinds of vague claims of national character that could refer to any national or ethnic group, and that reflects the idea that characterized nineteenth- and twentieth-century ballet choreographers that ballet character dance or "national" dance as it is sometimes called, such as the "Polish variation" or the

"Hungarian variation" could capture the "essence" of one's national character with one or two "culturally specific" gestures. In the 1958 The Igor Moiseyev Dance Company program, the Suite of Old Russian Dances are described as, "The dances illuminate various aspects of Russian character, their gentleness, nobility, energy, and humor" (The Igor Moiseyev Dance Company From Moscow. Program, 1958, n.pag.). For *Summer* (which I describe in detail below):

> "Humor, mischief, romance, lyricism all the elements we associate with people of the Russian countryside – are to found in this dance from Moiseyev's suite, 'The Seasons.' It is harvest time, the appropriate time to celebrate a betrothal resulting from a love affair that took root in the spring and blossomed in the summer. Young and old villages gather to cheer the couple on, dancing to the music of old Russian folk songs".
> (The Igor Moiseyev Dance Company. Program, 1958, n.pag.)

(The "old" part of the young and old villagers is never seen in a Moiseyev choreography.)

Khorovods, lyrical and competition dances, and quadrilles appear in several of Igor Moiseyev's choreographies. There was a khorovod in his first concert in the United States (The Igor Moiseyev Dance Company. Program, 1958, n.pag.). The lyrical dances and

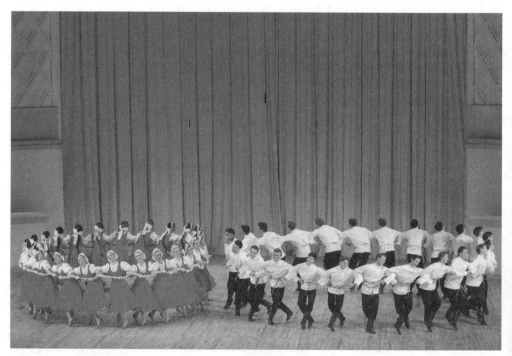

Figure 6: Scene from *Leto*.

khorovods are also staples of the Beryozka Ensemble and of the dance unit of the Pyatnitsky chorus and sometimes the chorus members themselves.

Among the steps and movements in *khorovods* and solo improvised dances, Uralskaya describes three common steps:

1. Simple, slow, measured, rhythmic steps with alternating right and left feet.
2. A small stamping step. Before stepping forward, the heel brushes the floor from back to front.
3. Changing step. Three steps are performed on the first three eighth notes of 2/4 music. The fourth eighth note is a pause that prepares for the next combination of three steps. The basic three-step has a multitude of versions, such as putting the legs together before moving out, stepping on demi-pointe, adding a small jump, stamping on the floor.

(445)

These steps appear frequently in Moiseyev's choreographies. They are useful to move large numbers of dancers. In addition to the steps, Uralskaya notes that movements of the arms are also important: "Movements of the arms are important, especially in dances for women. All gestures should be soft and flowing. The play of the arms, neck, and shoulders is a key to the mood of the dance" (445). For the interested reader, the Tkachenko volume has many illustrations and descriptions of Russian dances. An English translation also exists by Joan Lawson (*Soviet Dances, More Soviet Dances*). The viewer of Moiseyev's work will note that stylized Russian arm movements provide the "Russian" feeling in his choreographies, and while they are related to ballet *port de bras*, they are distinctly different.

The solo improvised dance, which may be performed individually by several soloists or couples can be highly competitive as Tkachenko and Uralskaya both describe for the Russian countryside. "The movements of young men demonstrate strength adroitness and passion; he dances intricate stamping, clapping and jumping (prisyadkas) showing his mastery" (Tkachenko 16). Moiseyev has made his trademark of The Igor Moiseyev Dance Company with the spectacular, virtuosic *prisyadkas* (squats, coffee grinders, barrel rolls, etc.), movements he includes in most of his dances, which have awed audiences with the prowess of the male virtuosic dancing for nearly a century.

The most recent layer of dances is patterned dances, such as the widespread quadrille. Uralskaya notes that "Of the social forms of folk dance, quadrilles were common in Russia at the end of the seventeenth and the beginning of the eighteenth century" (445). Instead of having four couples with which many are familiar in the West, Russian quadrilles featured as many as eight and sixteen couples. Typically, quadrilles have four, five, or six figures. Each figure has its own musical motif, and according to Tkachenko can be musically accompanied either by accordion or singing (Tkachenko 16). Some of the quadrilles took on regional characteristics, for example Tkachenko notes that the Ural quadrille ended each figure with a stamp or a clap, which makes it distinctive among the quadrille genre from other regions. Quadrilles, like *khorovods* and the lyrical dance tradition, have a local and

regional character (Tkachenko 17). Among the quadrilles, Russians perform the Lancers, which was popular in Europe and North America in the nineteenth century. Quadrilles come from the dancing masters of the elite classes of that period; however, so popular is the quadrille that "scores have been created by the people themselves" (Tkachenko 17). She adds that as the folk created new quadrilles, "they continually changed in form and content. The difference between old quadrilles and the quadrilles of today is great" (17).

Tamara Tkachenko also notes that "Russian dances have links to the dances of the brotherly people of Ukraine and Belorussia. The three dance cultures have in common the *khorovod*, they share similar positions of the hand, uniformity of steps and movements, for example changing steps, stamps and squats" (17). Types of *khorovods*, or dances accompanied primarily by singing, are one of the most widespread dance types of Eastern Europe.

For example, the squat steps, called prisjadkas/prysiadky, seem to be less common to Russian dances than those seen in Ukrainian dances, although Moiseyev and other Russian choreographers make use of a wide variety of kicks and squats, and many people associate them with Russian dances, especially those exposed to Moiseyev choreographies. This is often because many individuals are unable to distinguish between what is Russian and what is Ukrainian. Certainly, dance is no respecter of national borders, and it is more than likely that such movements can be found among both Russians and Ukrainians. In the JVC film on Russian dance, it is found only once, among young boys from a Moscow dance collective.

They [prysiadki] became very popular on stage in Ukrainian ethnographic theatrical productions during Ukraine's nation building era in the late 1800s […]. At its extreme, some national dance compositions consist of *prysiadky* above all else. Such is Avramenko's dance *Zaprozhs'kyi herts'*, for example and Pavlo Virsky's famous *Povzunets'* […]. Though Polish, Hungarian and Slovak peasant dance also included such squatting accents this type of movement was being claimed as a national symbol by Ukrainians.

(Nahachewsky 108)

Nahachewsky contrasts that with the appearance of prisyadkas in Russian ethno-identity dances: "When Russian staged folk dance was developing its own standards and national symbols, there was no perceived problem in using the *prysiadky* that were so popular in Ukrainian dance. From a Russian perspective, the *prysiadky* were a legitimate part of Russian dance just as Ukraine was a legitimate part of Russia. Dances that symbolize Russia today include frequent use of squatting steps. There is a sense in many diaspora Ukrainian dance communities that 'the Russians stole our *prysiadky*.'" However, as he notes, "Ethnographically, of course, the truth is not so black and white. Squatting steps were and still are quite widespread in vival dance of that part of the world generally" (108–09). Moiseyev, Virsky, and Avramenko's ethno-identity works lead the viewer to believe that they were more widespread in the field than they are.

Like much folklore, in general, Tkachenko notes that Russian dances are not frozen, museum-like artifacts, but living phenomena that change with contemporary needs. Part of that change came about through the intervention and support of the government, the

support of amateur groups, and the establishment of professional folk song and dance ensembles. Tens of thousands of groups were established throughout the country. "As a result of the emphasis given to national cultures in the mid-1930s, folk dance groups sprouted in hundreds of towns and cities, with even the NKVD having its own Song and dance Ensemble [...]. In 1956, 3,000,000 people were reported to have taken part in the preliminary contests in the USSR" (Swift 241).[6]

Another feature of folk dance in the former Soviet Union, where many new dances were "created", depicted agricultural movements to celebrate the most famous crop of each republic. This became a feature of each of the Soviet Republics. Igor Moiseyev, for example, created, *bulba* (potato), which depicted the planting, and growth, "and the happiness of the people over a plentiful harvest" (The Igor Moiseyev Dance Company 1965, n.pag.). These agricultural dances became a feature of all of the state-supported folk dance ensembles of the Soviet Union.[7]

Character Dance, Folk Dance, Ethno-Identity Dance

One of the important beliefs that urban, classically trained choreographers like Igor Moiseyev held (and can still be found) is that the choreographer can identify certain "traits" or "character elements" in dance, and distill them in a choreography. This belief is echoed in many of the Russian publications that describe Moiseyev's work (see Chudnovsky, *Folk Dance Company of the USSR*; Sheremetyevskaya, *Rediscovery of the Dance*; Ilupina and Lutskaya, *The Igor Moiseyev's Dance Company*). "The Russian suite is so arranged as to bring out very vividly the beauty of the national character" (Chudnovsky 44). This is an important element in many Moiseyev choreographies.

This meant that dances were often choreographically painted in primary colors. Describing the quality of Moiseyev's choreography of Russian dance, Chudnovsky wrote: "The dance was an enchanting study in contrasts. Delicate lyricism, unusual tenderness and deep feeling alternated with an ebullient recklessness" (19). Other dances, reflecting the character of the people were described as "light and graceful," "charming," "austere," "gay" (Chudnovsky 20). The primary colors are reflected in this description: "This company has brought to the stage a wholesome optimism, a wealth of feeling, joy, merriment, a beauty and harmony of sound and movement" (Chudnovsky 20).

A clue to the marriage of classical ballet, character dance, elements of folk dance, and Igor Moiseyev newly created movement vocabulary is the following observation: "And here it must be said that folk dance by contact with the classical dance also gains much in the way of polish, depth of content and means of expressiveness" (Chudnovsky 12). This demonstrates the hybrid quality of Moiseyev's work; he created a synthesis of these elements that characterize his choreographies, a quintessential movement vocabulary that a new dance genre that falls into my ethno-identity dance category. Chudnovsky adds in confirmation: "It was necessary, he [Igor Moiseyev] knew, to seek for new forms, both artistic and organizations, to enable the folk dance to develop full" (13). The Moiseyev Ballet today finds itself trapped into the morass of meaning of folk dance because currently

concert producers tell the Moiseyev Ballet administration that today's audiences are not interested in folk dance. After using that term for decades in the former Soviet Union, the current Moiseyev Ballet administration finds it difficult to convince producers that they are not performing folk dances; that Moiseyev's creations are, in fact, not folk dance in the field, but a new dance genre. "At its very first performance the company swept the audience off its feet. Here was something new" (Chudnovsky 19).

Thus, as I use the term, folk dance refers to dances that form an organic part of individuals who have learned them from family, friends, and neighbors. They constitute regionally specialized forms of choreographic expression. Character dance, sometimes called national dance, constitutes a balletic portrayal of folk dance, which like the dances of Moiseyev, distill the essence of "national character." In sum, Moiseyev's original choreographic voice consists of elements of character dance, classical ballet, a huge dollop of virtuosic gymnastics, some steps from folk dance, and above all new and creative mass movement strategies. From this brew, Moiseyev created a new dance genre. However, as Andriy Nahachewsky usefully reminds us, the Moiseyev choreographies are more distant from actual folk dance than the "promotional materials claim" (210).

An important thing to remember is that character dance was extremely popular from the nineteenth century and well into the twentieth. It was in the air. For example, Ukrainian character-based folk dance was extremely popular in the Russian Empire, and several seminal figures, both in Ukraine and in the diaspora, promoted Ukrainian spectacularized dance as a show of national sentiment. Beginning early in the nineteenth century, Ukrainian historian Orest Subtelny observes, "Another absorbing and widespread activity among the early Ukrainian gentry-intelligentsia was the study of folklore […]. Because Ukrainians were largely a peasant people, one of their most appealing features was a rich, vibrant folklore" (227, 228). Another reason that folk music and dance were featured in the Ukrainian theater was political: "The subject matter of Ukrainian plays, moreover, was restricted to folkloric themes and comedies. Serious drama, including translations of classical works from other countries could be performed only in Russian" (Magocsi 400). Many people did, and still do, regard folklore as harmless and apolitical. This led to the staging of many musical plays with peasant themes and plots, starting with *Natalka Poltavka* (Little Natalia from Poltava) in 1819, and a string of others during the tsarist period. The dances had to be spectacularized for these plays to attract an audience. It did not matter if the actor could act, so long as she or he could dance well. "By the 1890s, the folk dance had become an intrinsic component of the Ukrainian theatre […]. They staged second-rate peasant melodramas and vaudevilles featuring vulgar comedy routines, scenes of prodigious drinking, highly stylized and inauthentic peasant costumes, and mongrel 'folk dances' that introduced acrobatic tricks and parodied village dances" (Martynowych 9).

This use of Ukrainian ethno-identity dance also made its way to the Ukrainian diaspora through figures like Vasile Avramenko who got his start in theater and dance in Ukraine and in the New World made dance a means of instilling emotions of Ukrainian nationalism among diaspora Ukrainians. We know that Avramenko did not use authentic dances but rather they

were "more complex and stylized than any of the folk dances that Ukrainian immigrants might have danced on social occasions" (Martynowych 26–27). As historian Orest T. Martynowych notes Avramenko's fame was "as a producer of ethnic folk dance festivals" (3).[8]

None of the above is to diminish Igor Moiseyev's contributions to dance, but rather to contextualize his approach. His major achievements: creating a new genre of dance, using spectacularized movements, and creating mass choreographies can be better understood in the context of a world in which staged folk dance was already extremely popular.

Andriy Nahachewsky's "Three Principles of Staging"

Dance scholar Andriy Nahachewsky provides us with a useful framework in which to describe and analyze Igor Moiseyev's choreographies, as well as those of other performances. Nahachewsky posits three staging strategies or principles for choreographing staged folk dance; in his "first principle of staging dances composed according to the first principle of theatricalization involve the most serious efforts at preservation of the original form" (192). Nahachewsky notes that in the former Soviet Union, this was largely limited to local people creating dances with their own living dances. I would stress that the Dora Stratou Greek Folk Dances Theatre, the Greek State Ensemble, in fact used this strategy. They did not use choreographers, but left the staging to the lead dancers.

Nahachewsky continues: "In first principle stagings, accommodations are made grudgingly to the stage, the choreographer wishing to remain faithful to the imputed dance unless forced to deviate by the new context for the reflective dance. Dances arranged according to the second principle however, are less rigorously faithful to the participatory vival dance prototypes. For second principle compositions, the choreographer is no longer apologetic about his theatricalization [...]" (194). This second principle-style staging includes a great deal of virtuosic affects. "Second-principle dances such as these [*hopak, tinikling*] tend to be very frontal and monumental, and tend to highlight formational work, including lines, blocks, circles, semicircles, diagonals, and diverse transitional shapes. The *Hopak* involves 21 different formation that do not repeat" (196). Certainly some of Moiseyev's choreographies can be subsumed under this rubric.[9]

"Ethnic dances arranged by the third principle of staging involve the greatest artistic license and are mostly overtly engaged with spectacular dance conventions in the choreographer's contemporary community. Though folk roots are often claimed in promotional materials about such choreographic works, the actual relationship with any participatory tradition is very tenuous. In fact, third principle dances are sometimes not really stagings of earlier vival dances at all, but are born directly in the theater" (Nahachewsky 197). Many of Moiseyev's choreographies fall into this category, some, such as his naval and soccer choreographies, do not have any ethnic references. Others that intentionally have ethnic references were "born in the theater." For example, the dance *Bulba* may be termed as "artistic invention" (Chudnovsky 40). "The movements, of course, have been conventionalized. They resemble

in a remote way the Byelorussian [sic] national style of ornamentation. The end of this newly-created dance is very effective [...]" (40). The writer notes that the dance is now a "folk dance," danced all over the Soviet Union. As I describe and analyze Moiseyev's work, I keep Nahachewsky's three principles as a means of analysis.

Igor Moiseyev's Movement Vocabulary

As a ballet artist and choreographer, one should not expect Igor' Moiseyev to become a dance ethnologist, transferring authentic dances onto the stage as in Nahachewsky's first principle. In an article that he wrote in 1952, in which he criticizes the stagnation in the Bolshoi Ballet Theatre, he suggested turning to new dance sources, including folk dance; however, he admonished his readers not to take this advice in a literal sense:

> One must not, of course, turn the national dance in ballet into an ethnographic document. It is not slavish photographic reproduction of folklore that can stimulate the classical ballet. Artistic adaptation of folklore can stimulate it, however, and can give it the living qualities, the expressiveness and the character of an art created by the people and by life. If the richness of folk choreography were infused into the classical ballet, its powers of expression would become immeasurably greater.
>
> (Moiseyev, "The Ballet and Reality" 18)

In a 1970 Interview in the *Los Angeles Times*, Moiseyev stated, "Folklore in the strictest sense is confining. I was never interested in that. I merely take the folk dance and its related customs as a point of departure for fanciful interpretation" (quoted in Abbot 144). Moiseyev was a professional choreographer and, as his words demonstrate, used elements of folk dance for inspiration to create his work. Alana Joli Abbot notes, "He [Moiseyev] is credited with creating folk dancing as a stage performance" (144). This Russian folk dancing was a new style of dancing that Igor Moiseyev created.

Moiseyev characterized his philosophy of staging folk dance thus:

> We do not attempt exact renditions or copies of folk materials. We try to present a synthesis and summary of a national character, a reflection of the folk culture, history and spirit. In folk dancing I saw qualities which could well enrich the art of the ballet, an art which reveals the soul of the people. We regard folk dancing as a living process. Its best traditions are constantly developing and acquiring new traits.
>
> (The Igor Moiseyev Dance Company From Moscow. Program, 1958, n.pag.)

Los Angeles Times dance critic Lewis Segal characterized Moiseyev's choreographic approach: "Moiseyev virtually invented folk dancing as a professional stage spectacle, insisting that he had both a right and a duty to change a participatory endeavor to a serious choreographic

idiom worthy of standing beside classical ballet and modern dance" (B10). Thus, we should put to rest the idea that Igor Moiseyev wished to stage authentic folk dances, that is, notating dances as they are performed in the field and performing them in the same way on stage. As Segal notes, Moiseyev's dance style enabled spectacle, one of the main arguments that I make in this study. He not only, in Segal's words, "invented folk dancing," he also invented new folk dances. Dance critic John Martin observes, "'Bul'ba' is another interesting variant on Moiseyev's creative practice. Here he has taken a traditional song about growing potatoes and simply made up a dance to fit it, using his own traditional background for his material. It is such a little beauty that native groups more or less all over the Soviet Union are said to have adopted it as a folk dance, thus transforming art back to nature for a change" (The Igor Moiseyev Dance Company. Program, 1961, n.pag.). Even when Moiseyev created dances with ethnic references, he created dances from whole cloth.

It is important to note that Moiseyev has one basic movement vocabulary, and that is derived largely from classical ballet character dance, as well as folk dances in the field. In discussing the movement vocabularies of The Igor Moiseyev Dance Company, as well as that of other professional Russian ensembles, such as Beryozka and the dance unit of the Pyatnitsky chorus, Tkachenko notes, "These ensembles cultivate a varied view of men's dancing, built from the basic materials of Russian dance, but also enriched with the difficult art of Russian classicism. Russian folk dance is insolubly connected to professional ballet" (17). It is more earthbound than classical ballet character dance, although viewing his choreography, *Road to the Dance*, one can see many of the movements found in Pagels (1984, see and compare especially the barre and center exercises, 9–50, 95–110; Lopoukov et al. 7–79, and all of Lawson [*Soviet Dances, More Soviet Dances*]). Igor Moiseyev's dance style was not restricted to professional dance ensembles, but was embraced and encouraged for use by amateur dance companies throughout the former Soviet Union, at least to the degree that, as amateurs, they were able to achieve the physical prowess necessary to perform Moiseyev's style. The Moiseyev style is still seen in many of the former republics, including Russia, after the collapse of the Soviet Union.[10]

His dance vocabulary is used for dances from all of the republics in his company's repertory, with local specific movements added such as the shoulder shimmies from the Kalmyk dance, as well as from folk dances from other countries. There is one Russian style, and like the homogenized vocal styles of the Pyatnitsky Chorus, regional differences in dances in the field, described at length by both Tkachenko (*Narodny Tanets*) and Uralskaya ("Russia: Traditional Dance"), are expunged. Nevertheless, as much as this new genre was informed by ballet it was importantly different: the dancing under Moiseyev's influence became lower to the ground – significantly earthier. This is very important in conveying the idea that the spectator is viewing folk dances. *New York Times* dance critic Jack Anderson notes that Moiseyev, "created a new form of theatrical folk dance in Russia" (n.pag.), an observation with which I agree. While the dancers still used ballet positions and pointed toes, they did it in boots and shoes with hard heels and soles, not slippers or ballet shoes. This footwear mitigated the ballet movements to the point that Moiseyev's invented tradition appeared to be more like folk dance.

Nevertheless, in Igor Moiseyev's own words ballet formed the base of his work. "Moiseyev attributed his dancers' virtuosity and versatility to their training in classical ballet, which he described in a 1970 interview as 'the grammar of movement [...].' With ballet as a base one can do everything" (Anderson n.pag.). This use of ballet technique is nowhere more obvious than in seeing the ballet workout/warm-up in his choreography: *Road to the Dance*. Moiseyev never gave up choreographing classical ballet, and he did not appear to want his company to be considered less than the Kirov or Bolshoi companies, and this choreography demonstrates the high level of his dancers in a positive light for those viewers and critics who consider classical ballet and modern dance more important than folk dance, no matter how balletic it appears. He created works for both his own ensemble, such as *Night on Bald Mountain* (Mussorgsky), and *Polovtsian Dances* (Borodin) as well as choreographies for several ballet companies, like the Young Ballet Company, which he founded in 1967 for choreographic experimentation. These dances clearly fall in the classical genre.

Since Moiseyev's training spread throughout the vast Soviet Union to the other republics, "Such a system was common in all larger folk dance ensembles in towns because it was absolutely necessary to learn at least the basics of classical ballet to perform choreographic compositions created during the Soviet period under the name of folk dance" (Kapper 7). Classical ballet formed, perhaps, the most important basic movement element in Moiseyev's invented tradition of folk dance.

He also created several novelty numbers with little, if any, ethnic references: *Rock 'N Roll* (also called *Planet of the Apes*), a satiric look at American teen popular culture, *Soccer*, *Two Boys in a Fight*, which inspired Marianne Moore to write a poem about The Igor Moiseyev Dance Company (see Kodat 1–9), and *A Day on Board Ship*, a choreography that would not have been out of place in a Broadway or Hollywood musical like *On the Town*. *Partisans*, which I describe and analyze below, was created as a loving tribute to the Partisans of World War II, is a choreography that stands in a unique class by itself.

The bulk of the dances in the Moiseyev repertoire consist of simple running steps, pas de basques, polka steps, skips, rapidly alternating left and right feet at enormous speed, a step-brush, step-brush step, r-l-r stamp left and l-r-l stamp right, moving to the side first right with right foot in front left behind, and then repeated on other foot in the opposite direction. A typical movement for the Eastern Slavic (Russian, Ukrainian, Belarus) dances, performed in place is: step right, step behind left, step right, face diagonally left, extend the leg and touch or hit the heel, using the same foot kick up high in the same direction. Repeat that step in the opposite direction. The strategy of using these simple and basic dance steps gives the illusion that the dancers are performing simple folk dances. Importantly, the very simplicity of these steps allows the dances to be performed at great speed, as well as an important choreographic strategy to move large numbers of dancers through space, an important element in the Moiseyev oeuvre.

The importance of Igor Moiseyev's newly developed movement vocabulary and choreographic strategies was that his style of movement and his genius for moving large numbers of dancers in literally awesome formations was not to be the hallmark of The Igor

Moiseyev Dance Company alone; it quickly came to characterize the ways in which the dances of the Soviet Republics and many state-supported companies around the world performed. For example, Estonian dance scholar Sille Kapper notes, and I quote at length as she emphasizes the important point I wish to make about the power of Moiseyev's dance tradition,

> Following the example of the Soviet Moissyev [*sic*] Ballet, Estonian choreographers pursued to "ennoble" (Ullo Toomi in Kermik 1982, 186) former peasant dance, mainly proceeding from esthetic ideals of the classical ballet [...]. Such "ennobled" dance was characterized by technical and artistic peculiarities of classical ballet, from body alignment, turnout, extended leg lines, graceful arm movements and gravity defiance to extreme synchronicity in performance and choreographic symphonism in composition. Those characteristics – specific to Russian and other Slavic stage folk dance since the beginning of twentieth century – were applied to Estonian stage folk dance compositions and training systems during the Soviet period, thus shaping Estonian dance according to the cultural model provided by the colonizing culture [...]. In addition to body discipline, sophisticated movements, trajectories and formations, Soviet aesthetics prescribe symphonic rearrangement of musical accompaniment of dances and dressed dancers into national costumes – uniform from head to toe. The same principles were introduced in Latvia and Lithuania, whereas the especially high technical level of Latvian stage folk dance provided the most pronounced expression of Soviet colonial mimicry.
>
> (7)

What is interesting in Kapper's description is, in the words of Ullo Toomi, "Estonian folk dance is not especially dashing or temperamental" (quoted in Kapper 7) and, thus Estonian, Latvian, and Lithuanian polkas and other folk dances did not lend themselves easily to the Moiseyev touch. Nevertheless, Moiseyev's invented folk dance tradition spread rapidly throughout the former Soviet Union from Estonia to Kazakhstan in a one-size-fits-all mode.

Igor Moiseyev and the Invention of the New Russian Folk Dance

In fact, these various companies can be considered as performing a Soviet Russian dance genre. "After the revolution the new 'School of Russian Ballet' was based more on character than on classical ballet style. This was the basis for the teaching of folk dancing in Russian schools" (Olson 252, n. 128). This new genre of revival folk dance has become the stereotype of Russian folk dance, both among many Russians and among foreign viewers. For the Russians, this "new" music and dance constitute a potent symbol of Russian ethnic identity.

A major point that I wish to make is that the foundational reason for the establishment of The Igor Moiseyev Dance Company, known in the Soviet Union as the State Academic Ensemble of Folk Dances of the Peoples of the USSR, was to valorize Russian ethnic identity through spectacularized dance. And for this reason "The Russian dance was the

first number on the first programme [...]" (Ilupina and Lutskaya 10). Ilupina and Lutskaya further comment on the position of Russian dance in the Moiseyev ensemble's programs: "The company today has a marvelous and quite unique collection of dance suites dedicated to Armenia, Mexico, Moldavia and the Soviet Baltic republics. But the *Russian Suite* should be mentioned first. It reflects all that is best in the Russian character" (11).

The general Russian population quickly accepted the invented dance tradition that Igor Moiseyev created as authentically representative of Russian identity. To the average Russian to this day the ways in which Igor Moiseyev valorized Russian dance gave them a pride in their ethnic identity. As the Ilupina and Lutskaya study of the company observes: "as a nation, Russians have an amazing gift for dancing which knows no age barriers" (9). In this foregrounding of the Russian presence in the repertoire, the Soviet Union stressed the pride of place that the Russian ethnic population occupied in the former Soviet state.

Ukrainian dance scholar Andriy Nahachewsky notes, "The Moiseyev State Folk Dance Ensemble of the USSR, based in Moscow has been an extremely important group in the history of folk-staged dance, and has had a profound influence on spectacular ethnic reflective dance, directly or indirectly the whole world over. This influence is perhaps as great in Ukraine as anywhere" (202). Nahachewsky observes that the Ukrainian state ensemble was founded "in Kyiv [Kiev] a few months later" than Moiseyev (202). Moiseyev always presents the smiling face of the former Soviet Union and today's Russian Federation, and this happy model informed the way all of the Soviet folk dance companies represented the Soviet Union.

The companies that most closely emulated The Igor Moiseyev Dance Company outside of the Soviet Union were the ensembles in the satellite states, whose directors would have seen Moiseyev at the many Youth Festivals held in the USSR and throughout Eastern Europe in the late 1940s and early 1950s in Prague, Warsaw, Budapest, and other capital cities. It is no accident that shortly after the Soviet Union's consolidation of its political and military grip on Eastern Europe that Mazowsze, the Polish State Ensemble (Jouglet, *Mazowsze*) and the Hungarian State Ensemble were founded in 1950 (Varjasi and Horváth 6), and the Bulgarian State Ensemble also founded in 1950 after a visit of the Pyatnitsky choir, which had a Moiseyev-like dance ensemble, gave its first performance in 1952 (Kouteva 76, 78).

By the late 1950s, ensembles outside of the direct influence of the USSR such as Bayanihan in 1958 (*Bayanihan Philippine Dance Company*), the Dora Stratou Greek Folk Dances in 1953 (Shay, *Choreographic Politics* 180), and the Reda Company of Egypt in 1959 (Shay, *Choreographic Politics* 147) followed in the steps of Moiseyev. Mahmoud Reda saw The Igor Moiseyev Dance Company in the Moscow Youth Festival of 1957 (Shay, *Choreographic Politics* 147). In 1952 Dora Stratou saw the Soviet-inspired combination folk dance performance of Kolo, Lado, and a group of Macedonian village dancers that formed the basis of the future Macedonian State Ensemble, Tanec, which was her inspiration to create a professional-level folk dance ensemble in Greece (Shay, *Choreographic Politics* 180). These ensembles differ in detail, especially given the very different dance and music traditions found within each of the ethnic and national units, which requires local elements be introduced. Thus, some companies have choirs, such as the state ensembles of Bulgaria, Poland, Mexico, and Hungary, while others do not.[11] The Bulgarian Filip Koutev chorus has recorded several prize-winning audio

recordings that have been popular in many circles outside of Bulgaria since the 1950s. In some companies, the dancers themselves sing, like Croatia, Serbia, Greece, and Macedonia, and the Croatian State Folk Dance Ensemble, Lado, has achieved international renown for their singing, winning many prizes in international choral contests. Some ensembles use native instruments while others use theater orchestras of Western instruments, such as Moiseyev and the Polish National Folk Ensemble, Mazowsze. Some use authentic village costumes while others create costumes, but the basic idea of spectacularized folk dance, and the establishment of state-sponsored folk dance ensembles, many numbering over 100 dancers, and its success in representing the nation state, I suggest in this essay began and originated with Igor Moiseyev.

It is important to remember that: "Stalinist Russia (as well as the entire Soviet Union) made a cult of folklore, and especially Russian folklore, since the Russians dominated the Union. But in that cult, real, authentic folklore hardly found a place" (Harkins ix). Folklore performances in the former Soviet Union could take on a more sinister aspect, especially under Stalin. Izaly Zemtsovsky and Alma Kunanbaeva, folklorists in the former Soviet Union, observed:

> The "amateur artistic activity" that the regime so prominently supported consisted, for the most part, of an imagined folklore, one fabricated by socialism for its own purposes. There actually existed a system of made-to-order folklore, under which obedient scholars and frightened performers produced folklore on command, sometimes under the threat of immediate physical violence.
>
> (6)

Thus, we can see that innocent folk dances are not only political, but also have the potential to be downright dangerous.

Moiseyev's Choreographic Strategies

Ukrainian *Gopak*

Let me describe Igor Moiseyev's *Gopak*, his spectacular take on a Ukrainian folk dance, which served as the spectacular ending to many of his concerts, including the first tour of the United States in May–June, 1958. I suggest that although recorded, two-dimensional images can never convey the immediacy and excitement of a live performance one can view Moiseyev's choreographies on YouTube, and seeing them, along with the descriptions I provide below, will give the reader an idea of the power of his works. The recordings are useful for analyzing movements.

It opens as a bevy of village "girls" (I use the word girls instead of women because they are dressed in maiden's festive clothing from the Poltava area of Ukraine, one of the iconic looks found in virtually every Ukrainian dance company) run onto the stage and form a loose circle, excitedly whispering into one another's ears, behaving like teenage girls. This girlish

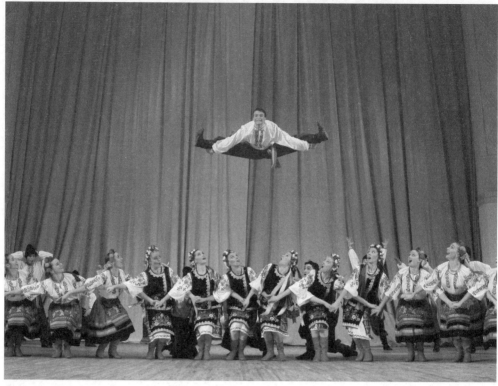

Figure 7: *Gopak*: Scene from the Ukrainian dance from Poltava.

glee announces that this will be one of the staples of ethno-identity dance stage settings: "it's fun in the village." The Igor Moiseyev Dance Company members are dressed in approximate copies of the Poltava costumes – adjusted at the waist and shortened for mid-twentieth-century taste, and there are six girls each in red, blue, green, and black sleeveless jackets, that during the choreographic process will coalesce in the various figures of the dance with girls garbed in the same color dancing together. Suddenly, the circle parts in two, revealing a pair of male dancers. The music slows to a purposeful rhythm, and as the two men perform virtuosic squats and leg extensions, the girls retreat to both sides of the stage strategically grouped in threes, according to the appropriate colors of their jackets. Throughout the dance, the girls add a decorative element to the choreography as male soloists and duos appear, each with a highly athletic choreographic/gymnastic athletic skill, designed to wow audiences of all ethnicities. It is the male dancers and their virtuosic dancing that form the centerpiece of most of Moiseyev's dances. The "boys" (I also use this word advisedly, for they, too, are dressed in the clothing of the bachelor) execute "coffee grinders," prisyadkas (kicking the legs forward while in a squatting position), squats, rapid spins, and other highly athletic and virtuosic movements associated in the popular mind with Russian dancing.

Among the dancers are two or three "character" dancers who sport moustaches and are depicted as fatter, shorter, taller, and/or older, thus dividing them from the "innocent boys." They do not, however, exhibit a threatening masculinity in his largely heteronormative choreographies, but curiously an almost asexual, or presexual crowd of dancers, reflecting the prudishness of the former socialist government, as well as Putin's Russia. Rather, they are droll and play the role of fun-loving village buffoons.

As each soloist or duo finishes, the dancers move to form a line behind the girls. As the last male soloist finishes the most spectacular of leaps, he is hoisted by the other boys over the top of the girls – performing a perfect split in the air – the music crescendos and the tempo quickens. This scene is one of the iconic photographic images of The Igor Moiseyev Dance Company (see the cover of Shay, *Choreographic Politics*). The company suddenly erupts as one into a series of trios, one boy between two girls, and revolves in a counterclockwise circle around the stage. If you are seated in the audience, you can feel the level of excitement in the spectators rise. By a choreographic sleight of hand the dancers move into a formation of three spokes and, by more choreographic legerdemain, they dissolve into a presentational formation of eight rows of six dancers each. With a flourish, the front row of dancers, raising their hands and making a bridge, move rapidly to the side and, using a high-lifting running step, they move swiftly backward, followed by each succeeding row. As they arrive at the back, each row now runs forward under the upraised arms of their comrades to regain their original positions, ending the dance with hands raised in the air. This spectacle has been followed by an instant standing ovation from every audience I ever sat in, whether in Moscow or Los Angeles.

The choreography of the *Gopak* is very characteristic of Igor Moiseyev's large-scale choreographies. They frequently begin with the ensemble performing a series of simple steps, followed by a section of virtuosic, awe-inspiring athletic movements usually involving a soloist, a duo, or a trio, what I call circus, followed by the ensemble moving together to perform a finale. This is what we have seen in *Gopak*. In sum, in the *Gopak* a choreography that often serves as a finale in a typical Moiseyev concert, the same pattern of large group movements with simple footwork, climaxed by the athleticism of soloists and small groups, characterizes the work. This choreography, with its dazzling array of virtuosic, highly athletic figures, almost always constitutes the finale, bringing audiences around the world to their feet.

Humanities scholar Catherine Gunther Kodat characterizes Moiseyev's choreographies: "Moiseyev's choreography could not be termed modernist. Emphasizing technical virtuosity and bravura physical display, the repertory of The Igor Moiseyev Dance Company favored the broad, flat road of the circus act, its folk details working largely to solicit state sanction of production values more in the spirit of Radio City Music Hall than of a collectivized farm or factory" (3).[12] This assessment, while sounding harsh, actually captures part of the appeal that The Igor Moiseyev Dance Company has for spectators and grasps the kernel of Igor Moiseyev's choreographic skills and talent. I have actually used the shorthand term "circus" to characterize the sections of many of his dances in which the male dancers, one after another, display the athletic prowess and gymnastic skills that his male dancers display to the awe of the spectators, and which are a hallmark of The Igor Moiseyev Dance Company.

Various scholars and popular writers have attempted to dismiss Moiseyev's work as "entertainment" and "middle brow," what arts administrators call "accessible." This means that large audiences will appear in the way they rarely do for ballet or modern dance. Part of such dismissiveness derives from the hierarchy that attempts to place (and fund) ballet at the apex of all art, followed by modern dance, and all else as entertainment only fit for the unwashed hoi poloi. In other words, however middle or low brow, Moiseyev has mostly produced huge successes.

Leto (Summer)

In *Leto (Summer)*, the dance opens with the entire ensemble on the stage in lines, with a boy and girl who perform some of the steps that I described above. The duet is coyly flirtatious with the music in turns, feminine and masculine, to suit the movements of the two dancers,

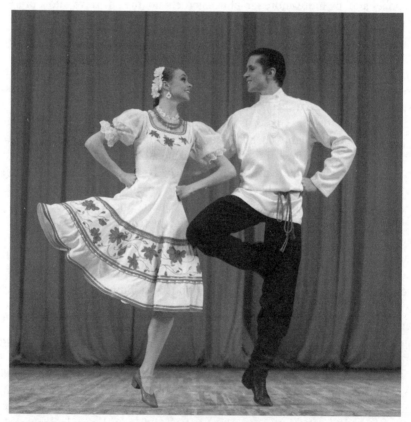

Figure 8: Opening scene from *Leto*. All images are sourced and used with permission from the The Igor Moiseyev Ballet.

with flutes and strings playing pianissimo to accompany the female, and brass and bass instruments playing forte to indicate the male. The duet finishes as the large ensemble moves in a walk creating several figures, and then form two circles. The music increases as the two circles rapidly turn, and suddenly, the dancers break out into couples that move alternatively right and left. It is at this point that the discerning viewer can witness Igor Moiseyev's choreographic genius revealed.

I would argue that while almost all of the Russian and Ukrainian ensembles make use of the spectacular athletic male movements, as does Moiseyev, his special genius lies in his ability to move large numbers of dancers into complex choreographic figures, often using simple runs and other steps to create sudden changes. The dancers create a maypole effect followed by "circus." The male dancers in row after row, using one of the many prisyadka steps, the female dancers fill in the spaces between them, and in a series of running steps, they create the finale with upraised arms. It was this dance, seen on the *Ed Sullivan Show* in 1958, that made America's collective jaw drop. The viewer can see references and figures from both khorovod, lyrical couple dancing, and solo competition dancing described by Tkachenko (*Narodny Tanets*). According to the programs in my collection, Igor Moiseyev frequently used this dance to open his concert programs.

One of Mr. Moiseyev's basic choreographic strategies is to identify one or two striking aspects of an ethnic dance or movement tradition, and to build a dance around those elements using the rather simple and basic steps and figures that constitute his movement vocabulary, some of which I described above. This is crucial to the success of his choreographies, because it is frequently the only element in the dances that differentiates one folk dance "tradition" from another.

As in the naïve fashion that I attempted to portray an essential "Croatian-ness" or "Serbian-ness" through the performance of dances by selecting one or two emotive states that I described in the "Introduction" to this volume, Igor Moiseyev clearly believed that he could evoke a national or ethnic "essence" through his dances, a belief current among ballet choreographers for over a century before. Another source notes: "The Russian Suite should be mentioned first. It reflects all that is best in the Russian character – its fervour and reserve, modesty and recklessness, pride and a sense of humour. Take any part of the Russian Suite and in it you will see a new fact of the national character" (Ilupina and Lutskaya 11). Thus, Moiseyev was able to choreographically portray the essential Russian character, or the essential character of any of the national groups; this nineteenth-century strategy was fully endorsed by the soviet state and became a way of staging dance.

Observing the DVDs of the company, dancers will immediately note that in addition to incorporating a specific movement or two--the trembling movements of the body, arms, and hands found in the Kalmyk dance, or the "broken ankle" movement in which the dancers allow their ankles to bend over and touch the floor, as one does when one sprains one's ankle, found in the *Malambo*, the Gaucho dance of Argentina, and the spectacular gliding alternating with a loping movement reminiscent of horseback riding in the Partisans–the majority of the steps come directly from Moiseyev's basic movement vocabulary. Because

Moiseyev utilizes a basic ballet vocabulary with named steps, as well as several of the simple steps I described above, it allows the choreographer to quickly move a large corps of dancers into effective formations that intricate footwork would not allow. For example, his Bulgarian suite from the Shope region eschews the use of the very intricate footwork found in that tradition and for which it is justly famous, but rather Moiseyev almost exclusively uses a rapid series of alternating left-right steps with high lifts, pas de basques, and punctuated with stamps in order to achieve the impression of enormous speed and high energy for which the Bulgarian Shope region is famous. Using a large number of the actual intricate steps and figures of the tradition would be lost in the basic movement palette that Moiseyev favors.

Another important characteristic of Moiseyev's choreographies is their unrelenting cheerfulness. "Folkorism – i.e. politicized folk adaptation – became a major industry in the Stalin era. Folk song and dance came back into favour on the wave of the Stalin's 'Great Retreat', a campaign to preserve or revive certain elements of Russian history and culture. In 1936, Igor Moiseev established a Theatre of Folk Art in Moscow and his own folk dance ensemble that brilliantly combined the rigour of classical ballet with folkloric steps and village scenes" (Stites, "The Ways of Russian Popular Music" 25). The dancers throughout a typical performance smile relentlessly, and his choreographies, despite the undoubted virtuosity of the dancers, can appear as naïve and innocent as befits idealized peasants. Moiseyev, like all artists in the former USSR, were required to follow the dictates of the government. And like the fading photographs that were featured in the old Soviet government house organ, *Soviet Life*, the Soviet people were to be shown as all smiling, all happy, all the time.

Moiseyev historian Mikhael A. Chudnovsky characterized the way in which folk art was regarded in the former Soviet Union: "Folk art, whatever its form, is always on the side of good, always wholesome and optimistic" (23). This description would characterize both *Gopak* and *Leto*. Indeed, Moiseyev's works reflect this concept in many of what I call "fun in the village" choreographies in the repertoire of The Igor Moiseyev Dance Company and appeal to wide swaths of the viewing public. Through the use of scenes such as the "girls" whispering in each other's ears, and the "boys" and the "girls" teasing one another, much in the way one might encounter on the playground of an elementary school, they represent the peasantry, and symbolically, the Soviet state as a place in which everyone is happily at work, and the work is like play. Thus, as Chudnovsky notes above, the Soviet people are to be portrayed as "wholesome and optimistic."

The dancers also seem to be asexual or presexual, no hint of sexuality or sensuality is found in Moiseyev's work, as throughout all soviet life, befitting the prudish nature of the Communist Party. Needless to say, a hegemonic sense of heteronormativity pervades throughout a Moiseyev performance, which appeals to many audience members, especially in America in the 1950s.

Moiseyev is a master at producing effective, large-scale choreographic formations: small circles become large circles or vice versa, circles become rows and columns, the rows become lines, which become weaving and interweaving hordes of dancers, that become pairs of dancers turning rapidly. So skillful is Igor Moiseyev in creating these

spontaneous-appearing effects, that the spectator must study the choreographies closely to observe how he is able to achieve these effects. He produced these effects in a kaleidoscopic manner, drawing "oohs" and ahs and gasps from adoring audiences, rather like a magician producing a mysterious feat from his bag of tricks.

An important signature element in almost every Moiseyev choreography, at least those featuring male dancers, is a section in the end of the dance before the finale, in which he produces a large number of solos and duets in which the dancers seem to explode, each soloist or pair executing a difficult series of virtuosic "tricks" like the many versions of "*prisyadka*," a generic name for the famous Russian and Ukrainian squats in which the dancer kicks out his foot, and either performs a series in a squatting position, or rises with each change of feet, barrel rolls, coffee grinders, and other gravity defying figures. The women's virtuosic figures consist of rapid spot turns or stamping figures, neither of which occurs in any of the films that I have seen of in the field Russian dancing.

Partisans (Partizani)

In *The Partisans*, for example, Moiseyev uses two movements in the beginning and end of the work in which the dancers, wearing floor-length capes, made of stiff felt, glide smoothly, or lope, as if on horseback, and in part two, casting aside the capes for the battle scene, they employ a piston-like rapid up and down movement of the legs. As the dancers glide onto the stage, audiences greet them with huge rounds of applause. Then, typical of many Moiseyev choreographies, the individual dancers begin a series of virtuosic athletic tricks and feats. Atypically, two or three female dancers, dressed in the same battle clothing as the men perform these same feats, but at the end they pull of their caps, letting their hair fall and exposing themselves as women, at which point the audience goes wild with appreciation for the female artists performing male steps and figures.

Dance historian Mary Grace Swift notes, "One of the most successful numbers every given by the Moiseyev Folk Dance ensemble is their depiction of the Partisans" (116). Audiences view with appreciation, over and over, the *Partisans (Partizani)*, the *Gopak*, and *Leto (Summer),* and other favorite works from the cornucopia of The Igor Moiseyev Dance Company repertoire, knowing that they can savor why they purchased their tickets to see the magic of Igor Moiseyev's choreographies. As the first dancers enter gliding around the stage, I always react with awe – it never fails to be exciting.

Once the Soviet repertory was established, Moiseyev turned to the dances of other countries: Hungary, Bulgaria, Poland, Greece, Egypt, Spain, and Argentina, among others. His depiction of Argentine gaucho dances displays a spectacular example of Moiseyev's talents.

The influence of Igor Moiseyev on newly founded dance companies in both the Soviet sphere, like Hungary, Poland, and Bulgaria, and Egyptian companies, as I stress several times, was very strong and resonates even today in productions like the Irish *Riverdance*

productions (see Shay, *Choreographic Politics*). As Kapper observes: "Influences of Soviet colonial rule have remained deeply embedded in Estonian collective bodily memory [...]. Colonial echoes of the soviet regime are visible not just in national staged dance performed by thousands of well-coordinated dancers at dance celebrations in huge stadiums [...] [but] also in small amateur dance groups, on the stages of local community and culture centers" (8, 10). My recent viewing, via YouTube, of dance companies in the former Soviet Union, including Uzbekistan, Georgia, Armenia, Tajikistan, and Azerbaijan, indicate that following the collapse of the former Soviet Union, the Moiseyev dance tradition has remained intact and the national companies, as well as amateur ensembles, in those regions continue to receive state support. Thus, Igor Moiseyev's creative vision lives on in the bodily memory of thousands of dancers.

Notes

Introduction

1 No person is born in a vacuum and few thoughts are original – they stem from reading and exposure to the intellectual furniture each of us lives with. Italian folklorist Giuseppe Coccharia (*The History of Folklore in Europe*) lays out the intellectual genealogy that informed Herder's thinking in great detail, which is beyond the scope of this study.

2 In spite of the name of these schools, choreography, the creation of dances, was not taught, but rather they existed to create professional dancers.

3 To this day a city the size of Los Angeles has never supported a professional-level ballet company. Financing for companies in America often comes mainly from old money, and Los Angeles is by and large nouveaux riches money who have little use for the arts.

4 This is the official version of the founding of the company. In a country as highly planned and supervised as the former Soviet Union, I believe that someone high in the government tapped Moiseyev to found the company.

Chapter 1

1 This is an expanded version of "The Spectacularization of Soviet/Russian Folk Dance: Igor Moiseyev and the Invented Tradition of Staged Folk Dance" that appeared in the *Oxford Handbook of Dance and Ethnicity*, edited by Anthony Shay and Barbara Sellers-Young, NY: Oxford University Press, 2016.

2 For photographic examples of monumental art, and socialist realism see Bown (*Art Under Stalin*, especially images 122 and 125, as well as the jacket cover).

3 Augustus reigned from 27 BC, and the first known performances of pantomime occurred in 22 or 23 BC.

4 Spectacle was not found only in European courts. Certainly spectacular court dances such as Japanese bugaku existed in Asia earlier than the *ballet de cour*, but is beyond the scope of this study.

5 The Igor Moiseyev Dance Company performed a parody of the decadent West performing rock 'n roll dances called "Back to the Apes."

6 Dance historian Lisa M. Overholser chronicles a similar pattern in Hungary. During that period the Pearly Bouquet (*Gyöngyösbókréta*) movement, a movement that was created to use a type of character dance, rather than actual folk dance. In the 1950s I danced in

the Hungarian community folk dance group in Los Angeles that was directed by Laszlo Tabanyi, who was a member of the Pearly Bouquet movement as well as a character actor in Hungarian cinema and theater in the 1920s and 1930s and he taught us the dances that he had performed, which at the time many of us thought were authentic Hungarian folk dances. This was clearly a character dance form, derived from classical ballet, because the steps and figures of the *csardas* are the same as those depicted in Jurgen Pagels's book on character dance (106–19).

7 For information about the *dekady*, see Swift 159–62, passim.

8 Douglas Kennedy (*The Spectator and the Spectacle*) describes several instances of audience behavior in other cultures such as in India and Japan.

9 Victoria Anne Hallinan in her valuable study ("Cold War Cultural Exchange") attempts to analyze audience response in great detail, and I will let the interested reader consult her study for that aspect of The Igor Moiseyev Dance Company performances. I saw audience responses to The Igor Moiseyev Dance Company's performances personally. I know how difficult such analysis is.

10 Joan Lawson translated portions of the Tkachenko volume for the interested reader in two small volumes. They contain some of the choreographies with a description of the steps and movements required to perform them (*Soviet Dances, More Soviet Dances*). The books do not include the brief historical and ethnographic descriptions that are included in the Russian-language original volume.

11 Following the model set by Tkachenko, Uzbek dancer Roza Karimova (*Ferganskii tanets, Khorezemskii tanets, Bukharskii tanets, Tantsy Ansambl'a Bakhor*) published a set of books on Uzbek dance using the same types of illustrations and named vocabulary of movements.

12 Dance historian Lynn Garafola writes that Michel Fokine the first of the Diaghilev choreographers for the Ballets Russes developed a genre nouveau, which was a dance genre in which realism "was the foundation of Fokine's poetic, ethnic material provided the bricks and mortar" (*Diaghilev's Ballets Russes* 11). She adds, "by the end of the [nineteenth] century, character dancing expressed little more than national stereotypes dressed in sanitized piquancy" (11). According to Garafola, Fokine attempted to restore more authenticity into character dancing. For Chopiniana, Fokine used a tarantella, and other character dances, although these were later removed. Margarita Isareva states that "Moiseyev was greatly influenced by Michel Fokine's Chopiniana" (444), but she did not indicate whether it was the version with character dances or without. If, however, as Garafola claims, "Fokine never abandoned the language of ballet" (*Diaghilev's Ballets Russes* 35), then Igor Moiseyev clearly developed a new dance genre, perhaps inspired by Fokine's character dance examples.

Chapter 2

1 I took the title "The Nation Dances" from the title of a film that the Soviet government made of the Moiseyev Company and from which the Gandy Dancers, a folk dance group I belonged to, learned several of the choreographies we performed. The Soviet Consulate in

San Francisco let us use it. At the time we did not know that it was The Igor Moiseyev Dance Company, because, of course, they used the formal Russian name: The State Academic Ensemble of Folk Dances of the People of the USSR that was used when the company danced at home, and it was the official title. Currently, the company is known as The Igor Moiseyev Ballet.

2 My friend Philip C. Nix reminded me after reading this chapter that in the 1950s a kind of romantic religious movement was afoot in America, in the shape of popular culture figures like Bishop Fulton Sheen and Billy Graham, both of whom wrote popular books and had radio broadcasts. "God is everywhere: He was in 10,000 balloons containing Bibles which were floated across the Iron Curtain by the Bible Balloon Project in 1954" (Saunders 235). They believed that by this act they could foment revolution against the "godless" communists.

3 Some Macedonians sometimes refer to Alexander The Great to evoke some kind of ancient Macedonian identity; however, Alexander was not a Slav, like contemporary Macedonians are. The ancient Macedonians were a separate ethnic group with their own language that has long ago disappeared (Poulton, *Who are the Macedonians?*). It would appear that the Slavs who invaded the Balkans in the sixth and seventh centuries settled in the area that had been formerly known as Macedonia and took the name.

4 The question of national and ethnic identity in Central Asia came up in three visits to Uzbekistan and Tajikistan in 1976, 1979, and 1989, and subsequently at a 1995 NEH summer seminar at Dartmouth under the direction of Dale Eickleman entitled "Reimagining the Middle East and Central Asia" during which I did considerable research into the issue. It is beyond the scope of a study of Russian nationalism to discuss the intricate details of Central Asian identity formation, but the subject provides considerable insight into the working of the nationalism issue in the former Soviet Union, as well as how the successor states in that region came into being. I recommend Hirsch 160–86; Rywkin ch. 4; G. Smith, Part VI.

5 Shortly after The Igor Moiseyev Dance Company appeared in the United States in 1958, an all-female ensemble, Beryozka, appeared. (The company later added male dancers.) However, Americans did not respond with much enthusiasm according to ticket sales, and they almost went under the radar of the concert public demonstrating that Americans, like many others, love spectacle.

6 Typical of the confusion and conflation of the terms was the 1959 tour of Sol Hurok Presents: Russian Festival of Music and Dance, which featured artists not only from Russia, but also Ukraine, Georgia, Armenia, and Uzbekistan. Thus, the Russian Festival was in fact a Soviet festival. It had a large cast including The Igor Moiseyev Dance Company members, the Pyatnitsky chorus, orchestra, and dancers, soloists from the Bolshoi and Kirov Ballet companies, members of the Ukrainian State Folk Dance Company, the Armenian State Folk Ensemble, the Georgian State Folk Dance Ensemble, and Uzbek soloist Galya Ismailova, whom I later met in Tashkent (*Russian Festival of Music and Dance*).

7 I took the notion of "Staging Russia" from Laura J. Olson's exemplary study of revivalist folk music in Russia, *Performing Russia*.

8 Laura J. Olson's study, *Performing Russia* provides a detailed study of this important revivalist movement. It is important to note that authentic Russian folk music and dance

continue to be performed, as do the former large-scale ensembles that characterized the Soviet period. The Moiseyev Ballet, as the company is now known, continues to prosper, as does the Pyatnitsky Chorus.

Chapter 3

1 The actual number of performers differs in almost all of the sources. That number of performers probably varied throughout the company's history. This might also indicate that some sources count only the performers, that is, dancers and musicians, while others might include staff, such as costumers, wardrobe workers, boot and shoemakers, masseurs, and other personnel.

2 For most Americans, including some scholars and writers, the terms Russian and Soviet were used interchangeably even though the Soviet Union was home to nearly two hundred ethnic groups, of which the Russians made up about half of the population of the former Soviet Union.

3 The term "Communism" was frequently interchanged with "Socialism," the effect of which is clearly still visible in the 2016 election cycle, in which Bernie Sanders, a self-described Western European-style socialist is laughingly equated to a Communist by the Republican candidates. I heard Donald Trump call Sanders a Communist in one of his rallies. Trump knew that the epithet Socialist was still equated with Communist among his supporters.

4 By saying that "women hardly counted in the 1950s," I am not trying to be provocative or anti-feminist, but rather to stress the fact that the American government attempted to drive women, who had taken men's places in factories and other work sites during World War II, back into their roles as domestic housewives, which historian Helen Laville characterizes as, "[…] the US promoted the measurement of the status of women according to what it argued were universal gender roles, which prioritized domesticity and consumerism" (524). In other words, women should stay home, "barefoot and pregnant," and look and dress like Harriet Nelson (from the TV show *The Adventures of Ozzie and Harriet*), and Lucille Ball, and above all buy. I remember, too, an attack on mothers who were blamed for producing and raising "soft" boys and were the clear reason that men became gay, resulting in the famous public bathroom graffiti: "My mother made me a homosexual" and its riposte: "Can she knit me one, too?" Laville noted a similar attitude toward women retaining traditional gender roles: "Strongly defined gender roles served as a bulwark against internal subversion and dangerous political ideologies" (525). Internal subversion was ultimately reduced to an attack on homosexuals. "[…] fears of vulnerability to communist subversion as a result of weak domestic structures went hand in hand with fears of sexual 'abnormalities' such as homosexuality and oedipal desires" (525). Thus, if women did not stay in their proper place, the home, they caused the weakening of masculinity and the creation of gay children, endangering American civilization. See also Gilbert 2005. Gilbert notes, "In a kind of Freudian nightmare, Moms seized the initiative in raising sons and in doing so, refused to allow them to mature, resulting in a variety of aberrant behaviors " (67).

5 My colleague Jonathan Hall stated, "they still exist" (personal interview, April 8, 2016).

6 Hallinan in her dissertation has listed the Moiseyev program repertories for 1958, 1965, and 1970, but, in addition to those programs, which I have in my files, I also have a program for 1961, which is signed by Igor Moiseyev, as well as several programs for later years extending into the twenty-first century. These programs are valuable to observe what types of dances were chosen to show to American audiences.

7 The Dance Panel ultimately did select the Berea College Folk Dance Group, an amateur company based at Berea College, Kentucky, that performed the dances and music of Appalachia throughout Central and South America. Naima Prevots observes, "The reports on the Berea dancers were all positive" (119).

8 See especially Prevots (31–35) for a sample of the hearings.

9 In the Soviet Union, The Igor Moiseyev Dance Company was known as the State Academic Ensemble of Folk Dances of the Peoples of the Union of Socialist Soviet Republics. Sol Hurok called the group The Igor Moiseyev Dance Company. After the collapse of the Soviet Union, the official name was shortened to the State Academic Ensemble of Folk Dances under the direction of Igor Moiseyev. Today it is called the Moiseyev Ballet.

10 I know this from having served for several years as a site visitor and a recipient of choreographic fellowships until the Republican congress cut individual fellowships in the wake of the Robert Mapplethorpe kerfuffle.

11 I want to thank Jonathan M. Hall for calling my attention to the Asian issues during this time period.

Chapter 4

1 This chronology shows the highlights of Moiseyev's long career. For a complete chronology of awards, honors, and choreographies, see Shamina and Moiseyeva, *Teatr Igoria Moiseyeva*; Koptelova, *Igor' Moiseyev: Akedemik*; and Moiseyev, *Ya Vspominaiu*, updated edition.

2 The question of possible Jewish origins becomes important because of the savage anti-Semitism that existed during the Stalin era when being Jewish could condemn someone to death or being sent to the Gulag. The Igor Moiseyev Dance Company was, reportedly, Stalin's favorite arts group. Moiseyev relates how he was called into the NKVD, and had a later brush with them and he worried if he would be able to walk out alive. A second reason that I thought that he might be Jewish revolved around the fact that the Moiseyev family, shortly after his birth in 1906 moved from Kiev to Paris. That was the year that Kiev was racked by a series of ferocious pogroms. A third reason suggested it to me is that after the fall of the Soviet Union, Moiseyev choreographed a Jewish wedding.

3 Kristin Roth-Ey notes, "What happened on the Soviet music scene after Stalin's death was an eruption of activity outside the official channels and a pattern of fitful official accommodation. By the mid-fifties, according to S. Frederick Starr, every town in the Soviet Union had a jazz band. [...] In the sixties and beyond, jazz and rock 'n roll could be heard performed at university and factory clubs, hotels restaurants, festivals, and even on radio and television" (164).

4 Christina Ezrahi identifies "antiformalism" in classical ballet: "[…] Creating a ballet based on a plot celebrating socialist life was simply not enough. Lopukhov's reliance on virtuoso classical dance to depict the life in a kolkhoz the Kuban was branded as formalism" (32).

5 In Russian the English word "choreographer" is rendered as "baletmeister" (ballet master), a term that is often used for a person who runs dance rehearsals and warm-ups.

6 I want to make clear that Igor Moiseyev was not the only individual creating folk and/or national dances in the Soviet Union at that time; however, unlike Moiseyev, most of these individuals were creating choreographic genres that were related to a single republic. For example, Pavlo Virsky was creating staged Ukrainian dances almost contemporaneously with Moiseyev (see Hemeniuk, *Ukrains'ki narodni tantsi*). In Uzbekistan, Mukarram Turganbaeva and others created a new "classical" style based on the dancing of the professional dancing boys (banned by the Soviet authorizes and never officially mentioned as a source of this new genre). See Karimova (*Ferganskii tanets, Khorezemskii tanets, Bukharskii tanets, Tantsy Ansambl'a Bakhor*).

7 I took the title for this section from Clare Croft's title (*Dancers as Diplomats*).

Chapter 5

1 Various sources cite both 1936 and 1937 as the founding years. This depends upon whether one dates it from the planning stages in 1936 (see Shamina and Moiseyeva 38) or from the first rehearsal, which in the Moiseyev legend began in February, 1937.

2 The number of dancers and musicians varies widely from source to source. The company was funded better in its earlier years.

Chapter 6

1 For a thorough discussion of Russian folk, traditional, popular, and classical music, including dance music, see Zemtsovsky, "Russia."

2 Russell Zguta claims that the skomorokhi: "I believe were originally priests of the pagan religion of the Eastern Slavs [Russians, Ukrainians, and Belarus], much of what is regarded as native in Russian culture might not have survived. In other words, it was not as professional minstrels, as is normally assumed, that the skomorokhi made their most significant contribution to Russian music, dance, theatre, and oral tradition, but rather as former cult leaders. It was in this capacity that they became, after 988 [the year of Christian conversion of the Kievan Rus' nobility] the heirs of a discredited native, pagan culture, which they kept alive for hundreds of years in the face of intense persecution and pervasive foreign (Byzantine and Western) influence (xiii). It is well beyond the scope of this study to delve into this startling claim, but certainly the Orthodox clergy damned them for singing pagan songs.

3 Many authentic dances from Russia can be viewed on the JVC Video *World Music and Dance*, volume 23. The video powerfully demonstrates my parallel traditions concept in

showing many levels of performances from clearly ethnographic scenes of amateurs who have not performed before cameras or audiences, mostly elderly villagers filmed out of doors, to what are groups that have been formed to show Russian village dances, sometimes filmed in a television studio. The demeanor of the latter dancers is sophisticated, they wear makeup, modern hairstyles and they smile at their audience. These performances can be compared to the performances of the Moiseyev Company listed in the "references" section below.

4 All translations from Russian are my own unless otherwise noted. I enjoyed the opening sentence in the Tamara Tkachenko chapter on Russian dance: "The leading role in the brotherly Soviet family belongs to the great and powerful Russian people who lighted the path to communism for the workers of the world" (15). It has a wonderful historical and quaint ring. The dances that Tkachenko describes are ethno-identity dances, that is, folk dances prepared for stage by professional choreographers like Igor Moiseyev.

5 Finnish scholar Petri Hoppu has written about the Skolt Sámi, a reindeer herding nomads in the far north of Finland, Norway and mostly neighboring Russia also, who under the influence of neighboring Russian inhabitants have naturalized the quadrille into their folk repertory. Hoppu notes, "The quadrille has become emblematic of the Skolt culture […]" (126).

6 This was also characteristic of other Eastern European countries in which young people flocked to newly opened clubs and institutions to pursue folk dance as way of exercising and socializing, but also as a means of expressing national feelings (Hanibal Dundović, personal interview, May 1, 2008).

7 Of the several similar agricultural dances I have viewed was *pakhta*, a dance about the cotton harvest in Uzbekistan; the Georgian State Ensemble performed an orange harvest dance, but one of the most amusing dance was a corn harvest dance created for the Ukrainian State Dance Ensemble in which the girls were the corn, tricked out in green and yellow costumes, with plastic corn ears depended from their sashes, and they were "harvested" by four boys in overalls with bibs. Moiseyev mentions several of these dances as examples of how to bring realism to dance, and suggests that such dances could enrich ballet.

8 While I was a member of the Gandy Dancers in the 1950s, we performed several of the dances that Avramenko choreographed, as taught to us by the late Vincent Evanchuk who was born and raised in a Canadian Ukrainian community. We danced *Kolomyka, Arkan, Kateryna, Hopak, Honyviter,* and *Metelytsa,* among others. Ukrainian dance historian Andriy Nahachewsky notes that "Ukrainian dance is strongly underrepresented in the activities of the international folk dance movement" of which the Gandy Dancers were a part (132). The Gandy Dancers were the exception. Not only was Vince Evanchuk a gifted dancer and teacher, but the Gandy Dancers boasted the strongest dance talent required to perform the physically demanding Ukrainian character dances, among the hundred or more folk dance clubs in Southern California during that period.

9 Tamara Tkachenko in her 1954 large compendium, *Narodny Tanec,* and the many handbooks with dance instructions that followed (without authorial credits). Those publications have codified and laid out this new style of dance in great detail. Each section begins with a short history of the dance traditions of each republic, then the movements employed, followed

by sample choreographies. It is important to stress that while this new style of dance is informed by classical ballet character dance, it is very different.

10 See, for example, the New Year (Nav ruz) celebrations in Tashkent, Uzbekistan on YouTube. The careful viewer can see the influence of Igor Moiseyev's choreographic style and strategies in the dancing. One can also view the types of Russian athleticism in the men's dancing, which did not exist in Uzbek male dancing before its inclusion in the Soviet Union. See also the dances from Turkmenia.

11 The Hungarian State Folk Dance Ensemble, Mazowsze, The Philip Koutev Ensemble of Bulgaria, and Ballet Folklorico of Mexico all had large choruses that sang in four-part harmony with Western bel canto styles of singing. Ballet Folklorico de Mexico dropped the chorus after several years because the costs of maintaining the chorus was prohibitive, although Amalia Hernandez achieved some interesting choreographic spectacular effects using the chorus to move. The Hungarian State Folk Dance Ensemble phased out the chorus after several decades for aesthetic reasons. The four-part singing was too distant from village practices. Instead they used the dancers to sing in a village style to achieve a more authentic impression, with great success.

12 Kodat sells Igor Moiseyev short. As we will see in the chapter on Moiseyev's life in this study, in his youth, Igor Moiseyev, as a dancer and beginning choreographer was very attracted to the avant-garde, attending salons at the residence of Anatoly Lunacharsky, a theater critic and the first Soviet Minister of Education, under Lenin, and Moiseyev suffered for defending his mentor, Kasyan Goleizovsky's modernist choreographies in the Bolshoi Ballet, ultimately causing him to leave. He was very vocal in his call for modernization in the Bolshoi, which he called "stagnant," publishing his opinion in Russian literary and artistic journals (see Slonimsky et al. 64; Brinson 11–19).

References

Abbot, Alana Joli. "Igor Moiseyev." *Newsmakers: 2009 Cumulation*, edited by Laura Avery, Gale, 2009, pp. 144–45.

Allen, Lindsay. *The Persian Empire*. University of Chicago Press, 2005.

Anderson, Jack. "Igor Moiseyev, Choreographer of Balletic Russian Folk Dance dies at 101." *New York Times*, Section B, Column 0, Art/Cultural Desk, 2007.

Arango, Tim. "Reviving an Old Idea for an Iraq Still in Turmoil: Splitting It Up." *New York Times*, International, A6, Apr. 29, 2016.

Arkin, Lisa C. and Marian Smith. "National Dance in the Romantic Ballet." *Rethinking the Sylph: New Perspectives on the Romantic Ballet*, edited by Lynn Garafola, Wesleyan University Press, 1997, pp. 11–68.

Barnes, Clive. "Attitude: Igor Moiseyev." *Dance Magazine*, vol. 80, no. 1, Jan. 2006, p. 242.

———. "Igor Moiseyev." *Dance Magazine*, Obituary, vol. 82, Feb. 2008, p. 138.

Barthes, Roland. *Mythologies*, The Noonday Press, 1972.

Bayanihan. Bayanihan Folk Arts Center, 1987.

Beacham, Richard C. *Spectacle Entertainments of Early Imperial Rome.* Yale University Press, 1999.

Belletto, Steven. *No Accident, Comrade: Chance and Design in Cold War American Narratives.* Oxford University Press, 2012.

Belmonte, Laura A. *Selling the American Way: U.S Propaganda and the Cold War.* University of Pennsylvania Press, 2008.

Bown, Matthew Cullerne. *Art Under Stalin*, Homes & Meier, 1991.

Brinson, Peter, editor. *Ulanova, Moiseyev and Zakharov on Soviet Ballet*, SCR, 1954.

"Britain in Disarray." Editorial. *New York Times*, June 10, 2017, p. A–22.

Brubaker, Rogers. *Nationalism Reframed: Nationhood and the National Question in the New Europe*, Cambridge University Press, 1996.

Brudny, Yitzhak M. *Reinventing Russia: Russian Nationalism and the Soviet State, 1953–1991*, Harvard University Press, 1998.

Buckland, Theresa J. *Dance in the Field: Theories, Methods, and Issues in Dance Ethnography*, St. Martin's Press, 1999.

Burt, Ramsay. *Alien Bodies: Representations of Modernity, Race and Nation in Early Modern Dance*, Routledge, 1998.

Calhoun, Craig. *Nationalism*, University of Minnesota Press, 1997.

Caute, David. *The Dancer Defects: The Struggle for Cultural Supremacy during the Cold War*, Oxford University Press, 2003.

Chudnovsky, Mikhael A. *Folk Dance Company of the USSR: Igor Moiseyev, Art Director*, Foreign Languages Publishing House, 1959.

Clover, Charles. *Black Wind, White Snow: The Rise of Russia's New Nationalism*, Yale University Press, 2016.

Coakley, John. *Nationalism, Ethnicity, and the State: Making and Breaking Nations*, Sage, 2012.

Coccharia, Giuseppe. *The History of Folklore in Europe*. Translated from the Italian by John N. McDaniel, Institute for the Study of Human Issues, 1981.

Cohen, Roger. "The Trump Possibility." *New York Times*, October 4, 2016, p. A–21.

Cohen, Ronald D. *Rainbow Quest: The Folk Music Revival and American Society, 1940–1970*, University of Massachusetts Press, 2002.

Connor, Walker. *Ethnonationalism: The Quest for Understanding*. Princeton, Princeton University Press, 1994.

Conquest, Robert. *The Harvest of Sorrow: Soviet Collectivization and the Terror-Famine*, Oxford University Press, 1986.

Corber, Robert J. *In the Name of National Security: Hitchcock, Homophobia, and the Political Construction of Power in Postwar America*, Duke University Press, 1993.

Cowart, Georgia J. *The Triumph of Pleasure: Louis XIV and the Politics of Spectacle*, University of Chicago Press, 2008.

Croft, Clare. *Dancers as Diplomats: American Choreography in Cultural Exchange*, Oxford University Press, 2015.

Cuordileone, K. A. *Manhood and American Political Culture in the Cold War*, Routledge, 2005.

"Dancing." WNET. Directed by Rhoda Grauer, 1992.

"Dancing is Pain: Captivated by Genius." RT and TV Novosti, 2015.

Debord, Guy. *Society of the Spectacle*, Black and Red, 2010 (reprint).

Demidov, Alexander. *The Russian Ballet Past and Present*. Translated by Guy Daniels, Doubleday & Company. Novosti Press Agency Publishing House, Moscow, 1977.

Dixon, Simon. "The Russians and the Russian Question." *The Nationalities Question in the Post-Soviet State*, edited by Graham Smith, Longman, 1996, pp. 47–74.

Dodge, Hazel. "Amusing the Masses: Buildings for Entertainment and Leisure in the Roman World." *Life, Death, and Entertainment in the Roman Empire*, edited by D. S. Potter and D. J. Mattingly, University of Michigan Press, 2010, pp. 229–79.

Don Cossacks of Rostov. Program, September 25, 1999.

Dundović, Hanibal. Former member and artistic director of Lado, Croatian State Folk Dance Ensemble, Zagreb, Croatia. May 1, 2008.

Eley, Geoff and Ronald Grigor Suny. "Introduction: From the Moment of Social History to the Work of Cultural Representation." *Becoming National: A Reader*, edited by Geoff Eley and Ronald Grigor Suny, Oxford University Press, 1996, pp. 3–27.

Erdbrink, Thomas. "After Attacks, Many Argue against a United Belgium". *New York Times*, April 8, 2016, p. A8.

Eriksen, Thomas Hylland. *Ethnicity and Nationalism*, 2nd ed., Pluto Press.

Ezrahi Christina. *Swans of the Kremlin: Ballet and Power in Soviet Russia*, University of Pittsburgh Press, 2012.

Ferenc, Anna. "Music in the Socialist State." *Soviet Music and Society under Lenin and Stalin: The Baton and Sickle*, edited by Neil Edmunds, Routledge, 2004, pp. 8–18.

Field, Douglas. "Introduction." *American Cold War Culture*, edited by Douglas Field, Edinburgh University Press, 2005, pp. 1–13.

Figes, Orlando. *Natasha's Dance: A Cultural History of Russia*, Picador, 2002.

Filanovskaya, Tatyana Aleksandrovna. *Istoriia Khoreograficheskovo Obrazovaniia v Rossii*, Planeta Muzyiki, 2016.

Fisher, Max. "Russian Meddling Was a Drop in an Ocean of American-Made Discord." *New York Times*, February 2, 2018, p.

Foner, Eric. "Introduction." *Dance for Export: Cultural Diplomacy and the Cold War*, edited by Naima Prevots, Wesleyan University Press, Published by the University Press of New England, 1998, pp. 1–9.

Fredrickson, George M. *Racism: A Short History*, Princeton University Press, 2002.

Freeze, Gregory L. "From Stalinism to Stagnation, 1953–1985." *Russia: A History*, edited by Gregory L. Freeze, Oxford University Press, 2002, pp. 319–82.

Fuller, William C., Jr. "The Great Fatherland War and Late Stalinism: 1941–1953." *Russia: A History*, edited by Gregory L. Freeze, Oxford University Press, 2002, pp. 319–46.

Gaddis, John Lewis. *The Cold War: A New History*, Penguin Books, 2007.

Garafola, Lynn. *Diaghilev's Ballets Russes*, Da Capo Press, 1989.

———. "Introduction." *Rethinking the Sylph: New Perspectives on the Romantic Ballet*, edited by Lynn Garafola, Wesleyan University Press, 1997, pp. 1–10.

Garrels, Anne. *Putin Country: A Journey into the Real Russia*, Farrar, Strauss, and Giroux, 2016.

Garoian, Charles R. and Yvonne M. Gaudelius. *Spectacle Pedagogy: Art, Politics, and Visual Culture*, State University of New York Press, 2008.

Gellner, Ernest. *Nations and Nationalism*, Cornell University Press, 1983.

Giersdorf, Jens Richard. *The Body of the People: East German Dance Since 1945*, University of Wisconsin Press, 2013.

Gilbert, James. *Men in the Middle: Searching for Masculinity in the 1950s*, Chicago University Press, 2005.

Gilbert, Paul. *The Philosophy of Nationalism*, Westview Press, 1998.

Goldstein, Richard. "Igor Moiseyev." Obituary. *International Herald Tribune* [Paris], November 3, 2007, p. 3.

Goldsworthy, Adrian. *Caesar: Life of a Colossus*, Yale University Press, 2006.

Graff, Ellen. "The Dance Is a Weapon." *Moving History/Dancing Culture: A Dance History Reader*, edited by Ann Dils and Ann Cooper Albright Wesleyan University Press, 2001, pp. 315–22.

Greenfeld, Liah. *Nationalism: Five Roads to Modernity*, Harvard University Press, 1992.

Guroff, Gregory and Alexander Guroff. "The Paradox of Russian National Identity." *National Identity and Ethnicity in Russia and the New States of Eurasia*, edited by Roman Szporluk, M. E. Sharpe, 1994, pp. 78–100.

Guss, David M. *The Festive State: Race, Ethnicity, and Nationalism as Cultural Performance*, University of California Press, 2000.

Halberstam, David. *The Fifties*, The Random House Publishing Group, 1993.

Hall, John A., editor. *The State of the Nation: Ernest Gellner and the Theory of Nationalism*, Cambridge University Press, 1998.

Hall, Jonathan Mark. Asst. Professor of Media Studies, Pomona College. March 24, 2016.

Hallinan, Victoria Anne. "Cold War Cultural Exchange and the Moiseyev Dance Company: American Perception of Soviet Peoples." Ph.D. Dissertation, Northeastern University, 2013.

Harkins, William E. "Preface." *Folklore for Stalin: Russian Folklore and Pseuofolklore of the Stalin Era*, edited by Frank J. Miller, M. E. Sharpe, 1990, pp. ix–xii.

Hedges, Chris. *Empire of Illusion: The End of Literacy and the Triumph of Spectacle*, Nation Books, 2009.

Hemeniuk, Andrii. *Ukrains'ki narodni tantsi*, Akademia Nauk Ukrain'skoi RSR, 1962.

Hicks, Jim. *The Persians*, Time Life, 1975.

Hilton, Wendy. *Dance of Court and Theater: The French Noble Style, 1690–1725*, Princeton Book Publishers, 1981.

Hirsch, Francine. *Empire of Nations: Ethnographic Knowledge and the Making of the Soviet Union*, Cornell University Press, 2005.

Hobsbawm, Eric and Terence Ranger, editors. *The Invention of Tradition*, Cambridge University Press, 1983.

Hodel-Hones, Sigrid. *Life and Death in Ancient Egypt: Scenes from Private Tombs in New Kingdom Thebes*, Cornell University Press, 2000.

Hoppu, Petri. "Dancing Multiple Identities: Preserving and Revitalizing Dances of the Skolt Sámi." *Oxford Handbook of Dance and Ethnicity*, edited by Anthony Shay and Barbara Sellers-Young, Oxford University Press, 2016, pp. 114–30.

Husband, William B. "The New Economic Policy (NEP) and the Revolutionary Experiment: 1921–1929." *Russia: A History*, edited by Gregory L. Freeze, Oxford University Press, 2002, pp. 263–90.

Ilupina, Anna and Yelena Lutskaya. *Moiseyev's Dance Company*, Progress Publishers, 1966.

Isareva, Margaritia. "Moiseyev, Igor." *International Encyclopedia of Dance*, Oxford University Press, 1998, pp. 443–46.

Iving, Victor. "The Russian Dance". *The Soviet Ballet*, edited by Juri Slonimsky and Others, Philosophical Library, 1947.

Johnson, David K. *The Lavender Scare: The Cold War Persecution of Gays and Lesbians in the Federal Government*, University of Chicago Press, 2004.

Jonas, Gerald. *Dancing: The Pleasure, Power, and Art of Movement*, Abrams, 1992.

Jory, John. "The Pantomime Dancer and His Libretto." *New Directions in Ancient Pantomime*, edited by Edith Hall and Rosie Wyles, Oxford University Press, 2008, pp. 157–63.

Jouglet, René. *Mazowsze: Chant et Danses du Folklore Polonais*, Cercle d'Art, 1954.

"JVC: World Music and Dance." vol 23. Soviet Union.

Kairser, Charles. *The Gay Metropolis*, Grove Press, 2007.

Kapper, Sille. "Post-colonial Folk Dancing: Reflections on the Impact of Stage Folk Dance Style on Traditional Dance Variation in Soviet and post-Soviet Estonia." *Journal of Baltic Studies*, vol. 47, no. 1, 2016.

Karimova, Roza. *Bukharskii tanets*, Literatura i Isskustvo, 1977.

———. *Ferganskii tanets*, Literatura i Isskustvo, 1973.

———. *Khorezemskii tanets*, Literatura i Isskustvo, 1975.

———. *Tantsy Ansambl'a Bakhor*, Literatura i Isskustvo, 1979.

Keating, Joshua. "The US Likes the World Map the Way It Is." *New York Times*, Sunday Review, September 24, 2017, p. 10.

Kenez, Peter. *A History of the Soviet Union from the Beginning to the End*. 2nd ed., Cambridge University Press, 2006.

Kennedy, Dennis. *Manhood in America: A Cultural History*, 2nd ed., Oxford University Press, 2006.

———. *The Spectator and the Spectacle*, Cambridge University Press, 2009.

Kinsey, Alfred C., Wardell B. Pomeroy, and Clyde E. Martin. *Sexual Behavior in the Human Male*, Indiana University Press, 1948.

———. *Sexual Behavior in the Human Female*, Indiana University Press, 1953.

Kisselgoff, Anna. "A Visionary of Balletic Folk Dance Turns 100." *New York Times*, January 8, 2006, p. C1, 13.

———. "Moiseyev Company Visits with Its Legendary Bravura." *New York Times*, September 26, 1991, publicity packet.

Kodat, Catherine Gunther. *Don't Act, Just Dance: The Metapolitics of Cold War Culture*, Rutgers University Press, 2015.

Koptelova, Evgeniia Dmitrevna. *Igor Moiseyev: Akedemik I Filosofov Tantsa*, Planeta Muziki, 2012.

Kouteva, Maria. *Našite 15 Godini*, Nauka I Iskustvo, 1966.

Krickovic, Andrej. Professor at the Institutes of Higher Economics, Moscow. Lecture and Personal Interview. Cres, Croatia, July 10, 2017.

Kyle, Donald G. *Sport and Spectacle in the Ancient World*, 2nd ed., Wiley Blackwell, 2015.

Lada-Richards, Ismene. *Silent eloquence: Lucian and Pantomime Dancing*, Duckworth, 2007.

LaPasha, Robin. "Amateurs and Enthusiasts: Folk Music and the Soviet State on Stage in the 1930s." *Soviet Music and Society under Lenin and Stalin: The Baton and Sickle*, edited by Neil Edmunds, Routledge, 2004, pp. 123–47.

Larson, Gary O. *The Reluctant Patron: The United States Government and the Arts, 1943–1965*, University of Pennsylvania Press, 1983.

Laruelle, Marléne. "Rethinking Russian Nationalism: Historical Continuity, Political Diversity, and Doctrinal Fragmentation." *Russian Nationalism and the National Reassertion of Russia*, edited by Marléne Laruelle, Routledge, 2009, pp. 13–48.

Laruelle, Marléne, editor. *Russian Nationalism, Foreign Policy, and Identity Debates in Putin's Russia, Ibidem*-Verlag, 2012a.

———. "Negotiating History: Memory Wars in the Near Abroad and the Pro-Kremlin Youth Movements." Marléne Laruelle, editor. *Russian Nationalism, Foreign Policy, and Identity Debates in Putin's Russia, Ibidem*-Verlag, 2012b, pp. 75–103.

Lasch, Christopher. *The Culture of Narcissism: American Life in an Age of Diminishing Expectations*, Norton, 1991.

Laville, Helen. "Gender and Women's Rights in the Cold War." *The Oxford Handbook of the Cold War*, edited by Richard H. Immerman and Petra Goedde, Oxford University Press, 2013, pp. 523–39.

Lawson, Joan. *Soviet Dances*, The Imperial Society of Teachers of Dancing, 1963.

———. *More Soviet Dances*, The Imperial Society of Teachers of Dancing, 1965.

Levin, Theodore. "Dmitri Pokrovsky and the Russian Folk Music Revival Movement." *Returning Culture: Musical Changes in Central and Eastern Europe*, edited by Mark Slobin, Duke University Press, 1996, pp. 14–36.

Lipfert, David. "Journeys to the Ends of the Earth." *The Dancers' Magazine*, vol. 16, no. 3, 2002, p. 17.

Lopoukov, Andrei, Alexander Shirayev, and Alexander Bocharov. *Character Dance*. Translated by Joan Lawson, Dance Books, 1986 [1939].

Loutzaki, Irene. "Dance as Propaganda: The Metaxas Regime's Stadium Ceremonies, 1937–1940." *Balkan Dance: Essays on Characteristics, Performance and Teaching*, edited by Anthony Shay, McFarland & Co., Inc., 2008, pp. 89–115.

Magocsi, Paul Robert. *A History of Ukraine: The Land and Its Peoples*. 2nd ed., University of Toronto Press, 2010.

Manning, Frank E. "Spectacle." *Folklore, Cultural Performances, and Popular Entertainments: A Communications-centered Handbook*, edited by Richard Bauman, Oxford University Press, 1992, pp. 291–97.

Martynowych, Orest T. *The Showman and the Ukrainian Cause: Folk Dance, Film, and the Life of Vasile Avramenko*, University of Manitoba Press, 2014.

McCauley, Martin. "From Perestroika towards a New Order, 1983–1995." *Russia: A History*, edited by Gregory L. Freeze, Oxford University Press, 2002, pp. 383–421.

McClintock, Anne. "'No Longer in a Future Heaven': Nationalism, Gender, and Race." *Becoming National: A Reader*, edited by Geoff Eley and Ronald Grigor Suny, Oxford University Press, 1996, pp. 260–84.

Meisner, Nadine. "Igor Moiseyev." Obituary. *The Independent* [London], November 5, 2007, p. 2.

Microsoft Encarta College Dictionary. St. Martin's Press, 2001.

Miller, Frank J. *Folklore for Stalin: Russian Folklore and Pseudofolklore of the Stalin Era*, M. E. Sharpe, 1990.

Minder, Raphael. "Catalonia Plans Vote on Splitting From Spain." *New York Times*, June 10, 2017, p. A6.

Moiseyev, Igor. "The Ballet and Reality." *Ulanova, Moiseyev and Zakharov on Soviet Ballet*, edited by Peter Brinson, SCR, 1954, pp. 11–19.

———. *Ya Vsponimaiu...Gastrol' Dlinoiu v Zhizn'*, Soglasie, 1996.

———. *Ya Vspominaiu...Gastrol' Dlinoiu v Zhizn'*, updated edition, Soglasie, 2016.

The Igor Moiseyev Dance Company from Moscow. Program, Hurok Artists, Inc., 1958.

The Igor Moiseyev Dance Company. Program, Hurok Concerts, Inc., 1961.

———. Program, Hurok Concerts, Inc., 1965.

———. Publicity, ICM Artists, Ltd., 1997.

The Igor Moiseyev Dance Company: State Academic Ensemble of Popular Dance of the USSR, 1986.

The Igor Moiseyev Dance Company: State Academic Ensemble of Popular Dance, 2002.

Morris, Gay. *A Game for Dancers: Performing Modernism in the Postwar Years, 1945–1960*, Wesleyan University Press, 2006.

Morrison, Simon. *Bolshoi Confidential: Secrets of the Russian Ballet from the Rule of the Tsars to Today*, Liveright, 2016.

Motyl, Alexander J. *Sovietology, Rationality, Nationality: Coming to Grips with Nationalism in the USSR*, Columbia University Press, 1990.

Nadel, Alan. "Cold War Television and the Technology of Brainwashing." *American Cold War Culture*, edited by Douglas Field, Edinburgh University Press, 2005, pp. 146–63.

Nahachewsky, Andriy. *Ukrainian Dance: A Cross-Cultural Approach*, McFarland & Co, 2012.

Nercessian, Andy. "National Identity, Cultural Policy and the Soviet Folk Ensemble in Armenia." *Soviet Music and Society under Lenin and Stalin: The Baton and Sickle*, edited by Neil Edmunds, Routledge, 2004, pp. 148–62.

Nevile, Jennifer. "Introduction and Overview." *Dance, Spectacle, and the Body Politick, 1250–1750*, edited by Jennifer Nevile, Indiana University Press, 2008, pp. 1–64.

Nix, Philip C. interview, February 6, 2016.

Olson, Laura J. *Performing Russia: Folk Revival and Russian Identity*, Routledge, 2004.

Orlovsky, Daniel. "Russia in War and Revolution, 1914–1921." *Russia: A History*, edited by Gregory L. Freeze, Oxford University Press, 2002, pp. 231–62.

Osgood, Kenneth. *Total Cold War: Eisenhower's Secret Propaganda Battle*, University Press of Kansas, 2006.

Overholser, Lisa M. "Staging the Folk Processes and Considerations in the Staging of Folk Dance Forms." Ph.D. dissertation, Indiana University, 2010.

Oxford Russian Dictionary. 4th ed., Russian-English, edited by Marcus Wheeler and Boris Ungeaun, English-Russian edited by Paul Falla. Revised and updated by Dellar Thompson, Oxford University Press, 2007.

Özkırmılı, Umut. *Theories of Nationalism: A Critical Introduction*. Foreword by Fred Halliday, Macmillan, 2000.

Pagels, Jurgen. *Character Dance*, Indiana University Press, 1984.

Parker, Ralph. "Ukrainian Dance Company". Program, 1972.

Patterson, James T. *Grand Expectations: The United States, 1945–1974*, Oxford University Press, 1996.

——— . *Restless Giant: The United States from Watergate to Bush V. Gore*, Oxford University Press, 2005.

Petrone, Karen. *Life Has Become More Joyous, Comrades: Celebrations in the Time of Stalin*, Indiana University Press, 2000.

Potter, David S. "Entertainers in the Roman Empire." *Life, Death, and Entertainment in the Roman Empire*, edited by D. S. Potter and D. J. Mattingly, University of Michigan Press, 2010, pp. 280–349.

Poulton, Hugh. *Who Are the Macedonians?*, Indian University Press, 1995.

Prazauskas, Algimantas. "The Influence of Ethnicity on the Foreign Policies of the Western Littoral States." *National Identity and Ethnicity in Russia and the New States of Eurasia*, edited by Roman Szporluk, M. E. Sharpe, 1994, pp. 150–84.

Prest, Julia. "The Politics of Ballet at the Court of Louis XIV." *Dance, Spectacle, and the Body Politick, 1250–1750*, edited by Jennifer Nevile, Indiana University Press, 2008, pp. 229–40.

Prevots, Naima. *Dance for Export: Cultural Diplomacy and the Cold War,* Wesleyan University Press, 1998.

Prokhorov, Vadim. *Russian Folk Songs: Musical Genres and History*, Scarecrow Press, 2002.

Raftis, Alkis. President of the Dora Stratou Theatre of Greek Folk Dances. Multiple interviews. Athens, Greece, February, 2000–June, 2015.

Reeves, Nicholas. *Akhenaton: Egypt's False Prophet*, Thames & Hudson, 2005.

Reynolds, Nancy and Malcolm McCormick. *No Fixed Points: Dance in the Twentieth Century*, Yale University Press, 2003.

Richmond, Yale. *US Soviet Cultural Exchanges, 1958–1986: Who Wins?* Westview Press, 1987.

——— . *Cultural Exchange and the Cold War: Raising the Iron Curtain*, Pennsylvania State University Press, 2003.

Robinson, Harlow. *The Last Impresario: The Life, Times and Legacy of Sol Hurok*, Viking, 1994.

Rockwell, David and Bruce Mau. *Spectacle*, Phaidon, 2006.

Rosenberg, Neil V., editor. *Transforming Tradition: Folk Music Revivals Examined,* University of Illinois Press, 1992.

Roth-Ey, Kristin. *Moscow Prime Time: How the Soviet Union Built the Media Empire that Lost the Cultural Cold War,* Cornell University Press, 2011.

Rouland, Michael. "A Nation on Stage: Music and the 1936 Festival of Kazak Arts." *Soviet Music and Society under Lenin and Stalin: The Baton and Sickle*, edited by Neil Edmunds, Routledge, 2004, pp. 181–208.

Russian Festival of Music and Dance. Program, Sol Hurok Presents. 1959–1960 Season.

Russian Village Festival. Program, David Eden Productions, Ltd. April 15, 1997.

Ryan, David. "Politics: Mapping Containment: The Cultural Construction of the Cold War." *American Cold War Culture*, edited by Douglas Field, Edinburgh University Press, 2005, pp. 50–68.

Rywkin, Michael. *Moscow's Lost Empire*, M. E. Sharpe, 1994.

Saunders, Frances Stonor. *The Cultural Cold War: The CIA and the World of Arts and Letters*, The New Press, 2013.

Schauert, Paul. *Staging Ghana: Artistry and Nationalism in State Dance Ensembles*, Indiana University Press, 2015.

Schechner, Richard. *Performance Theory*, Routledge, 2003.

Scholl, Tim. *From Petipa to Balanchine: Classical Revival and the Modernization of Ballet*, Routledge, 1994.

Searcy, Anne. "The Recomposition of Aram Khachaturian's Spartacus at the Bolshoi Theatre: 1958–1968." *Journal of Musicology*, vol. 33, no. 3, 2016, pp. 362–400.

Segal, Lewis. "Igor Moiseyev, 101; Elevated Folk Dancing into a Theatrical Art." *Los Angeles Times*, Obituaries, November 3, 2007, p. B10.

Shamina, Lidia. *Khoziani Tantsa/Master of the Dance*, Gostudarstvennii Akademitcheskii Ansambl' Narodnogo Tantsa Pod Rukovodstvom Igoria Moiseyeva, 2004.

——— and Olga Moiseyeva. *Teatr Igoria Moiseyeva*, Teatralis, 2012.

Shay, Anthony. "Dance and the Red and Lavender Scares." *The Dancer-Citizen*, May 2018, http://www.dancercitizen.org/.

——— . "Dance as the 'International Language': The Search for an American Cultural Voice at the Height of the Cold War: *Impulse* 1963–1964." *Perspectives on Contemporary Dance History: Revisiting Impulse, 1950–1970*, edited by Thomas K. Hagood and Luke C. Kahlich, 2013.

——— . "Lado, The State Ensemble of Croatian Folk Dances and Songs: Icon of Croatian Identity." *Oxford Handbook of Dance and Ethnicity*, edited by Anthony Shay and Barbara Sellers-Young, Oxford University Press, 2016b, pp. 256–78.

——— . *Ethno-Identity Dance for Sex, Fun, and Profit: Choreographing Popular Dances Around the World*, Palgrave Macmillan, 2016c.

——— . *The Dangerous Lives of Public Performers: Dancing, Sex, and Entertainment in the Middle East*, Palgrave Macmillan, 2014.

——— . "The Spectacularization of Soviet/Russian Folk Dance: Igor Moiseyev and the Invented Tradition of Staged Folk Dance." *Oxford Handbook of Dance and Ethnicity*, edited by Anthony Shay and Barbara Sellers-Young, Oxford University Press, 2016a, pp. 236–55.

Shay, Anthony and Barbara Sellers-Young. "Introduction." *Oxford Handbook of Dance and Ethnicity*, edited by Anthony Shay and Barbara Sellers-Young, Oxford University Press, 2016.

——— . *Choreographing Identities: Folk Dance, Ethnicity and Festival in the United States and Canada*, McFarland, 2006.

——— . *Choreographic Politics: State Folk Dance Companies, Representation and Power*, Wesleyan University Press, 2002.

Shcherbakova, Elena. Current Artistic Director of The Igor Moiseyev Dance Company. Multiple interviews. Moscow, Russia. May 28–June 2, 2016.

Sheremetyevskaya, Natalia. *Rediscovery of the Dance: Folk Dance Ensemble of the USSR Under the Direction of Moiseyev*. Translated by J. Guralsky, Novosti Press Agency Publishing House, 1960.

Siegelbaum, Lewis. "Building Staslinism, 1929–1941." *Russia: A History*, edited by Gregory L. Freeze, Oxford University Press, 2002, pp. 291–318.

Slezkine, Yuri. "The USSR as a Communal apartment, or How a Socialist State Promoted Ethnic Particularism." *Becoming National: A Reader*, edited by Geoff Eley and Ronald Grigor Suny, Oxford University Press, 1996, pp. 202–38.

Slobin, Mark. "Introduction." *Returning Culture: Musical Changes in Central and Eastern Europe*, edited by Mark Slobin, Duke University Press, 1996, pp. 1–13.

Slonimsky, Juri and Others. *The Soviet Ballet*, Da Capo Press, 1970.

Smith, Graham, editor. *The Nationalities Question in the Post-Soviet State*, Longman, 1996.

Smith, Stenson W. *The Art and Architecture of Ancient Egypt*. Revised with additions by William Kelly Simpson, Yale University Press, 1981.

Souritz, Elizabeth. *Soviet Chreographers in the 1920s*. Translated from the Russian by Lynn Visson and edited, with additional translation, by Sally Banes, Duke University Press, 1990.

——— . "Moscow's Island of Dance, 1934–1941." *Dance Chronicle*, vol. 17, no.1, 1994, pp. 1–92.

Sremac, Stjepan. "Folklorni Ples u Hrvata od Izvora do Pozornice: Izmedju drustvene I kulturne potrebe, politike, kulturnog I nacionalnog identiteta." University of Zagreb, Philosophy Faculty. Unpublished Ph.D. dissertation, 2001.

Stites, Richard. "Frontline Entertainment." *Culture and Entertainment in Wartime Russia*, edited by Richard Stites, Indiana University Press, 1995, pp. 126–40.

———. "The Ways of Russian Popular Music to 1953." *Soviet Music and Society under Lenin and Stalin: The Baton and Sickle*, edited by Neil Edmunds, Routledge, 2004, pp. 19–32.

Subtelny, Orest. *Ukraine: A History*. 4th ed., University of Toronto Press, 2009.

Swift, Mary Grace. *The Art of the Dance in the USSR*, University of Notre Dame Press, 1968.

Szporluk, Roman. "Introduction: Statehood and Nation Building in Post-Soviet Space." *National Identity and Ethnicity in Russia and the New States of Eurasia*, edited by Roman Szporluk, M. E. Sharpe, 1994, pp. 3–17.

———. "Thoughts about Change: Ernest Gellner and the History of Nationalism." *The State of the Nation: Ernest Gellner and the Theory of Nationalism*, edited by John A. Hall, Cambridge University Press, 1998, pp. 23–39.

Taruskin, Richard. *Defining Russia Musically: Historical and Hermeneutical Essays*, Princeton University Press, 1997.

Teague, Elizabeth. "Center-Periphery Relations in the Russian Federation." *National Identity and Ethnicity in Russia and the New States of Eurasia*, edited by Roman Szporluk, M. E. Sharpe, 1994, pp. 21–57.

"The Amazing Igor Moiseyev Dance Company." DVDs, Three Volumes, Video Artists International, 2007.

"The Igor Moiseyev Dance Company: A Gala Evening." V.I.E.W., n.d.

Ther, Philipp. *The Dark Side of Nation-States: Ethnic Cleansing in Modern Europe*. Translated from the German by Charlotte Kreutzmüller, Berghahn, 2014.

Tishkov, Valery. *Ethnicity, Nationalism and Conflict in and After the Soviet Union*, Sage, 1997.

Tkachenko, Tamara. *Narodny Tanets*, Isskustvo, 1954.

Tuminez, Astrid S. *Russian Nationalism since 1856: Ideology and the Making of Foreign Policy*, Rowan and Littlefield Publishers, 2000.

Uralskaya, Valeria I. "Russia: Traditional Dance." *International Encyclopedia of Dance, vol. 5*, Oxford University Press, 1998, pp. 443–45.

Varjasi, Rezsö and Vince Horváth. *Rhapsodie Hongroise: L'Ensemble Populaire de L'Etat Hongrois*, Corvina, 1956.

Volkov, Solomon. *Shostakovich and Stalin: The Extraordinary Relationship between the Great Composer and the Brutal Dictator*. Translated from the Russian by Antonia W. Bouis, Alfred A. Knopf, 2004.

Von Bibra, Anne. "Continuity and Change in the Dance Events of Two Lower Franconian Villages during the Twentieth Century." Unpublished MA Thesis, UCLA, 1987.

Webb, Ruth. *Demons and Dancers: Performance in Late Antiquity*, Harvard University Press, 2008.

Weber, Eugen. *Peasants into Frenchmen: The Modernization of Rural France, 1870–1914*, Stanford University Press, 1976.

Zelnik, Reginald E. "Revolutionary Russia, 1890–1914." *Russia: A History*, edited by Gregory L. Freeze, Oxford University Press, 2002, pp. 200–230.

Zemtsovsky, Izaly. "Russia." *The Garland Encyclopedia of World Music, vol. 8: Europe*, edited by Timothy Rice, James Porter, and Chris Goetzen, Garland Publishing, Inc., 2000, pp. 754–89.

——— . and Alma Kunanbaeva. "Communism and Folklore." *Folklore and Traditional Music in the Former Soviet Union and Eastern Europe: Proceedings of a One-day Conference*, edited by James Porter, Department of Ethnomusicology, 1994, pp. 3–23.

Zguta, Russell. *Russian Minstrels: A History of the Skomorkhi,* University of Pennsylvania Press, 1978.

Zhornitskaya, M. Ia. "The Study of Folk Dancing in the Soviet Union: Its State and Tasks." *The Performing Arts: Music and Dance*, edited by John Blacking and Joann W. Kealiinohomoku, Mouton Publishers, 1979, pp. 79–90.

Zinn, Howard. *The Twentieth Century*, Harper Perennial, 2003.

Index